dirty OLD
BOSTON

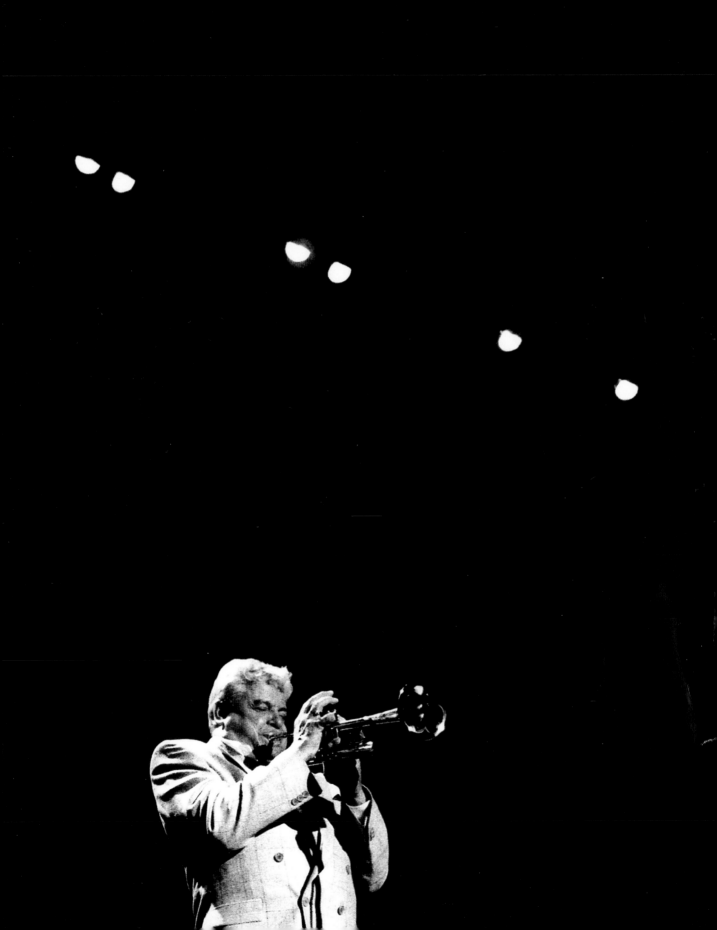

dirty OLD BOSTON

FOUR DECADES *of a* CITY IN TRANSITION

JIM BOTTICELLI

UNION PARK PRESS BOSTON

Union Park Press
Wellesley, MA 02481
www.unionparkpress.com

Printed in the U.S.A.
First Edition

Library of Congress Cataloging-in-Publication Data available upon request.
ISBN: 978-1-934598-12-2

Book and cover design by Vale Hill Creative. www.valehillcreative.com

Front cover image: © the Nick DeWolf Foundation
Back cover image: Photo by Richard Leonhardt

Although the author and Union Park Press have taken all reasonable care in
preparing this book, we make no warranty about the accuracy and completeness
of its content and, to the maximum extent permitted,
disclaim all liability arising from its use.

All information in this book was accurate at the time of publication
but is subject to change.

Please visit our website to learn more about our titles:
www.unionparkpress.com.

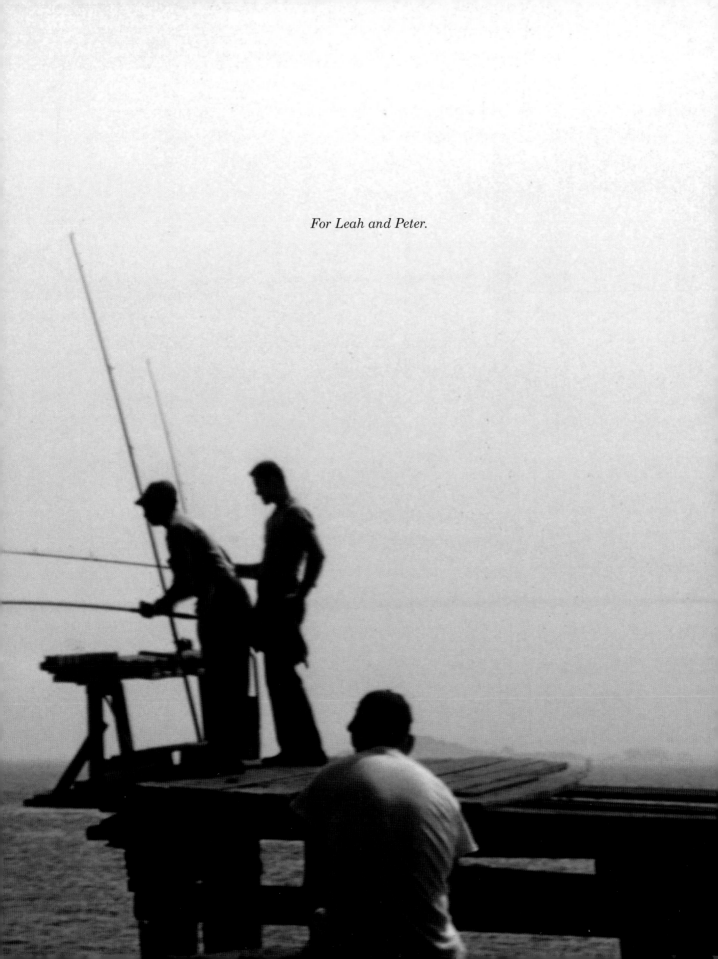

For Leah and Peter.

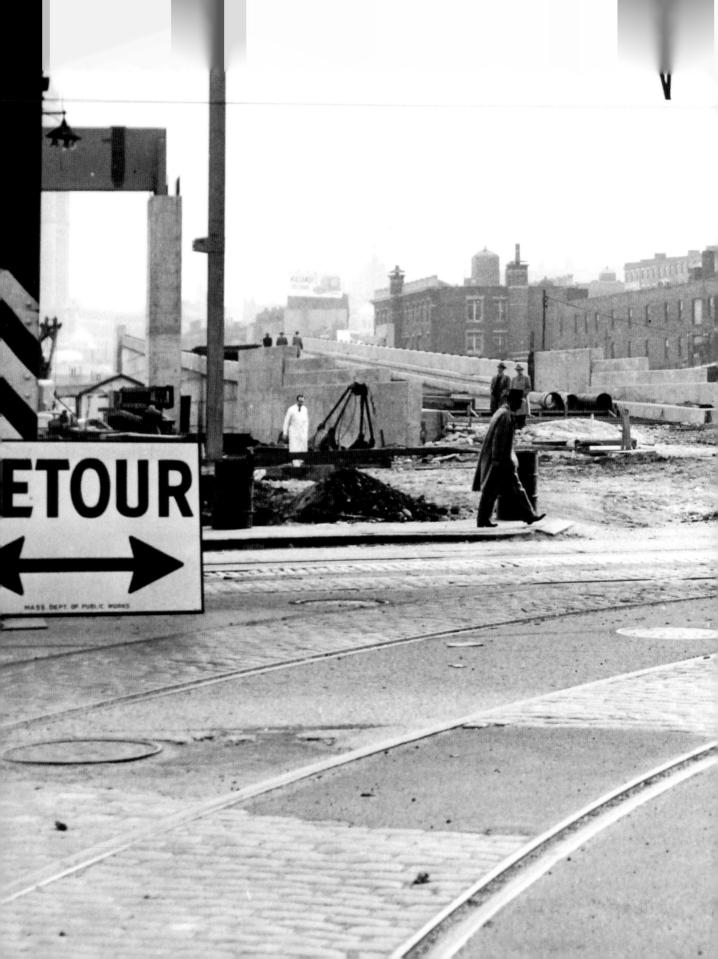

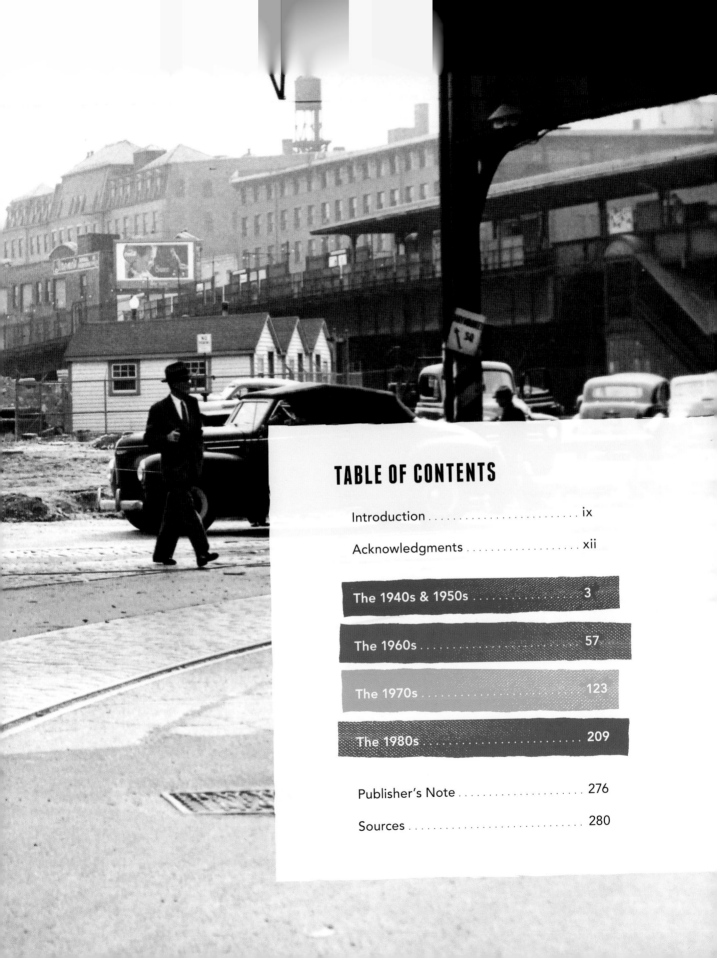

TABLE OF CONTENTS

INTRODUCTION

Greetings from Dirty Old Boston

Histories of Boston are often somber declarations of the "Seriousness" with which "Things" were "Once Done." "Magnificent Men" produced high-minded "Concepts" and "Ideas," the kind upon which nations and cultures were founded. And, of course, Boston's history is steeped in the very founding of this country. Just have a look at the city's sculpture, architecture, and literature and you'll see that pride reflected back at you. It seems like it's our right as Bostonians to claim such cultural importance as our own. It's Boston's to have and to hold. And hold it, this city does. Tightly.

But *Dirty Old Boston* is not about any of that. *Dirty Old Boston* is a salute to our more recent past. A past where ordinary people lived their day-to-day lives in a challenging but still affordable city. It was a place where you could find a parking spot when you needed it. A city where you could own your own home for about a quarter of your monthly take-home pay. A city where you didn't need a reservation to grab a bite, and would probably rather spend a Saturday night on the front steps with your neighbors anyway.

For our purposes, this story begins just after World War II with the birth of the first baby boomers. It ends in 1987, when the MBTA's elevated Orange Line came down and real estate prices went up. As Boston's boomers turned forty, the mid-1980s ushered in an era of rapid change and gentrification. Multi-generational triple-deckers turned into condos; mom and pop stores were replaced by corporate chains; kids who used to play ball out in the street lost their playgrounds to parking lots. Suddenly it became fashionable to expose brick walls. Well-worn carpeting was torn up and what lay beneath was beautiful: oak, maple, wide-planked pine begging for a shine. Suspended ceilings that camouflaged detailed molding, the likes of which is no longer made, exposed the past. Boston had history all right—if only these renovated triple-deckers could talk. The stories they would tell.

Dirty Old Boston is a collection of photographs documenting some of those stories—photographic vignettes, really. We see the celebrations and the drudgery of ordinary urban life. Professional photographers took some photos, but everyday people using their Brownies, Instamatics, and Polaroid Land Cameras shot many of the images in this book. There are cool moments as well as strange ones; there are images that will make you proud to be a Bostonian and some that will make you cringe. It's a book of film-noir images, grimy black and whites as well as over-saturated color. It's the story about Boston's ethnic enclaves attempting to survive, the marginalized raising their voices, and all those cheap and plentiful joints where a guy or gal could grab a beer and not break the bank. It's the shared grimace of surviving snowstorms and rush hour traffic jams on the Central Artery, knowing what the inside of the Rat's bathrooms are like, and aching for the Red Sox to finally win a series.

As a collection, the book shows the evolution of the city—how simplicity gave way to a shinier vision of what many believed our lives were supposed to look like. Sure,

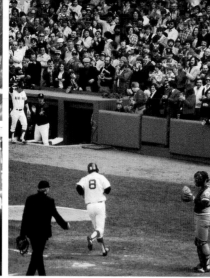

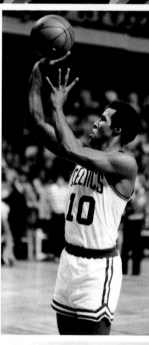
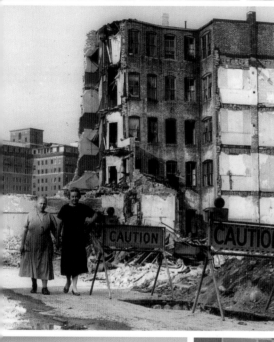
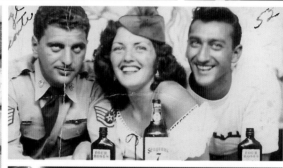
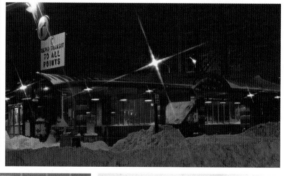
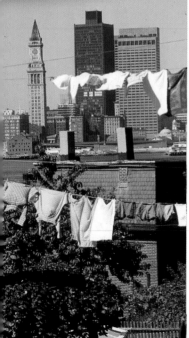
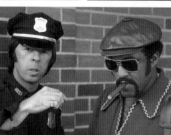
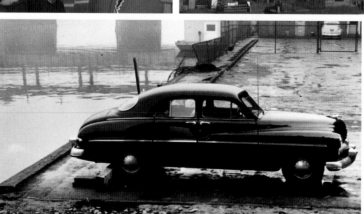

SOUTH END
NEEDS
AFFORDABLE
HOUSING
TENT
CITY

dirty old Boston was a shabbier place, but in many respects the city was home in a far more rooted, connected way. Practically anyone could live here and it sure seemed like everyone did. This book shows the city's struggles and challenges. It shows what turned us on—the music, the cars, and the clothes. The hair. *The hair!* We travel in time from the construction of the Central Artery to the moments when plans were hatched to take that behemoth down. It takes us out of Scollay Square and into the Combat Zone, from the Public Garden right on up to the Esplanade. These were the places we all knew and cherished. Like the city itself, this book shows the highs and the lows of culture and the highs and the lows of our collective experience during these four decades.

More than anything, though, *Dirty Old Boston* is a term of endearment for an era and an aura that personified this place. Today's Boston has left many of the city's most loyal denizens feeling jilted and jolted. There are those who say that Boston is better off than it has ever been. But as one noted Charlestown activist asked, "Better for who?" Maybe it's the march of time. The double-edged sword of "progress." But where is that world we used to know? This is a tribute to those people and places—warts and all. It is my hope that readers will find this tribute sincere and humorous. And for the city's newcomers, here you can peek behind the curtain to see Boston as it was, as it used to be, as some of us wish it still was. Have a nip of that magic potion, nostalgia.

———————

This book grew out of a Facebook page I started in 2012. I came to Boston in 1971 for an education and ended up calling the city home. The Dirty Old Boston page was an experiment to see what photos I could unearth of Boston from the mid-twentieth century. I'm a sucker for cultural debris from that period, and while I'm nostalgic for the era, my love of Boston really drove the project.

After a week or two of posting, people took notice and began adding images from their collections and albums. Suddenly, it was like being back in the old neighborhood. Each photo ignited discussion; people let their passion for the city's past soak through the site. There were tens of thousands of people who—like me—were misty for these lost decades. They remembered what Boston was like when they came back from the war, raised their families, and saw their kids riding the Orange Line through the South End. There were also thousands who were born too late and wanted to see what their city used to be.

I want to be clear: I am not a historian. I am just a guy who loves history. One of my favorite parts of running the Dirty Old Boston Facebook page was posing a question to the crowd, asking for details about location, the year, the people pictured. With these posts, I began to add the words that could almost be my catchphrase at this point: "Someone will know…" And guess what? *Someone always knew.* I love this town.

ACKNOWLEDGMENTS

My dear publishing team at Union Park Press suggested this book to me. Together, we started grinding out the work. We solicited our online community. We scoured city, state, and national archives. We visited historical societies, spoke to folks managing private collections, and visited various other institutions. Long story short, we got a lot of interesting photos depicting the fascinating everydayness of Boston during this period.

This book would not be possible without the enthusiasm so many people showed, whether it was in the online comments and emails or the family photos people scanned and sent in. We thank the amateur and professional photographers who were kind enough to contribute their work to the book. There are many.

I want to thank the contributors and followers of the Dirty Old Boston page. Because of your effort and participation, the page stays fresh, dynamic, and engaging.

We also offer condolences to the families and friends of Ed O'Connell and Michael Rizza, both of whom passed after contributing to the book. We are grateful their photographs will live on.

Jim Botticelli
2014

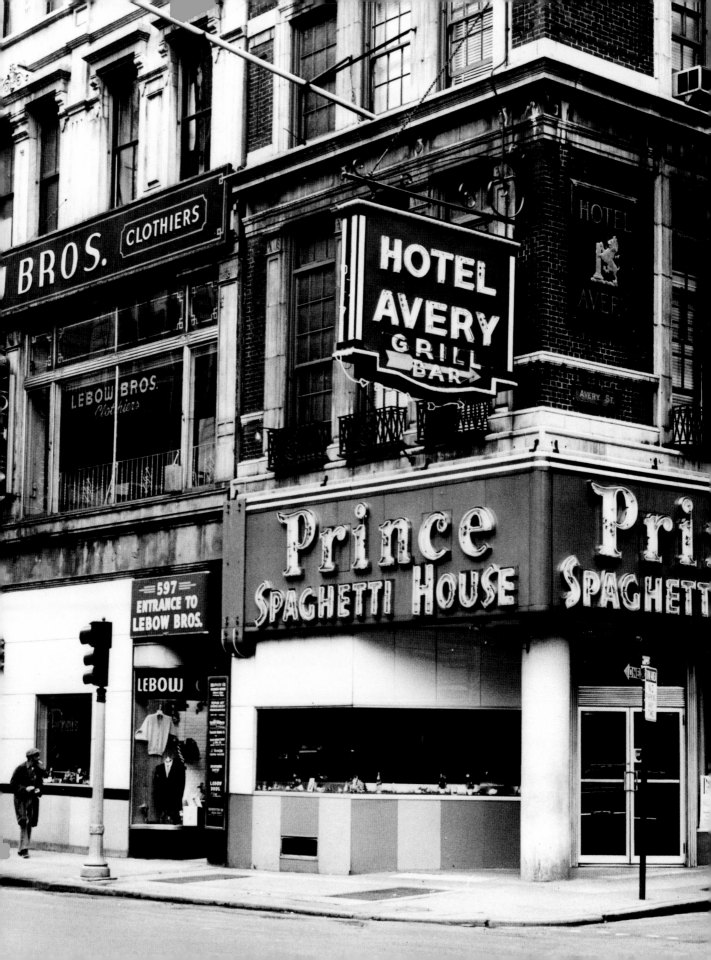

"**The Lowell School in J.P.**, Ms. McAndrew's sixth grade class.
The Boston Public School manual training class's Mass Turnpike
contest winners! Left to right: Ronald Morrow, Gerald Creedon,
and John Kamaiegian. We each received a small gift from
the City of Boston: a chauffeured tour of the State House and
our picture in the Herald Traveler!"

– Ronald Morrow

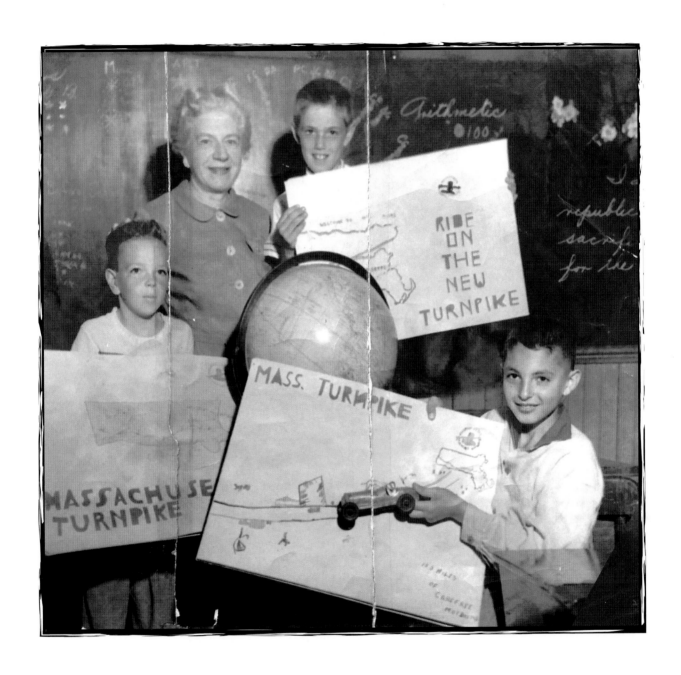

the **1940s** *&* **1950s**

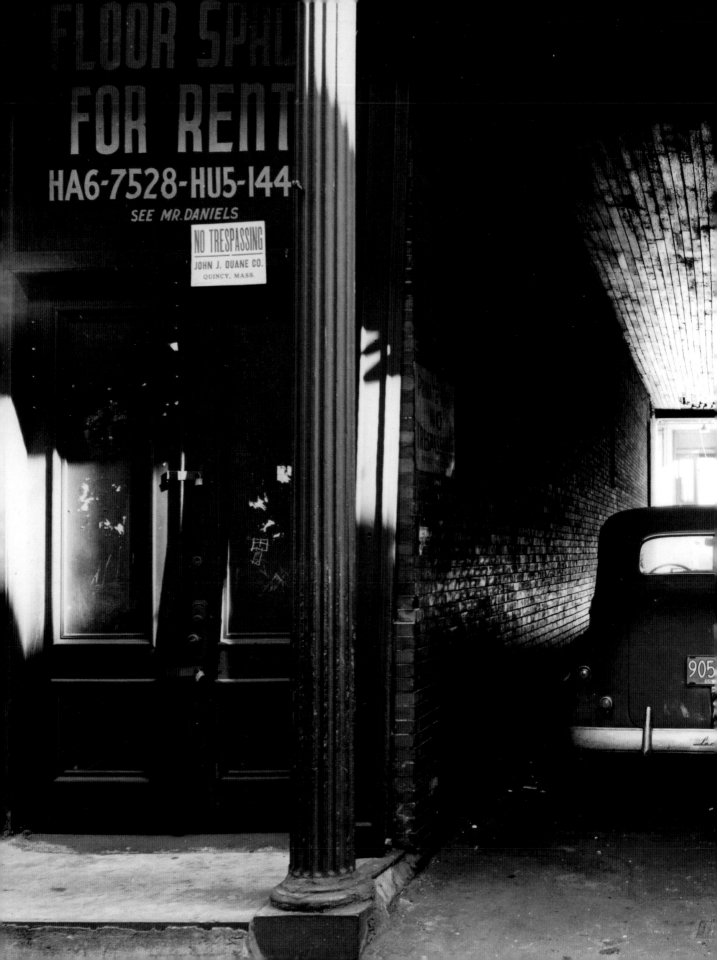

DELICI

HOM'S
DELICIOUS CHINESE FOOD
RESTAURANT

H

Madison Place, part of the New York Streets section of the South End, demolished in the late 1950s. *Courtesy City of Boston.*

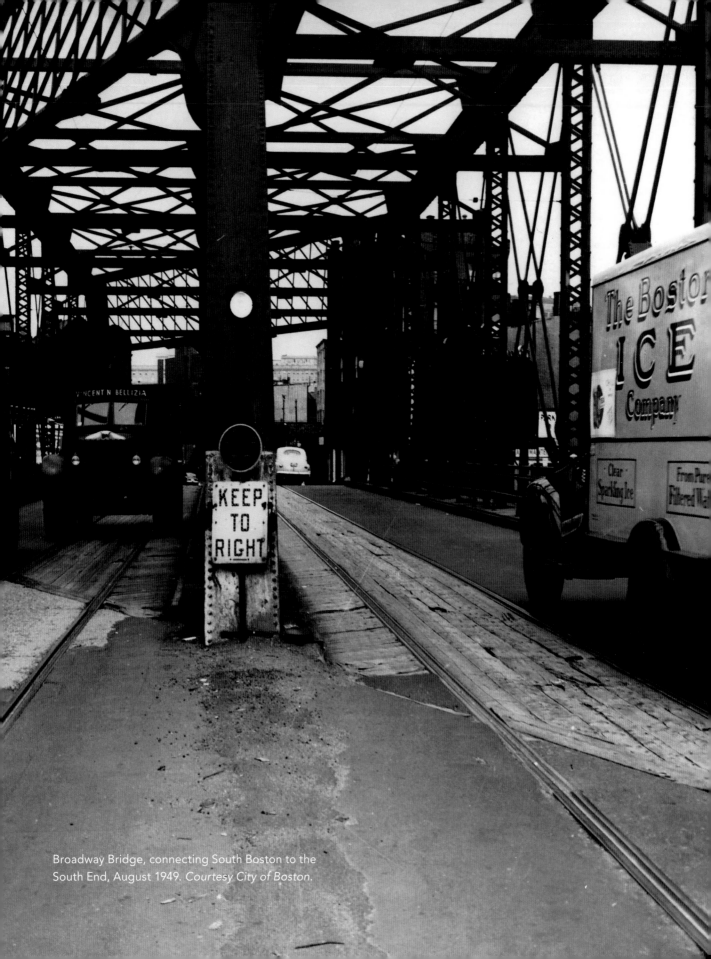

Broadway Bridge, connecting South Boston to the South End, August 1949. *Courtesy City of Boston.*

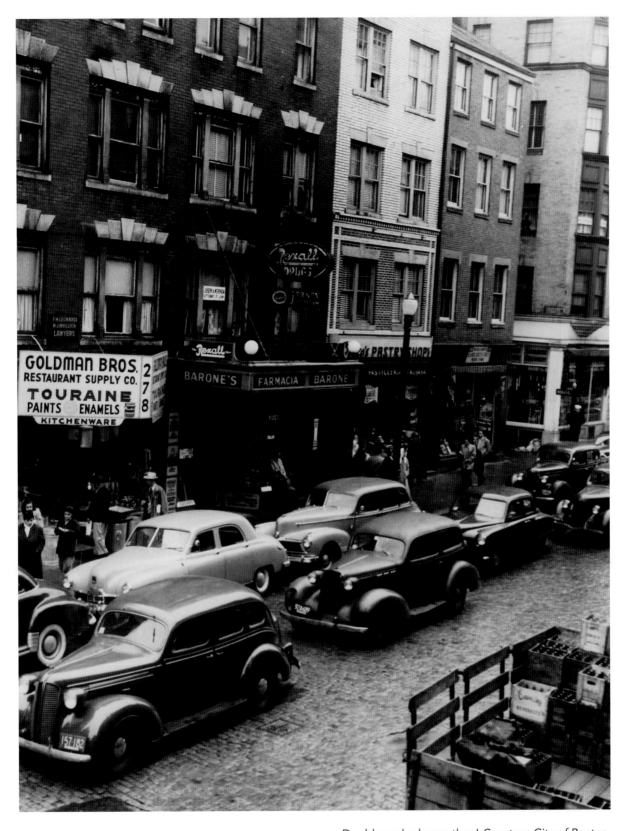

Double parked even then! *Courtesy City of Boston.*

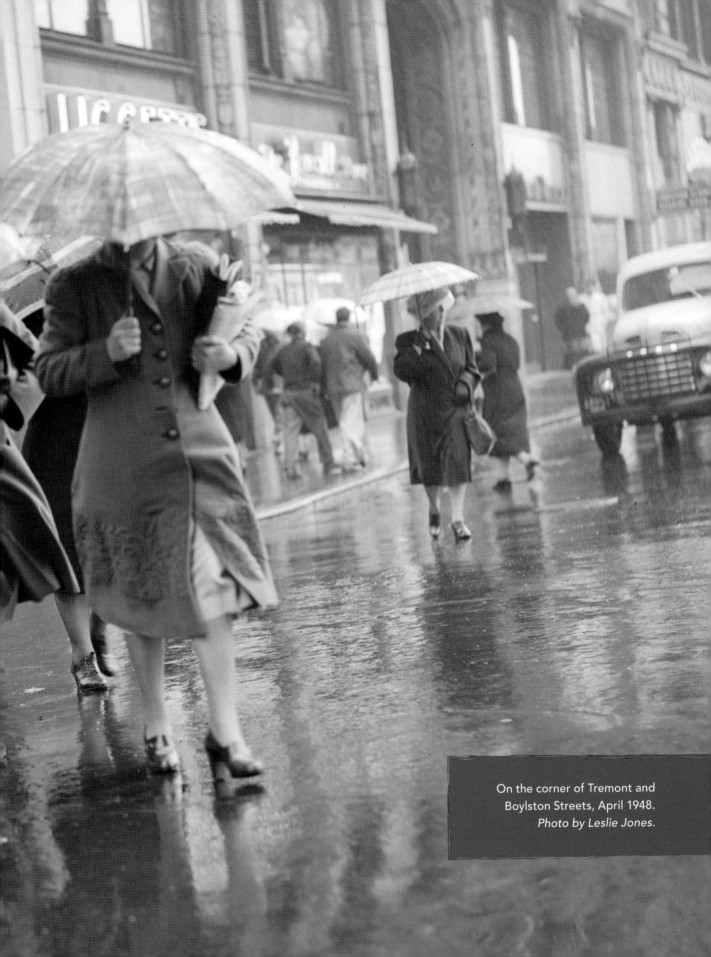

On the corner of Tremont and Boylston Streets, April 1948. *Photo by Leslie Jones.*

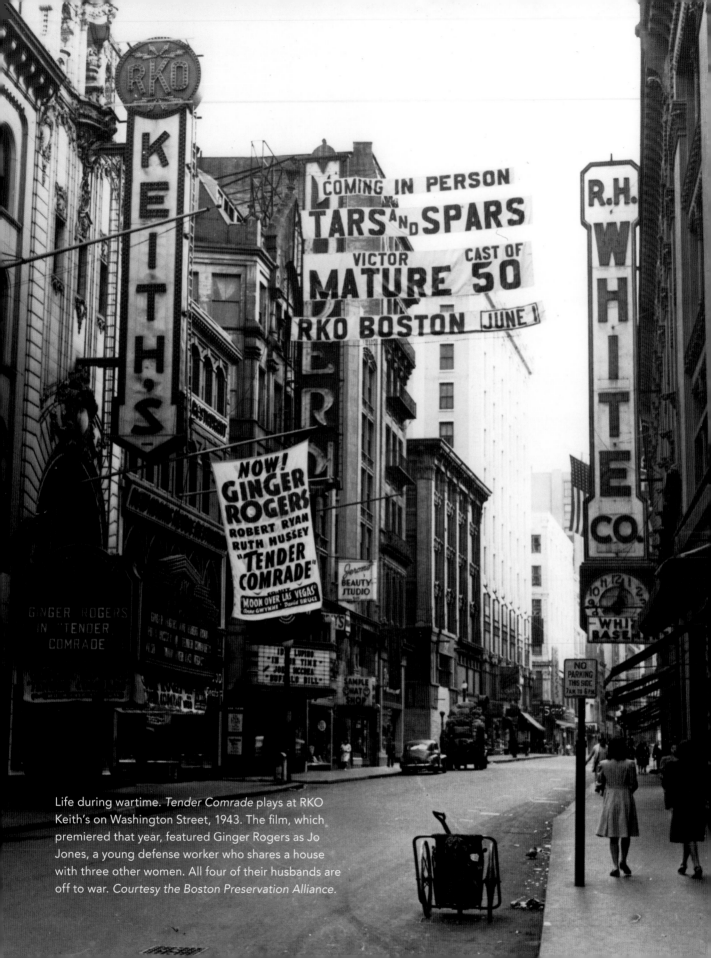

Life during wartime. *Tender Comrade* plays at RKO Keith's on Washington Street, 1943. The film, which premiered that year, featured Ginger Rogers as Jo Jones, a young defense worker who shares a house with three other women. All four of their husbands are off to war. *Courtesy the Boston Preservation Alliance.*

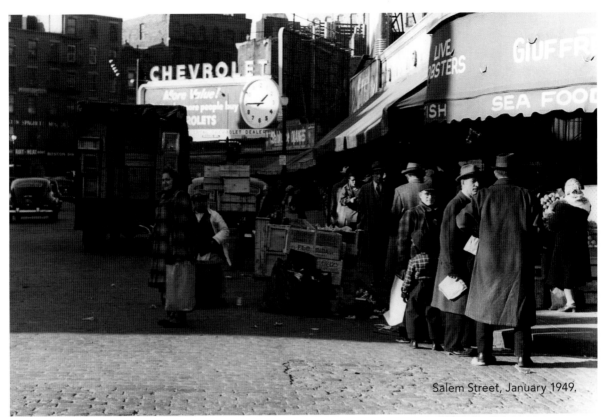

Salem Street, January 1949.

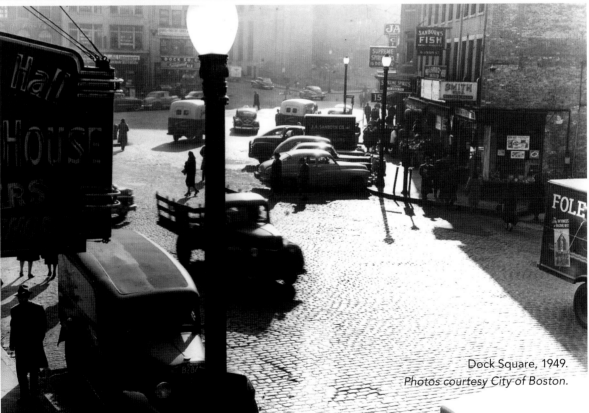

Dock Square, 1949.
Photos courtesy City of Boston.

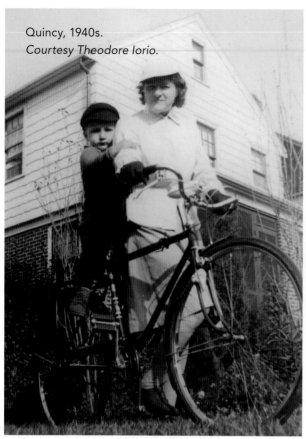

Quincy, 1940s.
Courtesy Theodore Iorio.

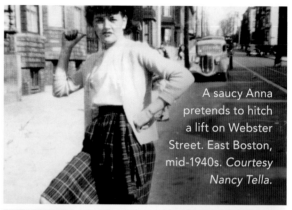

A saucy Anna pretends to hitch a lift on Webster Street. East Boston, mid-1940s. *Courtesy Nancy Tella.*

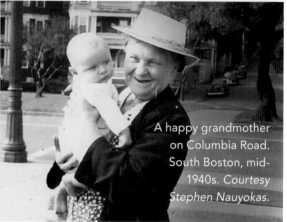

A happy grandmother on Columbia Road. South Boston, mid-1940s. *Courtesy Stephen Nauyokas.*

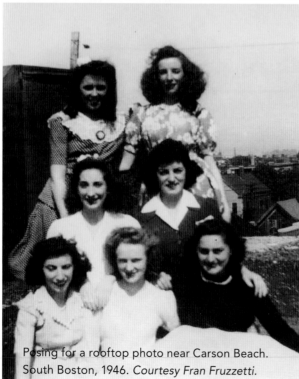

Posing for a rooftop photo near Carson Beach. South Boston, 1946. *Courtesy Fran Fruzzetti.*

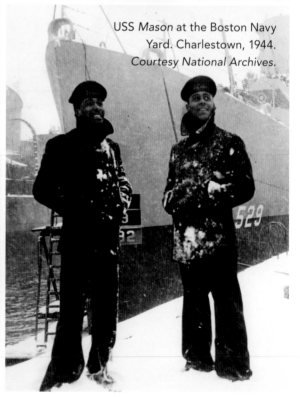

USS *Mason* at the Boston Navy Yard. Charlestown, 1944. *Courtesy National Archives.*

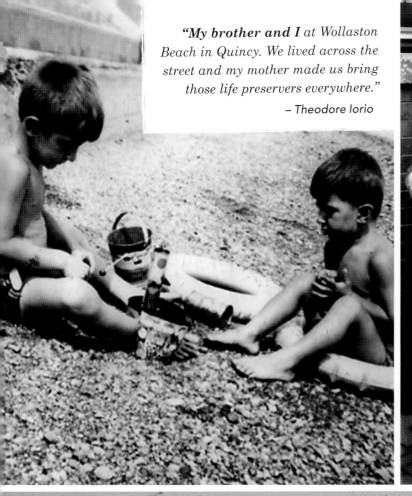

"*My brother and I* at Wollaston Beach in Quincy. We lived across the street and my mother made us bring those life preservers everywhere."

– Theodore Iorio

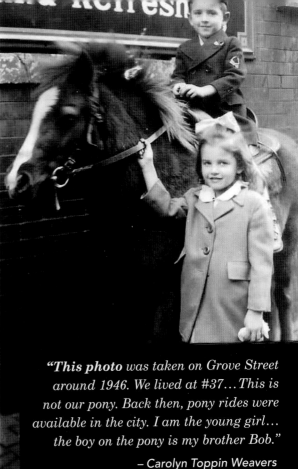

"*This photo* was taken on Grove Street around 1946. We lived at #37…This is not our pony. Back then, pony rides were available in the city. I am the young girl… the boy on the pony is my brother Bob."

– Carolyn Toppin Weavers

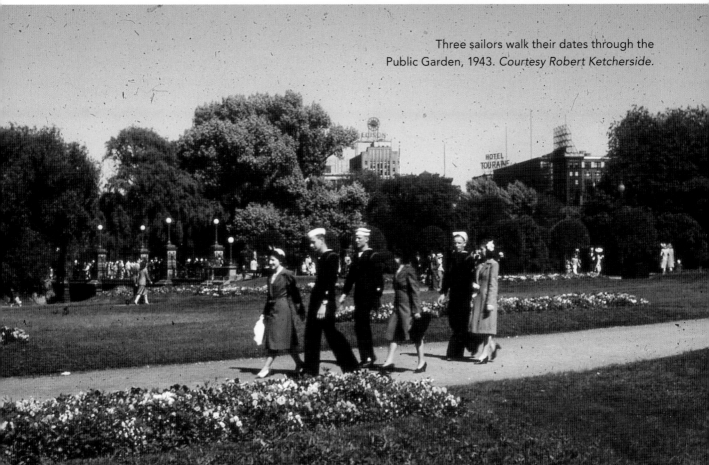

Three sailors walk their dates through the Public Garden, 1943. *Courtesy Robert Ketcherside.*

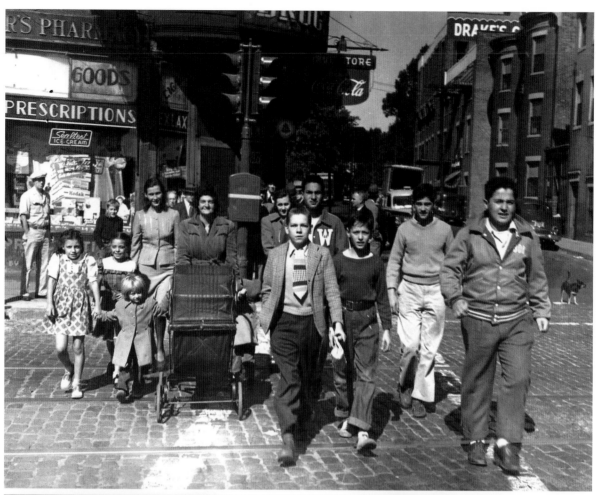

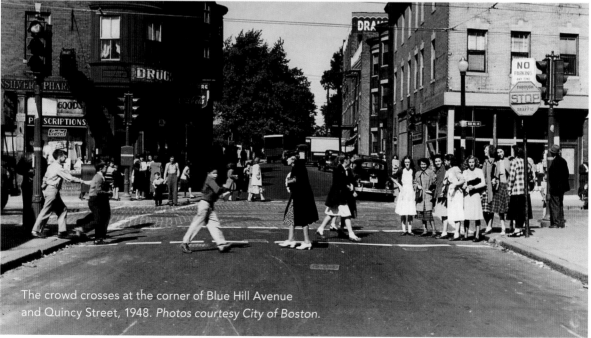

The crowd crosses at the corner of Blue Hill Avenue and Quincy Street, 1948. *Photos courtesy City of Boston.*

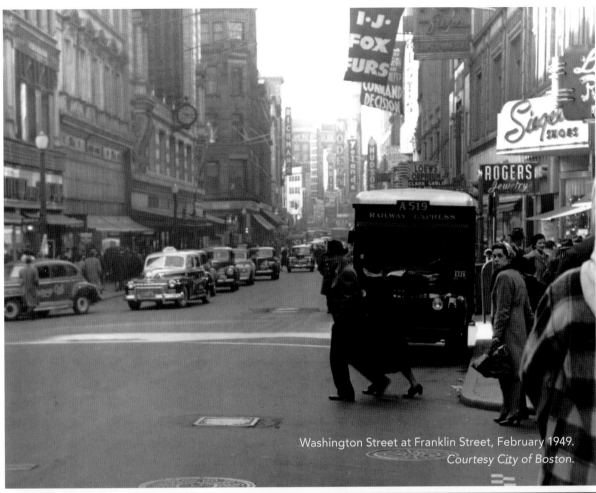

Washington Street at Franklin Street, February 1949.
Courtesy City of Boston.

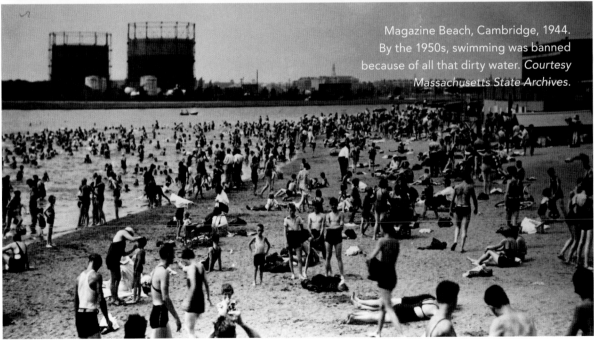

Magazine Beach, Cambridge, 1944.
By the 1950s, swimming was banned
because of all that dirty water. *Courtesy
Massachusetts State Archives.*

*"**My mom in pin curls.** Mary Harvey-Dingee, with my two brothers, Steve and Lee Dingee, at Columbia Point Projects around 1956. I wasn't born yet. She later divorced and was married to my step-dad, Nick Singelakis, who owned the Colonial Room and the Elite in South Boston."* – Renee Devine

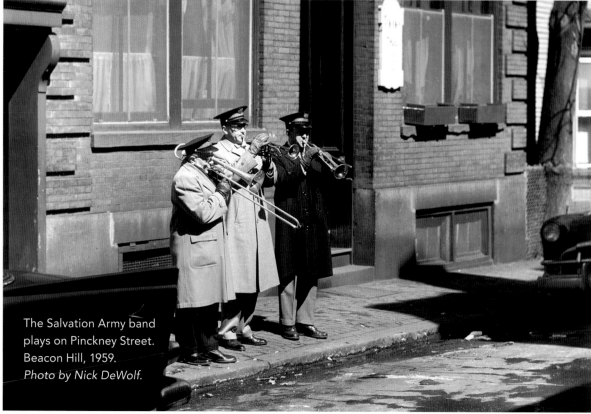

The Salvation Army band plays on Pinckney Street. Beacon Hill, 1959.
Photo by Nick DeWolf.

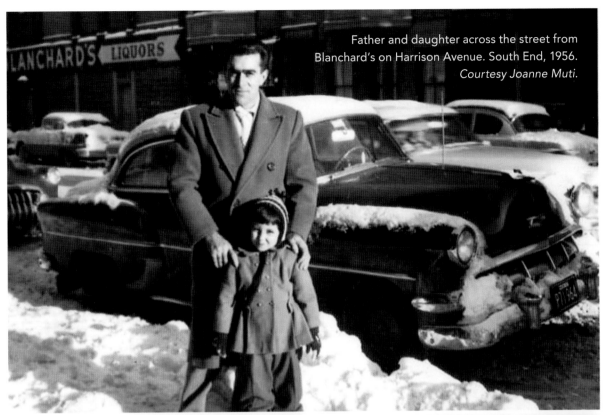

Father and daughter across the street from Blanchard's on Harrison Avenue. South End, 1956.
Courtesy Joanne Muti.

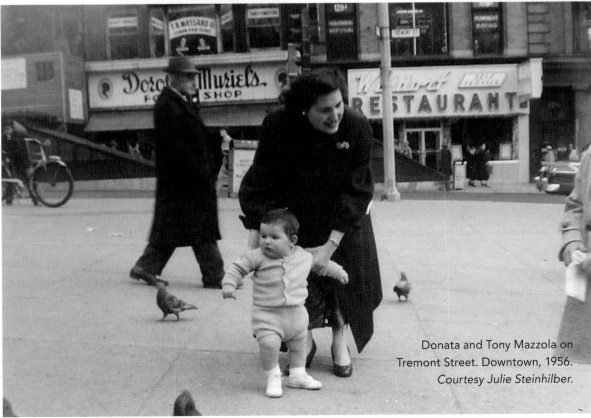

Donata and Tony Mazzola on Tremont Street. Downtown, 1956.
Courtesy Julie Steinhilber.

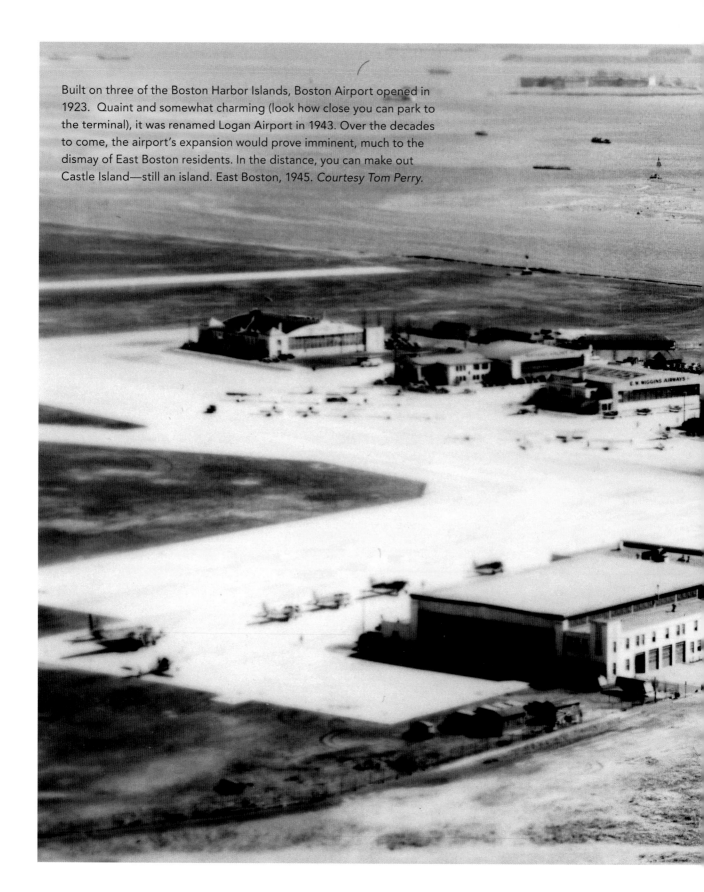

Built on three of the Boston Harbor Islands, Boston Airport opened in 1923. Quaint and somewhat charming (look how close you can park to the terminal), it was renamed Logan Airport in 1943. Over the decades to come, the airport's expansion would prove imminent, much to the dismay of East Boston residents. In the distance, you can make out Castle Island—still an island. East Boston, 1945. *Courtesy Tom Perry.*

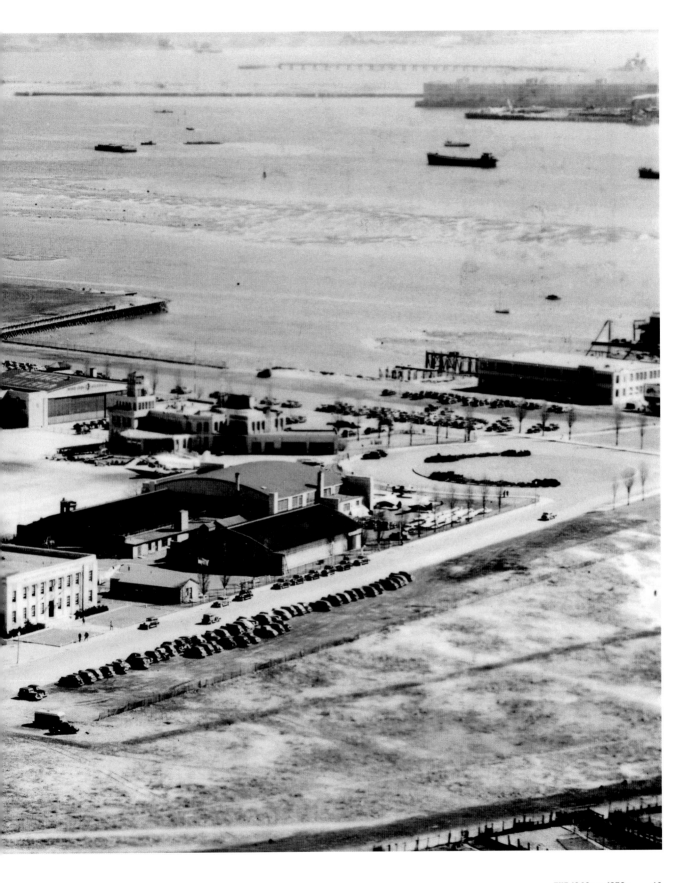

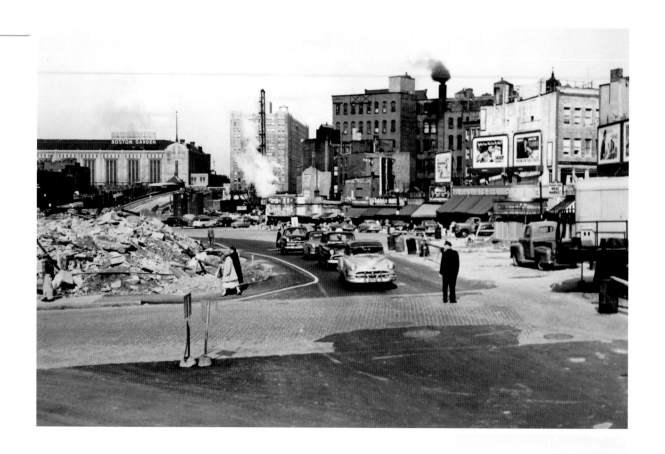

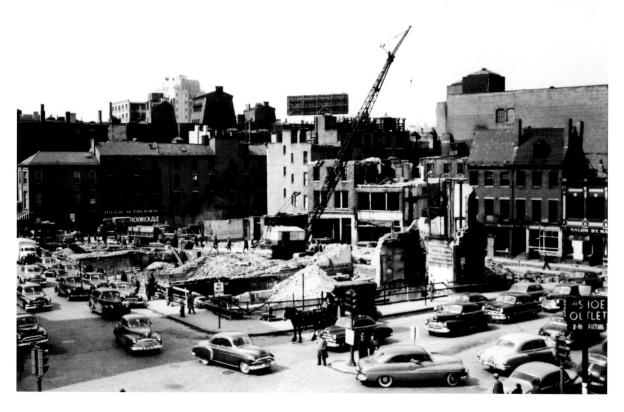

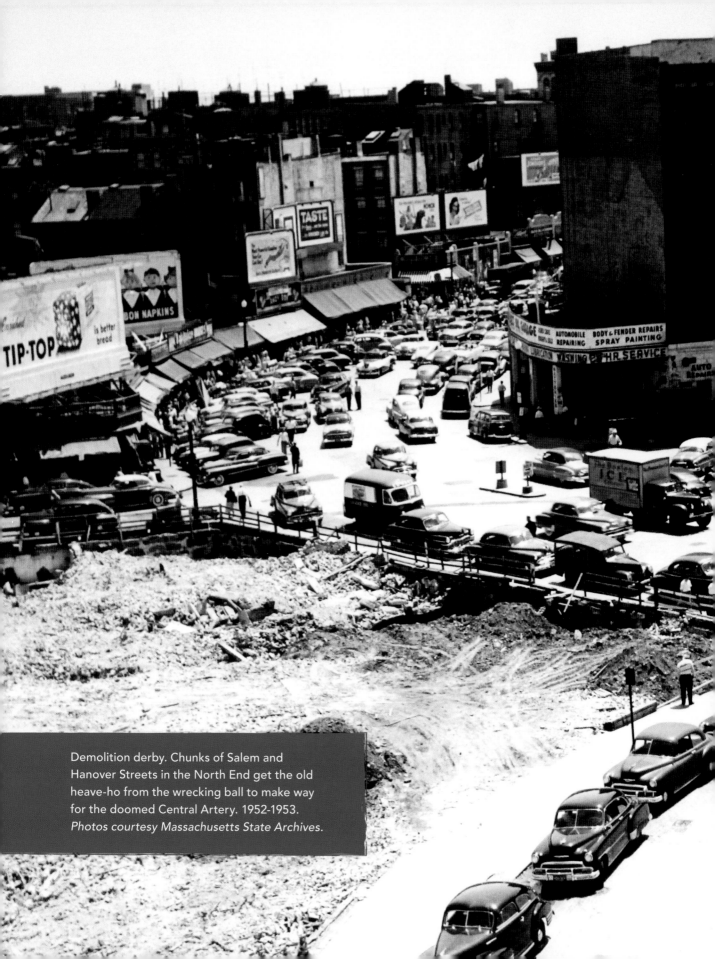

Demolition derby. Chunks of Salem and Hanover Streets in the North End get the old heave-ho from the wrecking ball to make way for the doomed Central Artery. 1952-1953. *Photos courtesy Massachusetts State Archives.*

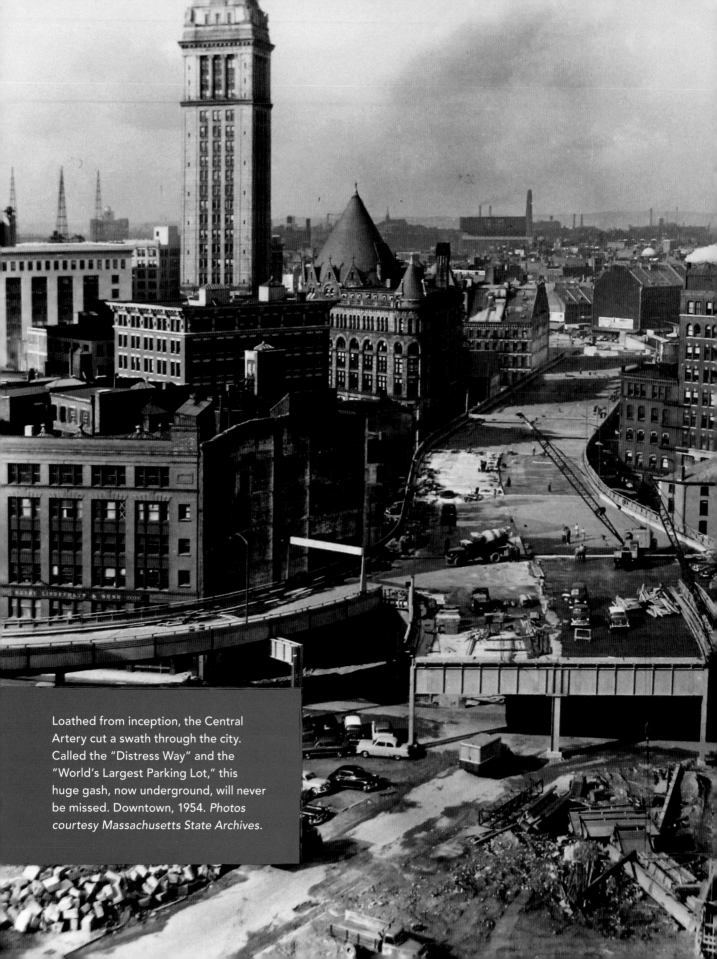

Loathed from inception, the Central Artery cut a swath through the city. Called the "Distress Way" and the "World's Largest Parking Lot," this huge gash, now underground, will never be missed. Downtown, 1954. *Photos courtesy Massachusetts State Archives.*

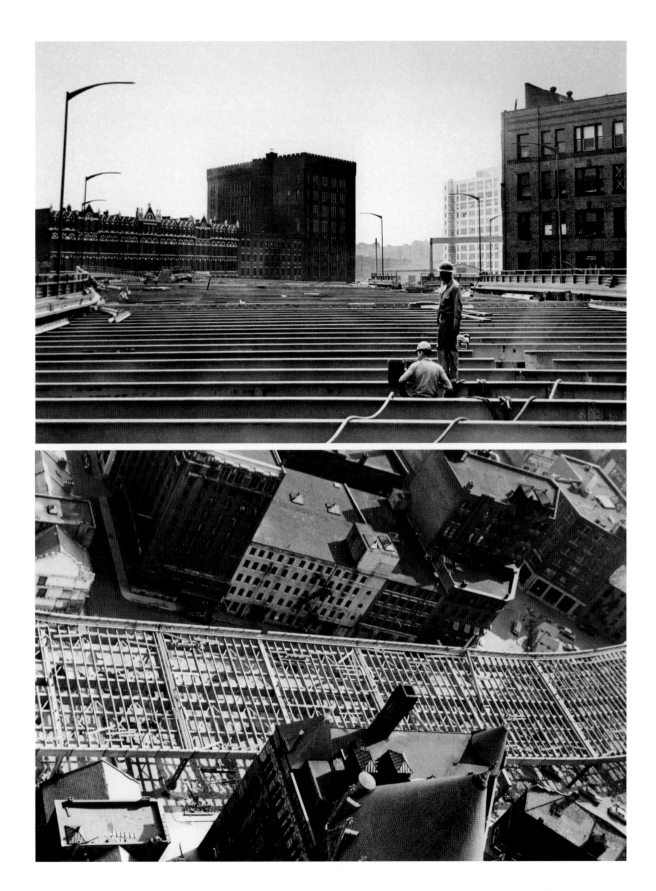

THE 1940s & 1950s

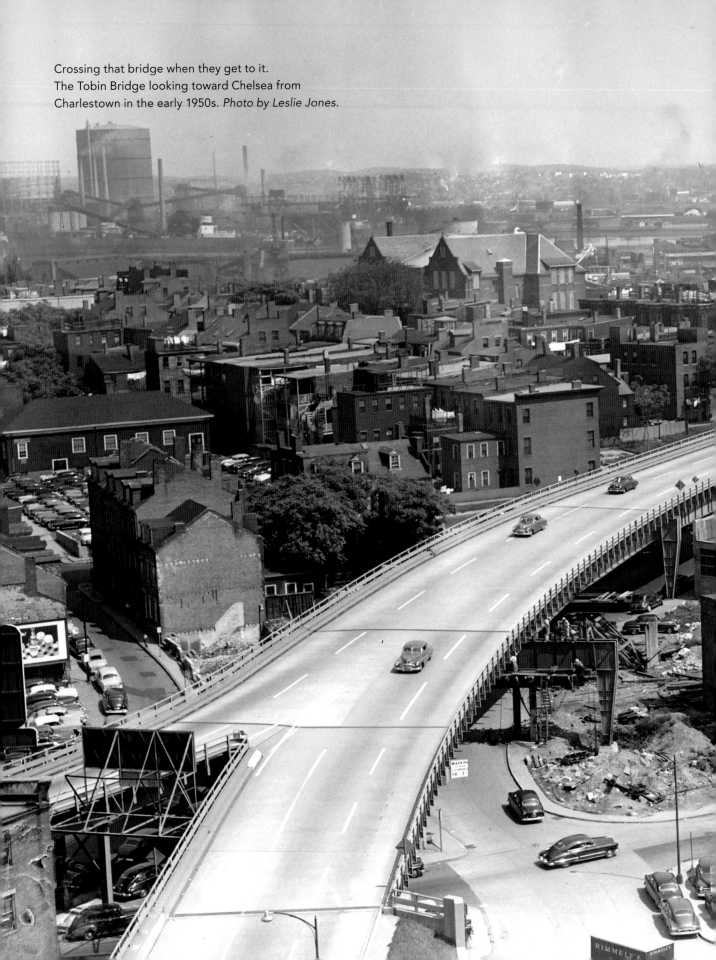

Crossing that bridge when they get to it.
The Tobin Bridge looking toward Chelsea from
Charlestown in the early 1950s. *Photo by Leslie Jones.*

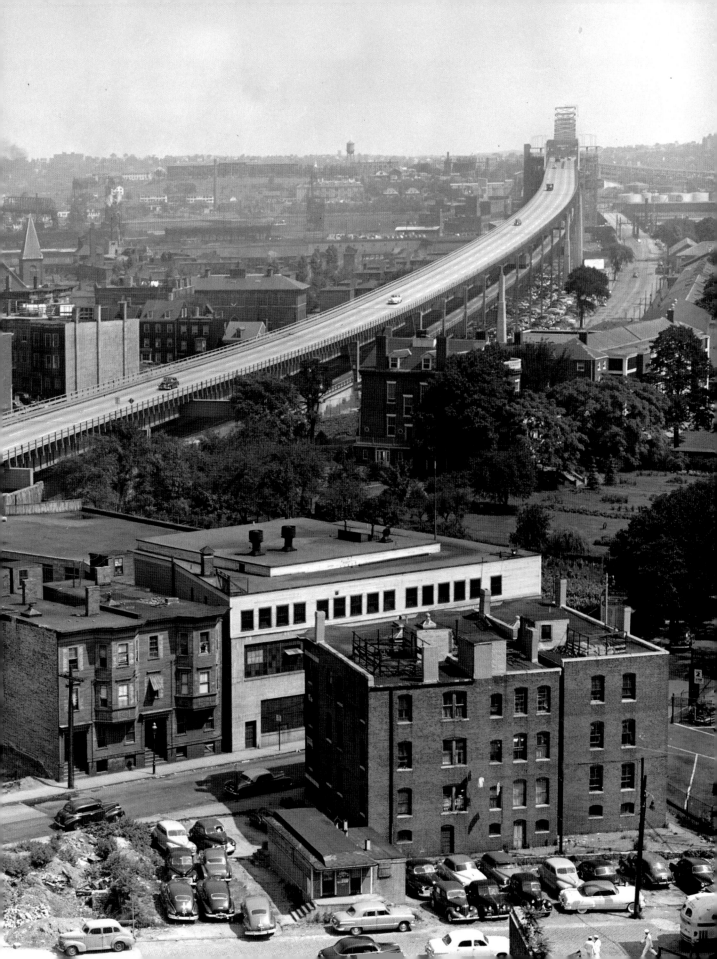

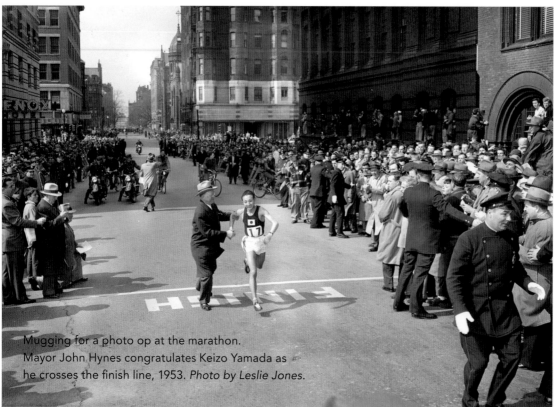

Mugging for a photo op at the marathon.
Mayor John Hynes congratulates Keizo Yamada as
he crosses the finish line, 1953. *Photo by Leslie Jones.*

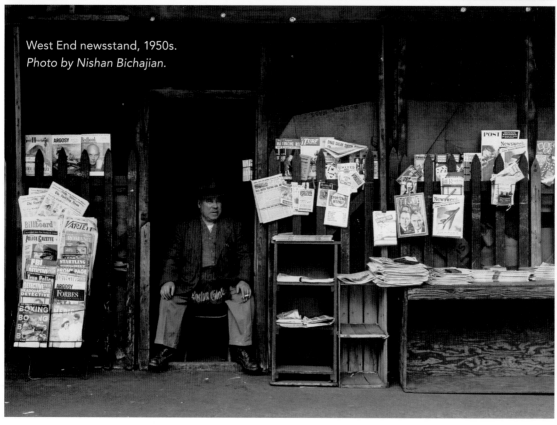

West End newsstand, 1950s.
Photo by Nishan Bichajian.

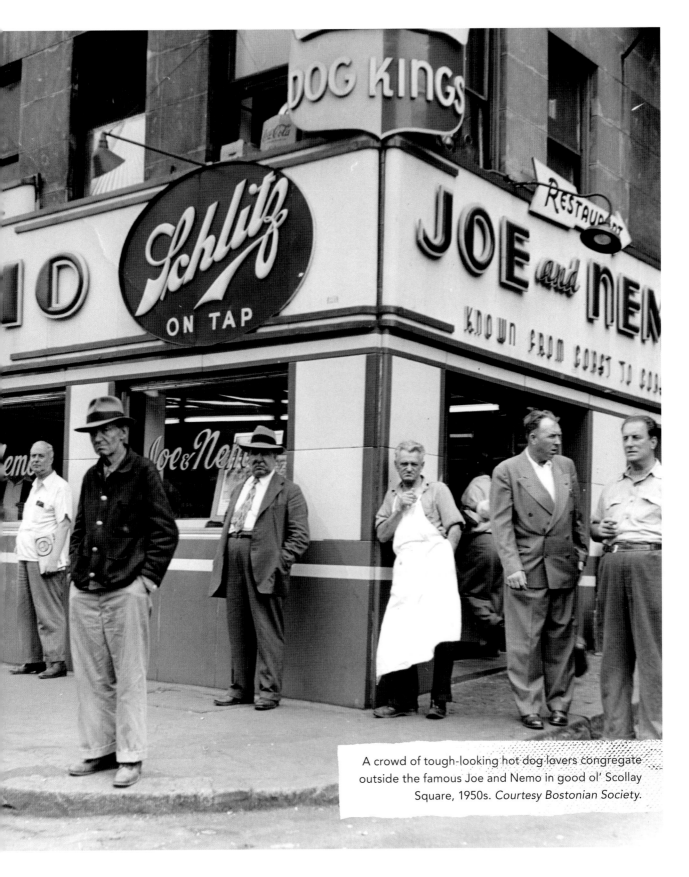

A crowd of tough-looking hot dog lovers congregate outside the famous Joe and Nemo in good ol' Scollay Square, 1950s. *Courtesy Bostonian Society.*

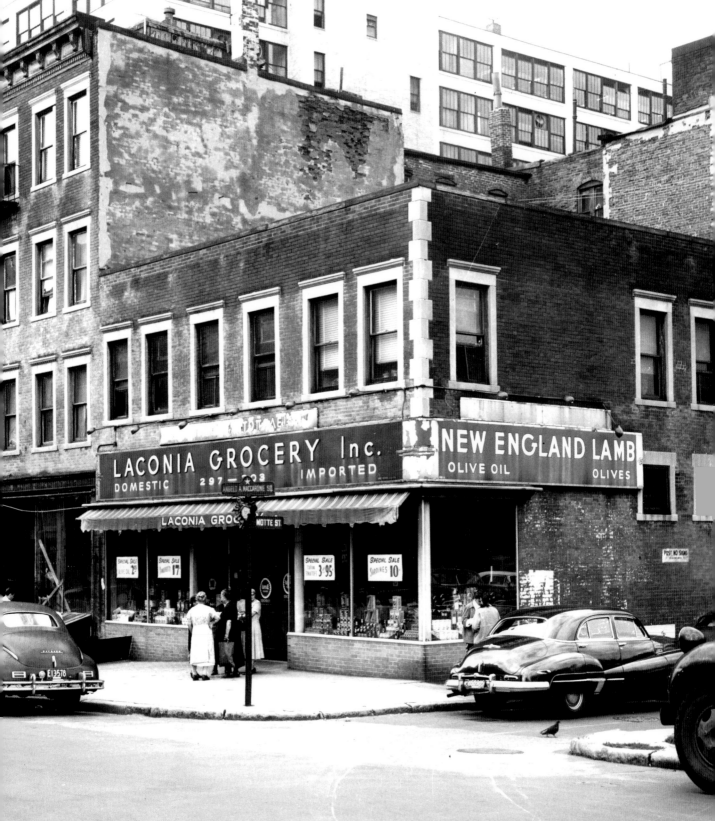

Motte Street, once alive and kicking, was razed along with the other New York Streets. South End, August 1955. *Courtesy City of Boston.*

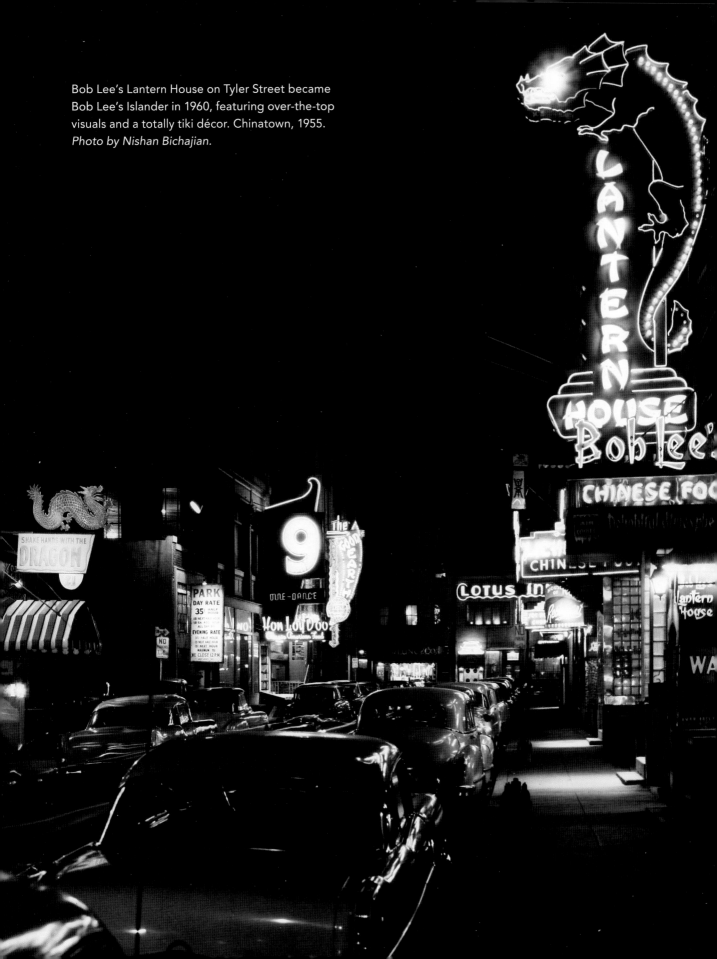

Bob Lee's Lantern House on Tyler Street became Bob Lee's Islander in 1960, featuring over-the-top visuals and a totally tiki décor. Chinatown, 1955. *Photo by Nishan Bichajian.*

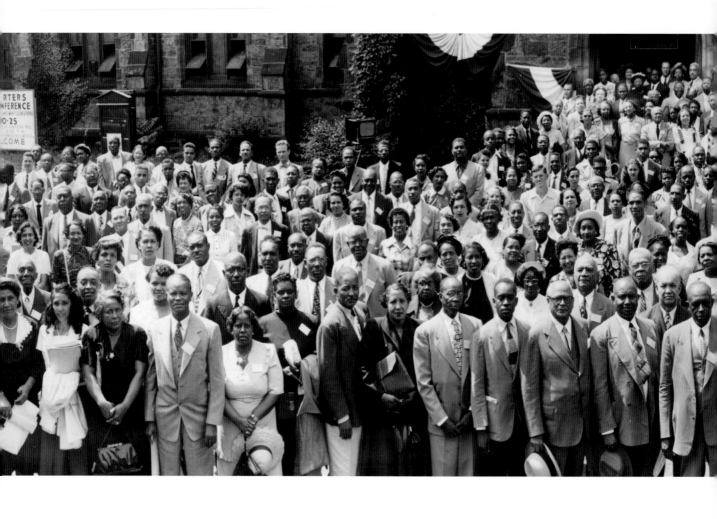

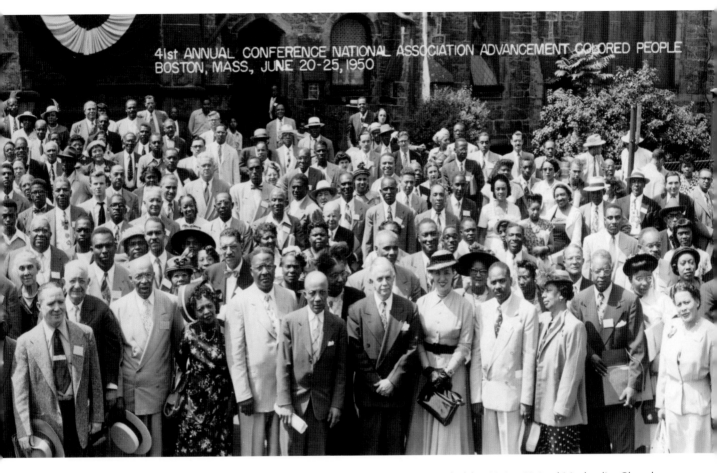

41st Annual NAACP Convention held at Union United Methodist Church. Delegates to the convention were urged to intensify political action and attack legal segregation wherever it existed. National NAACP Executive Secretary Walter White called for "unified action against those politicians who sold us out on civil rights." South End, 1950. *Courtesy Library of Congress.*

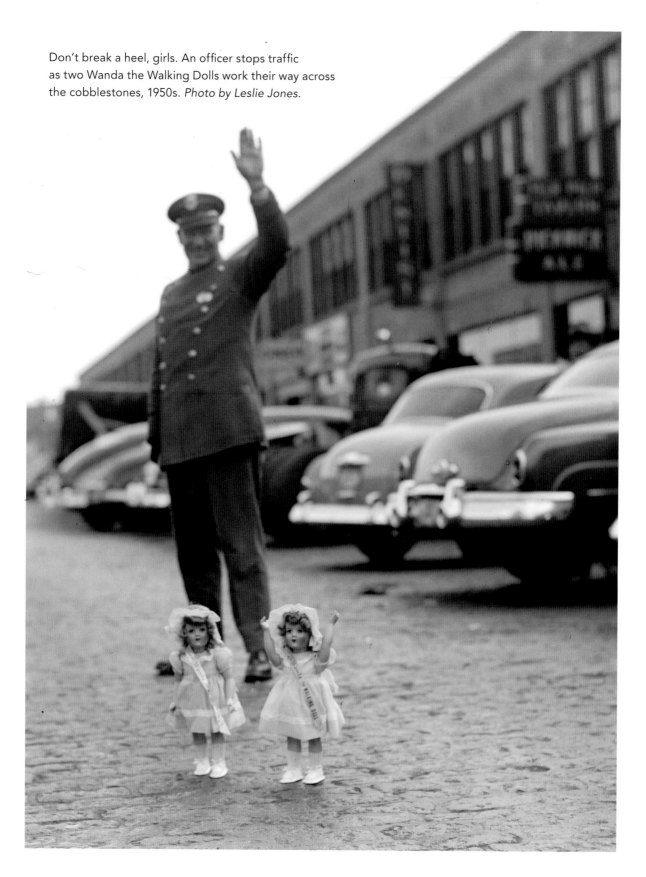

Don't break a heel, girls. An officer stops traffic as two Wanda the Walking Dolls work their way across the cobblestones, 1950s. *Photo by Leslie Jones.*

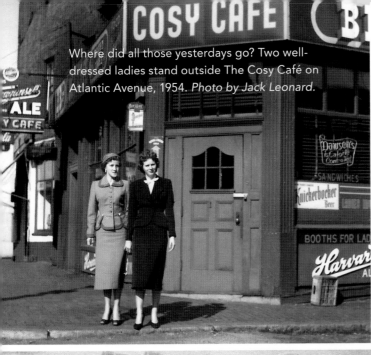

Where did all those yesterdays go? Two well-dressed ladies stand outside The Cosy Café on Atlantic Avenue, 1954. *Photo by Jack Leonard.*

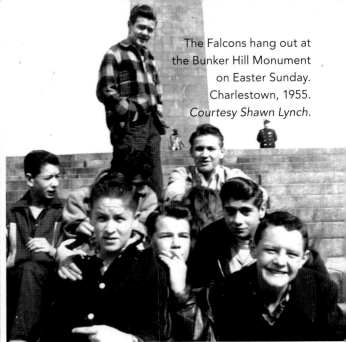

The Falcons hang out at the Bunker Hill Monument on Easter Sunday. Charlestown, 1955. *Courtesy Shawn Lynch.*

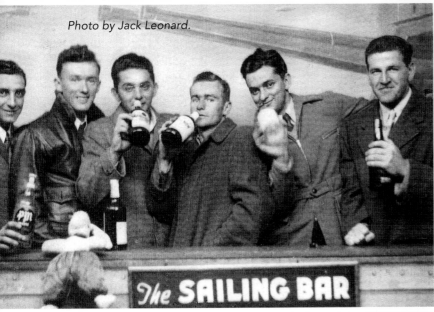

Photo by Jack Leonard.

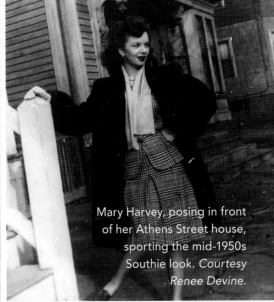

Mary Harvey, posing in front of her Athens Street house, sporting the mid-1950s Southie look. *Courtesy Renee Devine.*

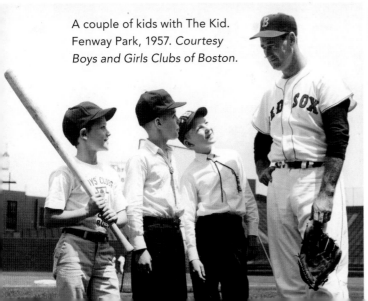

A couple of kids with The Kid. Fenway Park, 1957. *Courtesy Boys and Girls Clubs of Boston.*

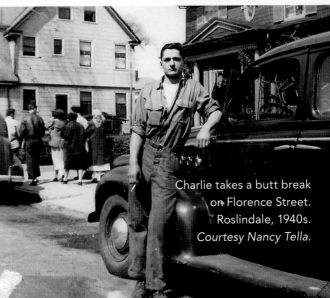

Charlie takes a butt break on Florence Street. Roslindale, 1940s. *Courtesy Nancy Tella.*

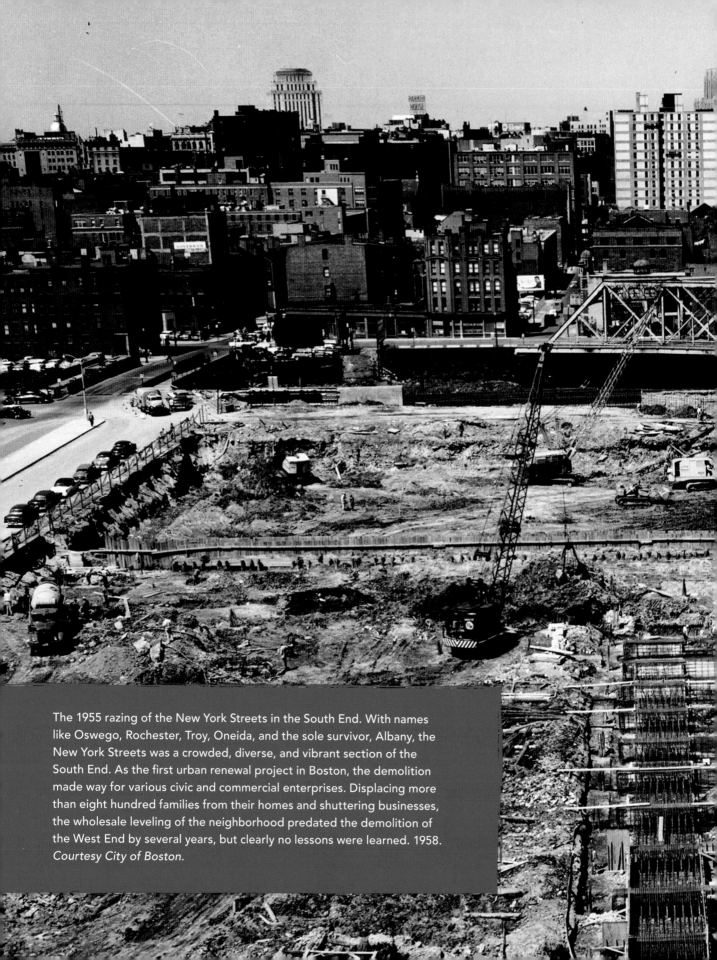

The 1955 razing of the New York Streets in the South End. With names like Oswego, Rochester, Troy, Oneida, and the sole survivor, Albany, the New York Streets was a crowded, diverse, and vibrant section of the South End. As the first urban renewal project in Boston, the demolition made way for various civic and commercial enterprises. Displacing more than eight hundred families from their homes and shuttering businesses, the wholesale leveling of the neighborhood predated the demolition of the West End by several years, but clearly no lessons were learned. 1958. *Courtesy City of Boston.*

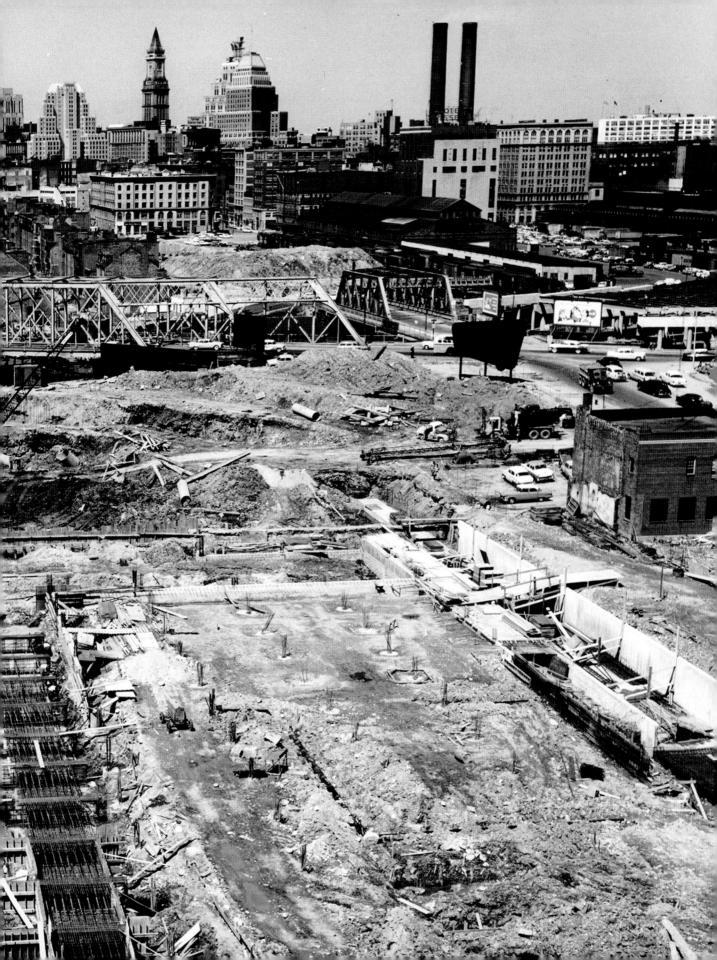

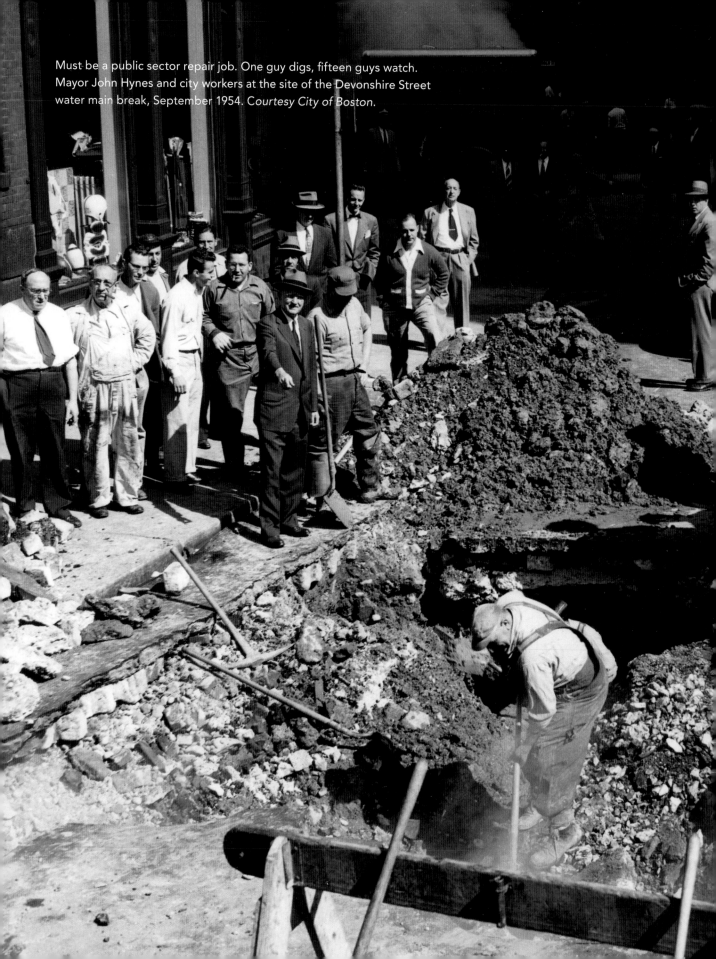

Must be a public sector repair job. One guy digs, fifteen guys watch. Mayor John Hynes and city workers at the site of the Devonshire Street water main break, September 1954. *Courtesy City of Boston.*

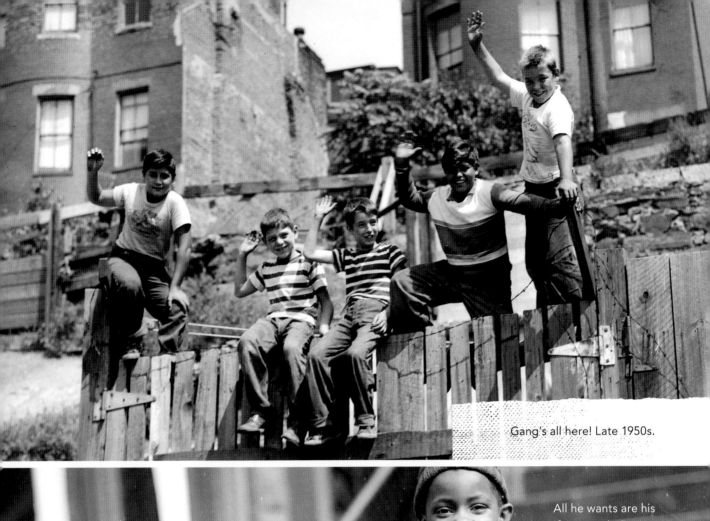

Gang's all here! Late 1950s.

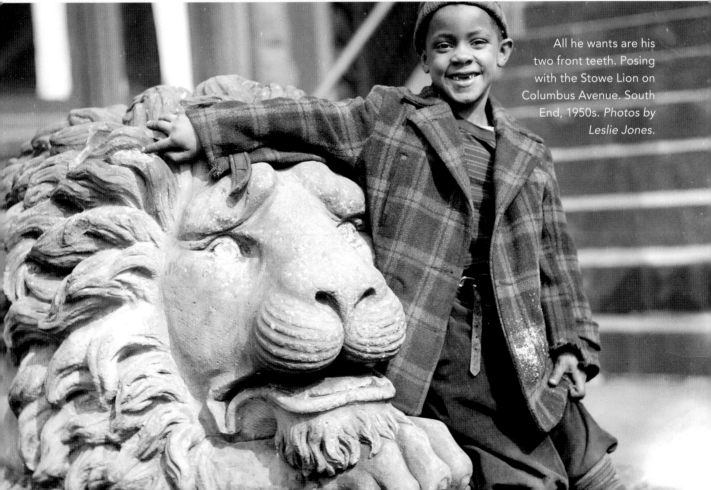

All he wants are his two front teeth. Posing with the Stowe Lion on Columbus Avenue. South End, 1950s. *Photos by Leslie Jones.*

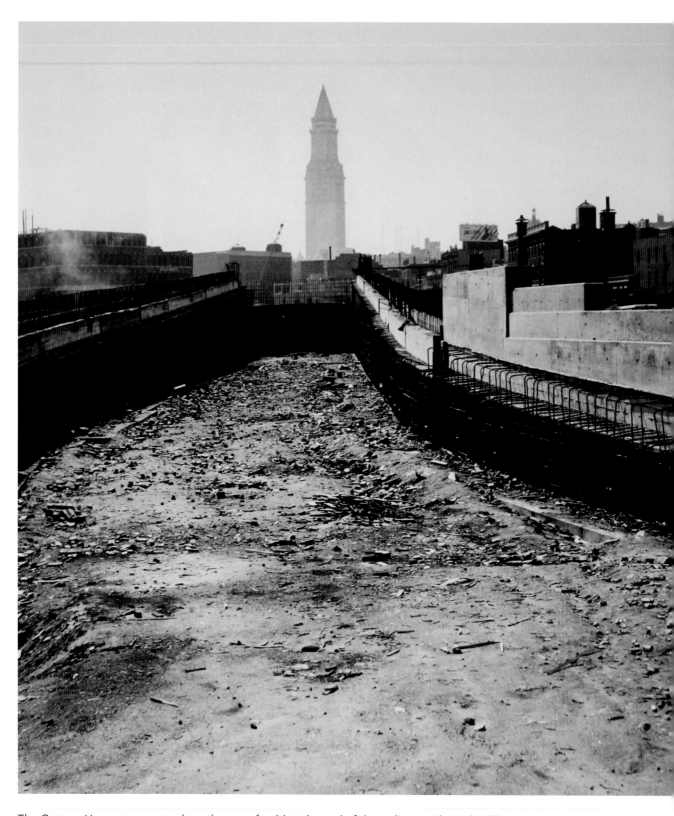

The Custom House tower stands as the pot of gold at the end of the tedious and ramshackle rainbow of roadways, June 1950. *Courtesy Massachusetts State Archives.*

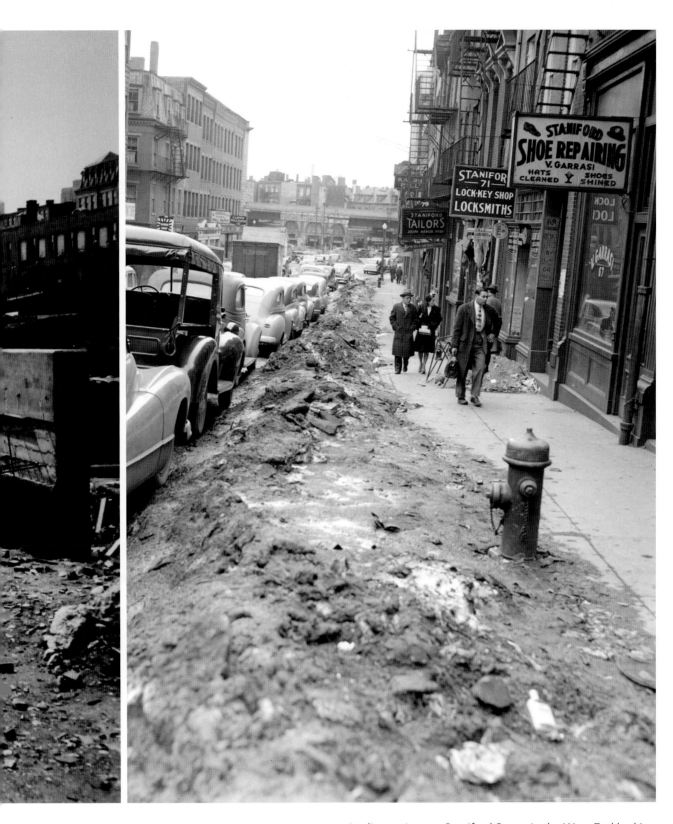

As dirty as it gets. Staniford Street in the West End looking toward North Station, early 1950s. *Photo by Leslie Jones.*

Crossroads under the city, 1958.

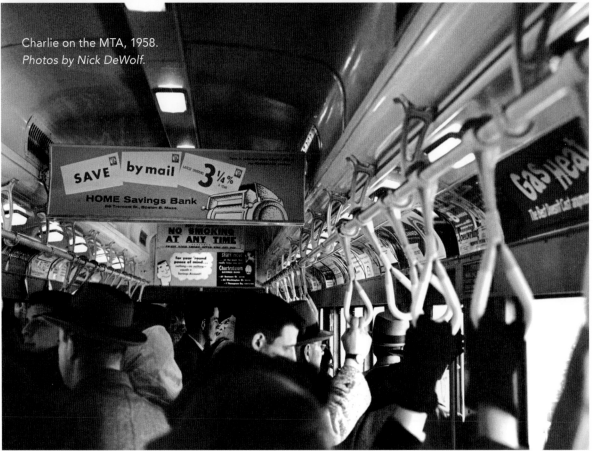

Charlie on the MTA, 1958.
Photos by Nick DeWolf.

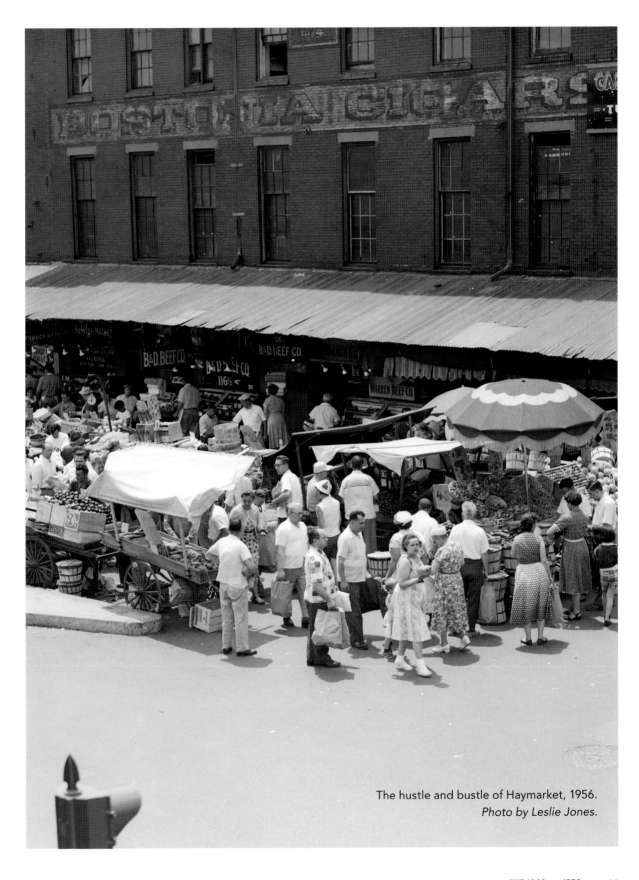

The hustle and bustle of Haymarket, 1956.
Photo by Leslie Jones.

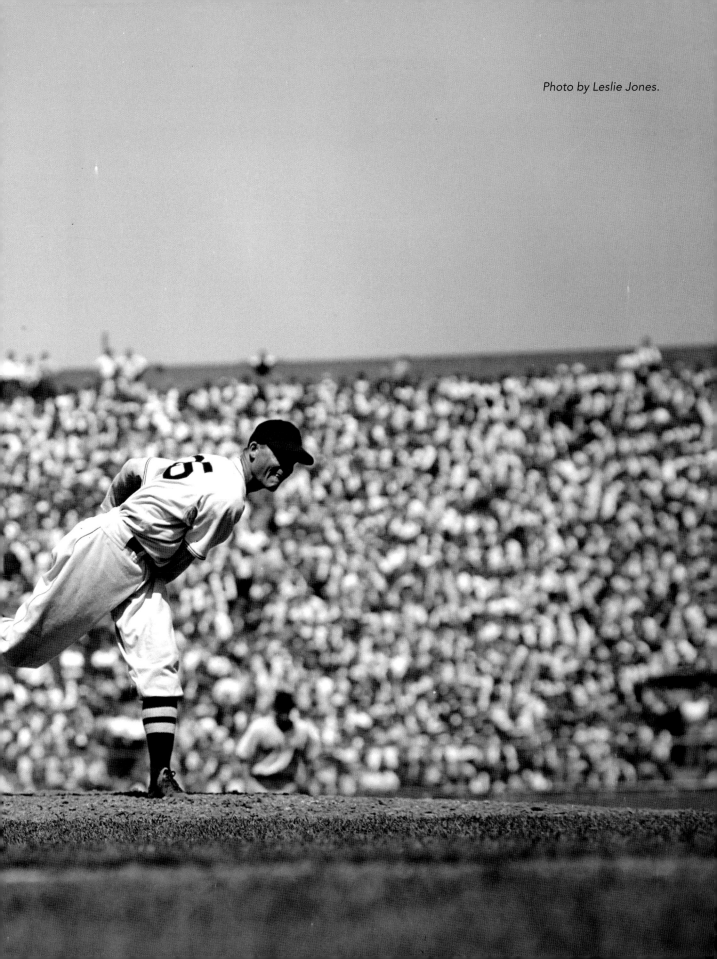

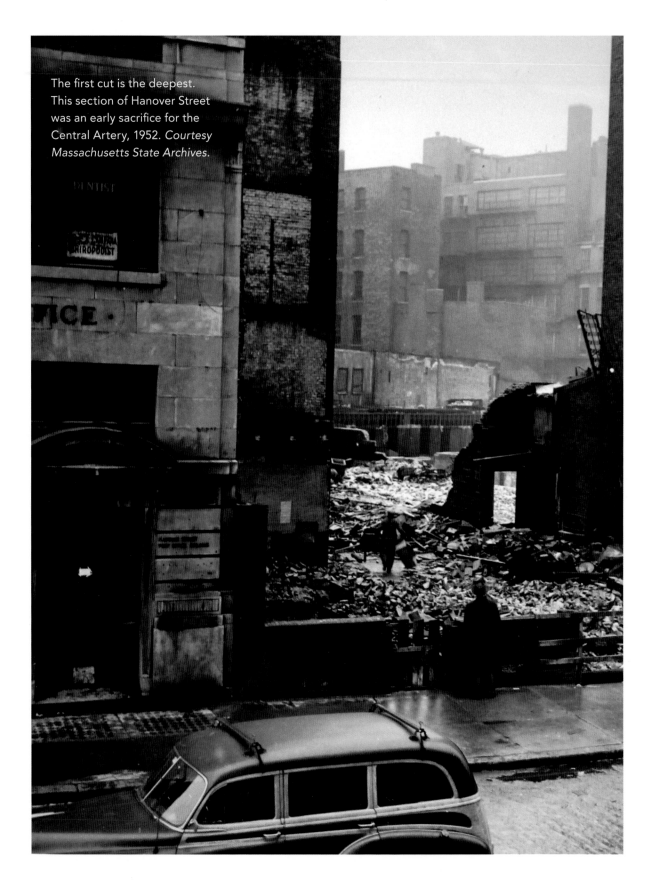

The first cut is the deepest. This section of Hanover Street was an early sacrifice for the Central Artery, 1952. *Courtesy Massachusetts State Archives.*

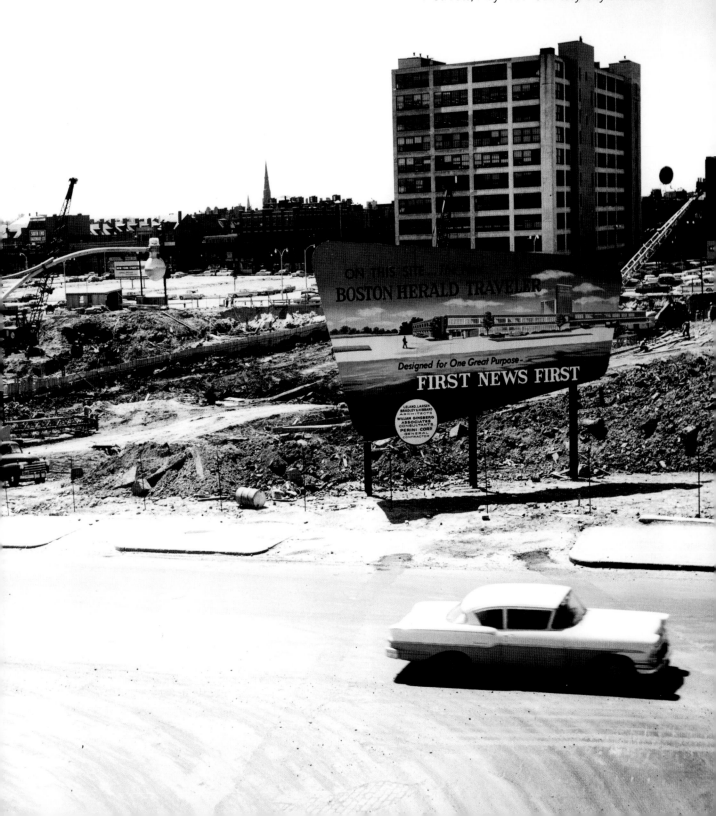

The news is on the move. The *Boston Herald Traveler* moves from Newspaper Row to make its new home upon the rubble of the New York Streets, May 1958. *Courtesy City of Boston.*

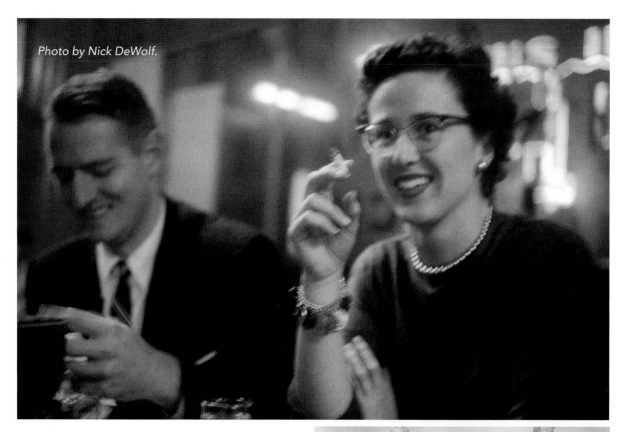

Photo by Nick DeWolf.

"**A photo of Jim Piersall** … *probably around 1953. My grandfather somehow got this one signed. My Dad really treasured it.*"
– Fran Sturgis

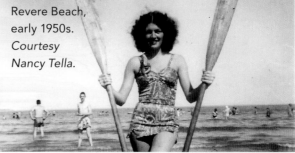

Revere Beach, early 1950s. Courtesy Nancy Tella.

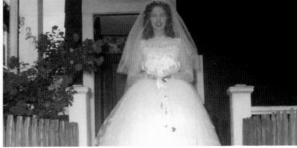

"**My mom,** *Nancy (Yonkers) Mickunas, on her wedding day, July 4, 1959, on the porch of her family's East Broadway home. She was nineteen or twenty, marrying Elmont Mickunas, a fellow South Boston Lithuanian.*" – Lydia Sampson

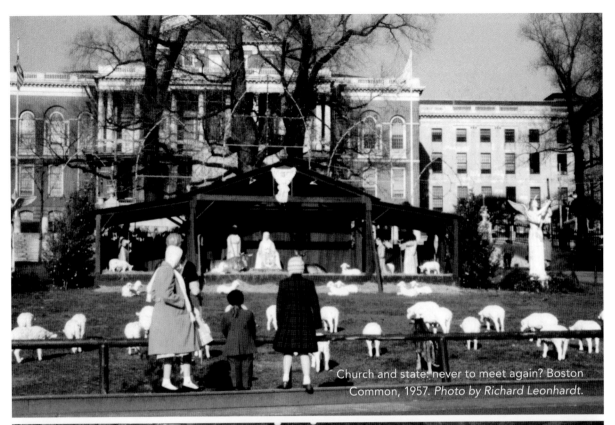

Church and state: never to meet again? Boston Common, 1957. *Photo by Richard Leonhardt.*

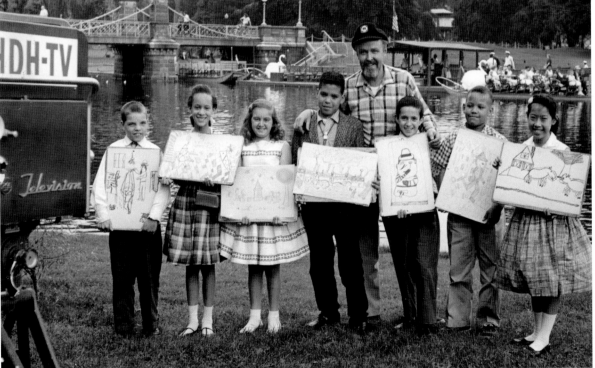

Captain Bob with students from the Children's Art Centre, which is still located in the South End, proudly display their artwork for WHDH TV. Public Garden, late 1950s. *Courtesy Northeastern University.*

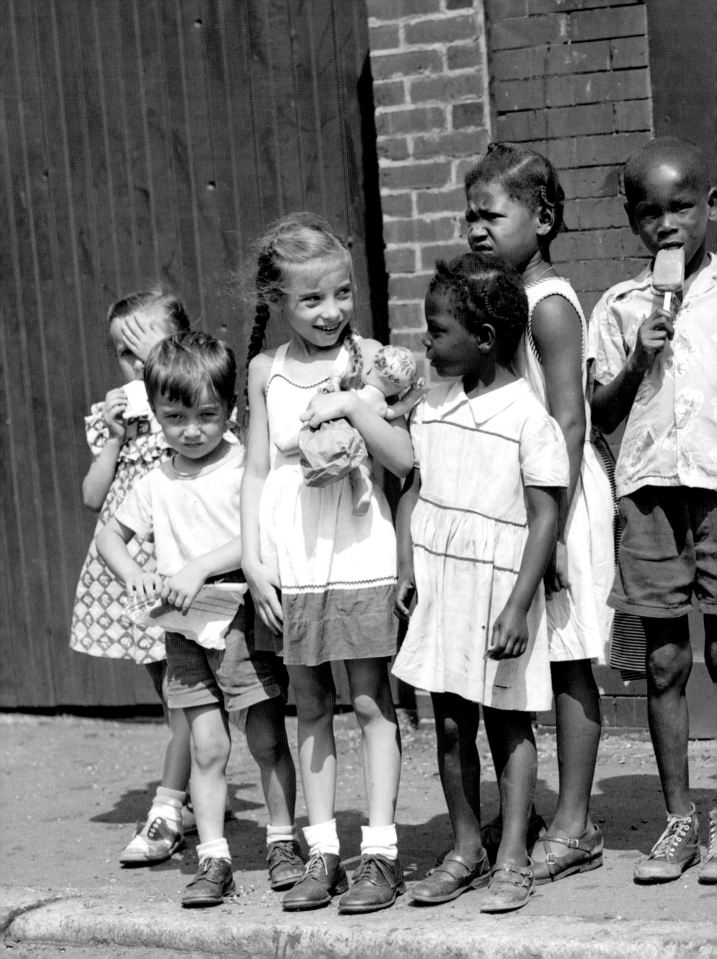

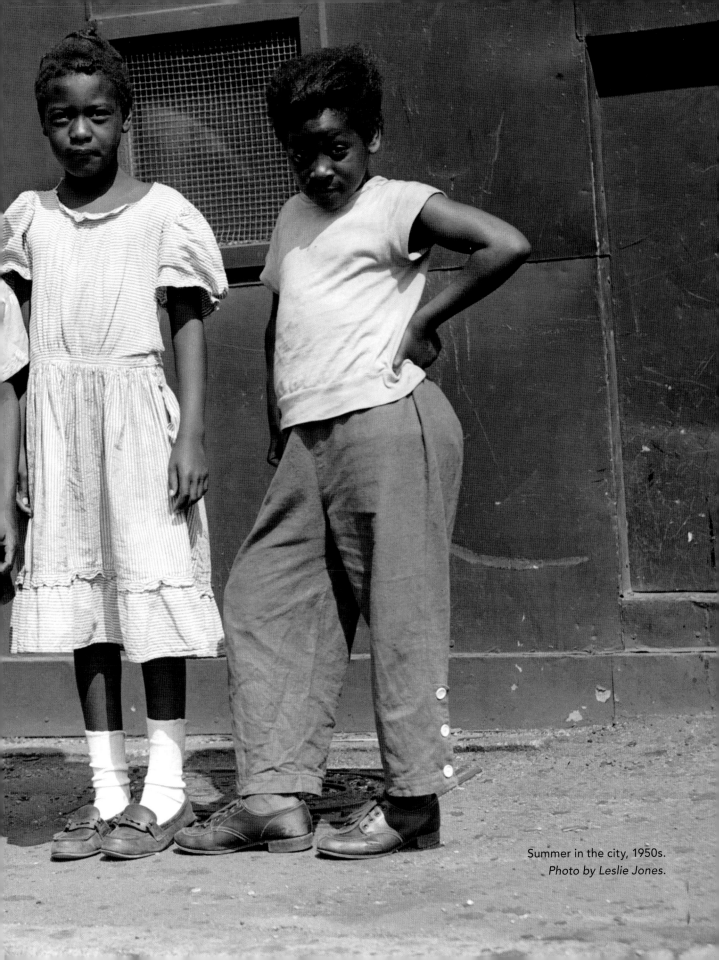

Summer in the city, 1950s.
Photo by Leslie Jones.

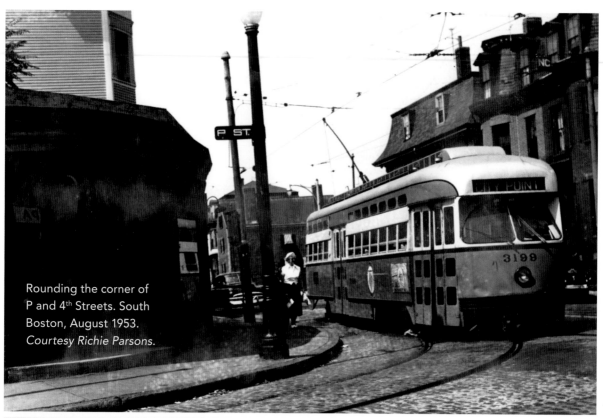

Rounding the corner of P and 4th Streets. South Boston, August 1953. *Courtesy Richie Parsons.*

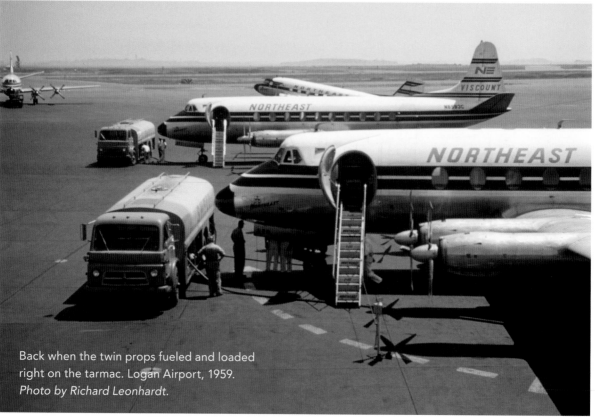

Back when the twin props fueled and loaded right on the tarmac. Logan Airport, 1959. *Photo by Richard Leonhardt.*

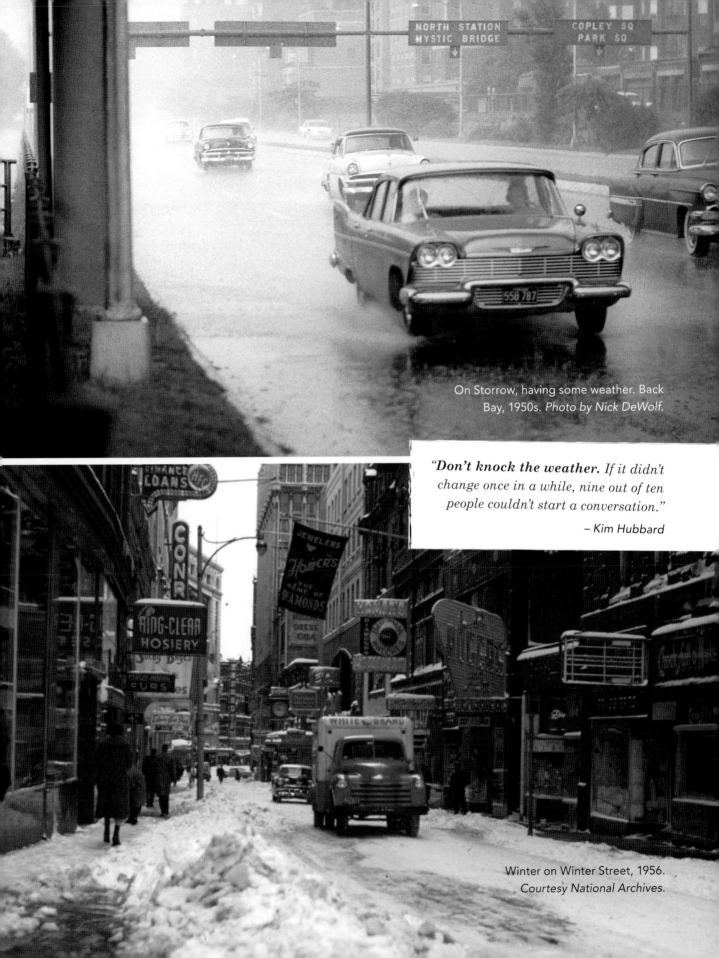

On Storrow, having some weather. Back Bay, 1950s. *Photo by Nick DeWolf.*

"Don't knock the weather. *If it didn't change once in a while, nine out of ten people couldn't start a conversation."*

– Kim Hubbard

Winter on Winter Street, 1956. *Courtesy National Archives.*

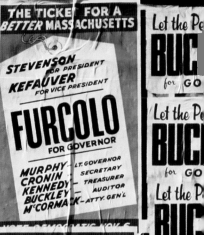
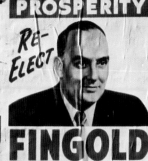
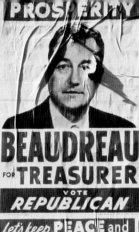
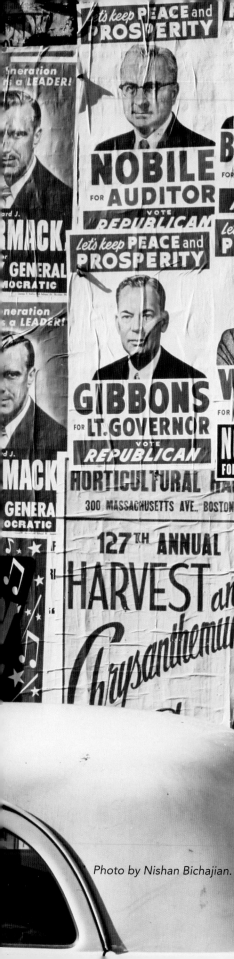

Photo by Nishan Bichajian.

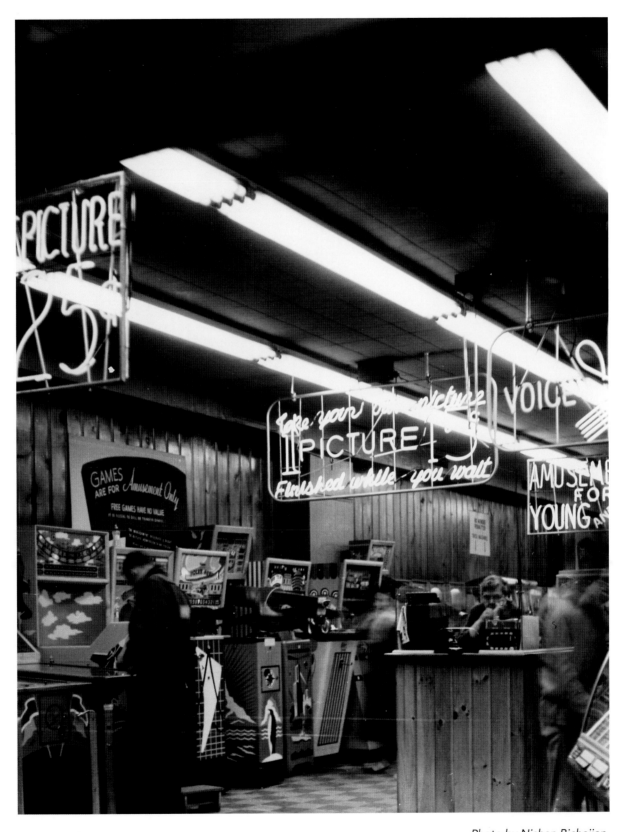

Photo by Nishan Bichajian.

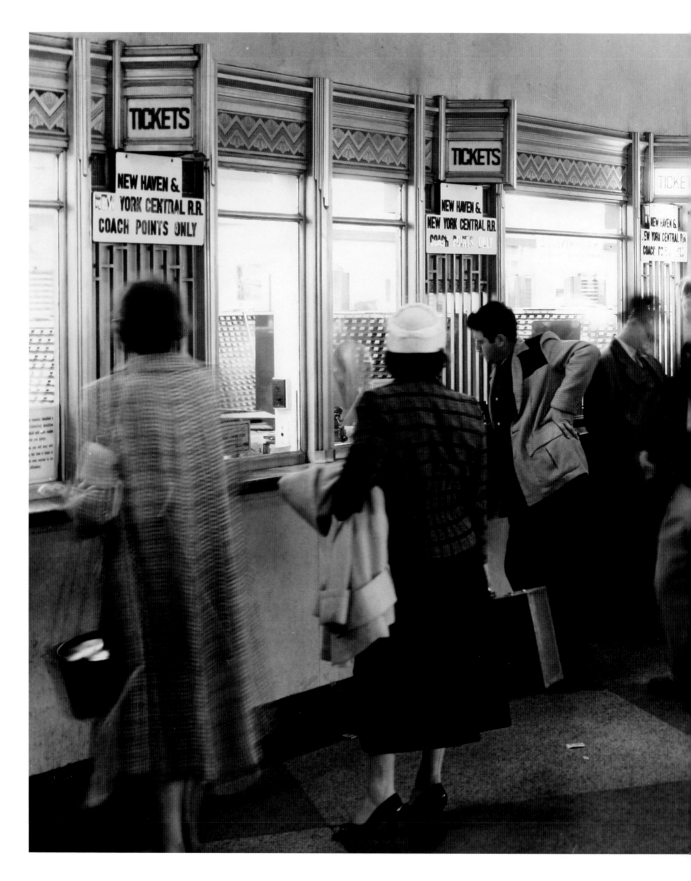

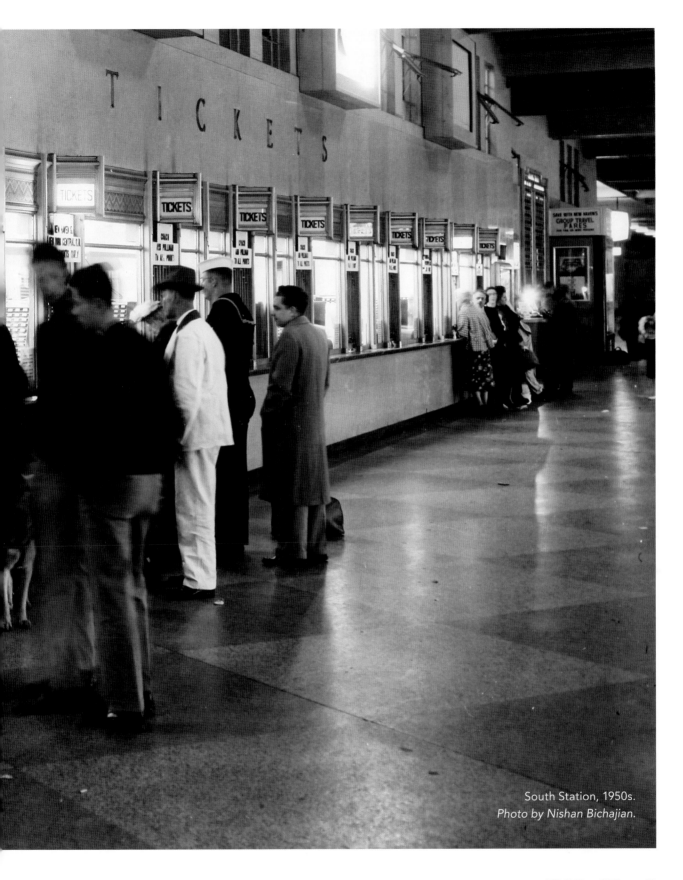

South Station, 1950s.
Photo by Nishan Bichajian.

Some called the West End a slum. Many called it home, 1962. *Photo by Charles Frani.*

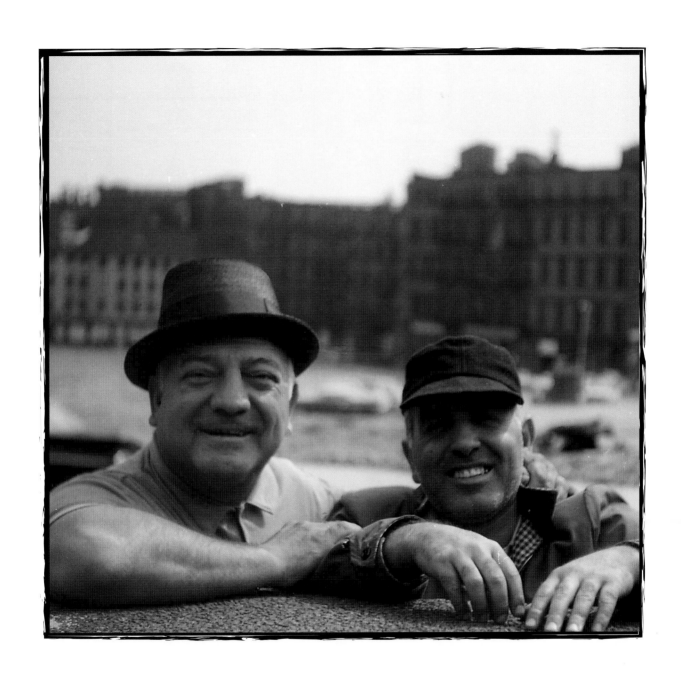

the **1960s**

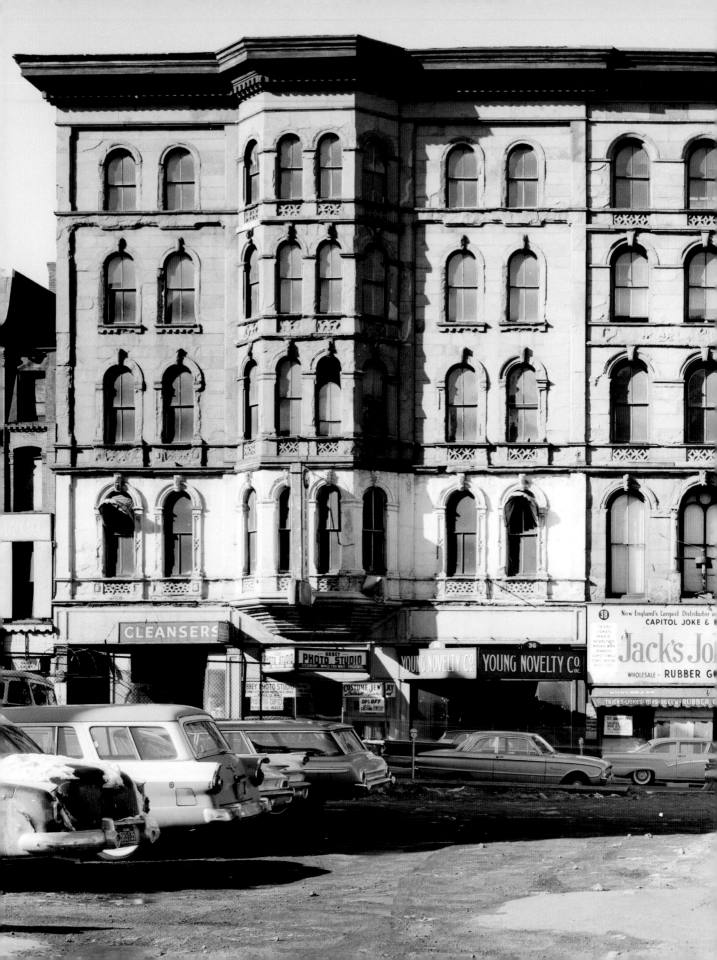

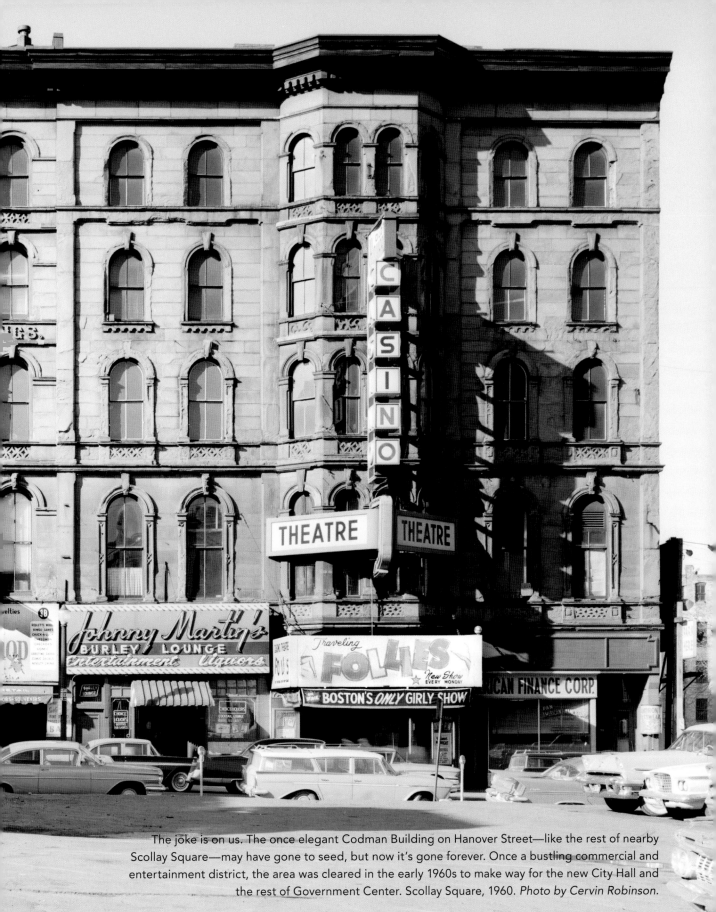

The joke is on us. The once elegant Codman Building on Hanover Street—like the rest of nearby Scollay Square—may have gone to seed, but now it's gone forever. Once a bustling commercial and entertainment district, the area was cleared in the early 1960s to make way for the new City Hall and the rest of Government Center. Scollay Square, 1960. *Photo by Cervin Robinson.*

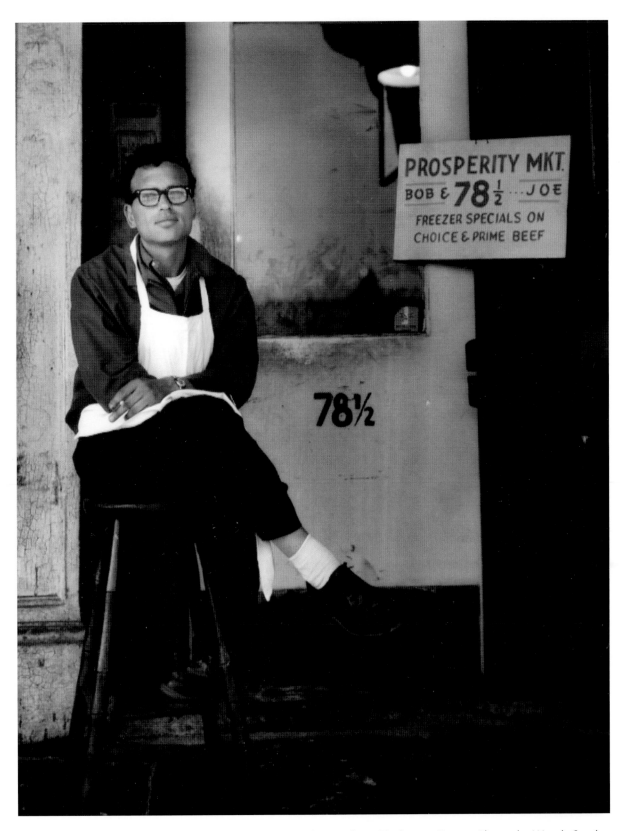

Scenes from Blackstone Street. *Photos by Wendy Snyder.*

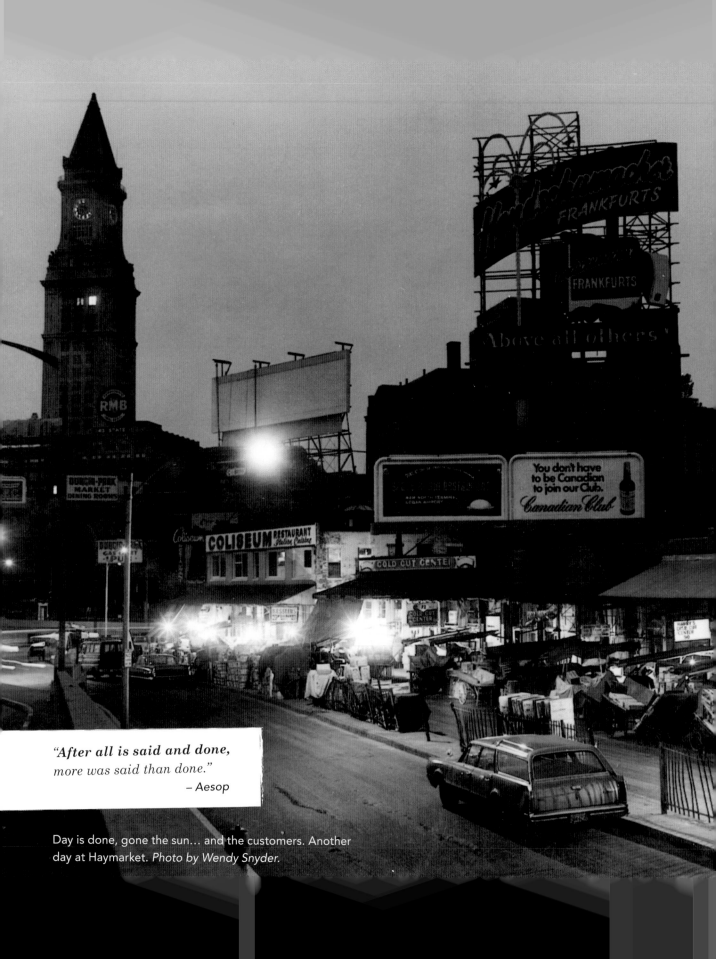

> "After all is said and done,
> more was said than done."
> – Aesop

Day is done, gone the sun… and the customers. Another day at Haymarket. *Photo by Wendy Snyder.*

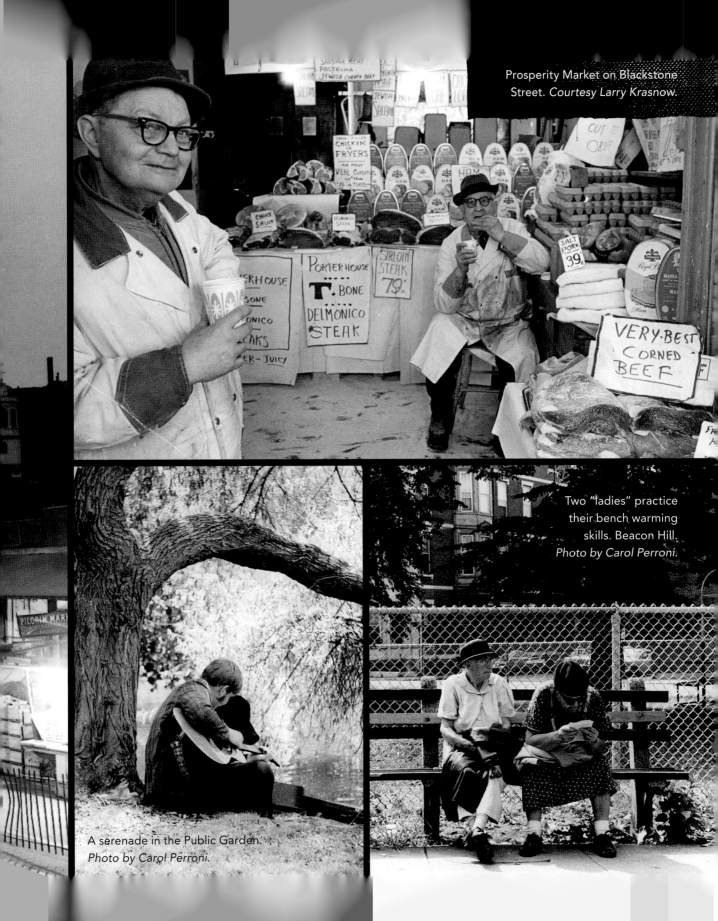

Prosperity Market on Blackstone Street. *Courtesy Larry Krasnow.*

Two "ladies" practice their bench warming skills. Beacon Hill. *Photo by Carol Perroni.*

A serenade in the Public Garden. *Photo by Carol Perroni.*

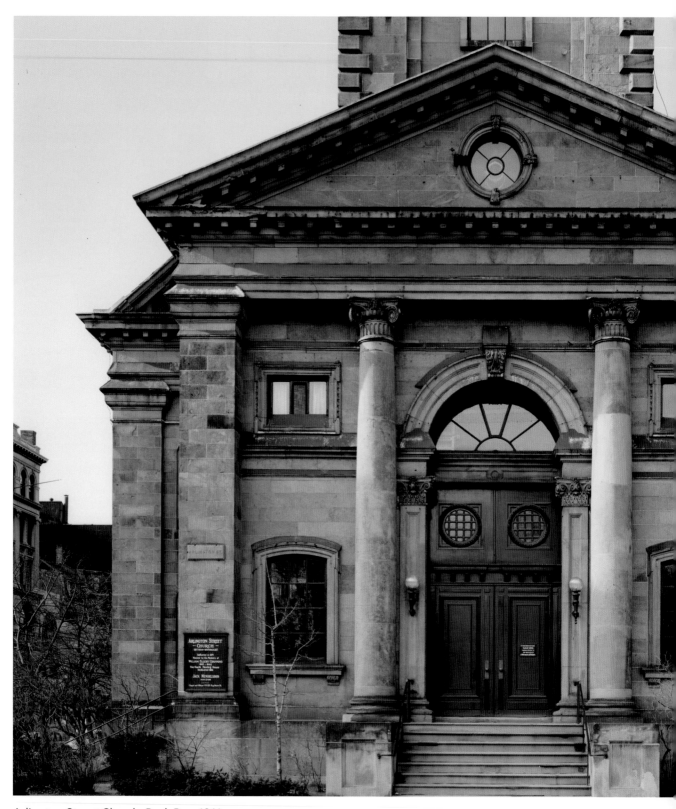

Arlington Street Church. Back Bay, 1961.
Photo by Cervin Robinson.

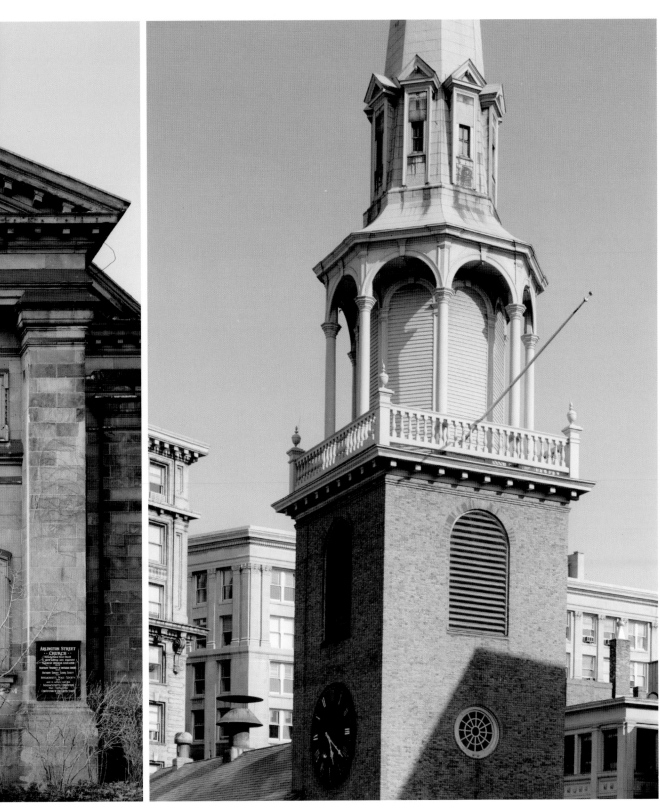

Old South Meeting House. Downtown, 1968.
Photo by Cortland V. Hubbard.

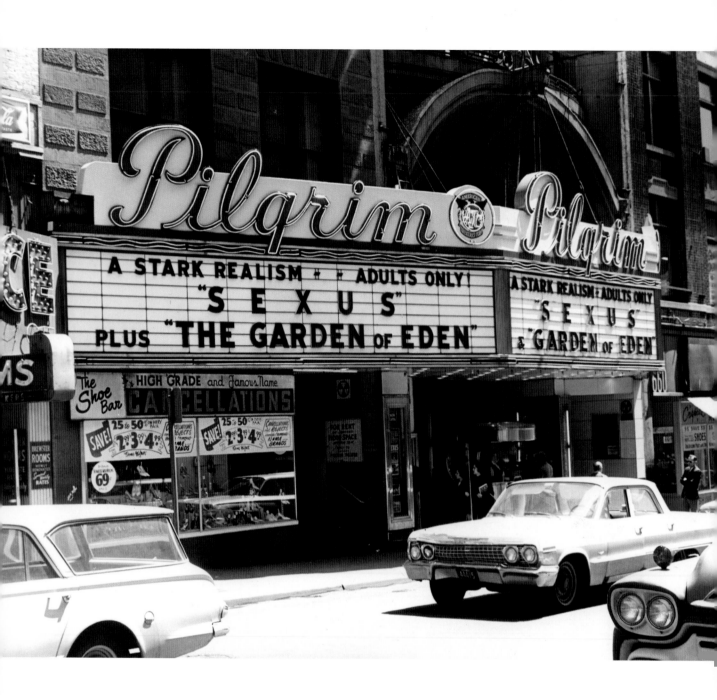

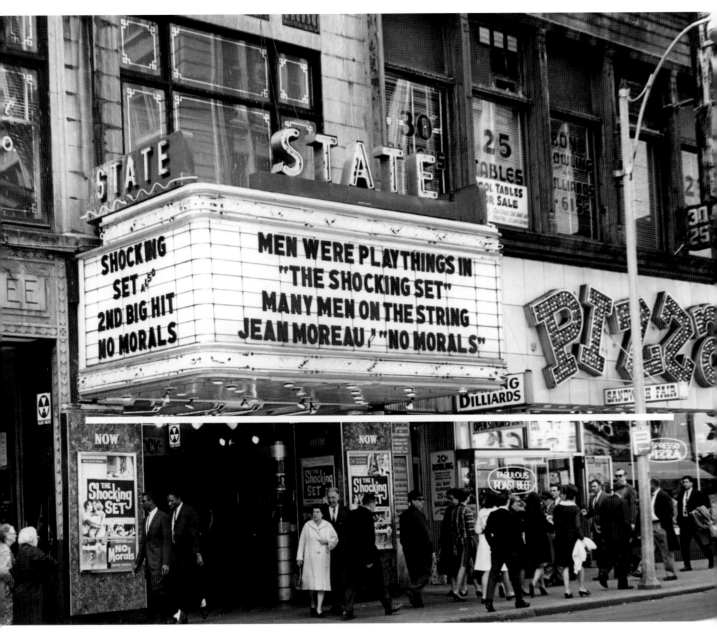

Two views of Boston's notorious Combat Zone, mid-1960s.
Photos courtesy City of Boston.

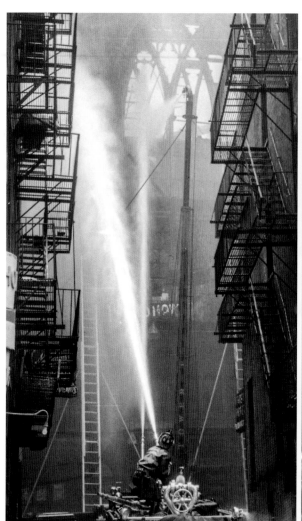

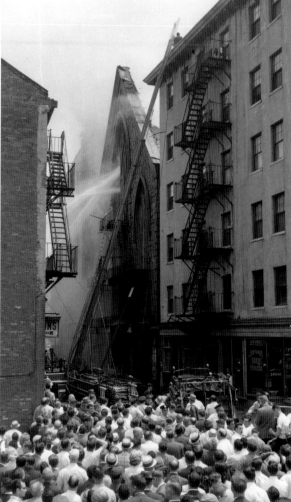

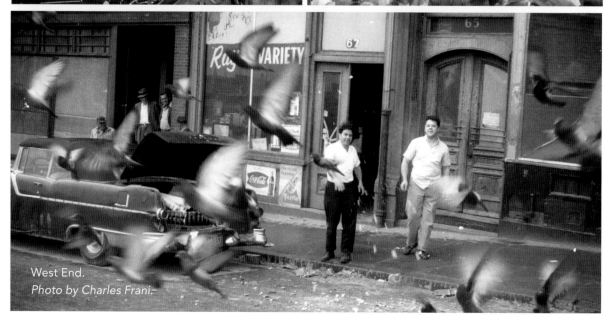

West End.
Photo by Charles Frani.

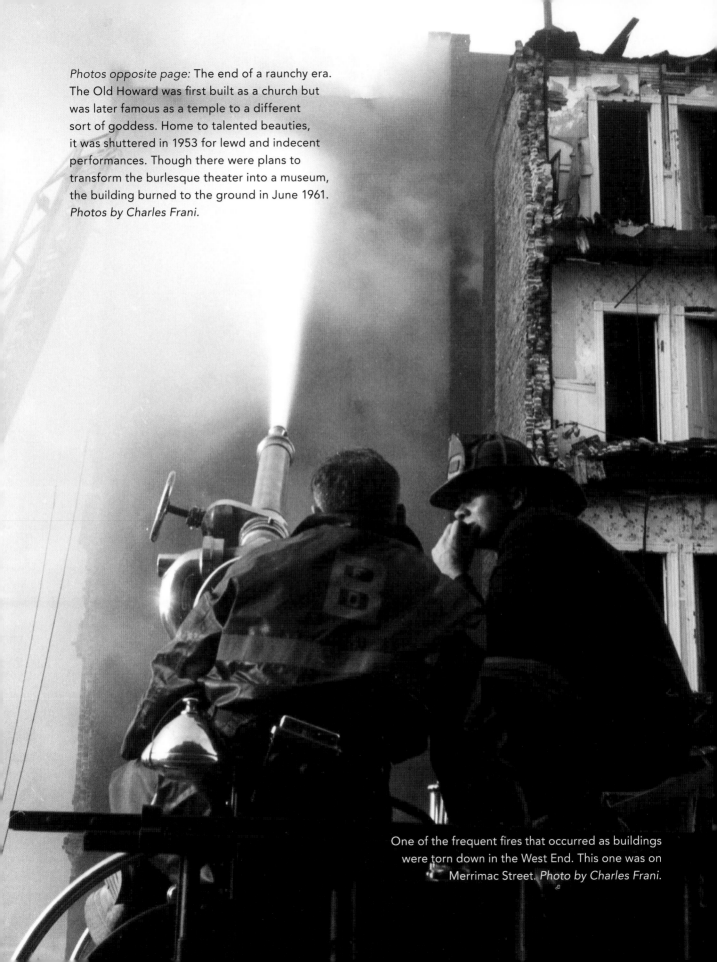

Photos opposite page: The end of a raunchy era. The Old Howard was first built as a church but was later famous as a temple to a different sort of goddess. Home to talented beauties, it was shuttered in 1953 for lewd and indecent performances. Though there were plans to transform the burlesque theater into a museum, the building burned to the ground in June 1961. *Photos by Charles Frani.*

One of the frequent fires that occurred as buildings were torn down in the West End. This one was on Merrimac Street. *Photo by Charles Frani.*

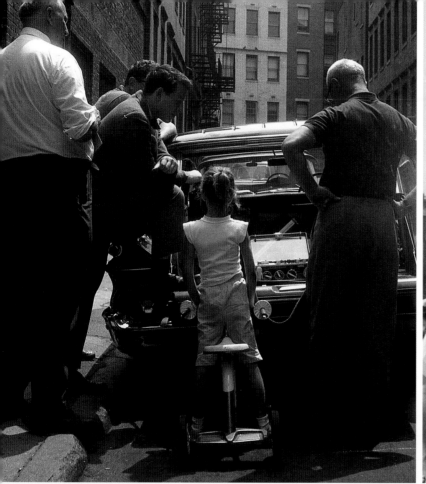

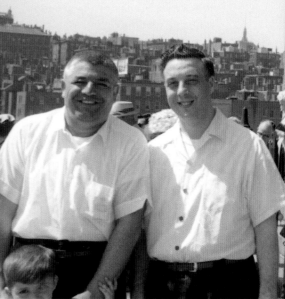

This row: Vibrant street scenes from the old West End. *Photos by Charles Frani.*

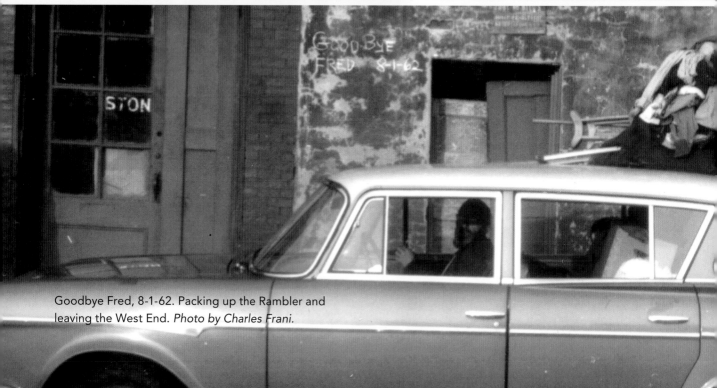

Goodbye Fred, 8-1-62. Packing up the Rambler and leaving the West End. *Photo by Charles Frani.*

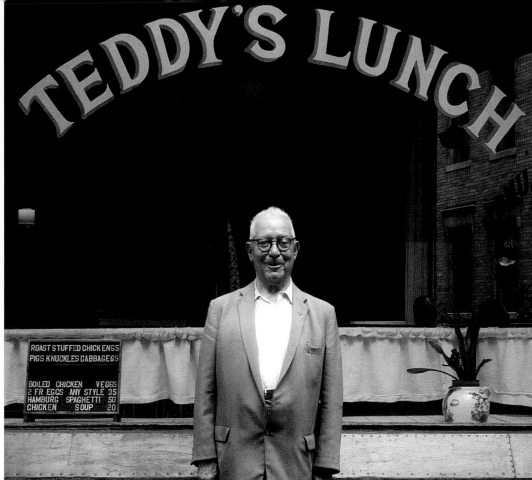

Boston's own Robert Moses: Edward J. Logue was a Boston Redevelopment Authority (BRA) powerhouse who put into motion the "New Boston." Folks in the West End didn't quite understand what was wrong with the Old Boston. *Courtesy City of Boston.*

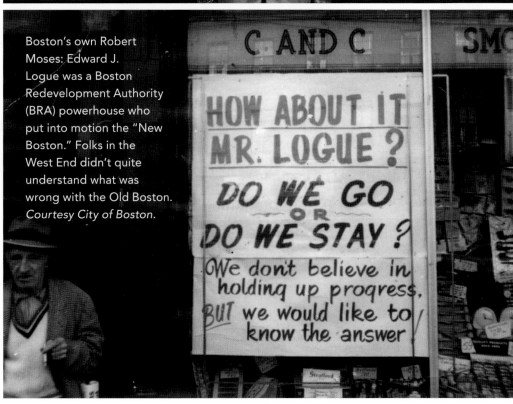

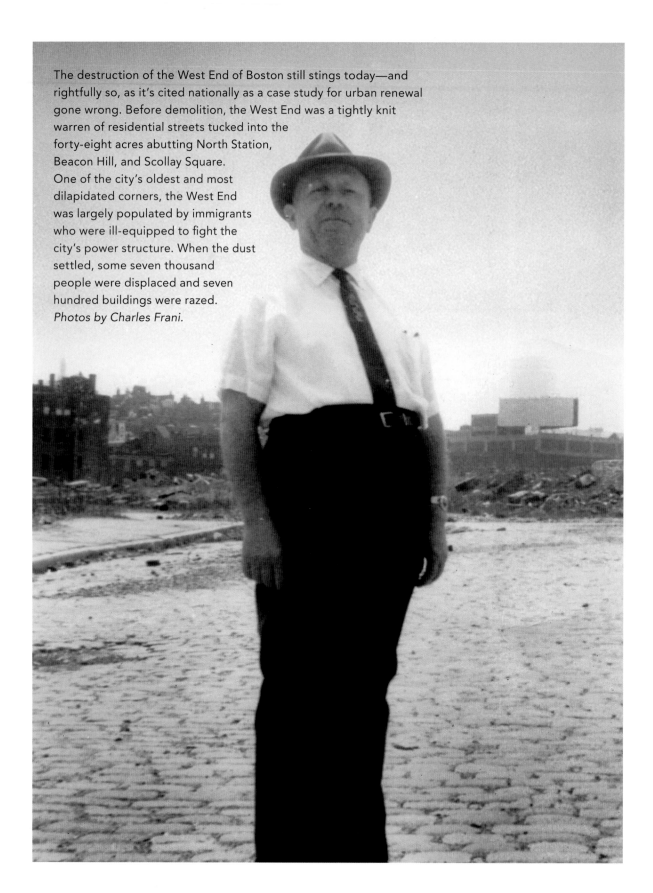

The destruction of the West End of Boston still stings today—and rightfully so, as it's cited nationally as a case study for urban renewal gone wrong. Before demolition, the West End was a tightly knit warren of residential streets tucked into the forty-eight acres abutting North Station, Beacon Hill, and Scollay Square. One of the city's oldest and most dilapidated corners, the West End was largely populated by immigrants who were ill-equipped to fight the city's power structure. When the dust settled, some seven thousand people were displaced and seven hundred buildings were razed. *Photos by Charles Frani.*

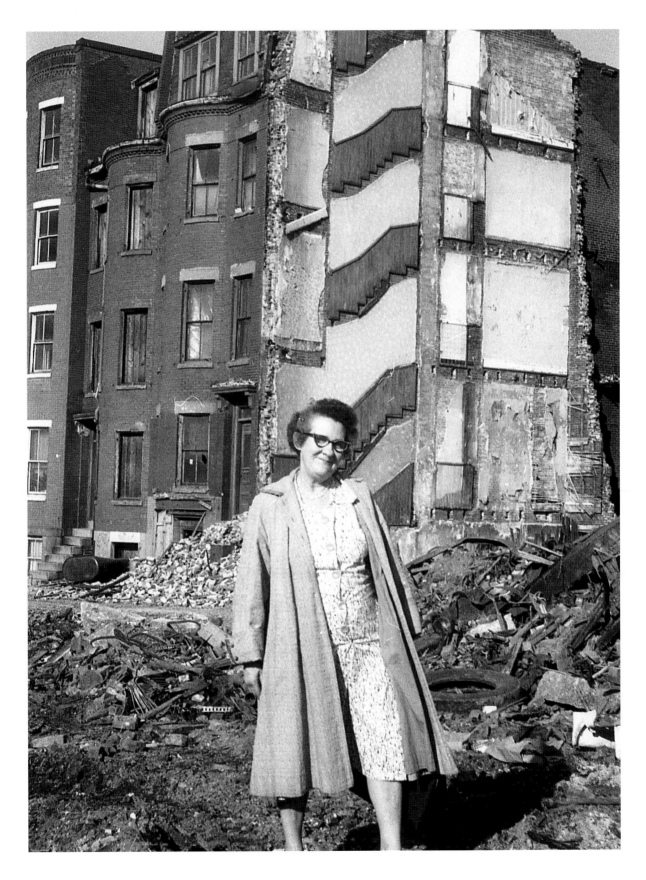

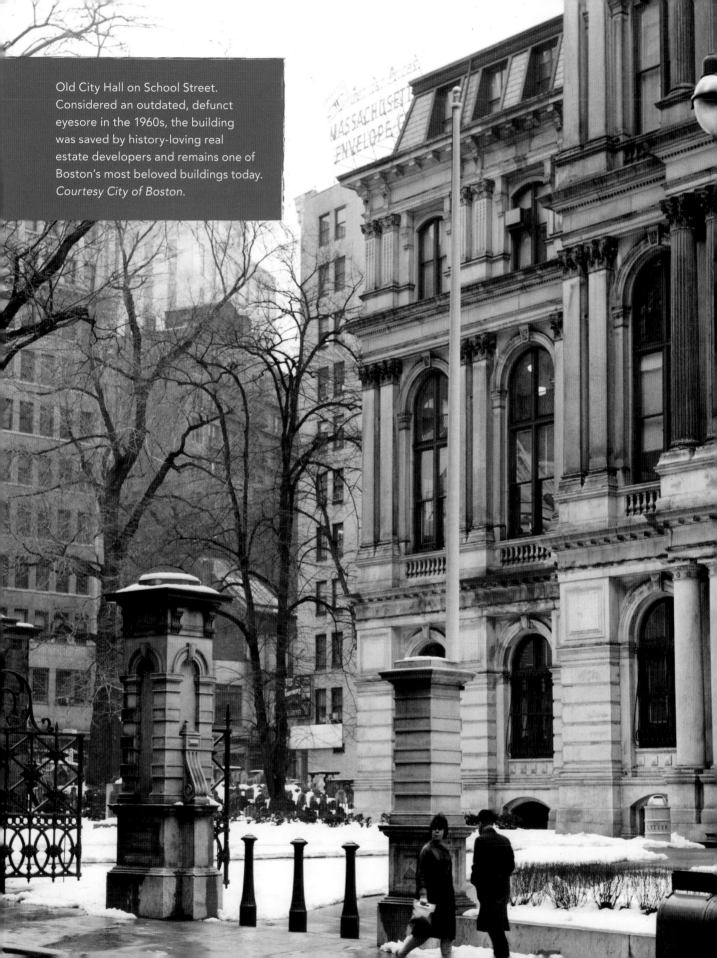

Old City Hall on School Street. Considered an outdated, defunct eyesore in the 1960s, the building was saved by history-loving real estate developers and remains one of Boston's most beloved buildings today. *Courtesy City of Boston.*

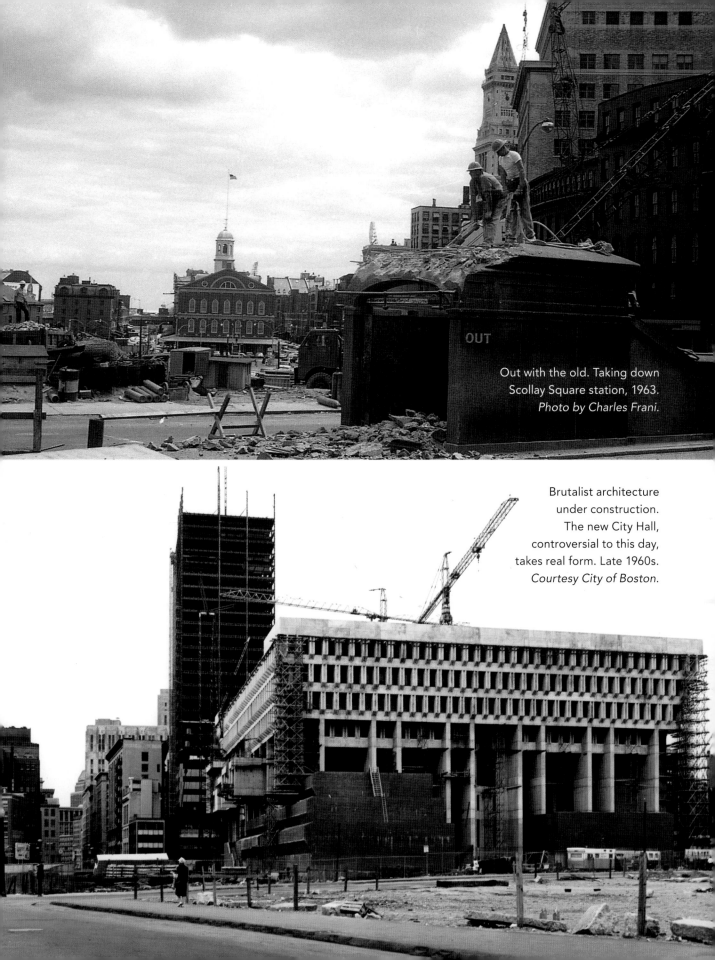

Out with the old. Taking down
Scollay Square station, 1963.
Photo by Charles Frani.

Brutalist architecture
under construction.
The new City Hall,
controversial to this day,
takes real form. Late 1960s.
Courtesy City of Boston.

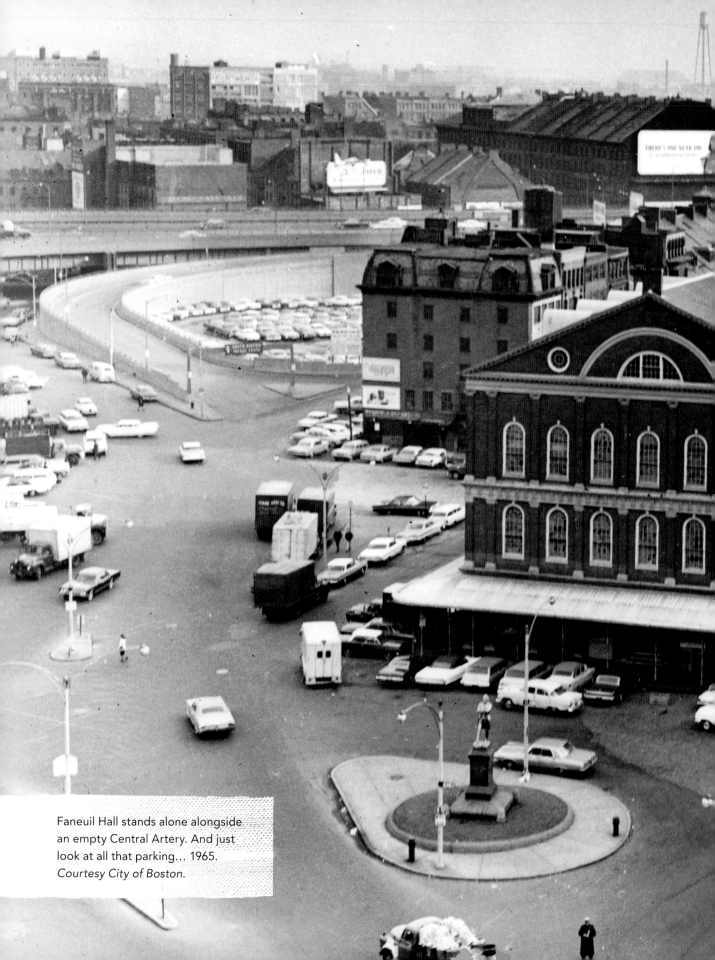

Faneuil Hall stands alone alongside an empty Central Artery. And just look at all that parking… 1965. *Courtesy City of Boston.*

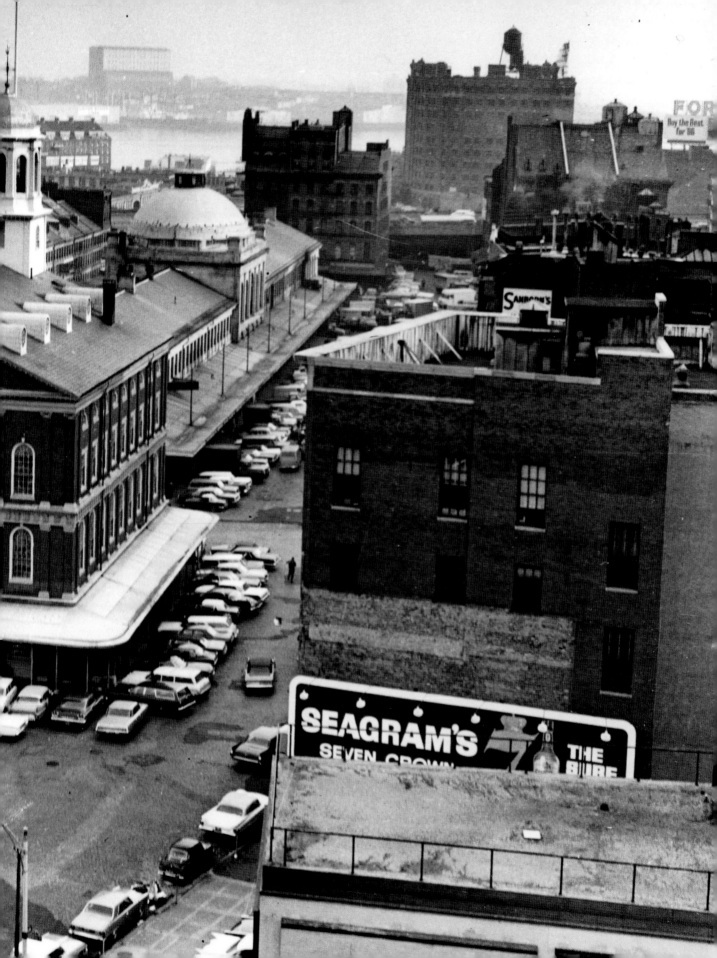

Urban renewal comes to Barry's Corner. Allston residents protest the BRA's plan to replace the ten-acre community of triple-decker houses with luxury apartments. The protests were so vehement that the city revised its plan to include low-cost housing. But by 1969, even the most tenacious residents were evicted.

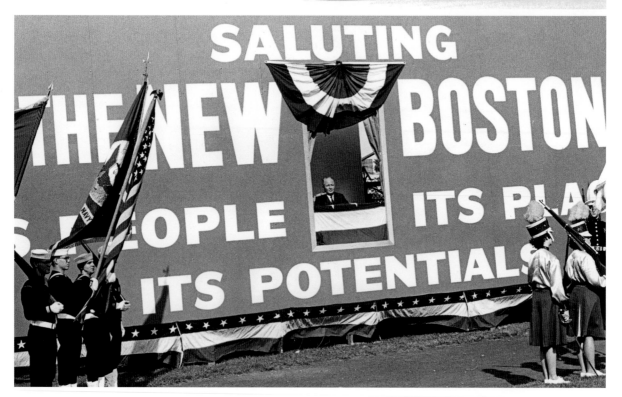

Selling the New Boston. Looking a little like Oz, Mayor Collins talks pretty about the merits of urban renewal at a Patriots game. Harvard Stadium, September 1962. *Photos courtesy City of Boston.*

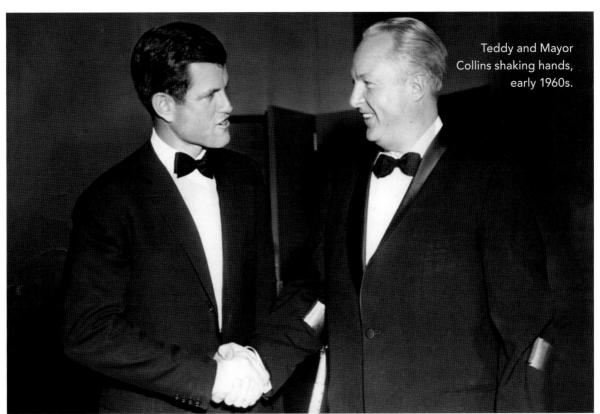

Teddy and Mayor Collins shaking hands, early 1960s.

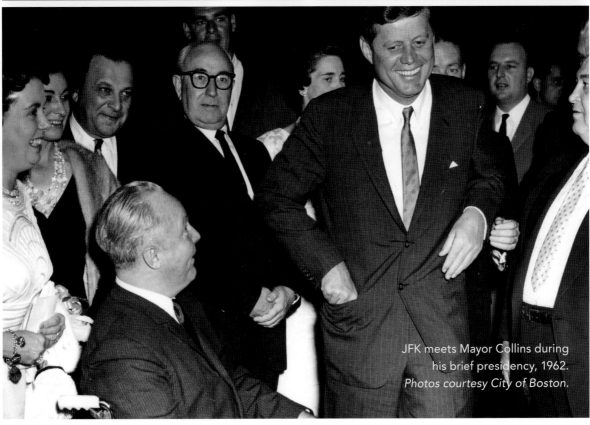

JFK meets Mayor Collins during his brief presidency, 1962.
Photos courtesy City of Boston.

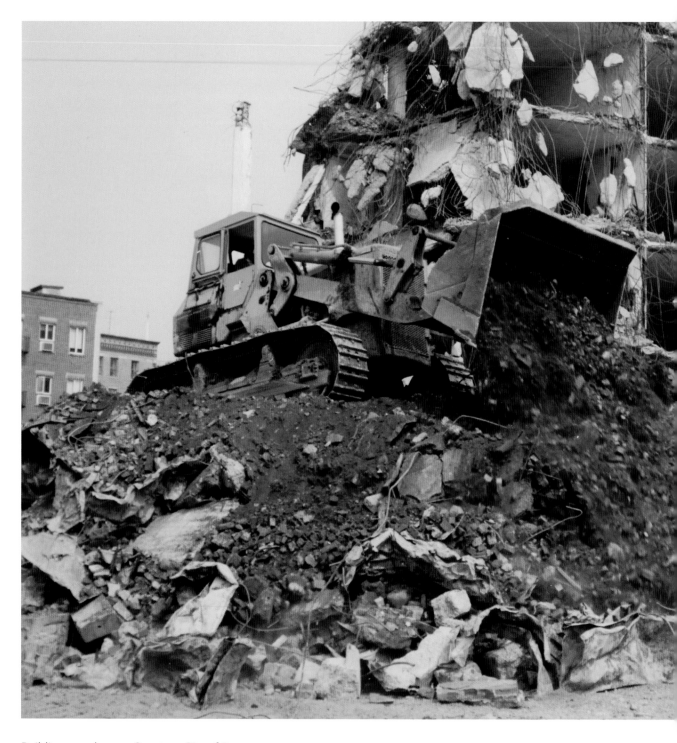

Buildings go down... *Courtesy City of Boston.*

*"**Architecture is** one part science, one part craft, and two parts art."*
—David Rutten

And buildings go up… The Prudential Building (the Pru), built upon railroad yards on Huntington Avenue, was one of Mayor Hynes' first urban renewal plans. Though the plan almost lost steam a number of times, the tower was finally built in 1964. It's said that both Edward Logue and Mayor Collins never had any real affection for it, but saw it as a necessary step in order to move forward with projects like Government Center. *Courtesy Frank Inserra.*

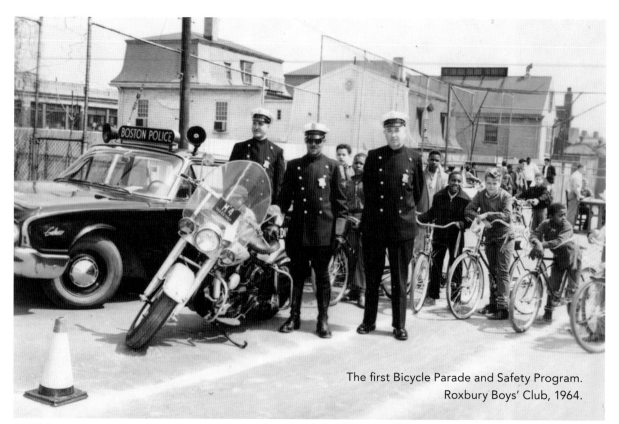

The first Bicycle Parade and Safety Program. Roxbury Boys' Club, 1964.

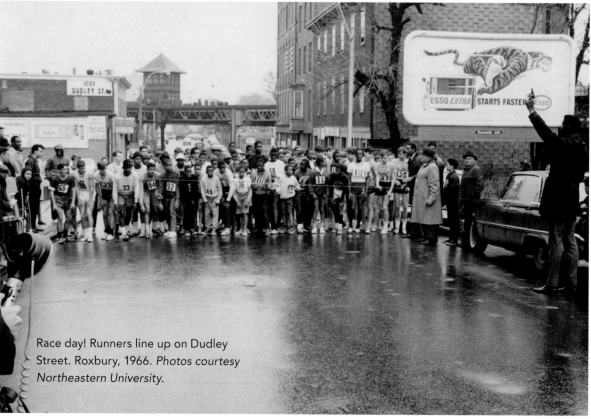

Race day! Runners line up on Dudley Street. Roxbury, 1966. *Photos courtesy Northeastern University.*

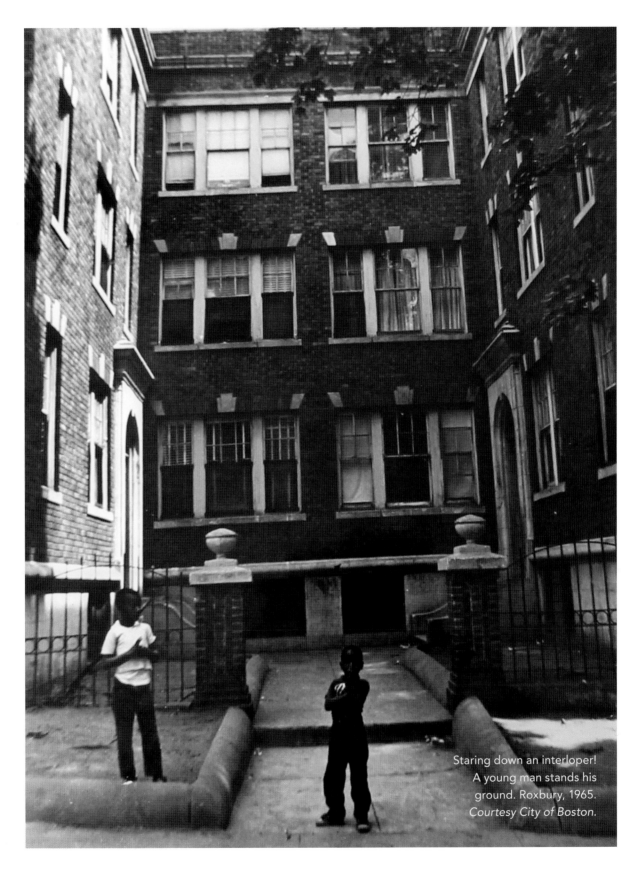

Staring down an interloper! A young man stands his ground. Roxbury, 1965. *Courtesy City of Boston.*

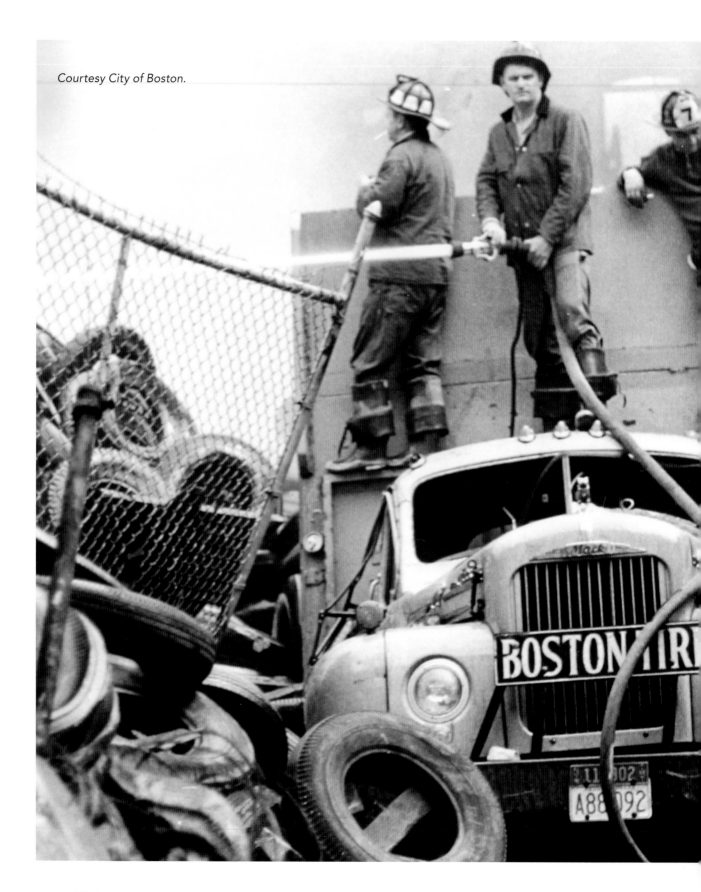

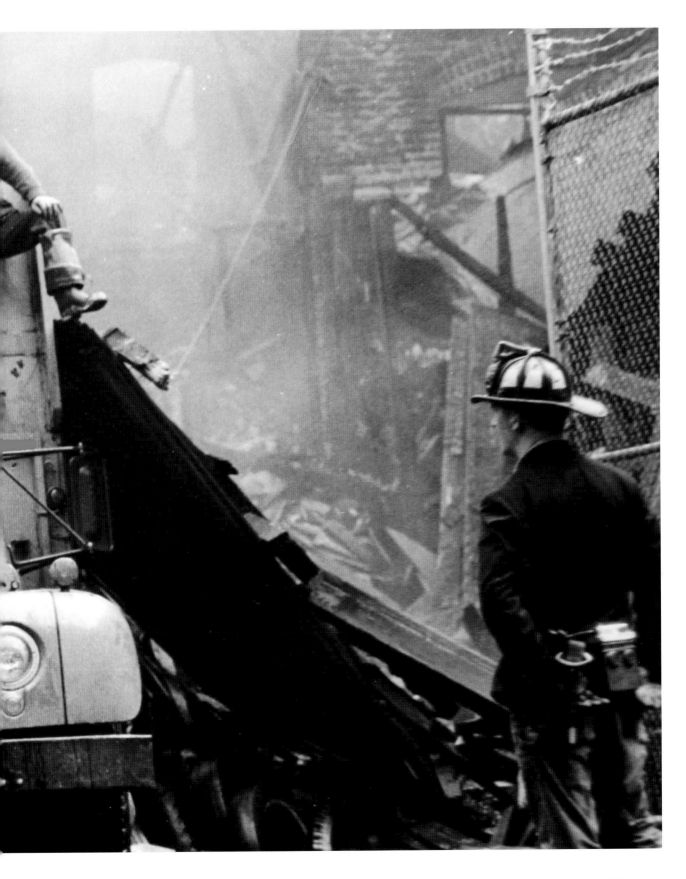

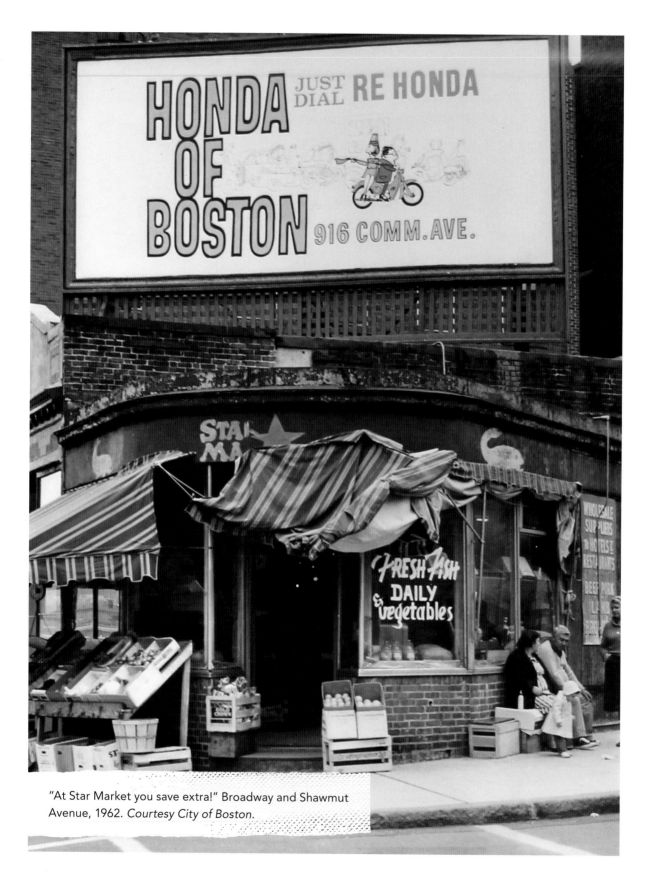

"At Star Market you save extra!" Broadway and Shawmut Avenue, 1962. *Courtesy City of Boston.*

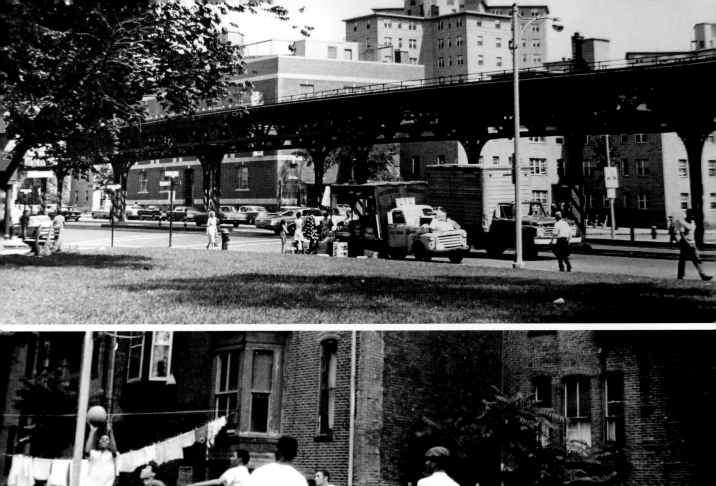

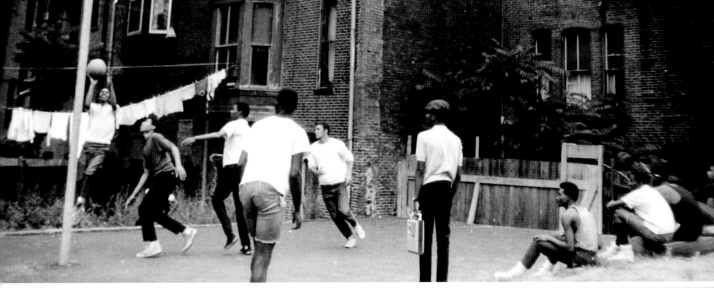

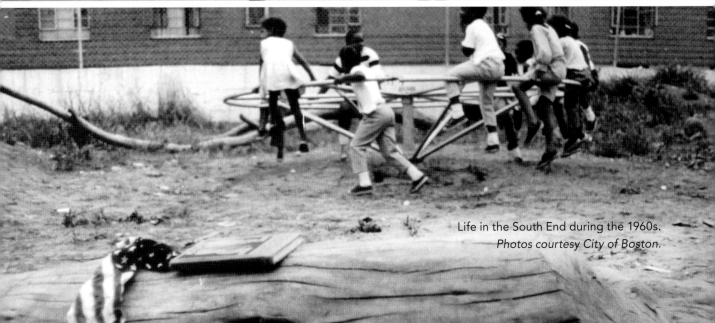

Life in the South End during the 1960s.
Photos courtesy City of Boston.

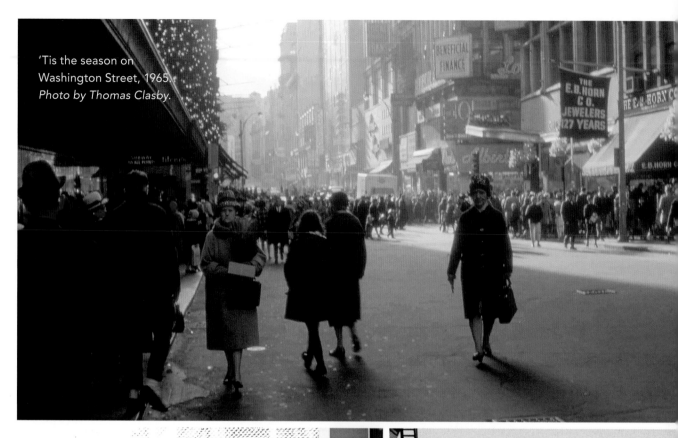

'Tis the season on Washington Street, 1965. *Photo by Thomas Clasby.*

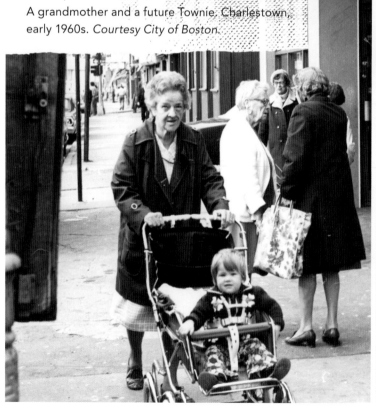

A grandmother and a future Townie, Charlestown, early 1960s. *Courtesy City of Boston.*

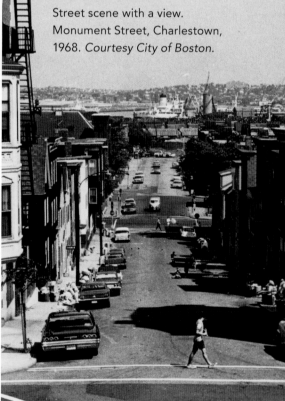

Street scene with a view. Monument Street, Charlestown, 1968. *Courtesy City of Boston.*

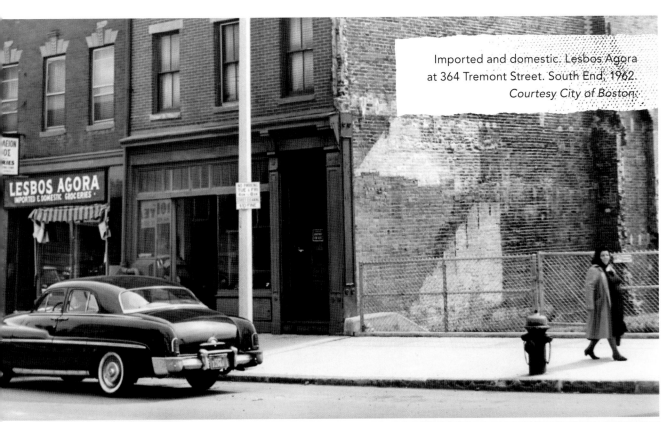

Imported and domestic. Lesbos Agora at 364 Tremont Street. South End, 1962.
Courtesy City of Boston.

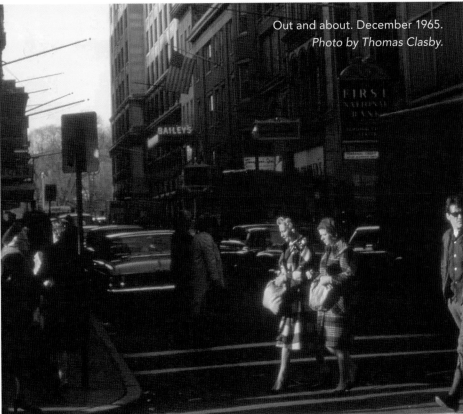

Out and about. December 1965.
Photo by Thomas Clasby.

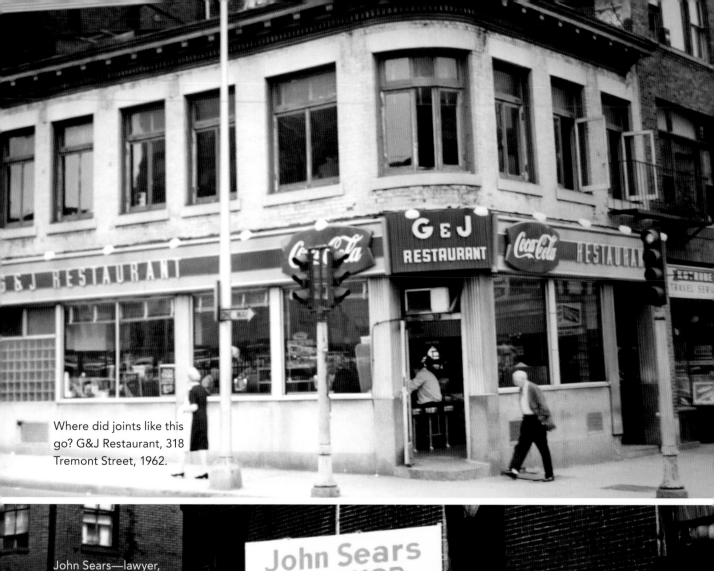

Where did joints like this go? G&J Restaurant, 318 Tremont Street, 1962.

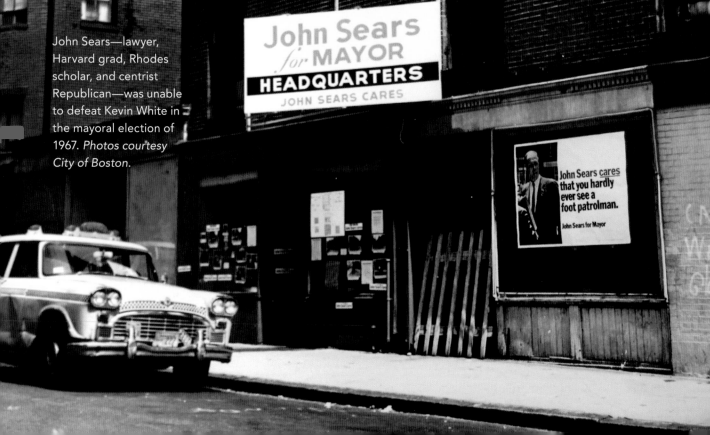

John Sears—lawyer, Harvard grad, Rhodes scholar, and centrist Republican—was unable to defeat Kevin White in the mayoral election of 1967. *Photos courtesy City of Boston.*

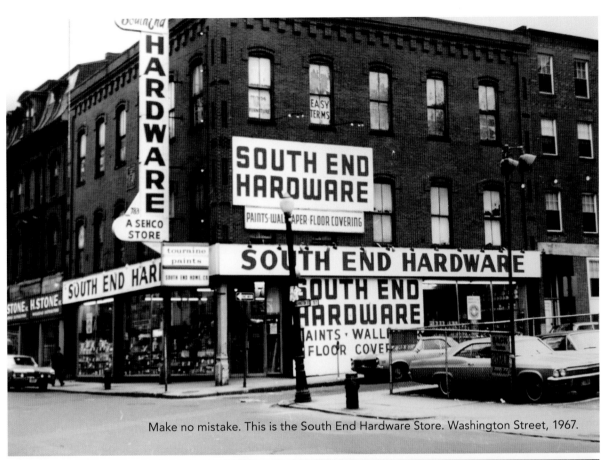

Make no mistake. This is the South End Hardware Store. Washington Street, 1967.

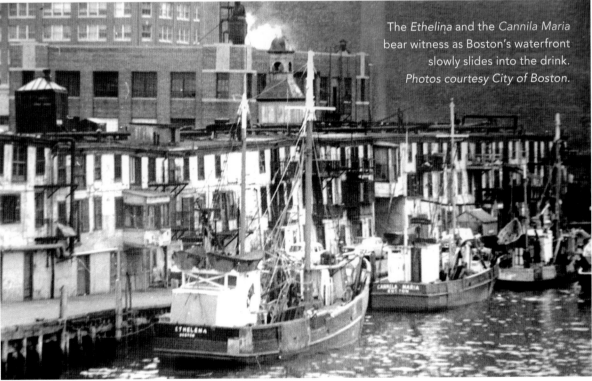

The *Ethelina* and the *Cannila Maria* bear witness as Boston's waterfront slowly slides into the drink. *Photos courtesy City of Boston.*

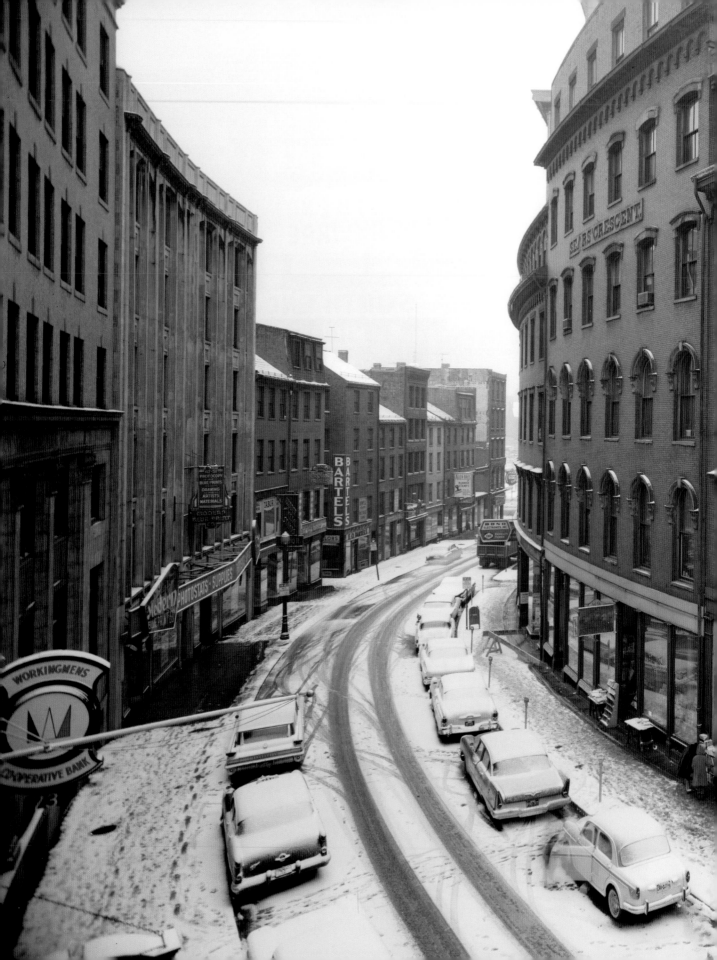

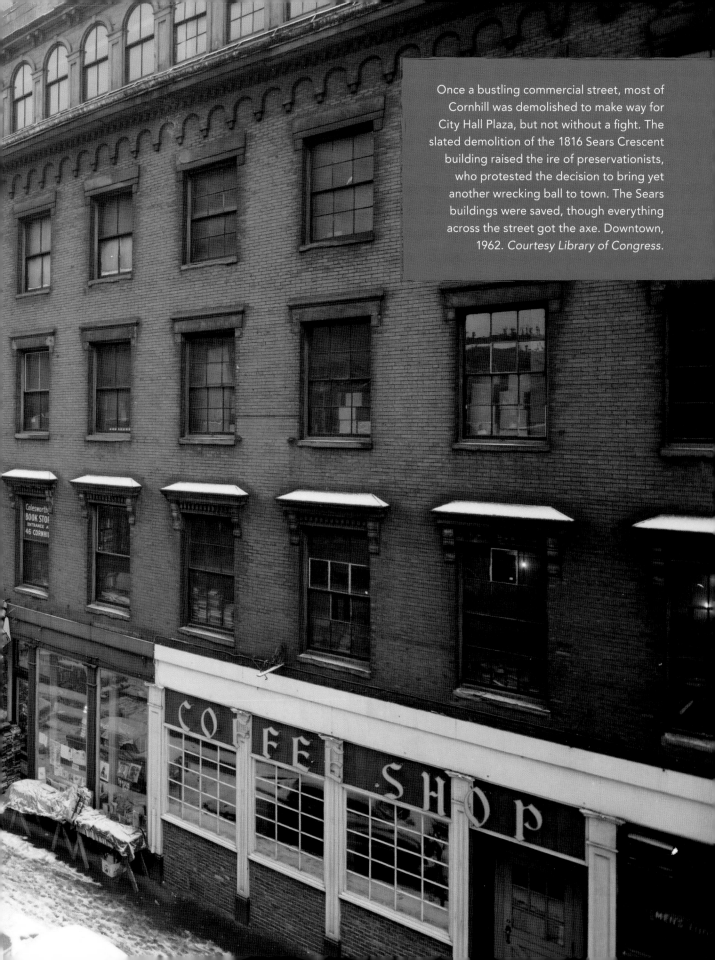

Once a bustling commercial street, most of Cornhill was demolished to make way for City Hall Plaza, but not without a fight. The slated demolition of the 1816 Sears Crescent building raised the ire of preservationists, who protested the decision to bring yet another wrecking ball to town. The Sears buildings were saved, though everything across the street got the axe. Downtown, 1962. *Courtesy Library of Congress.*

Blessed Sacrament Church. Jamaica Plain, 1969. *Courtesy Barbara Ward.*

Playground on the Esplanade. *Courtesy West End Museum.*

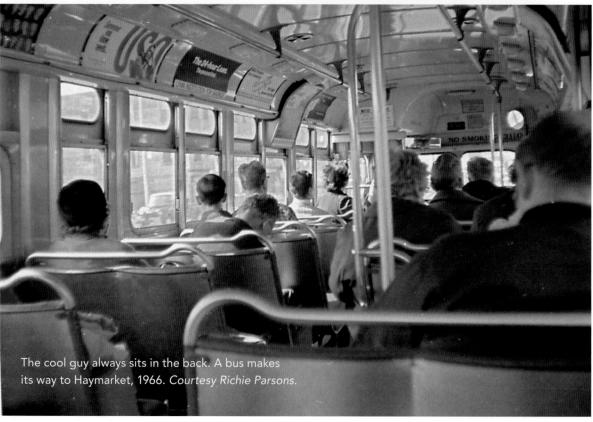

The cool guy always sits in the back. A bus makes its way to Haymarket, 1966. *Courtesy Richie Parsons.*

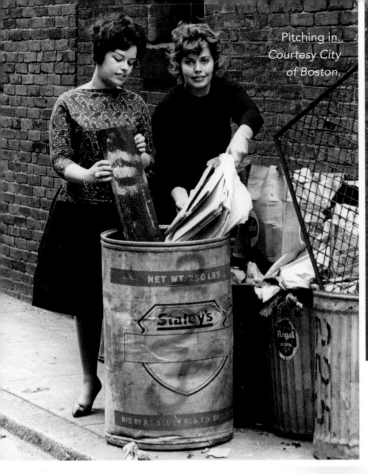

Pitching in.
Courtesy City
of Boston.

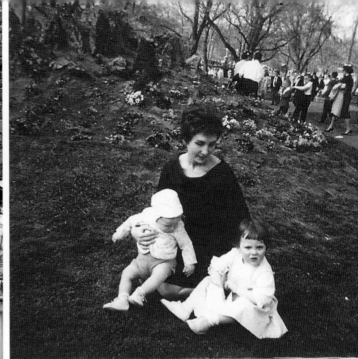

"Easter Sunday, 1962. In the Public Garden...I always thought my mom looked so beautiful in this photo!"
– Kathleen P. Moschella

Staying cool at the Lee Pool,
Charles River Esplanade.
Courtesy West End Museum.

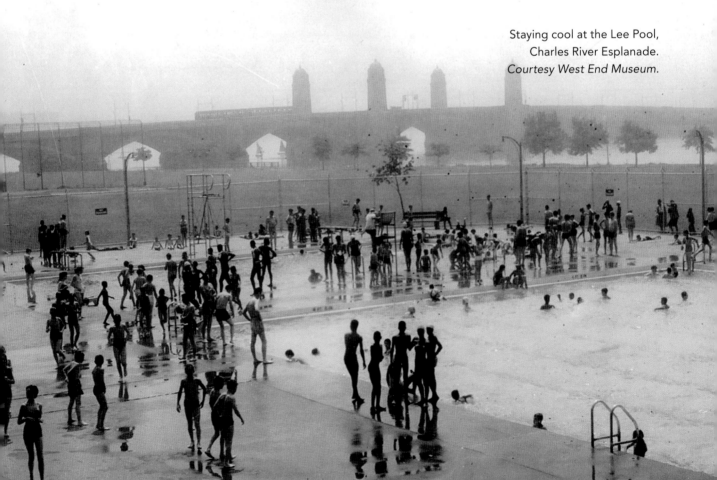

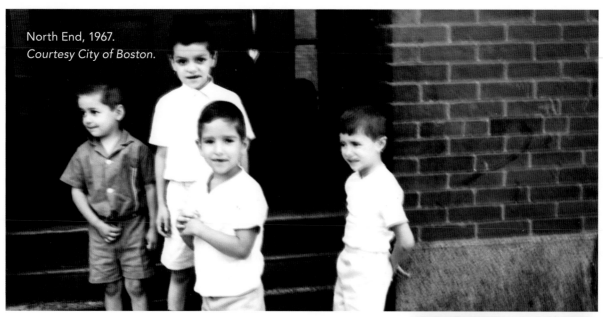

North End, 1967.
Courtesy City of Boston.

"Some of the gang at Clarkson Street and Quincy Street in Dorchester, November 1965. We were bored on a Sunday. My car, my idea. It's a '53 Chevy convertible." – Jim Adduci

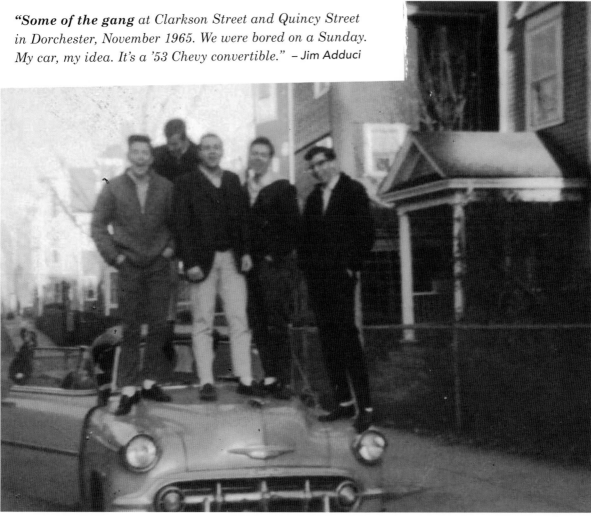

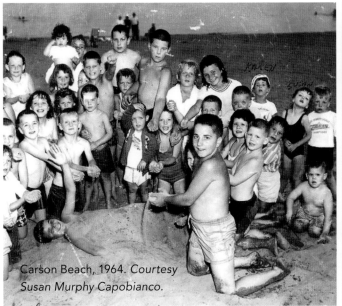

Carson Beach, 1964. *Courtesy Susan Murphy Capobianco.*

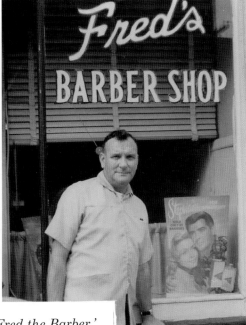

*"**This is a photo** of my father, Fred Ciliberto, a.k.a. 'Fred the Barber.' His barbershop was located on Sumner Street in East Boston…He had his shop there after he got out of the military after World War II. He is a disabled veteran. He retired in 2009."* – Fred Ciliberto

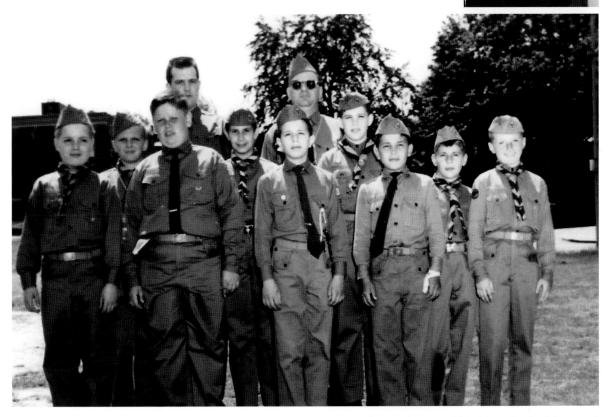

Scout's honor, 1966. *Photo by Jack Leonard.*

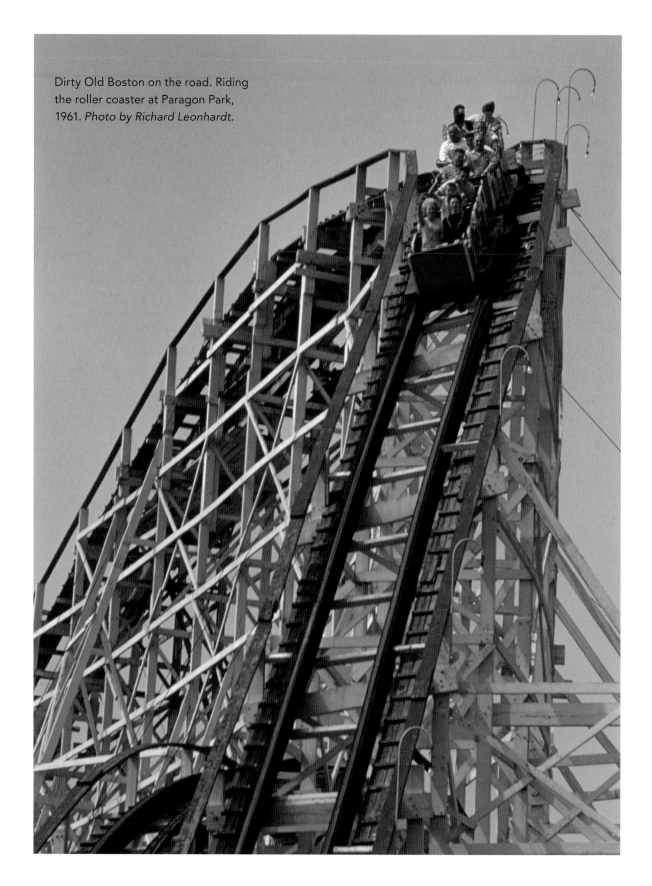

Dirty Old Boston on the road. Riding the roller coaster at Paragon Park, 1961. *Photo by Richard Leonhardt.*

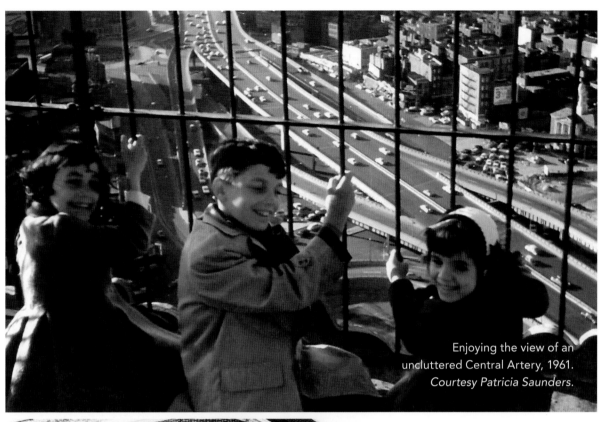

Enjoying the view of an uncluttered Central Artery, 1961. *Courtesy Patricia Saunders.*

Penguins on parade. Brighton Center, 1965. *Photo by Jack Leonard.*

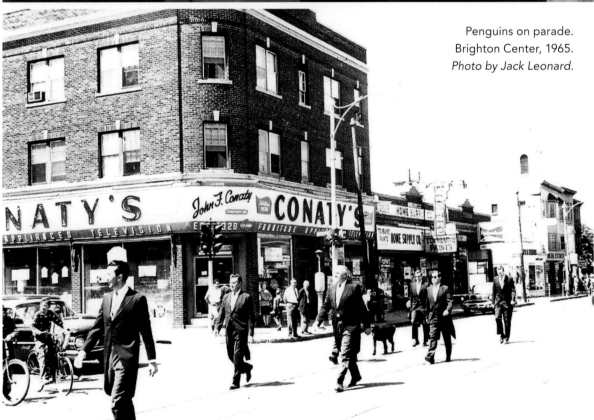

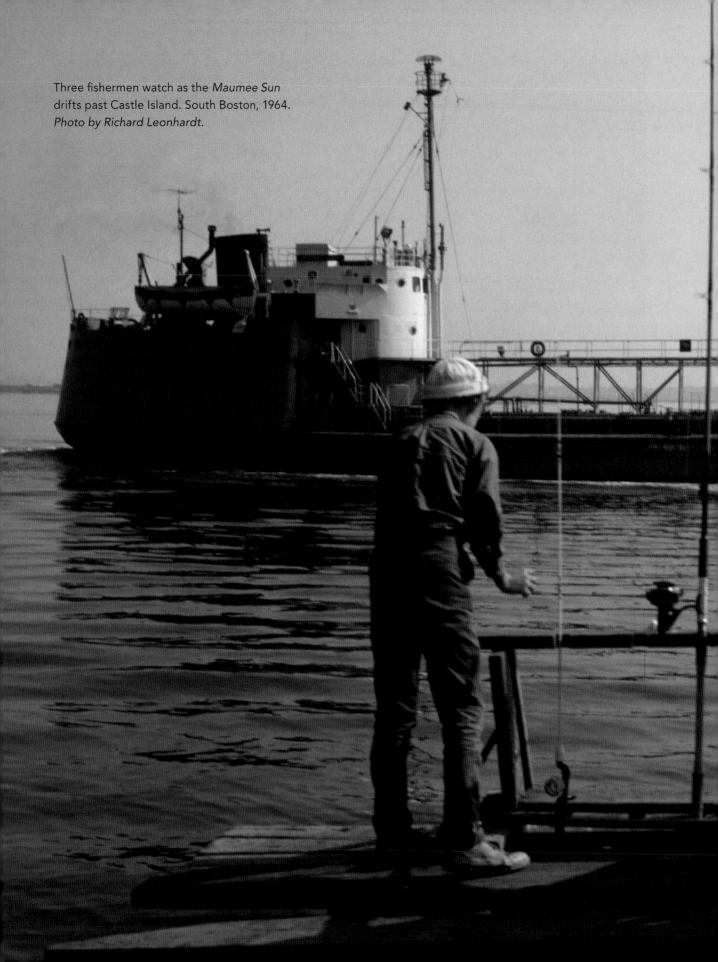

Three fishermen watch as the *Maumee Sun*
drifts past Castle Island. South Boston, 1964.
Photo by Richard Leonhardt.

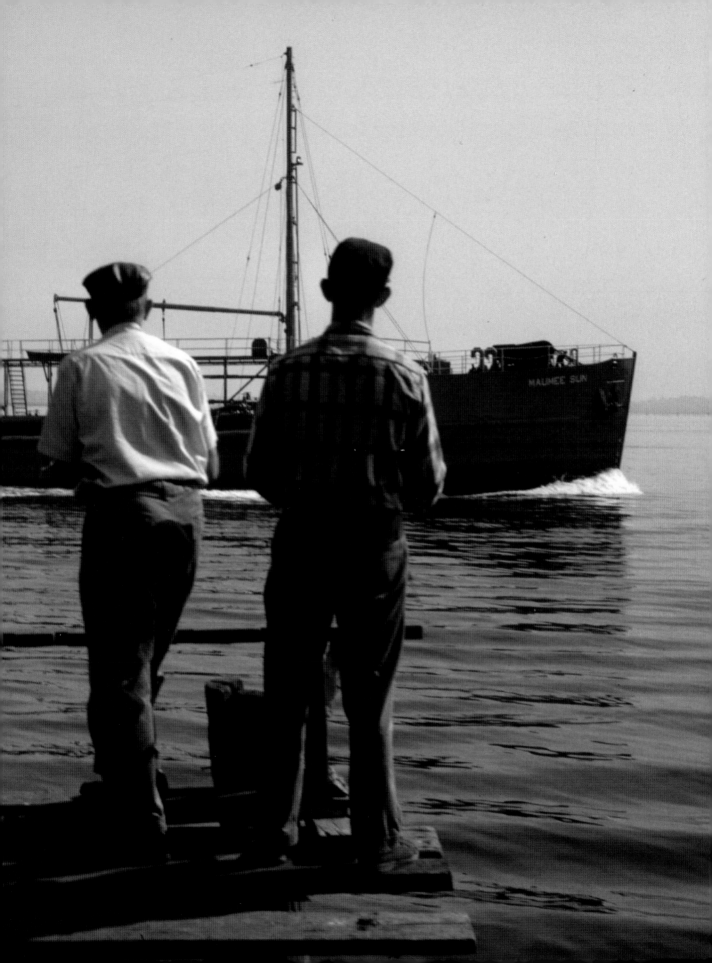

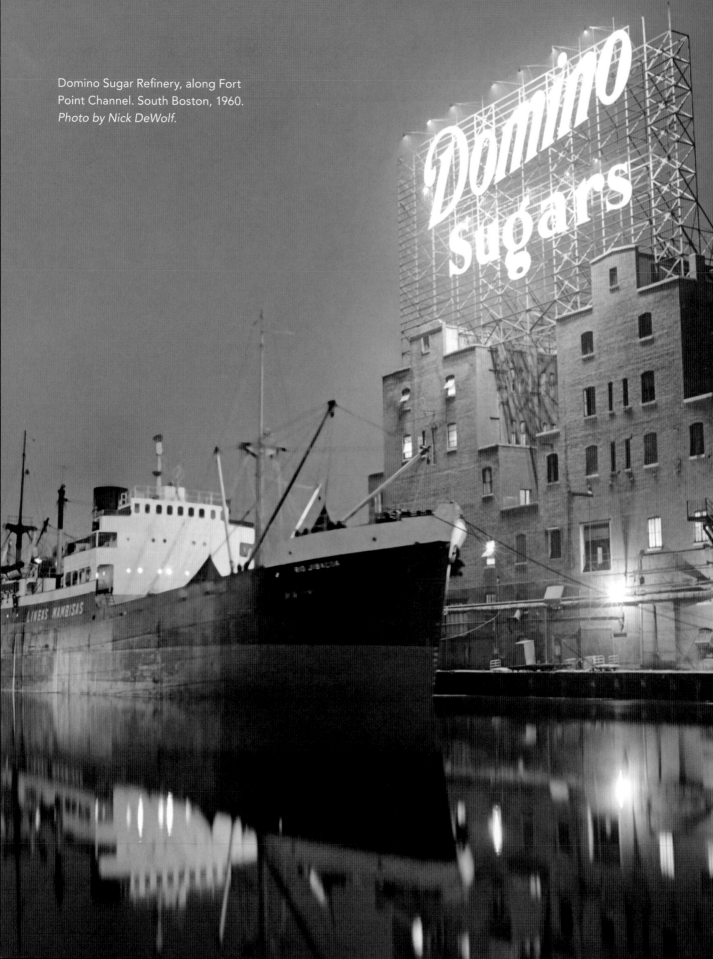

Domino Sugar Refinery, along Fort Point Channel. South Boston, 1960. *Photo by Nick DeWolf.*

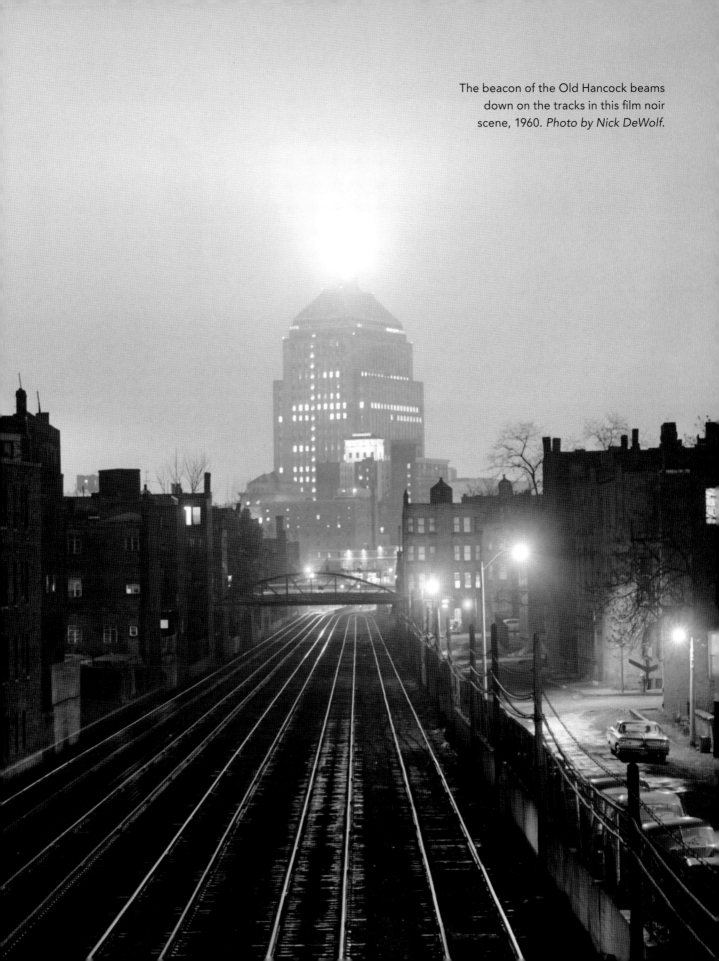

The beacon of the Old Hancock beams down on the tracks in this film noir scene, 1960. *Photo by Nick DeWolf.*

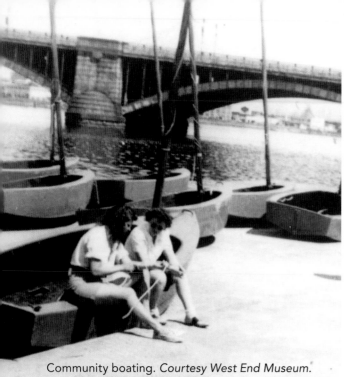

Community boating. *Courtesy West End Museum.*

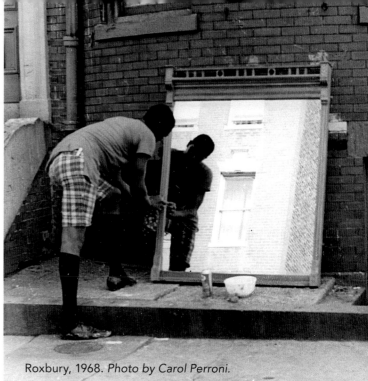

Roxbury, 1968. *Photo by Carol Perroni.*

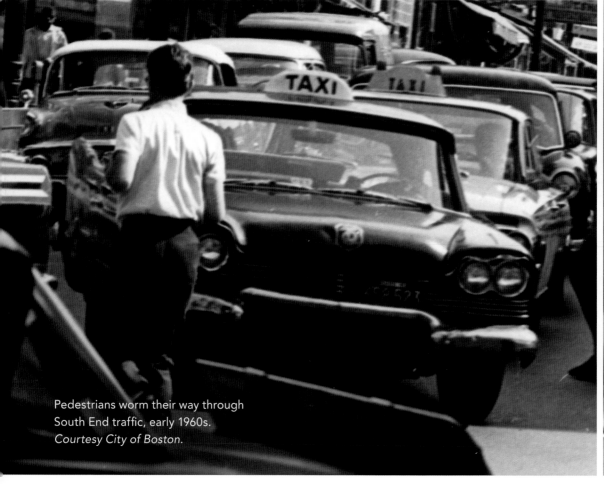

Pedestrians worm their way through South End traffic, early 1960s. *Courtesy City of Boston.*

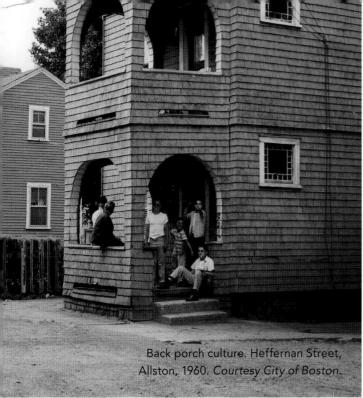

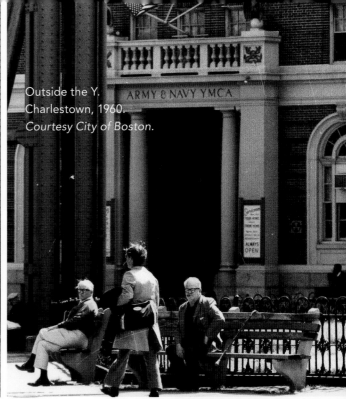

Outside the Y.
Charlestown, 1960.
Courtesy City of Boston.

Back porch culture. Heffernan Street,
Allston, 1960. *Courtesy City of Boston.*

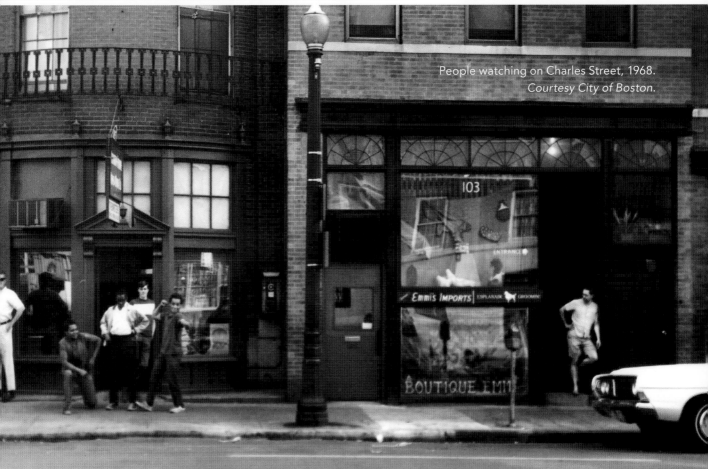

People watching on Charles Street, 1968.
Courtesy City of Boston.

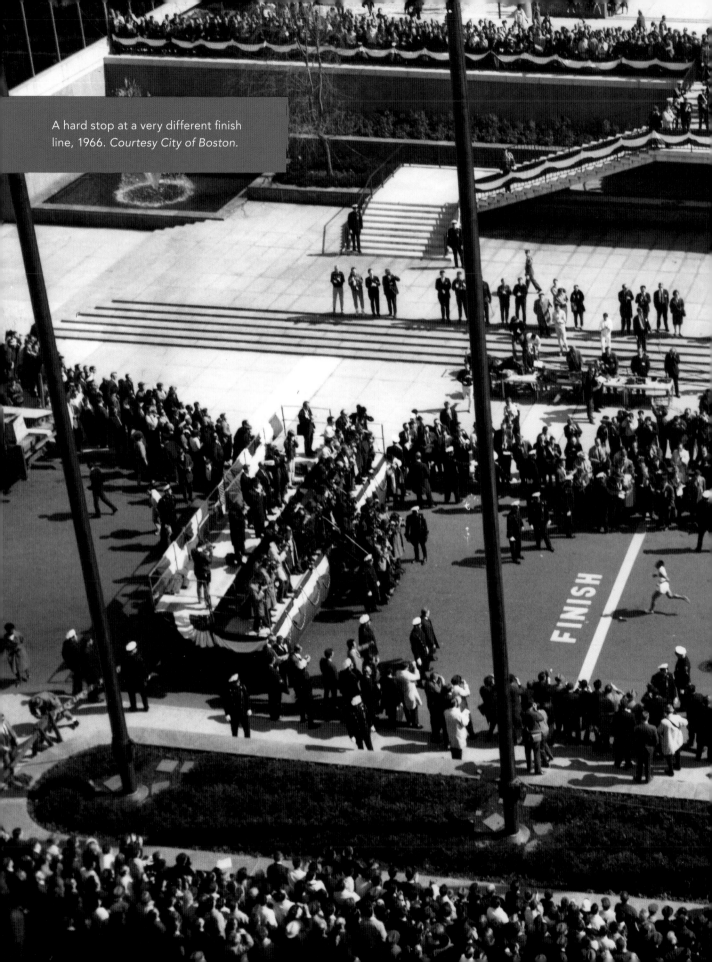

A hard stop at a very different finish line, 1966. *Courtesy City of Boston.*

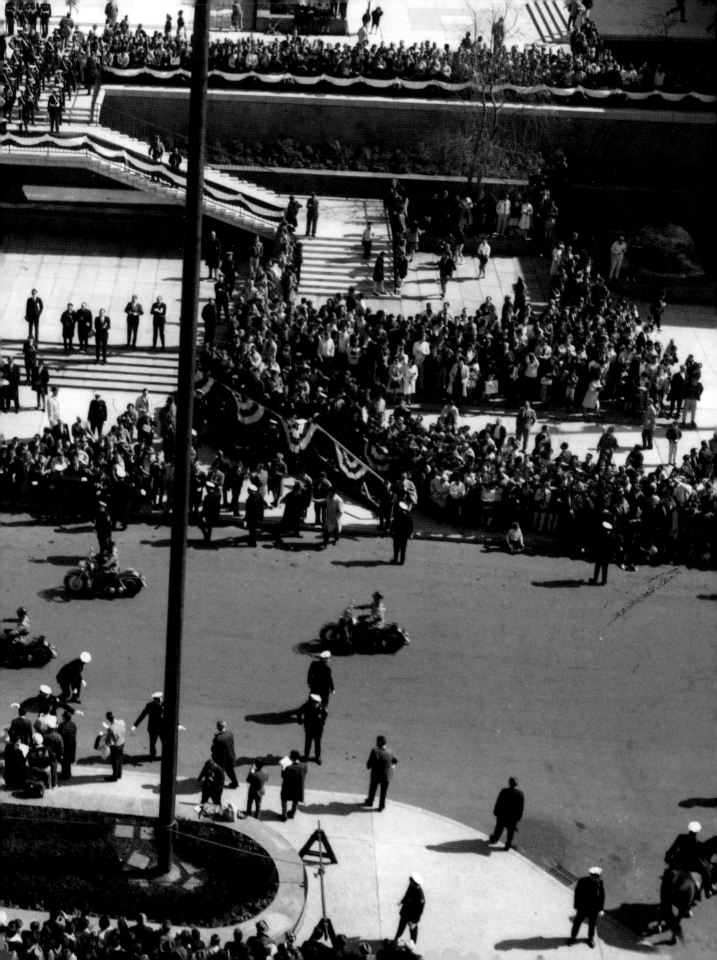

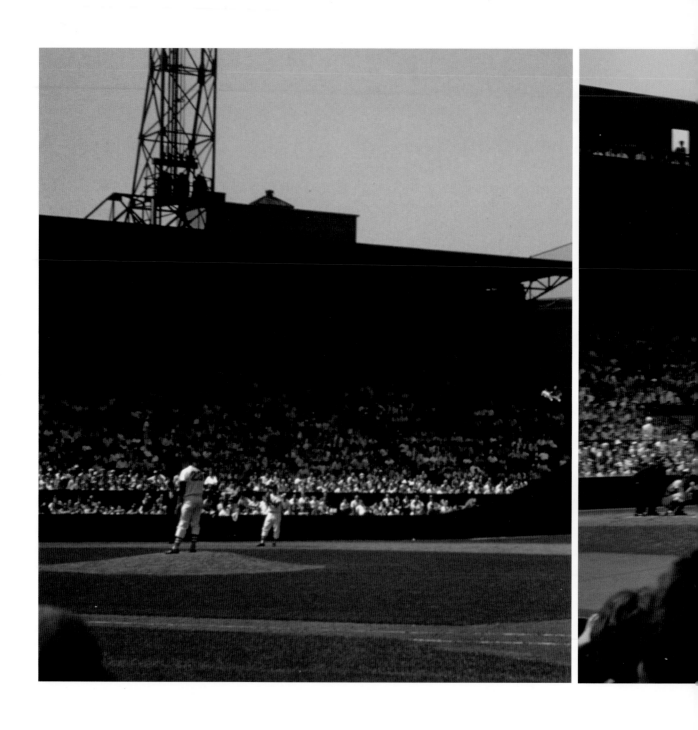

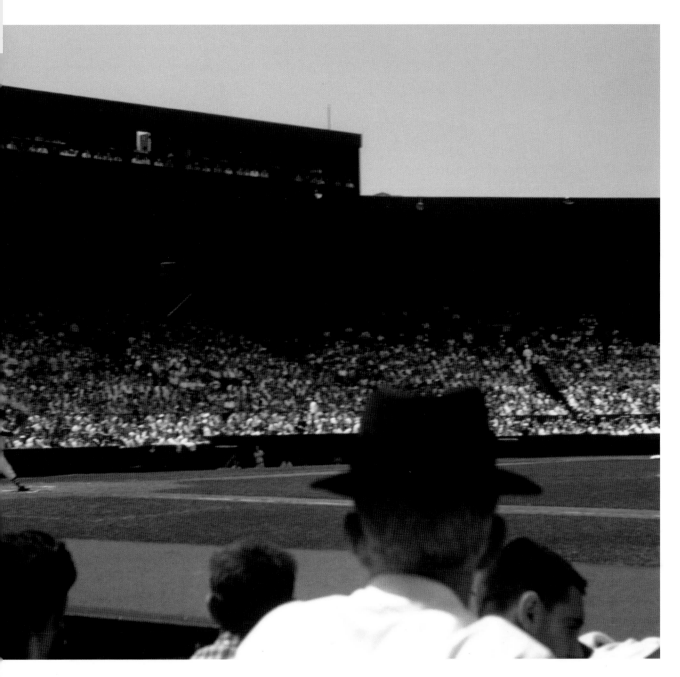

Hats off in front! Jim Perry pitching (left photo), Ted Williams batting, and Johnny Romano catching. Fenway Park, July 23, 1960. *Photos by Richard Leonhardt.*

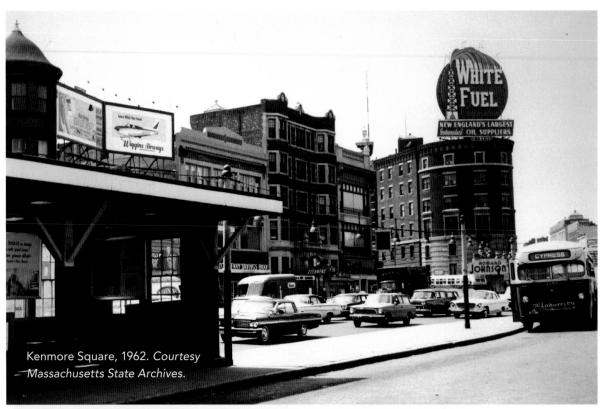

Kenmore Square, 1962. *Courtesy Massachusetts State Archives.*

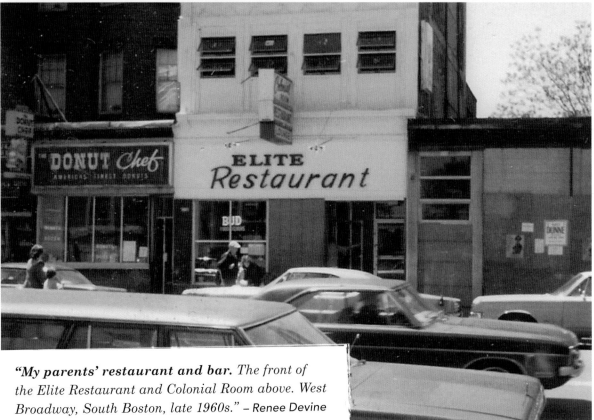

"My parents' restaurant and bar. *The front of the Elite Restaurant and Colonial Room above. West Broadway, South Boston, late 1960s."* – Renee Devine

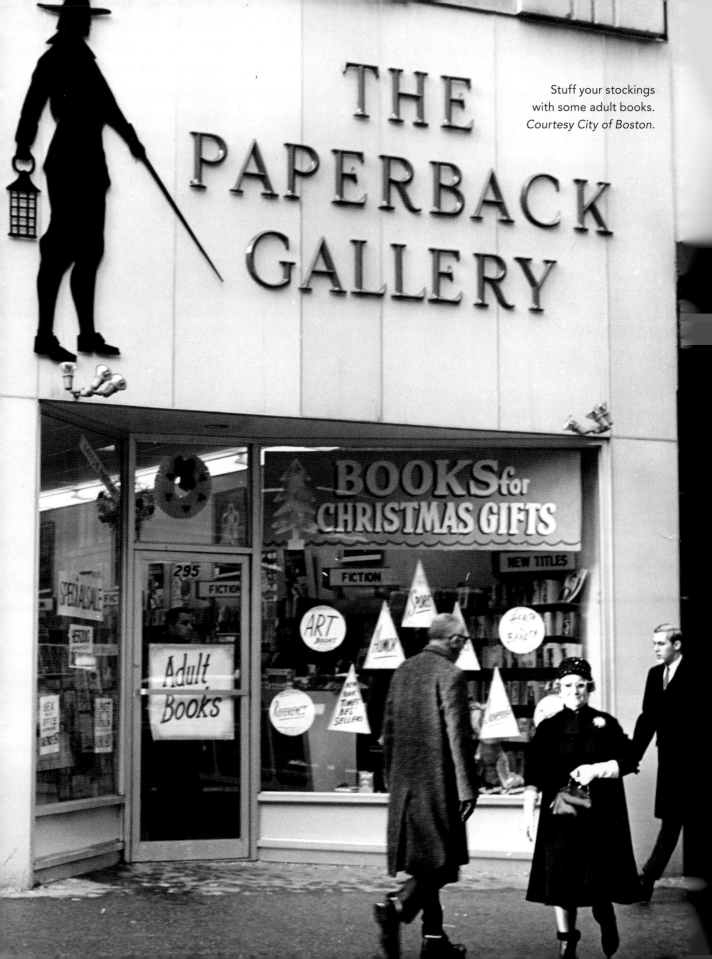

THE PAPERBACK GALLERY

Stuff your stockings with some adult books. *Courtesy City of Boston.*

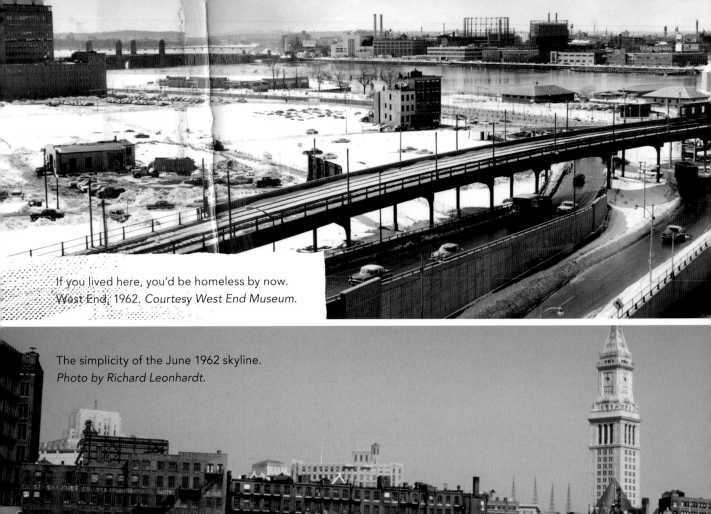

If you lived here, you'd be homeless by now.
West End, 1962. *Courtesy West End Museum.*

The simplicity of the June 1962 skyline.
Photo by Richard Leonhardt.

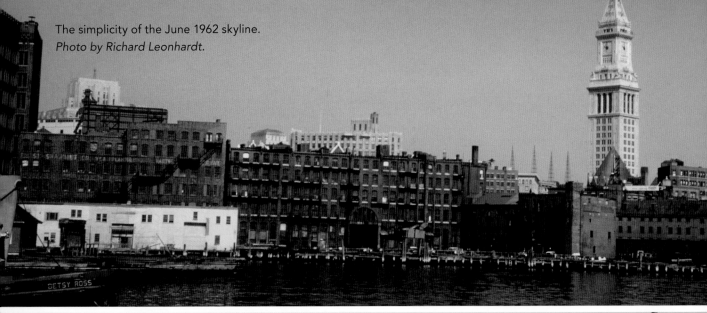

USS *Sampson* and USS *Beatty* dock in Boston,
June 1961. *Photo by Richard Leonhardt.*

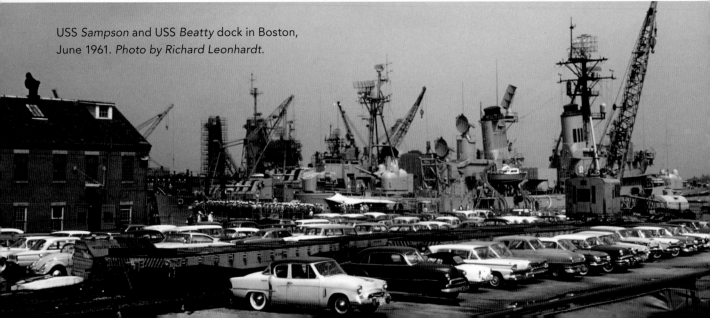

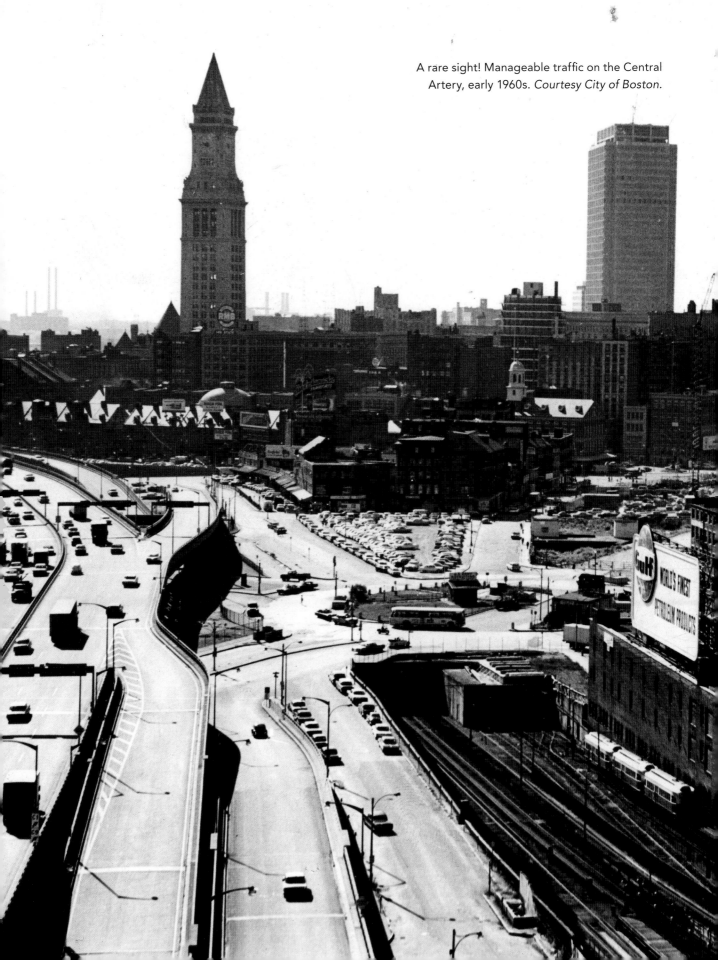

A rare sight! Manageable traffic on the Central Artery, early 1960s. *Courtesy City of Boston.*

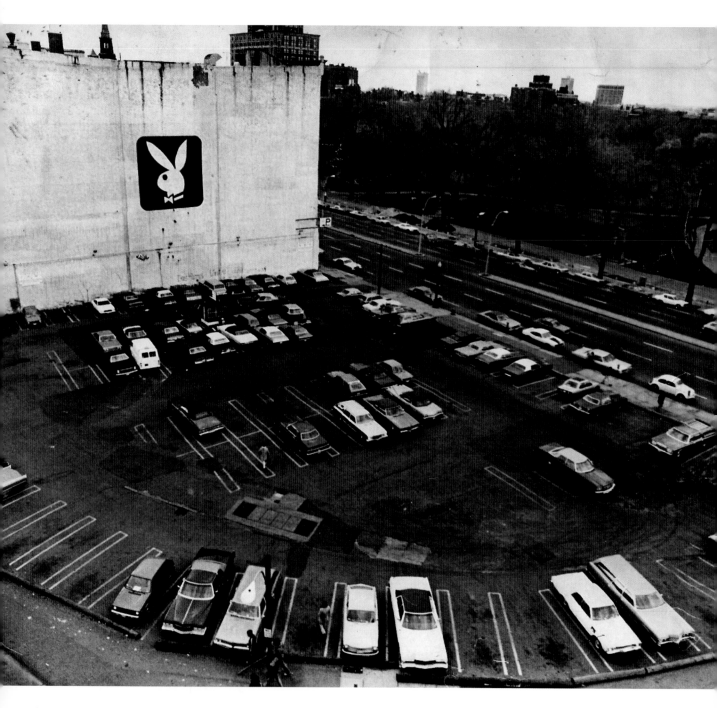

Opened in 1962, closed in 1976. The Playboy Club at 54 Park Square.
Courtesy Ronnie Keshishian.

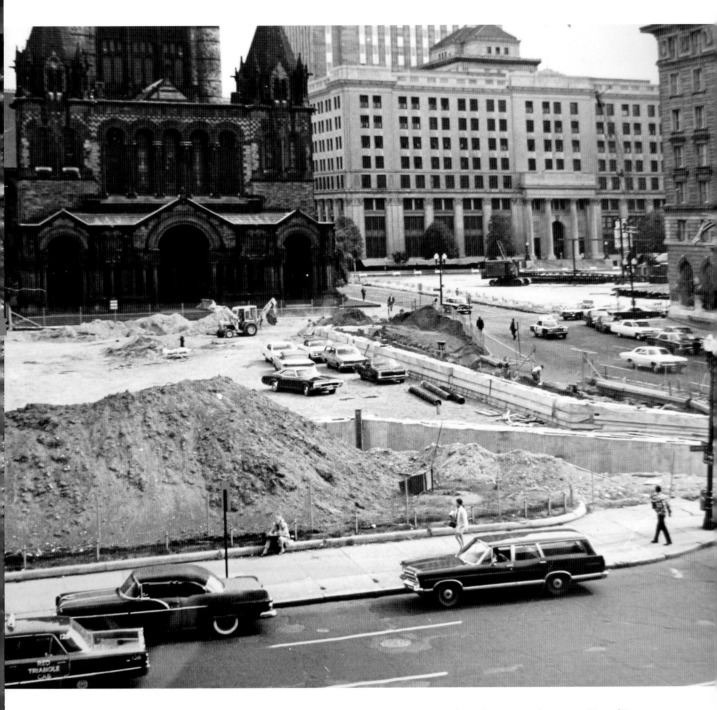

The squaring of Copley, 1961. *Courtesy City of Boston.*

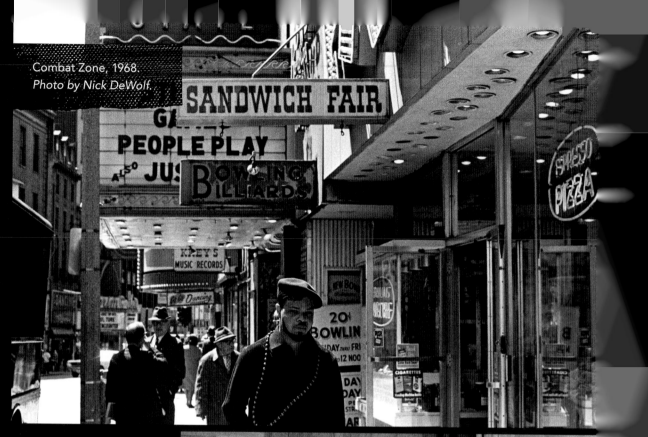

Combat Zone, 1968.
Photo by Nick DeWolf.

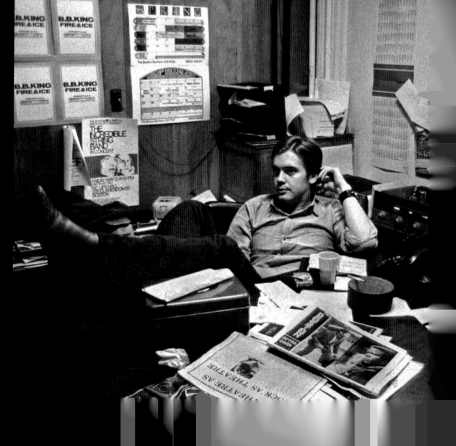

Don Law, the "Gentleman in the Jungle," began his career by promoting legendary Boston band Barry & the Remains. From there, he went on to play a part in the success of the Paradise, Brighton Music Hall, the Boston Opera House, and the House of Blues. Pictured in his office, 1969.
Photo by A.J. Sullivan.

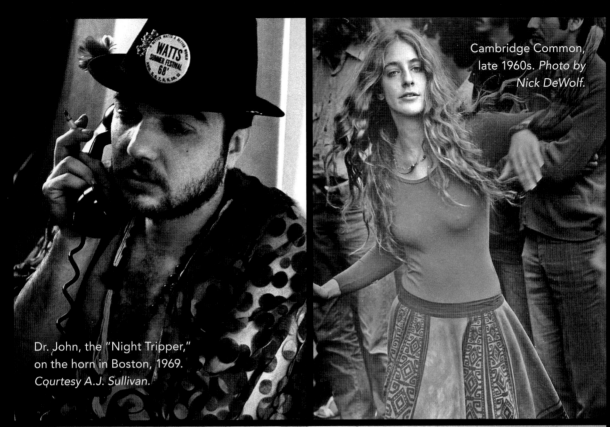

Dr. John, the "Night Tripper," on the horn in Boston, 1969. *Courtesy A.J. Sullivan.*

Cambridge Common, late 1960s. *Photo by Nick DeWolf.*

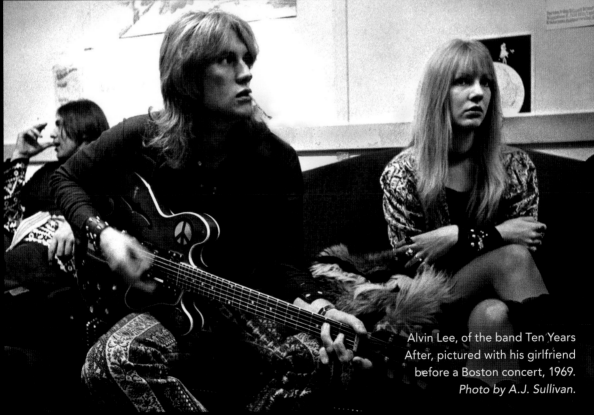

Alvin Lee, of the band Ten Years After, pictured with his girlfriend before a Boston concert, 1969. *Photo by A.J. Sullivan.*

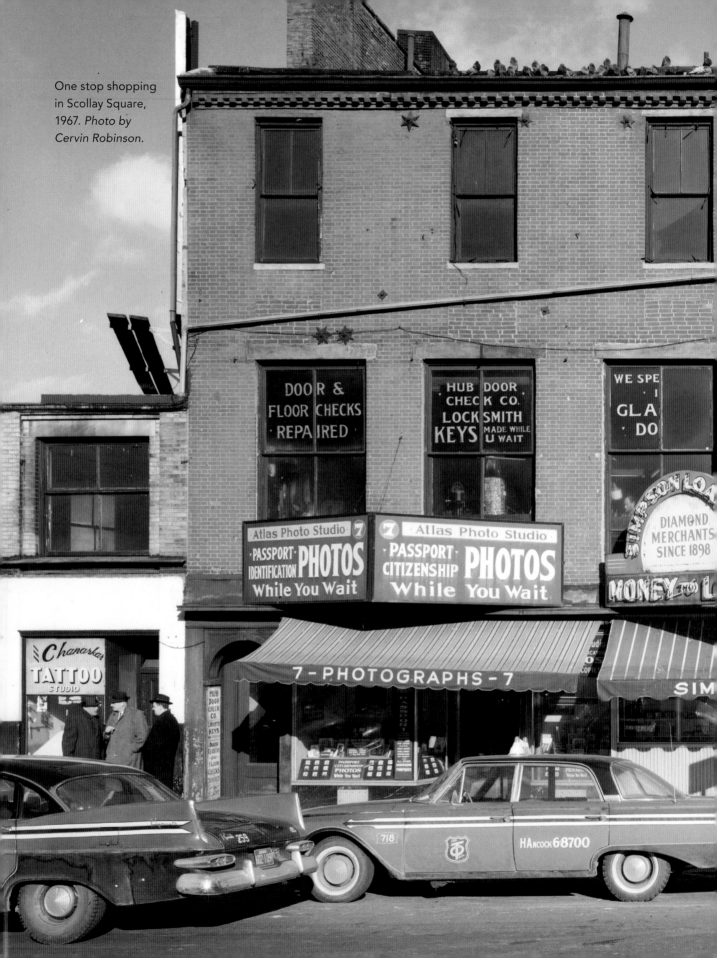

One stop shopping in Scollay Square, 1967. *Photo by Cervin Robinson.*

"The school busing issue was a very highly charged social moment in early 1970s Boston. Rather than record the events from the sidelines as a spectator, we joined the march and shot images of the people observing the event. This concept sometimes provided evocative images of a powerful moment. This was taken at the March Against Racism in the Fenway, December 1974."

– Chris Considine

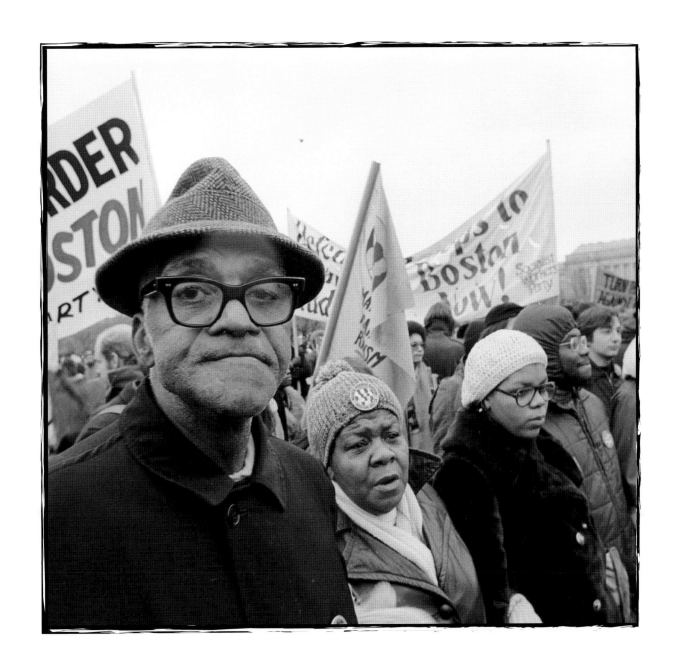

the **1970s**

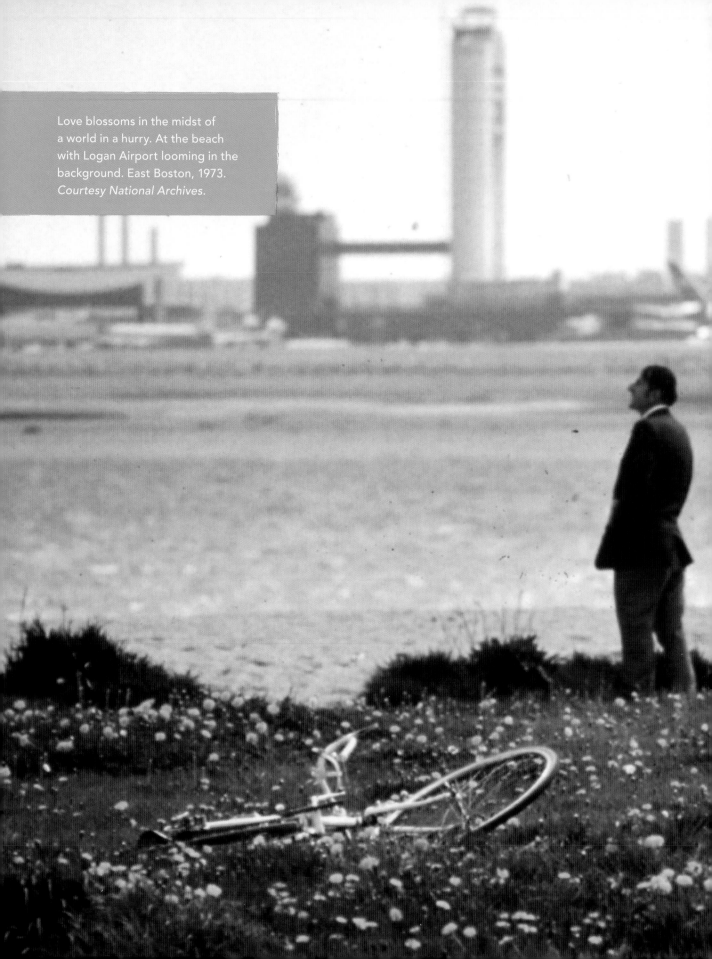

Love blossoms in the midst of a world in a hurry. At the beach with Logan Airport looming in the background. East Boston, 1973. *Courtesy National Archives.*

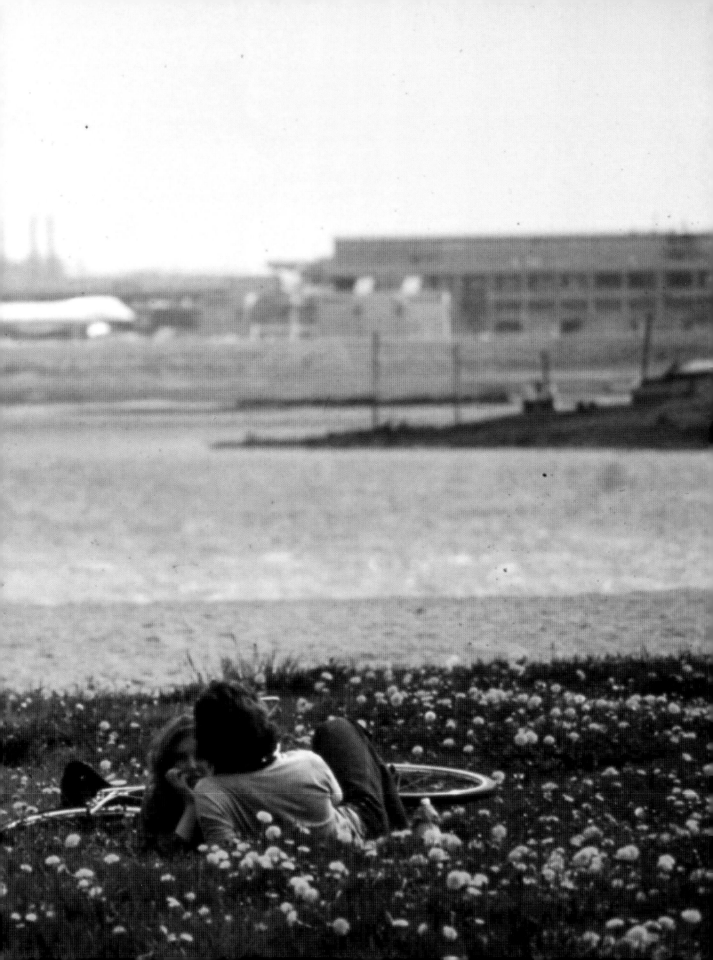

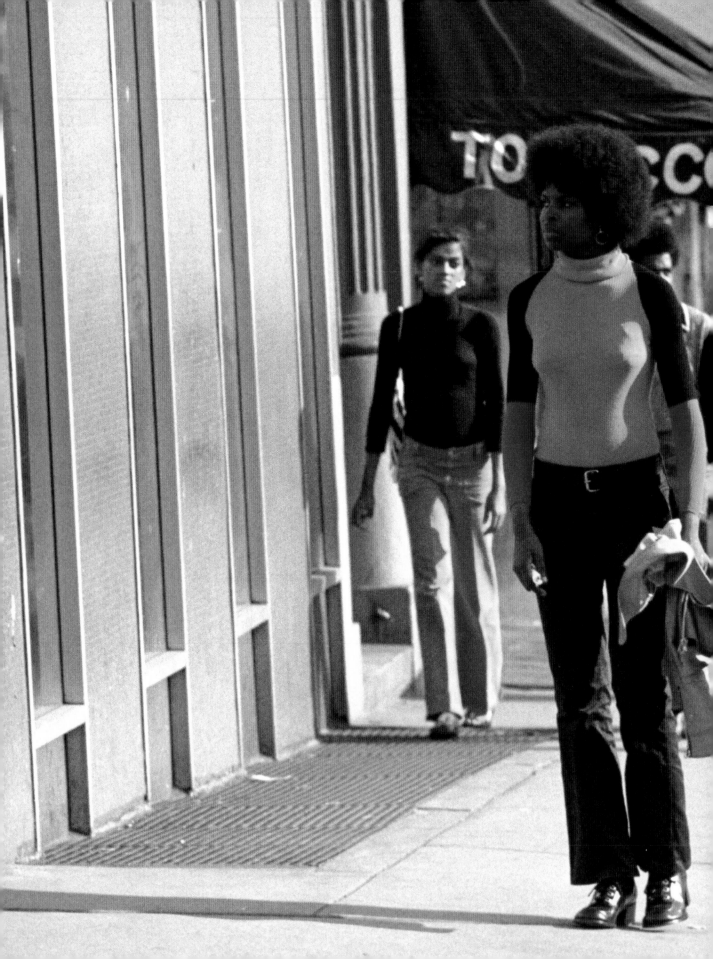

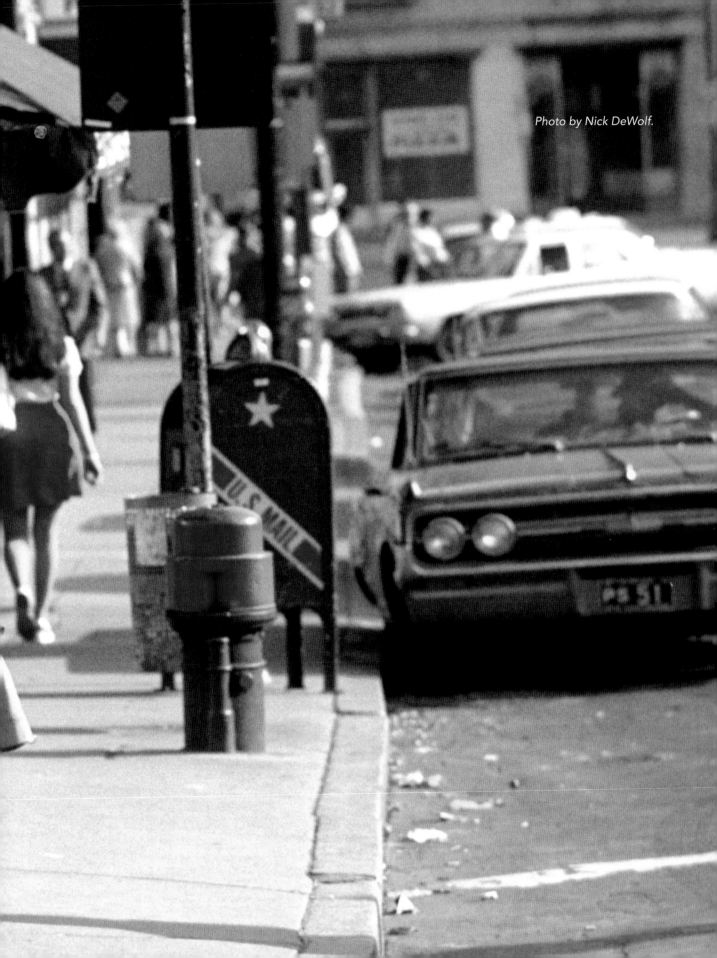

Photo by Nick DeWolf.

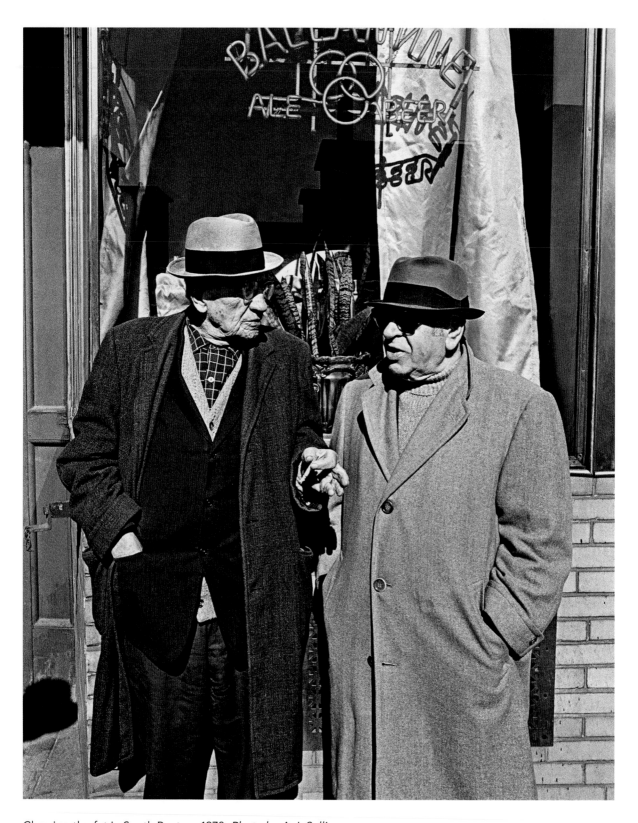

Chewing the fat in South Boston, 1970. *Photo by A.J. Sullivan.*

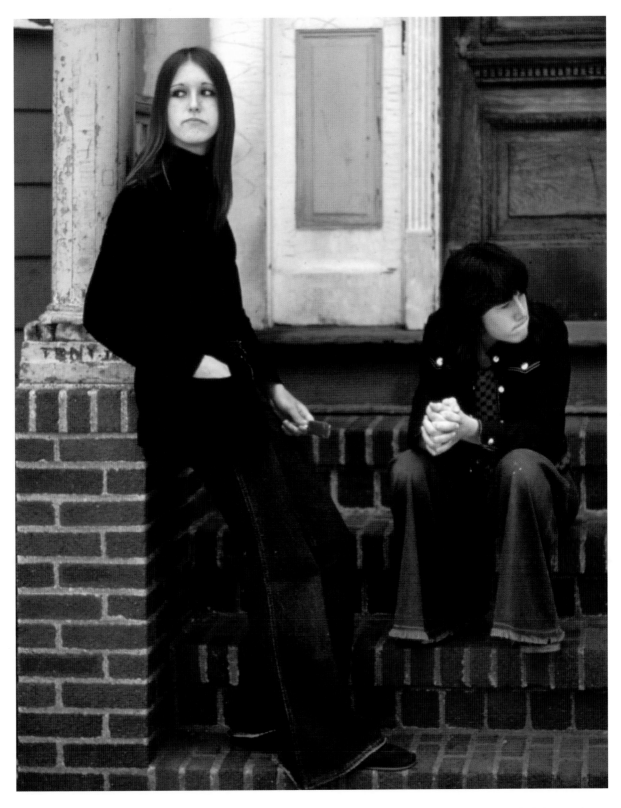

Stoop. East Boston, 1973. *Photo by Michael Philip Manheim.*

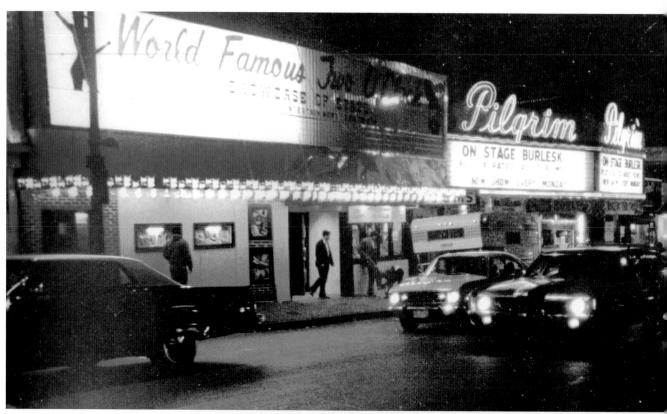

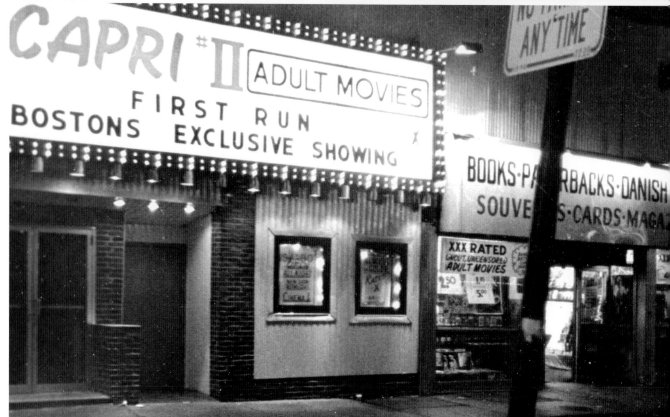

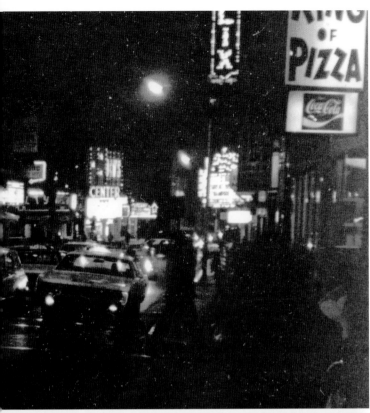

Scenes from the Combat Zone.
Washington and Boylston Streets, 1973.

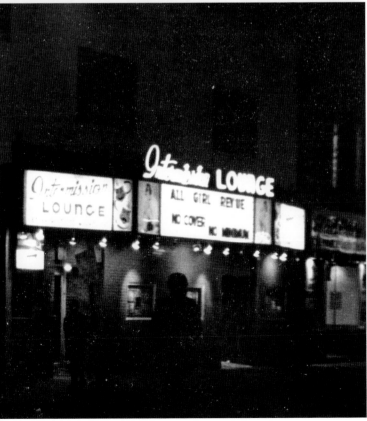

Washington Street near Kneeland Street,
1973. *Photos by Larry Crump.*

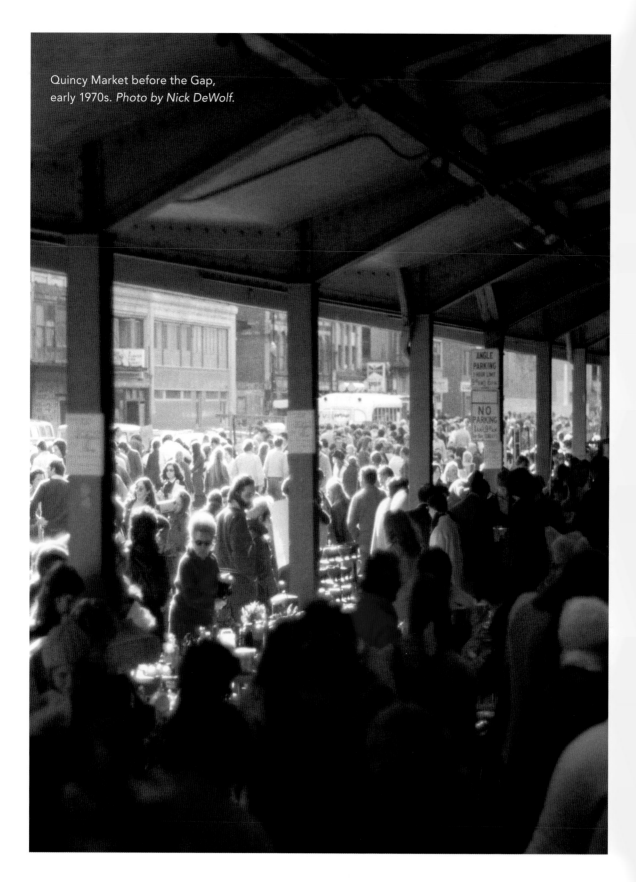

Quincy Market before the Gap,
early 1970s. *Photo by Nick DeWolf.*

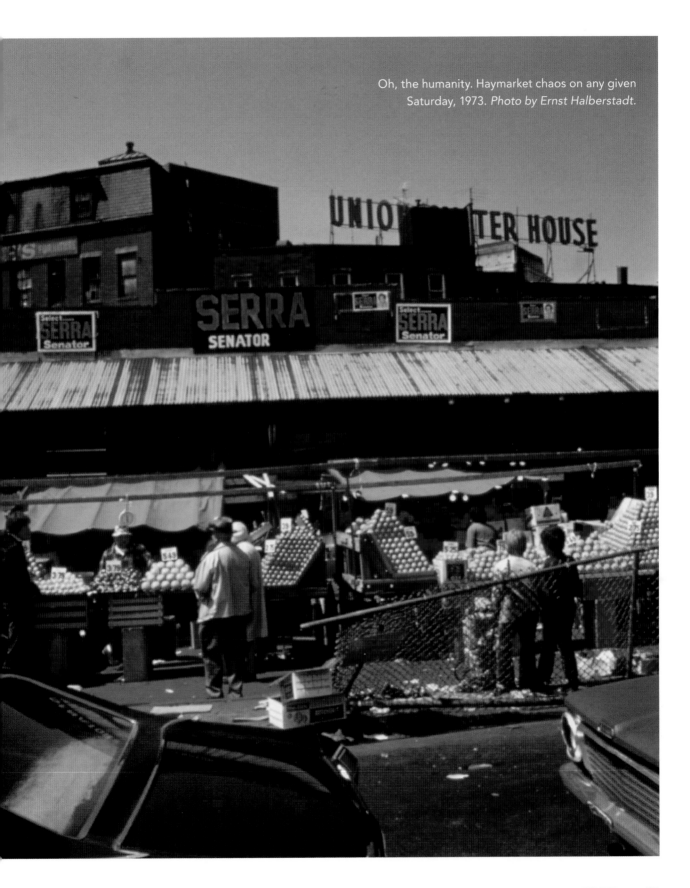

Oh, the humanity. Haymarket chaos on any given Saturday, 1973. *Photo by Ernst Halberstadt.*

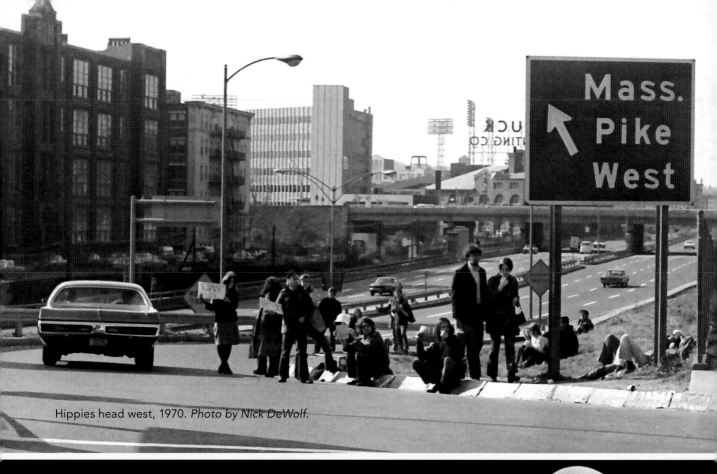

Hippies head west, 1970. *Photo by Nick DeWolf.*

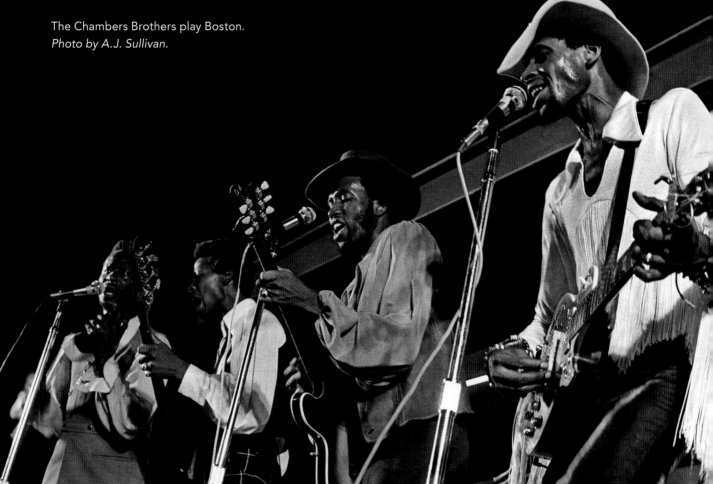

The Chambers Brothers play Boston.
Photo by A.J. Sullivan.

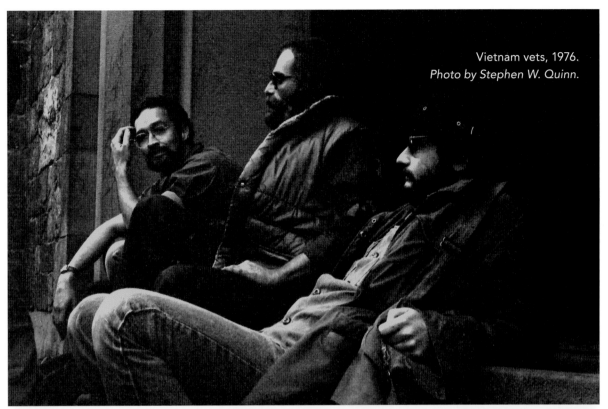

Vietnam vets, 1976.
Photo by Stephen W. Quinn.

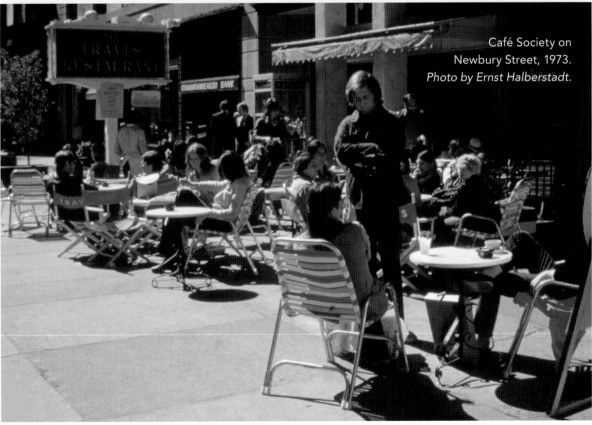

Café Society on
Newbury Street, 1973.
Photo by Ernst Halberstadt.

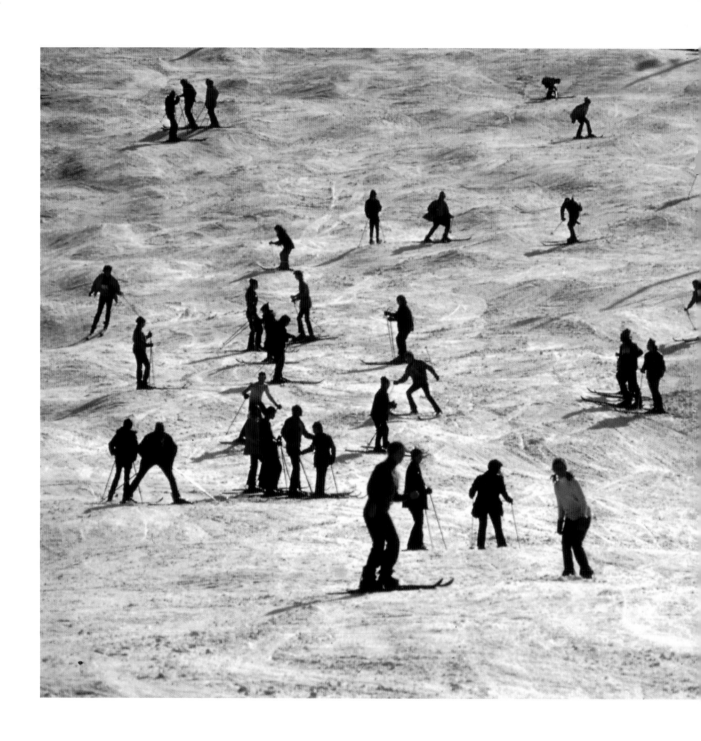

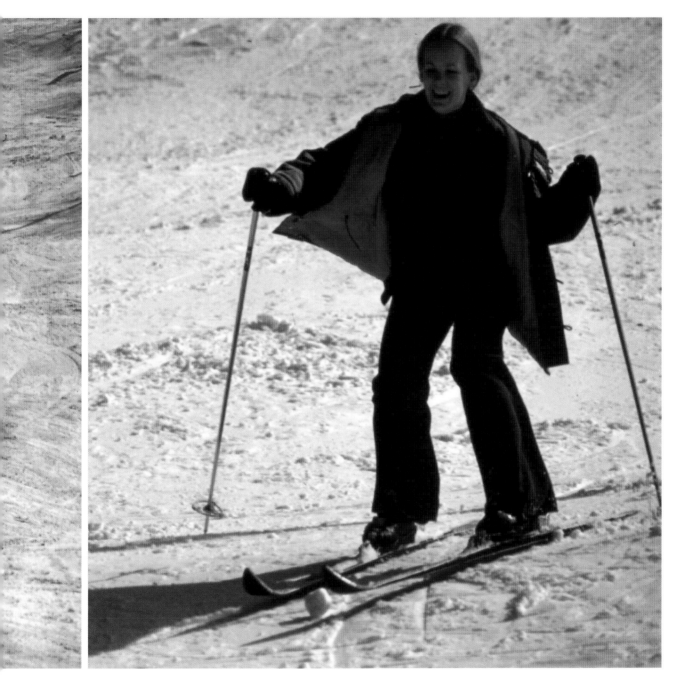

Skiing the Blue Hills, 1973. *Photos courtesy National Archives.*

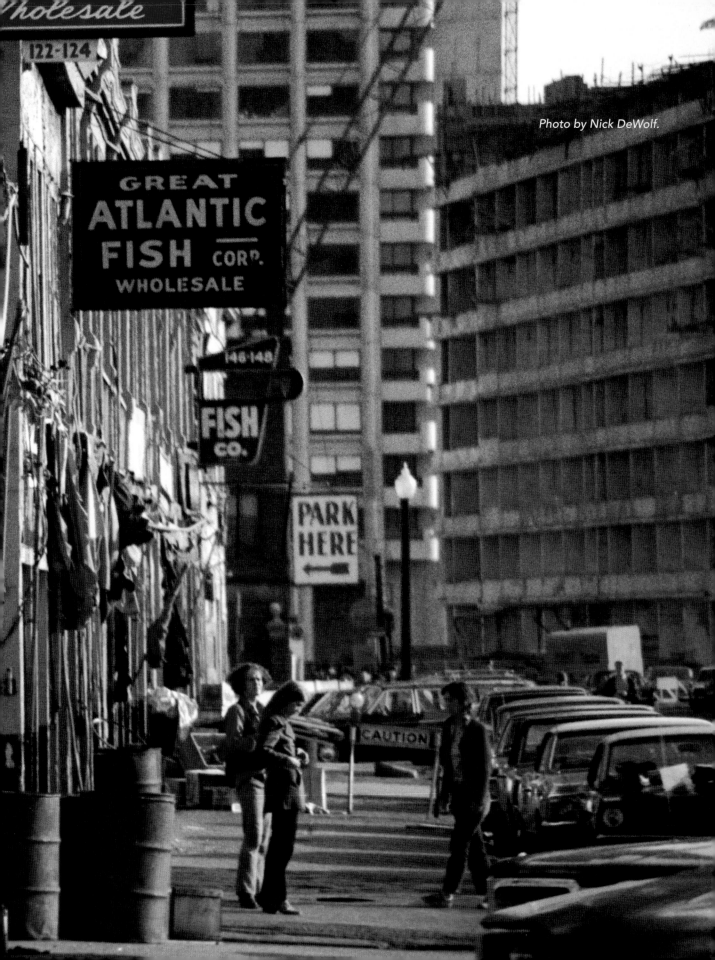

GREAT
ATLANTIC
FISH COR⁰.
WHOLESALE

Photo by Nick DeWolf.

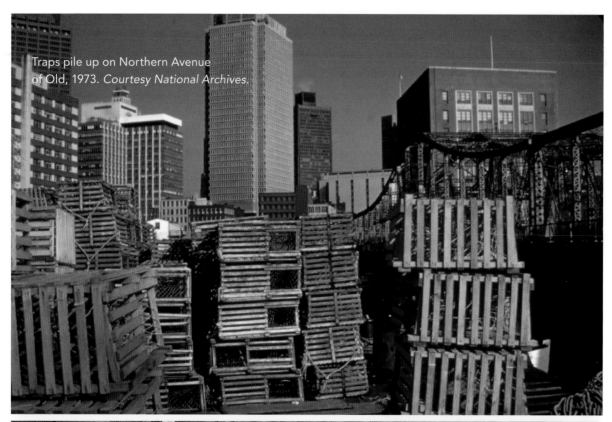

Traps pile up on Northern Avenue of Old, 1973. *Courtesy National Archives.*

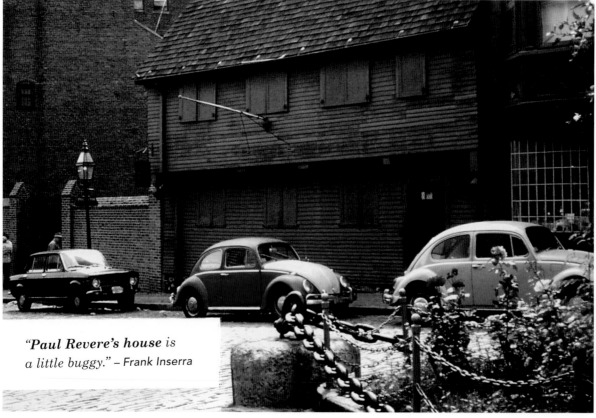

"Paul Revere's house is a little buggy." – Frank Inserra

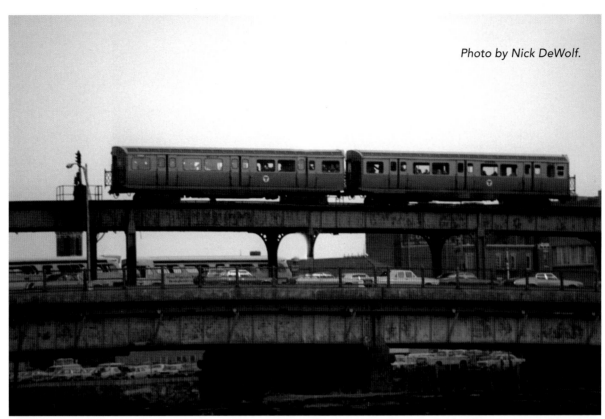

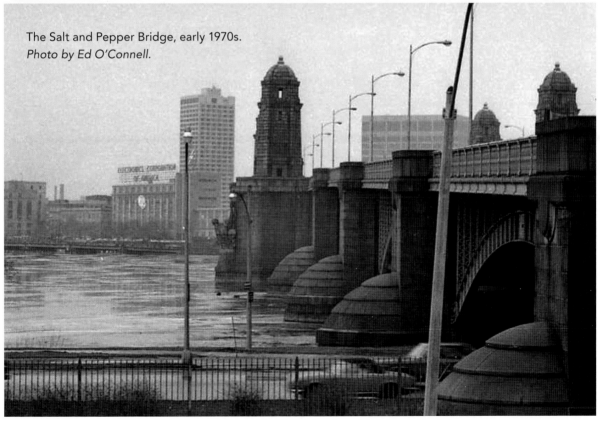

The Salt and Pepper Bridge, early 1970s.
Photo by Ed O'Connell.

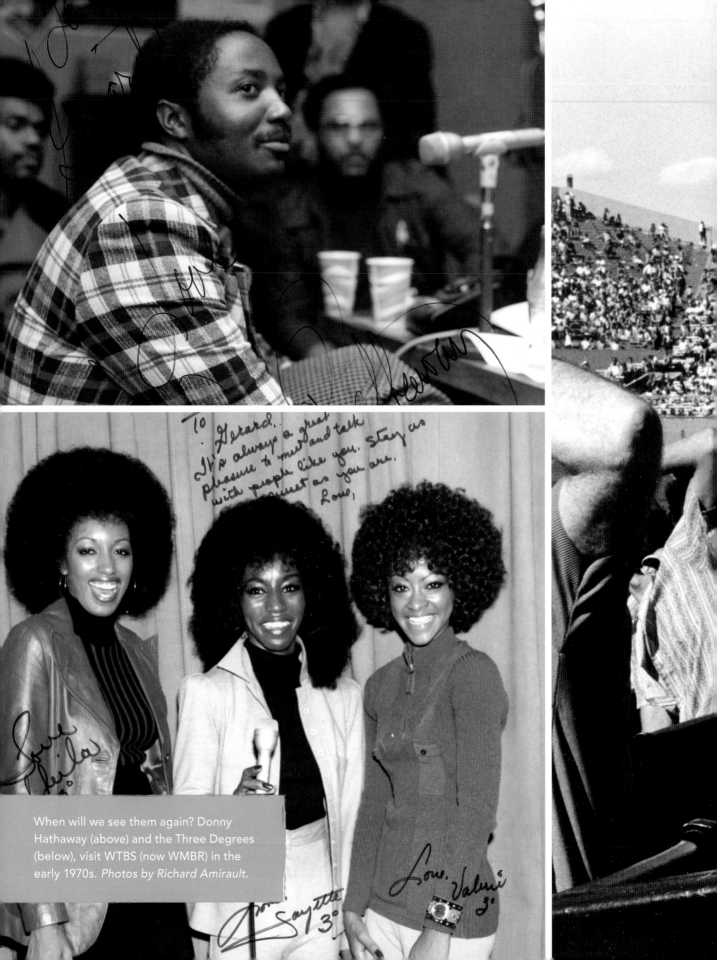

When will we see them again? Donny Hathaway (above) and the Three Degrees (below), visit WTBS (now WMBR) in the early 1970s. *Photos by Richard Amirault.*

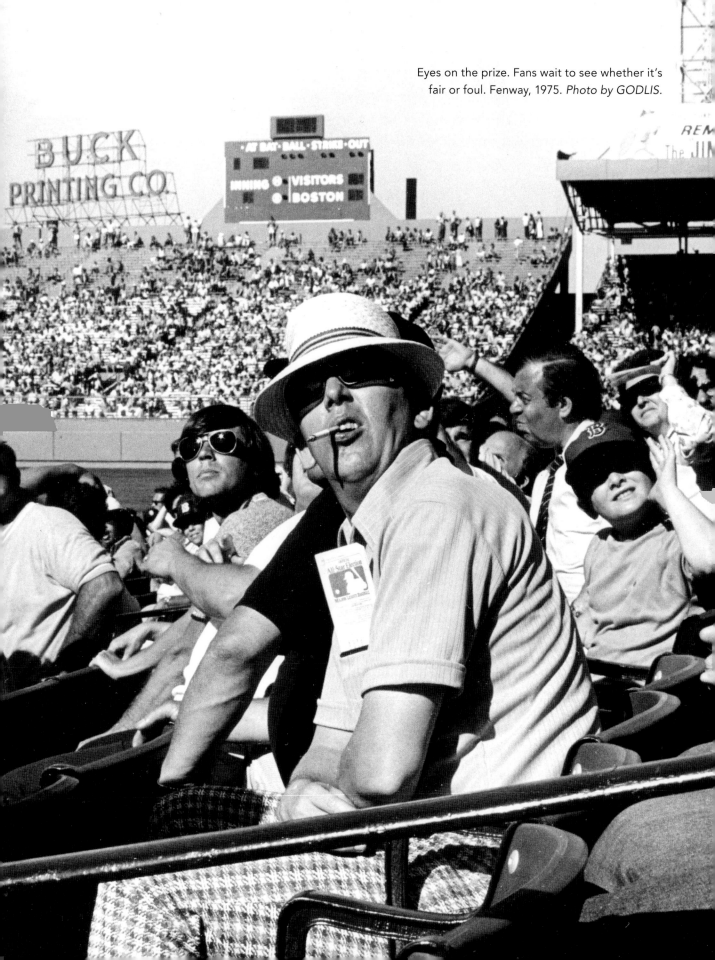

Eyes on the prize. Fans wait to see whether it's fair or foul. Fenway, 1975. *Photo by GODLIS.*

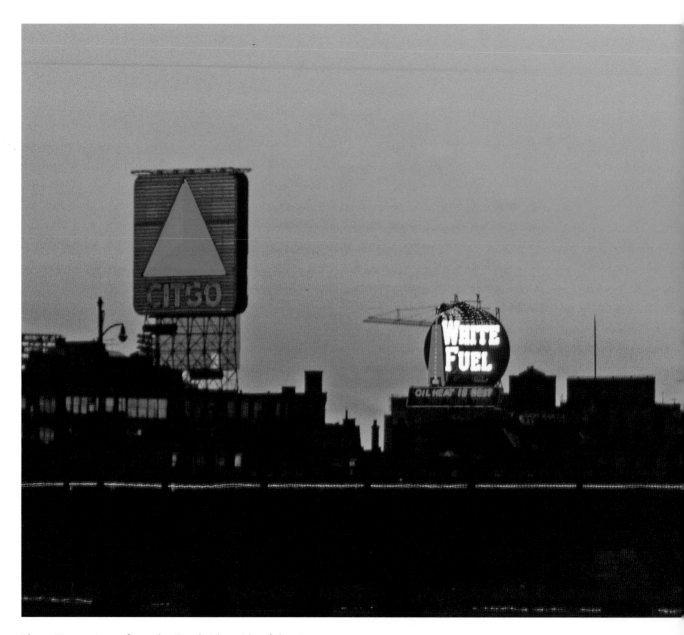

Three Boston icons from the Cambridge side of the river.

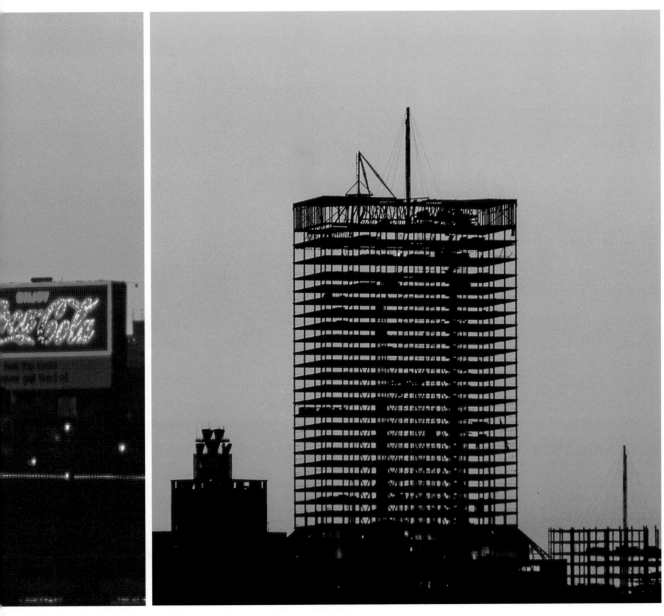

The "new" John Hancock building under construction in the early 1970s.
Photos by Ed O'Connell.

After watching the West End go down, the Townies of Charlestown fought back against a 1963 BRA proposal to demolish and redevelop 60 percent of the neighborhood's housing stock. Instead, the BRA tore down a mere 11 percent of the housing and demolished the elevated tracks. This is the old Thompson Square station, 1970.

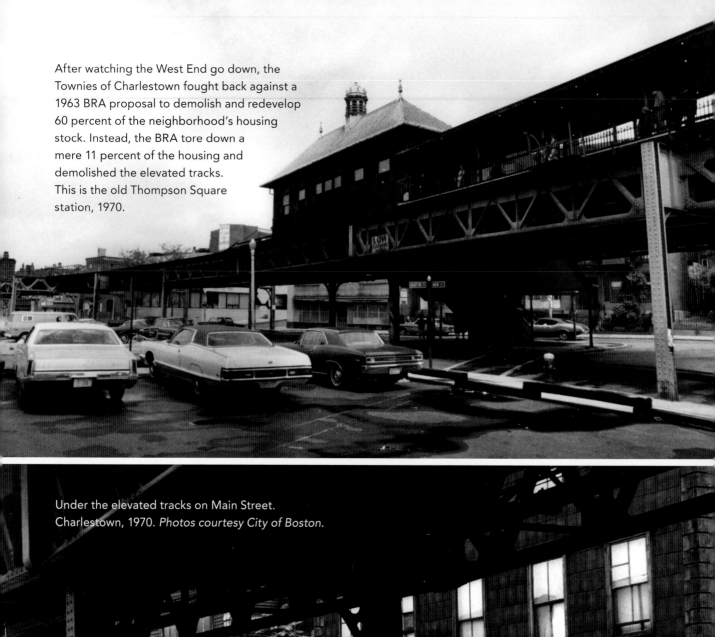

Under the elevated tracks on Main Street. Charlestown, 1970. *Photos courtesy City of Boston.*

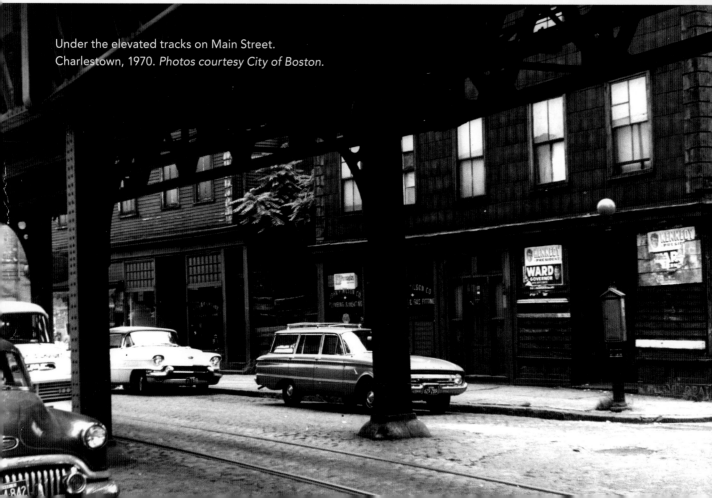

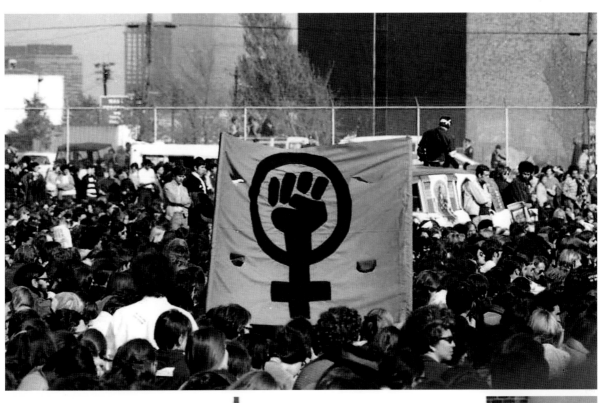

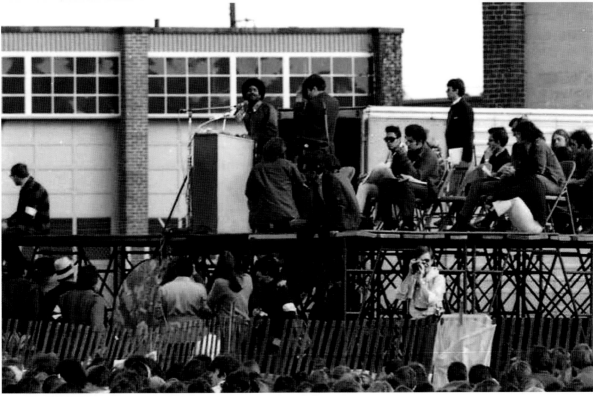

Speeches and demonstrations on Boylston Street (now JFK Street) followed
the Kent State shootings. Cambridge, 1970. *Photos by Ed O'Connell.*

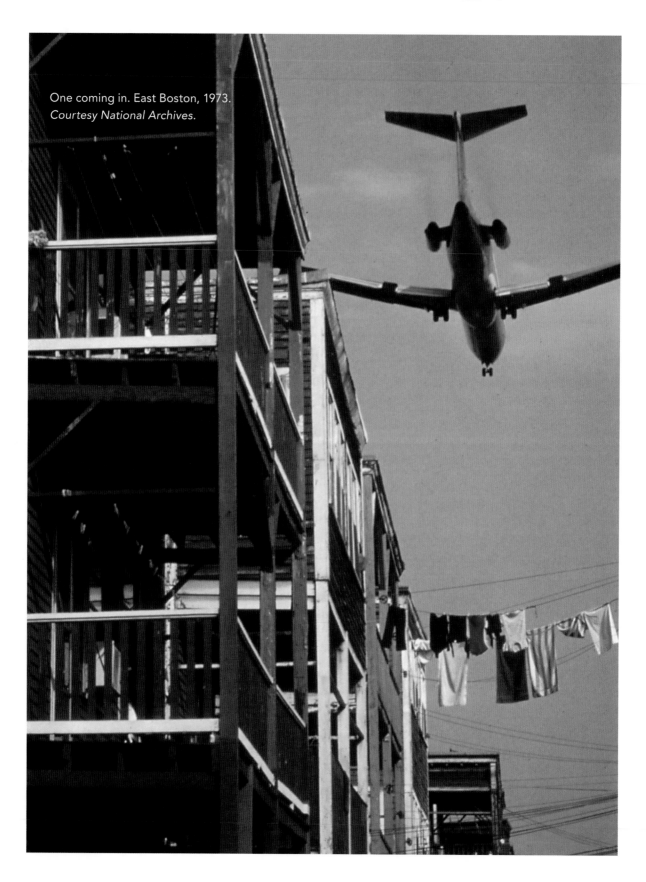

One coming in. East Boston, 1973.
Courtesy National Archives.

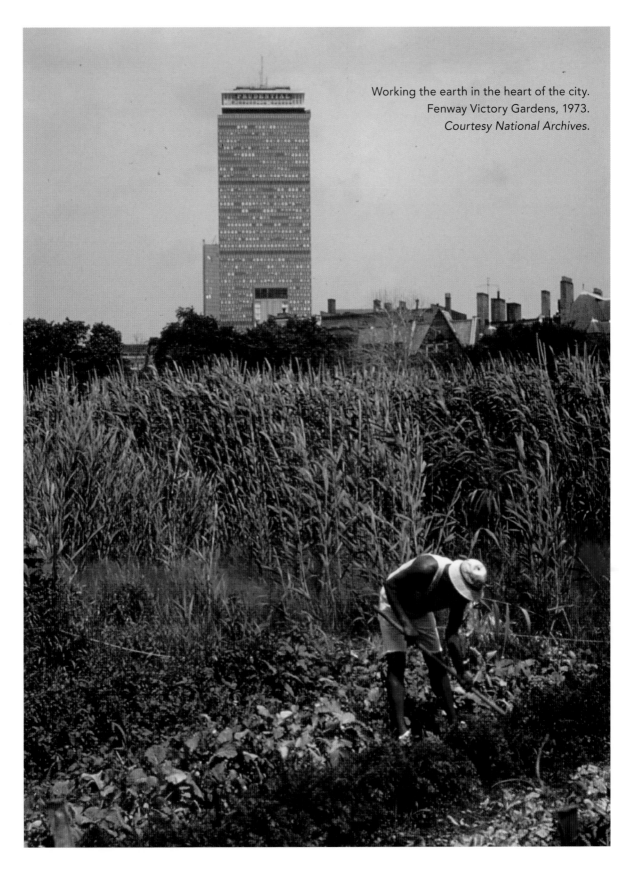

Working the earth in the heart of the city.
Fenway Victory Gardens, 1973.
Courtesy National Archives.

Copley Square.
Photo by Nick DeWolf.

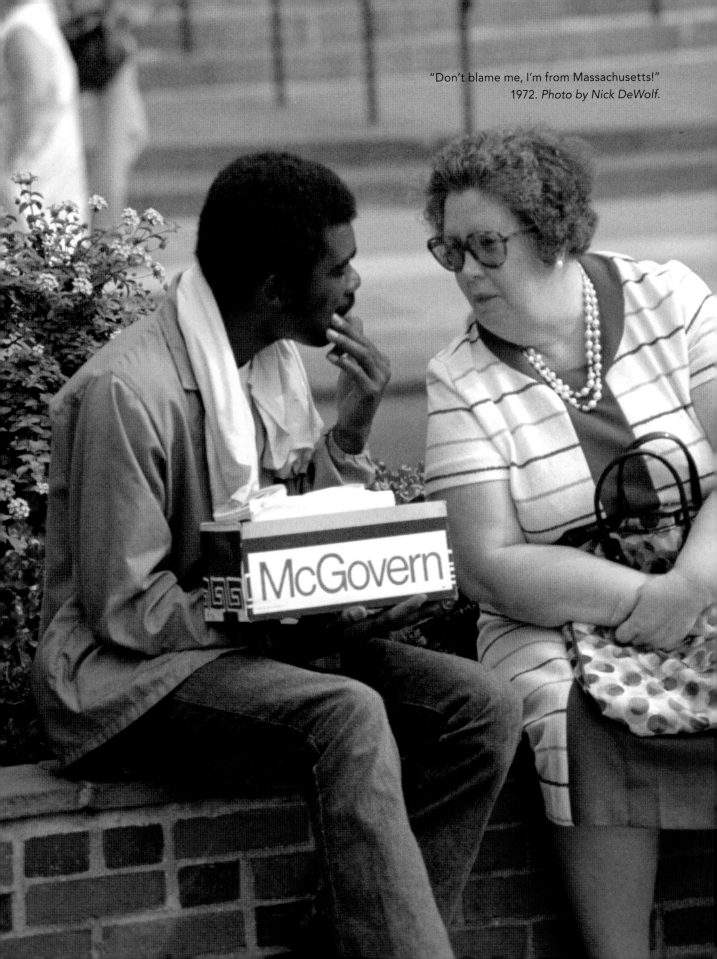

"Don't blame me, I'm from Massachusetts!"
1972. *Photo by Nick DeWolf.*

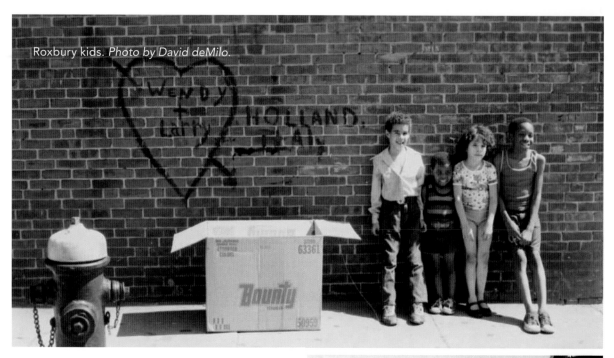

Roxbury kids. *Photo by David deMilo.*

"This is my dad, *Detective Kenny Ellis of the old Boston Police District 13 in Jamaica Plain. He is leading a murder suspect out of BPD headquarters in 1973."* – Kenneth Ellis, Jr.

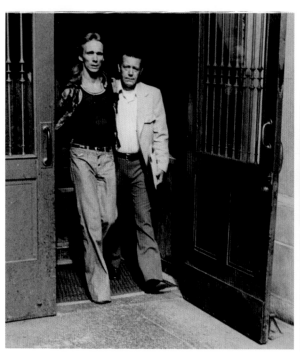

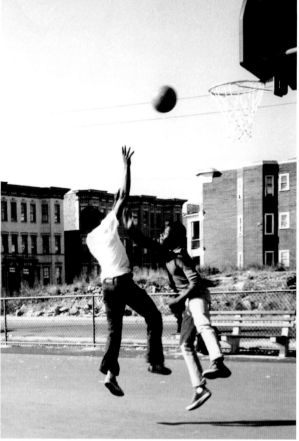

There's actually a net! A game of one-on-one on Ceylon Street. Roxbury, 1970. *Courtesy City of Boston.*

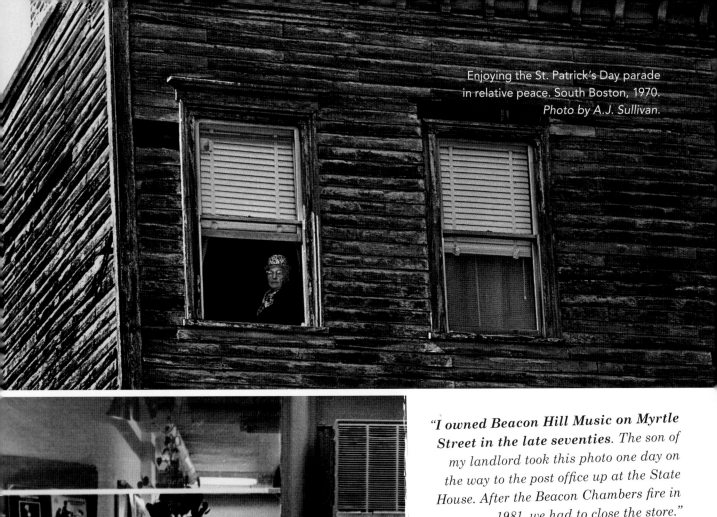

Enjoying the St. Patrick's Day parade in relative peace. South Boston, 1970. Photo by A.J. Sullivan.

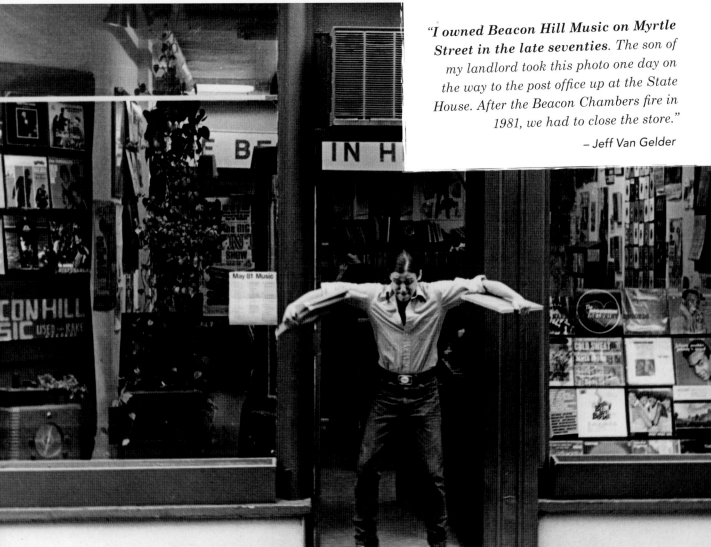

"I owned Beacon Hill Music on Myrtle Street in the late seventies. The son of my landlord took this photo one day on the way to the post office up at the State House. After the Beacon Chambers fire in 1981, we had to close the store."

– Jeff Van Gelder

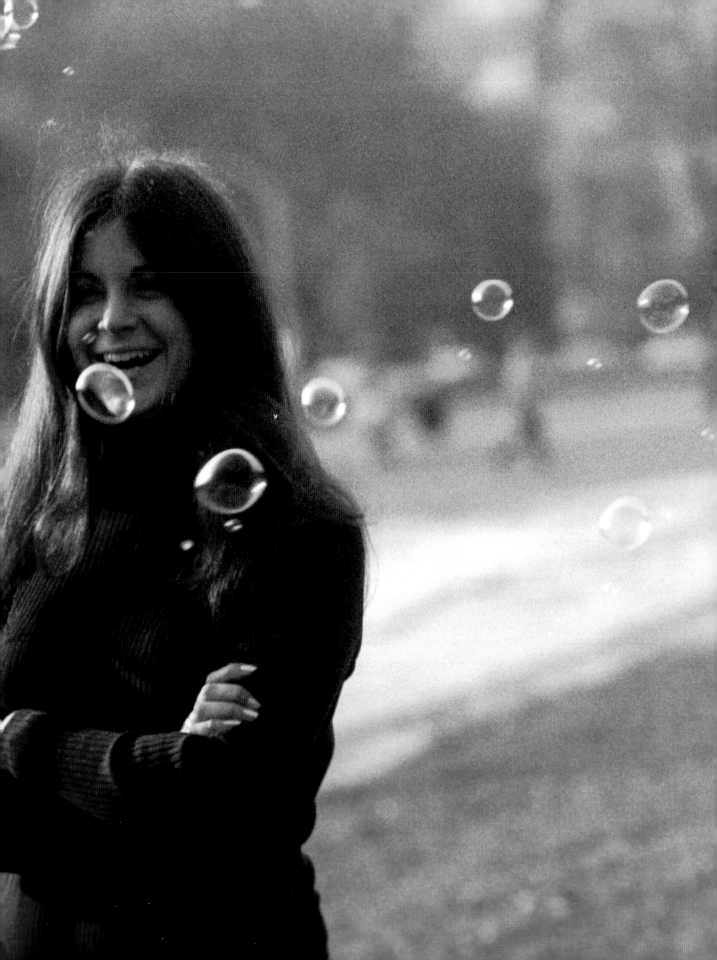

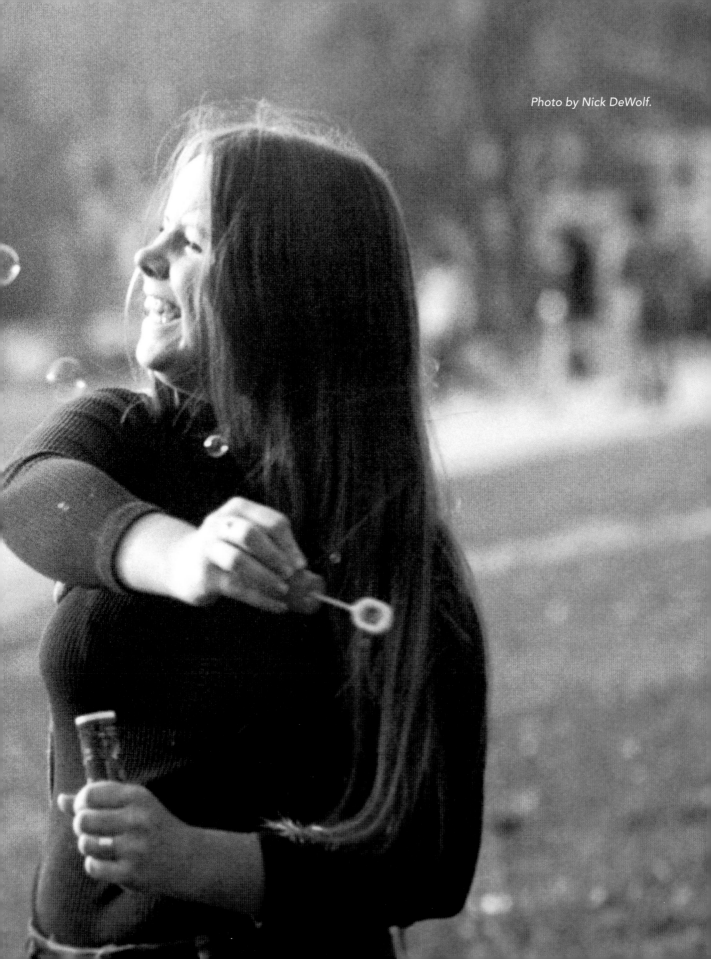

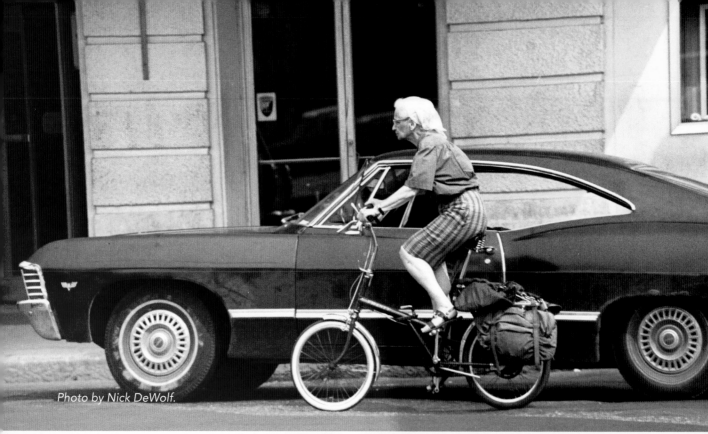

Photo by Nick DeWolf.

Making hay while the sun shines.
Courtesy National Archives.

Brahmin booty call, Beacon Hill.
Photo by Nick DeWolf.

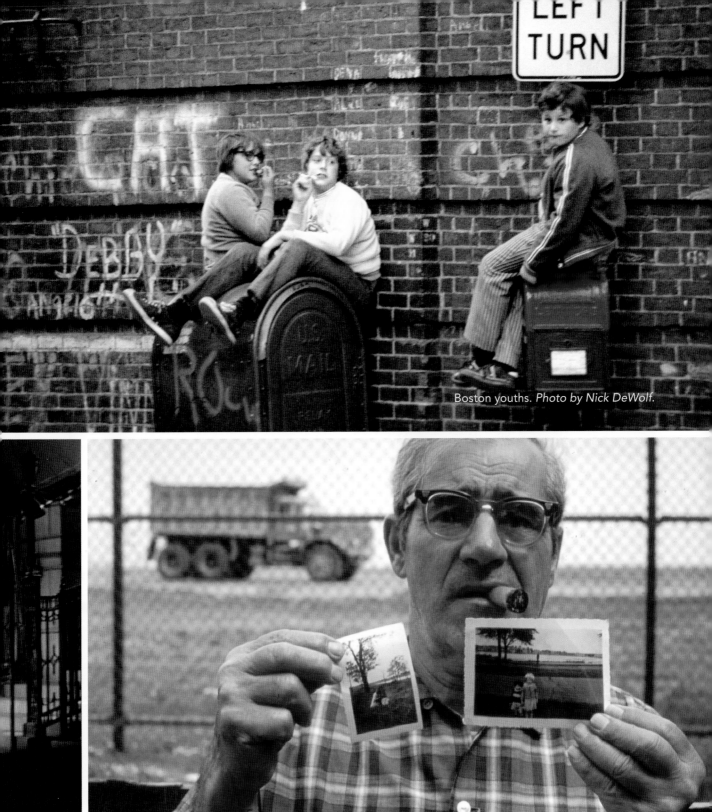

Boston youths. *Photo by Nick DeWolf.*

Matthew Vieira, photographed at the site of Wood Island Park, where his children played. At the time of this photo, the land had been taken to expand Logan International Airport, causing heartbreak among residents. East Boston, 1973. *Courtesy National Archives.*

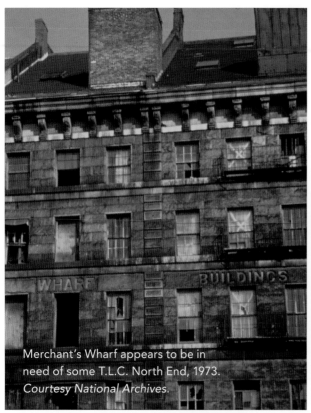

Merchant's Wharf appears to be in
need of some T.L.C. North End, 1973.
Courtesy National Archives.

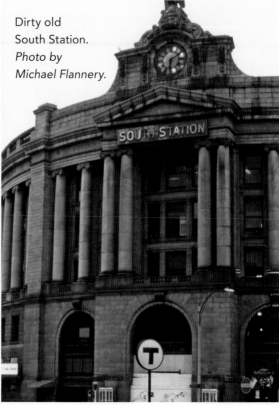

Dirty old
South Station.
*Photo by
Michael Flannery.*

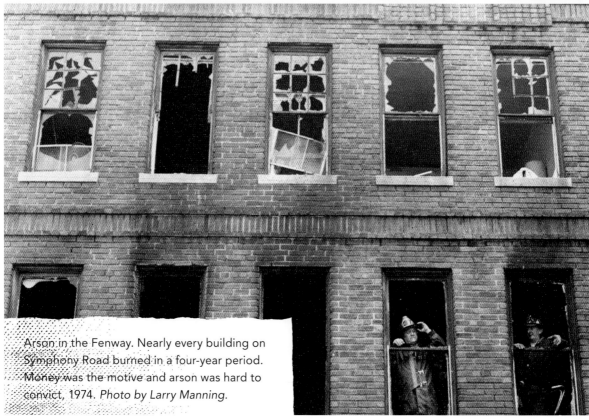

Arson in the Fenway. Nearly every building on
Symphony Road burned in a four-year period.
Money was the motive and arson was hard to
convict, 1974. *Photo by Larry Manning.*

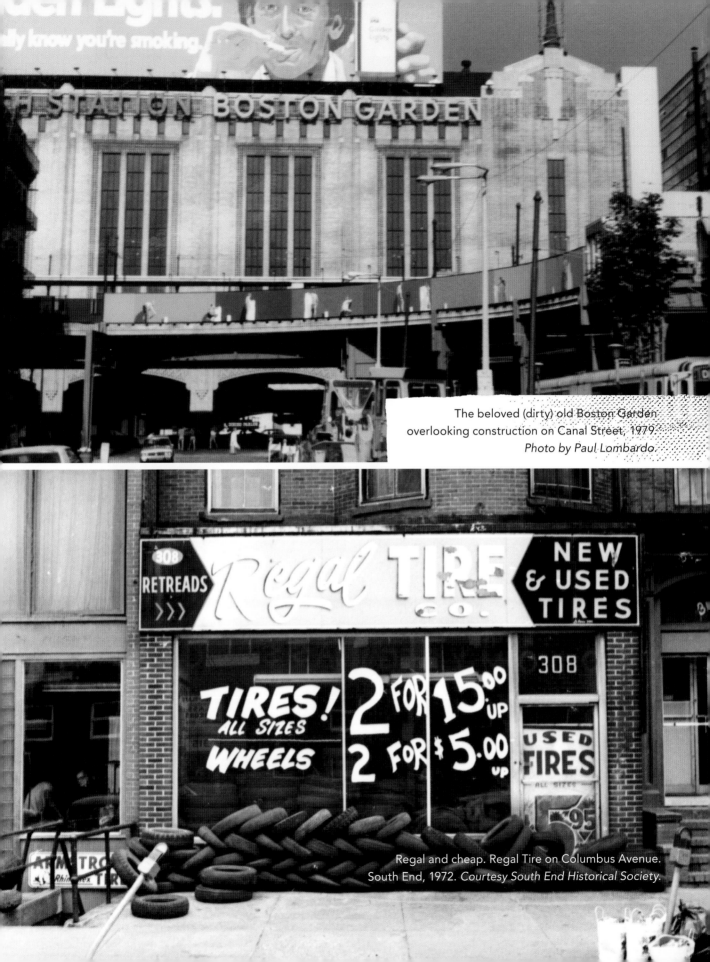

The beloved (dirty) old Boston Garden overlooking construction on Canal Street, 1979. *Photo by Paul Lombardo.*

Regal and cheap. Regal Tire on Columbus Avenue. South End, 1972. *Courtesy South End Historical Society.*

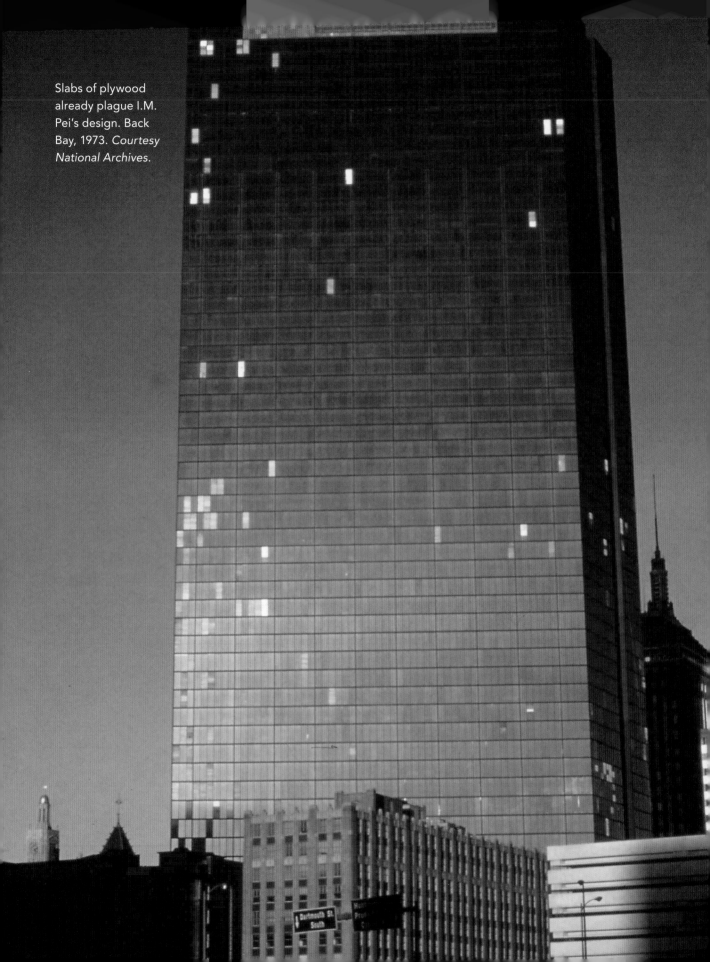

Slabs of plywood already plague I.M. Pei's design. Back Bay, 1973. *Courtesy National Archives.*

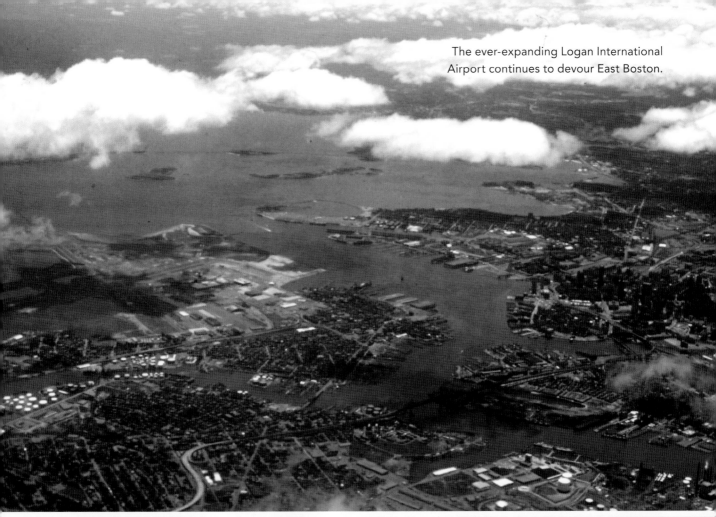

The ever-expanding Logan International Airport continues to devour East Boston.

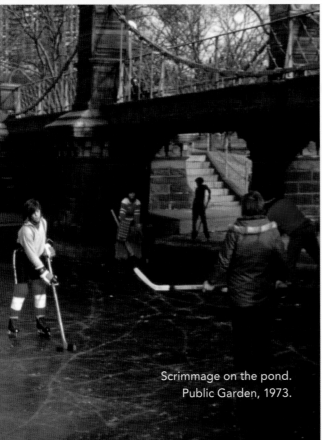

Scrimmage on the pond.
Public Garden, 1973.

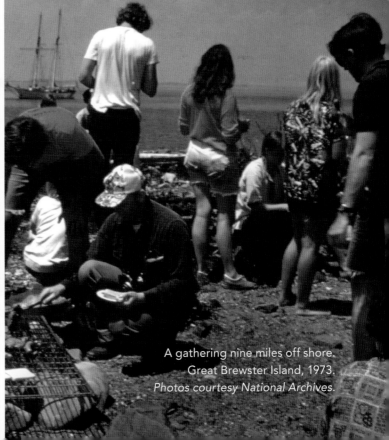

A gathering nine miles off shore.
Great Brewster Island, 1973.
Photos courtesy National Archives.

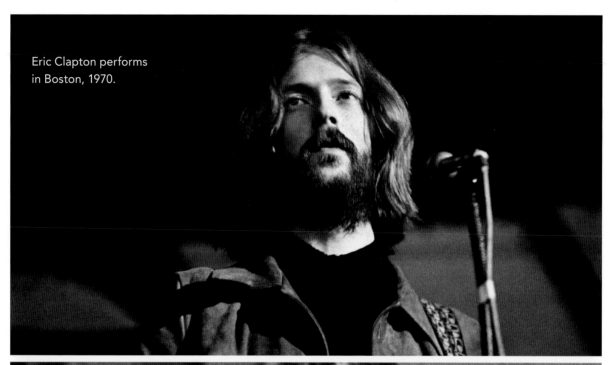

Eric Clapton performs in Boston, 1970.

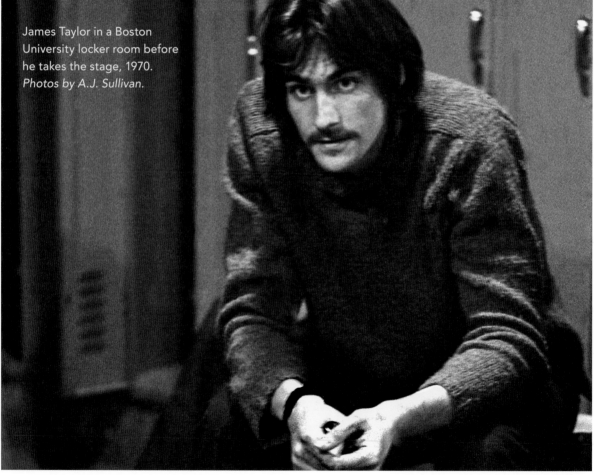

James Taylor in a Boston University locker room before he takes the stage, 1970. *Photos by A.J. Sullivan.*

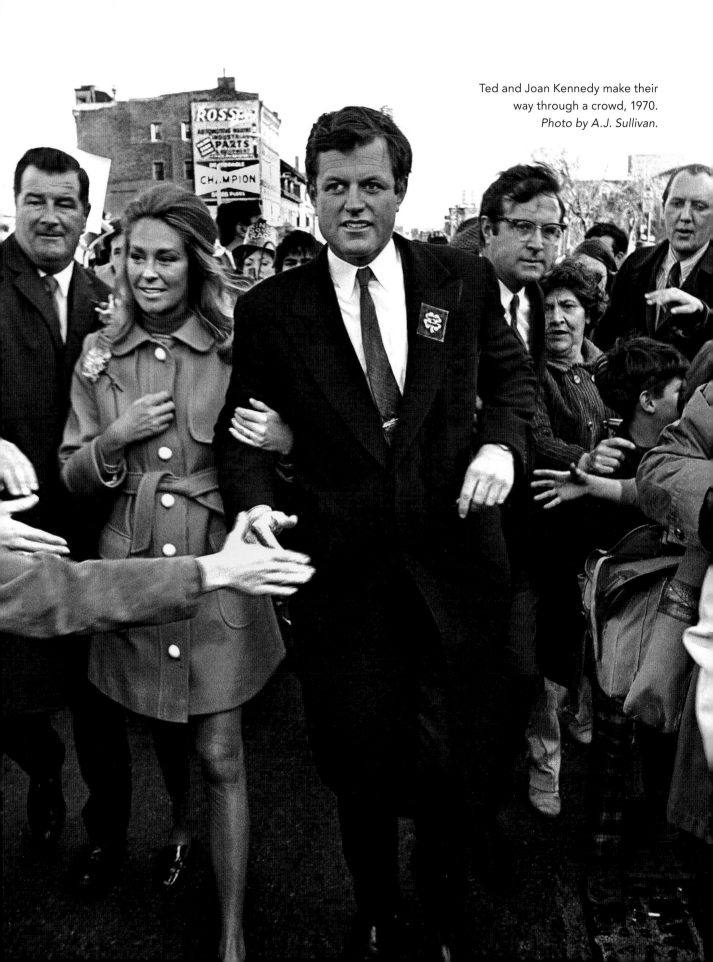

Ted and Joan Kennedy make their way through a crowd, 1970.
Photo by A.J. Sullivan.

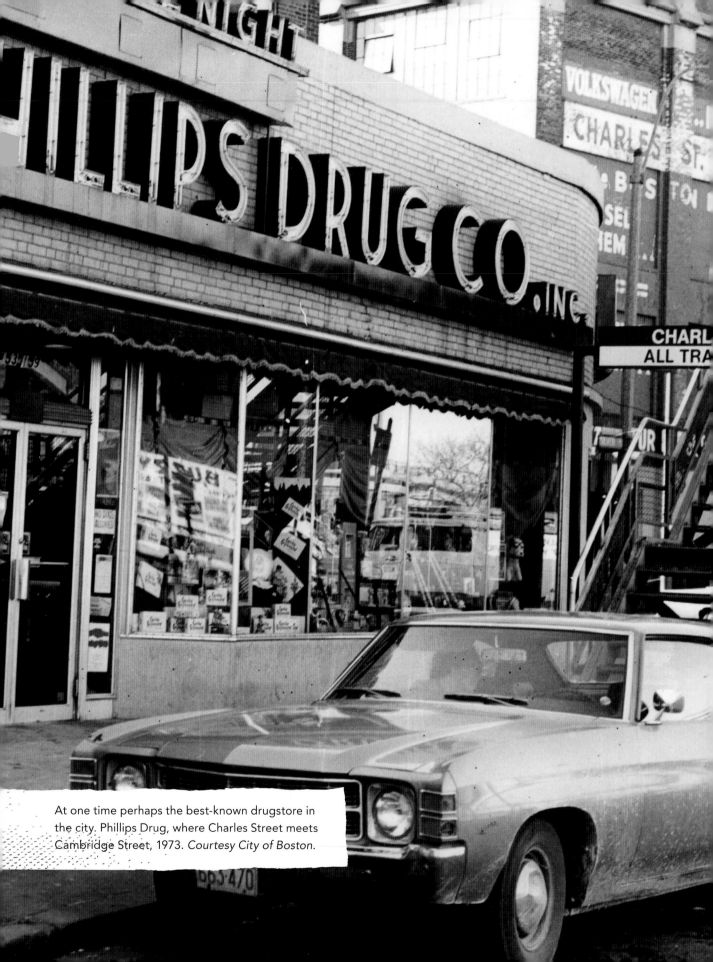

At one time perhaps the best-known drugstore in the city. Phillips Drug, where Charles Street meets Cambridge Street, 1973. *Courtesy City of Boston.*

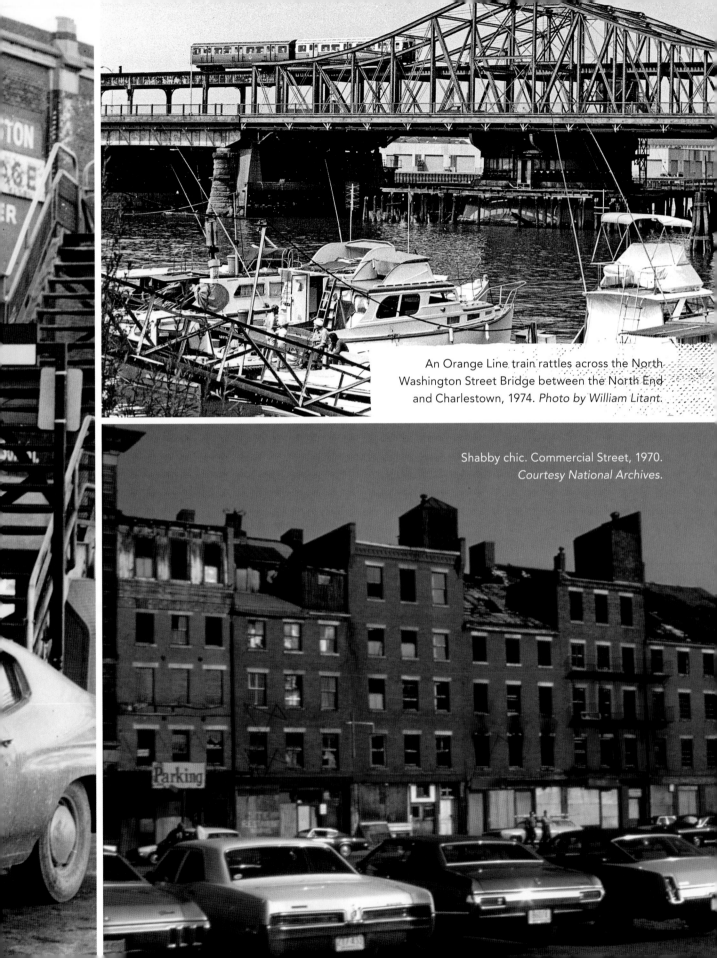

An Orange Line train rattles across the North Washington Street Bridge between the North End and Charlestown, 1974. *Photo by William Litant.*

Shabby chic. Commercial Street, 1970.
Courtesy National Archives.

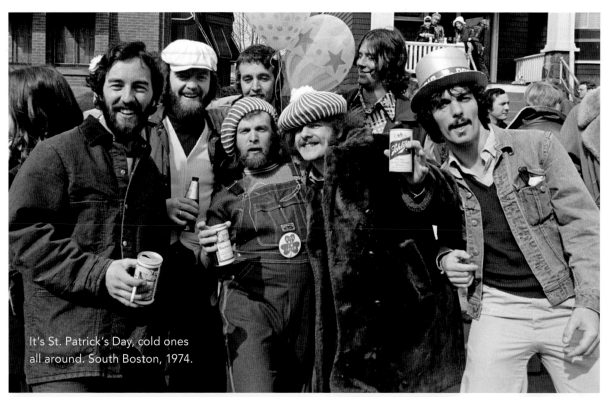

It's St. Patrick's Day, cold ones all around. South Boston, 1974.

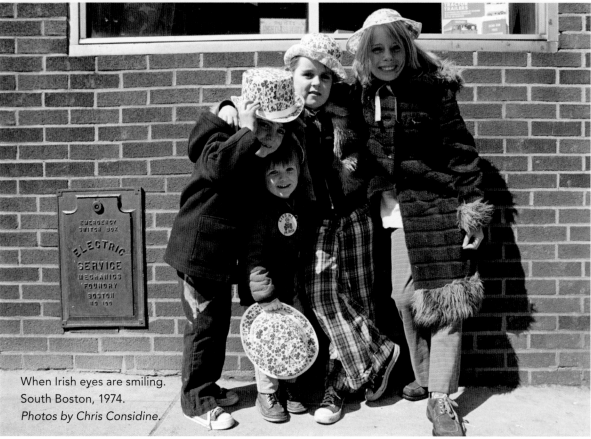

When Irish eyes are smiling.
South Boston, 1974.
Photos by Chris Considine.

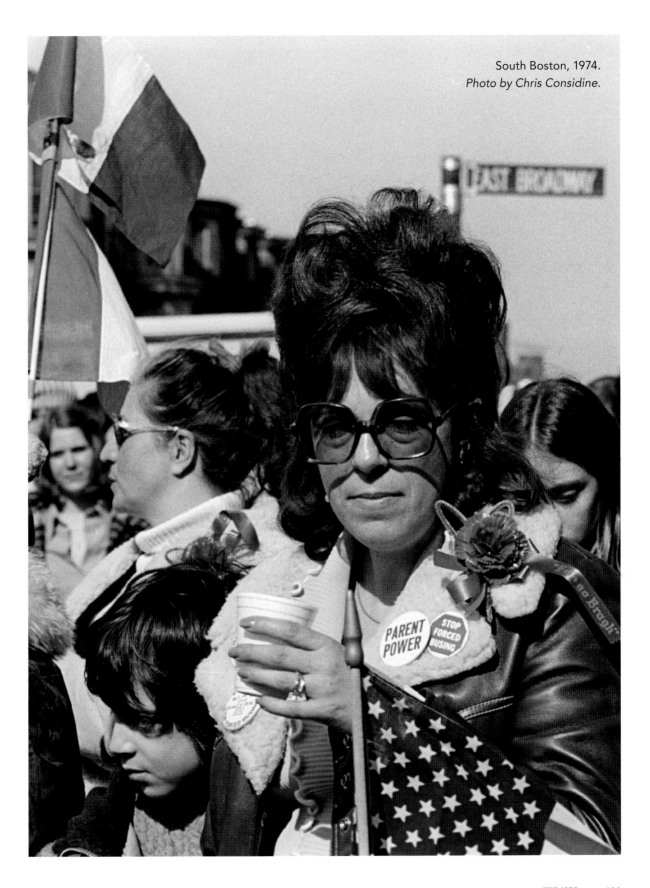

South Boston, 1974.
Photo by Chris Considine.

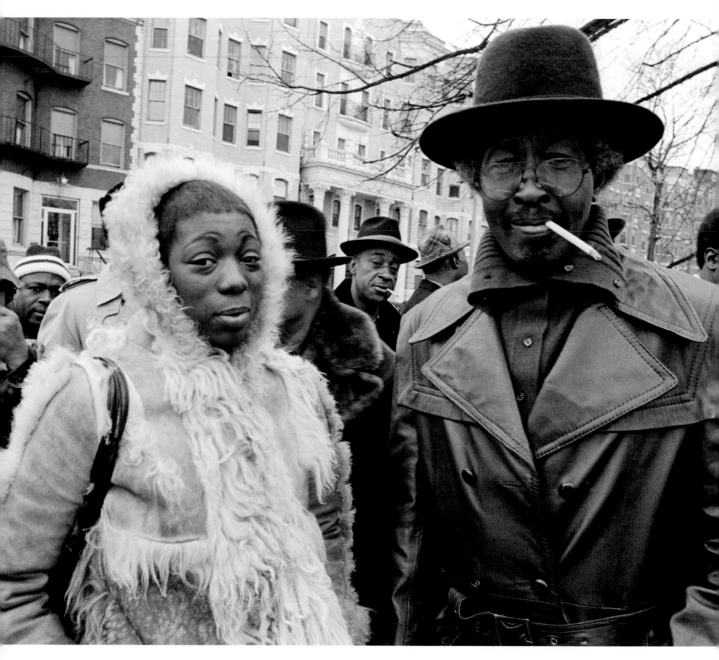

The March Against Racism. Fenway, 1974.
Photo by Chris Considine.

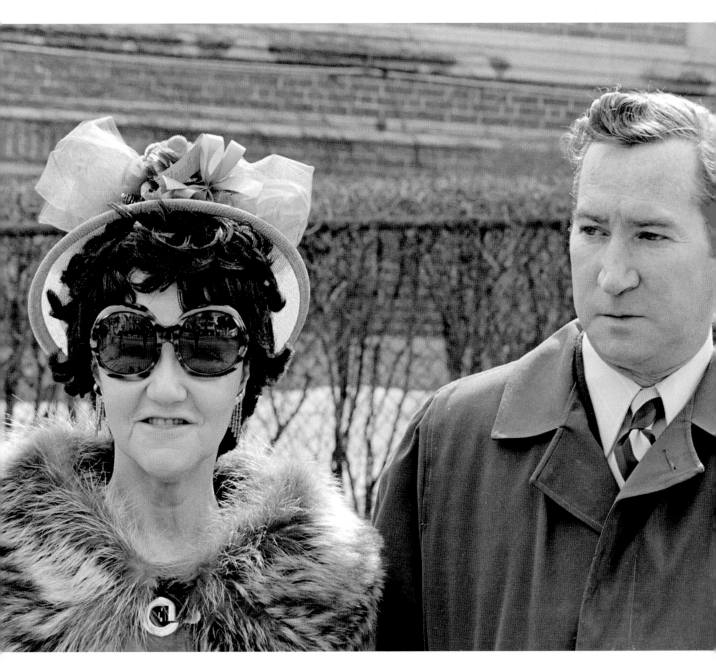

St. Patrick's Day parade. South Boston, 1974.
Photo by Chris Considine.

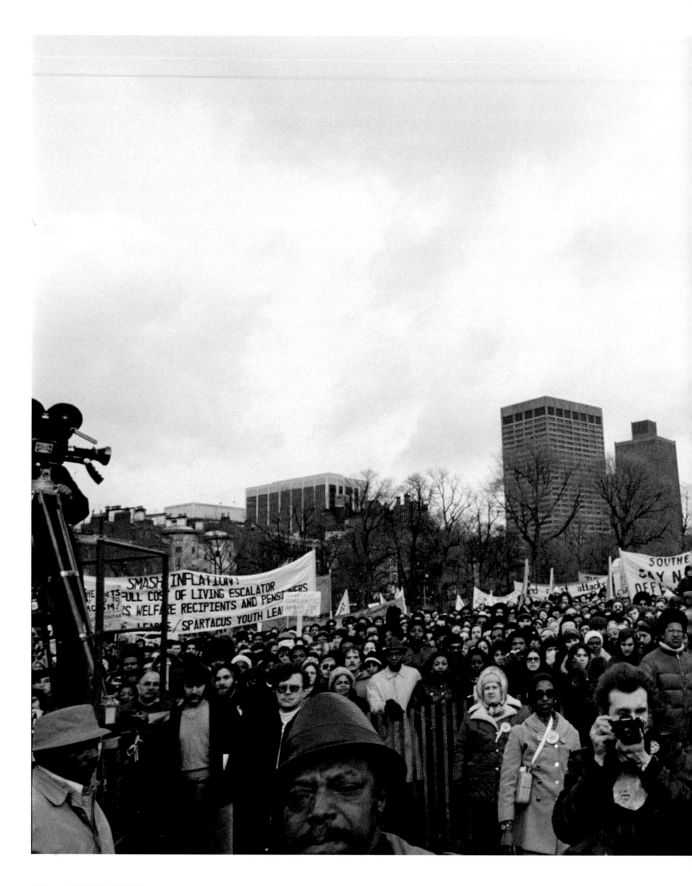

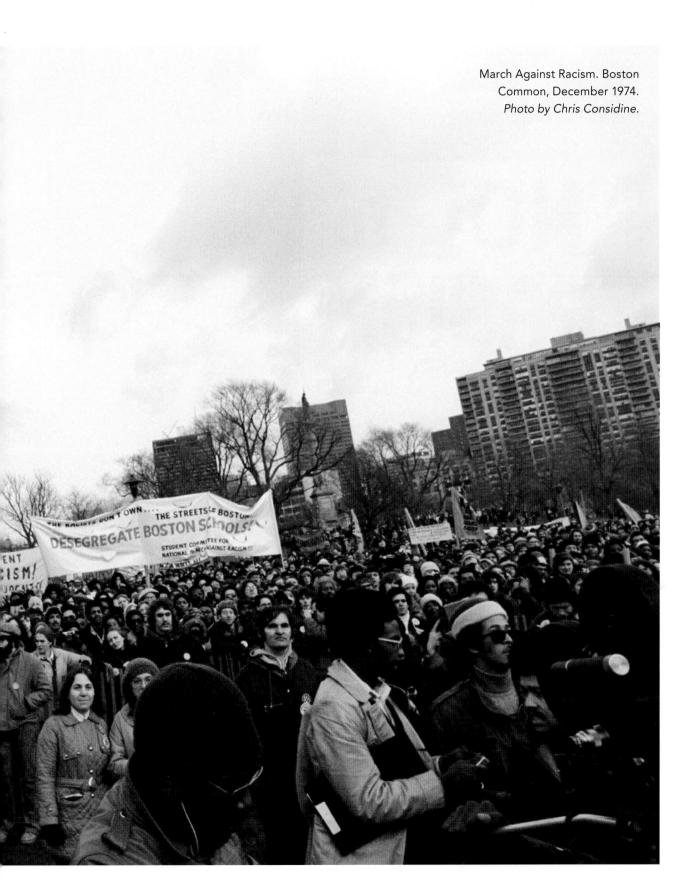

March Against Racism. Boston Common, December 1974.
Photo by Chris Considine.

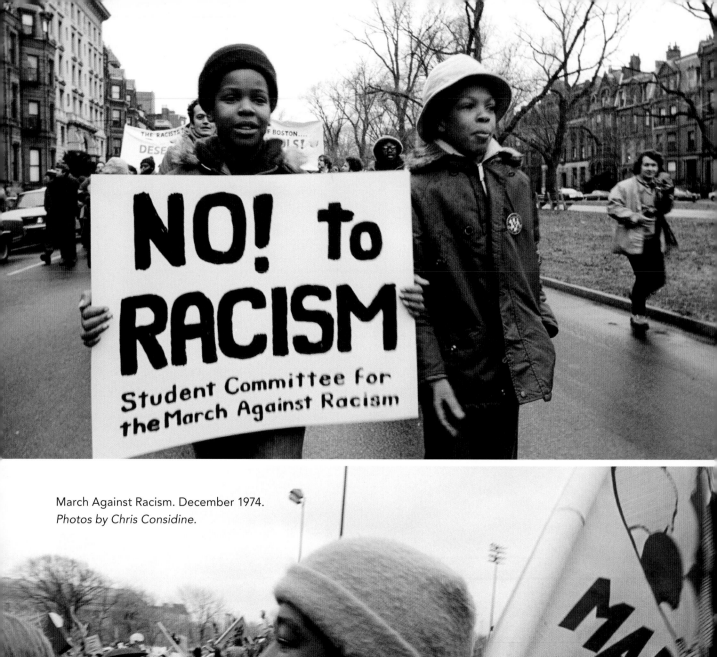

March Against Racism. December 1974.
Photos by Chris Considine.

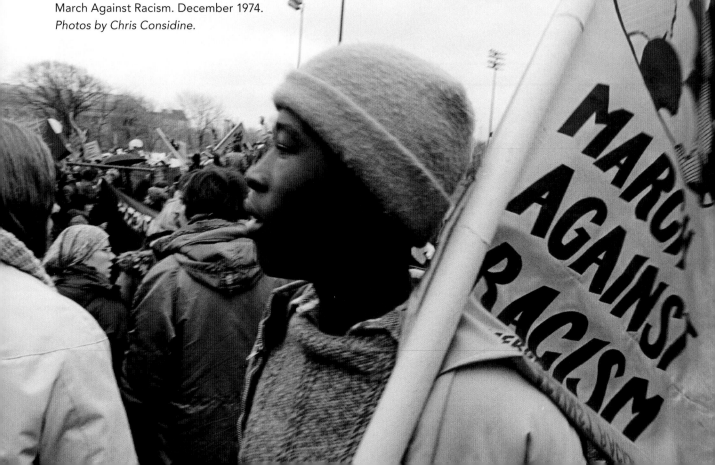

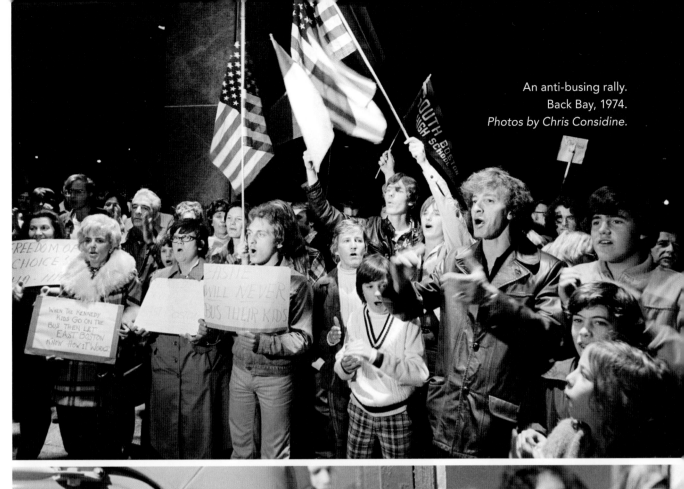

An anti-busing rally.
Back Bay, 1974.
Photos by Chris Considine.

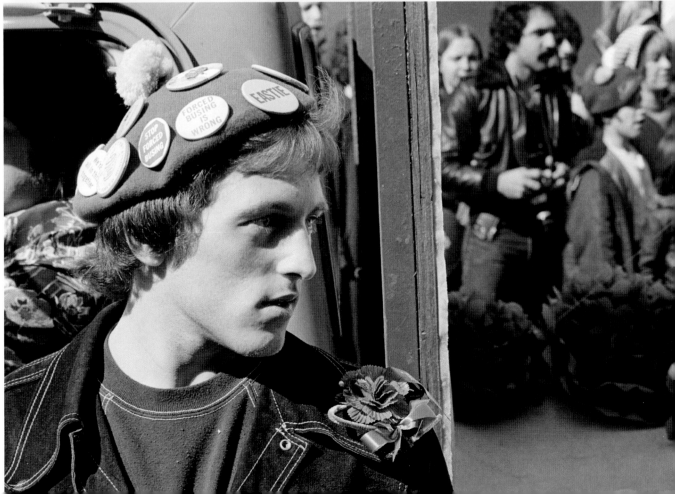

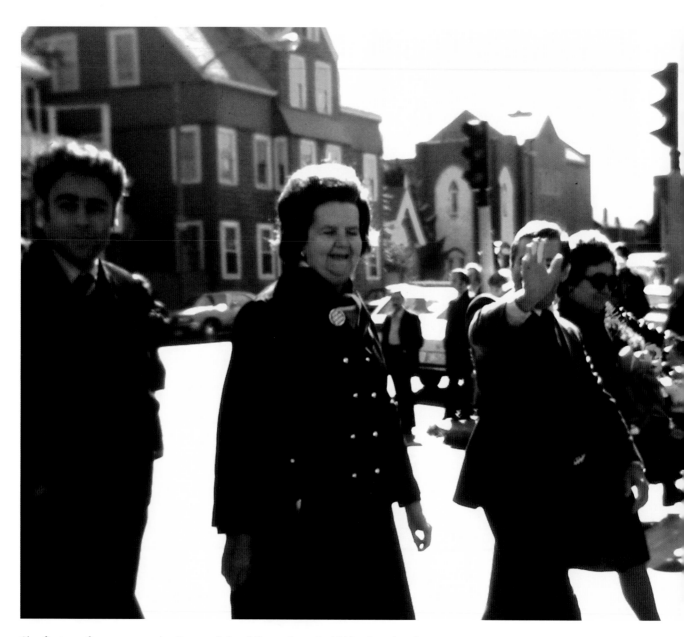

She first ran for a seat on the Boston School Committee in 1961 using the slogan, "The only mother on the ballot." In later elections she liked to say, "You know where I stand." Those who backed Louisa Day Hicks did so with fervor. Those who did not were equally passionate. *Courtesy James W. Kelley.*

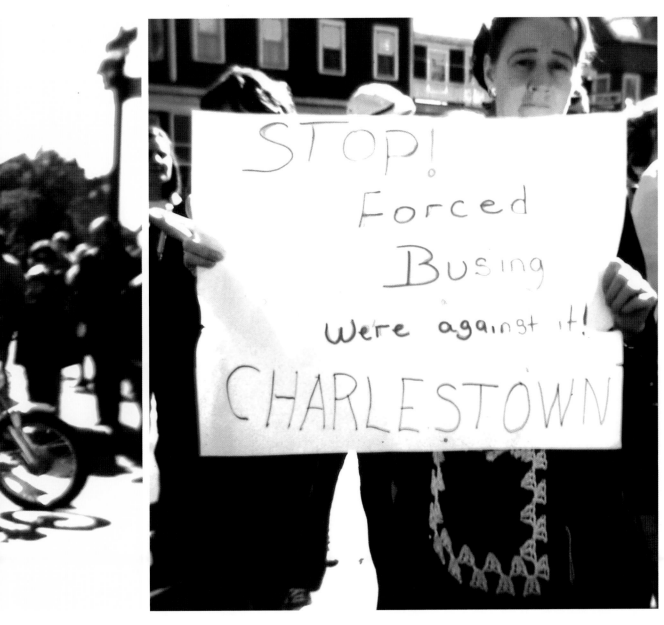

Protesting Judge Garrity's decision.
Courtesy James W. Kelley.

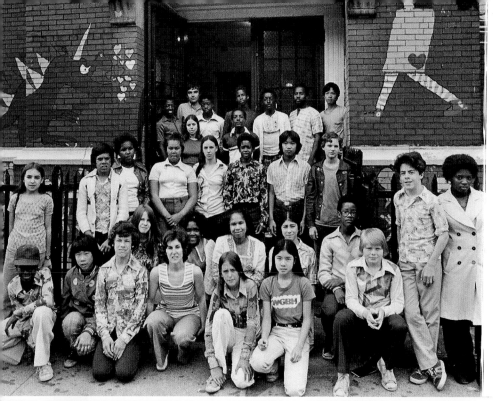

"This is my eighth grade class at the George Bancroft School in the South End. It's 1976, when Boston was in a very ugly turmoil over busing. The South End was an oasis of integration in this mess. No one was bussed to the Bancroft, so the racial makeup of the school reflects the natural integration of the neighborhood...I am the white girl kneeling in the front row."

– Jennifer Watkins

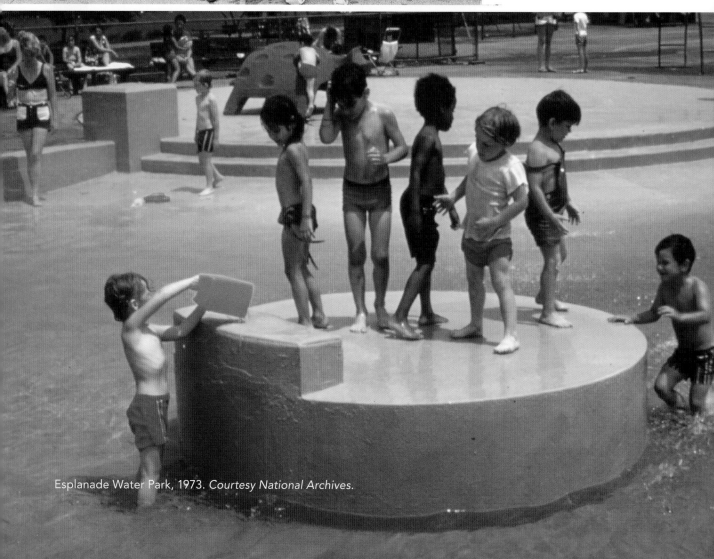

Esplanade Water Park, 1973. *Courtesy National Archives.*

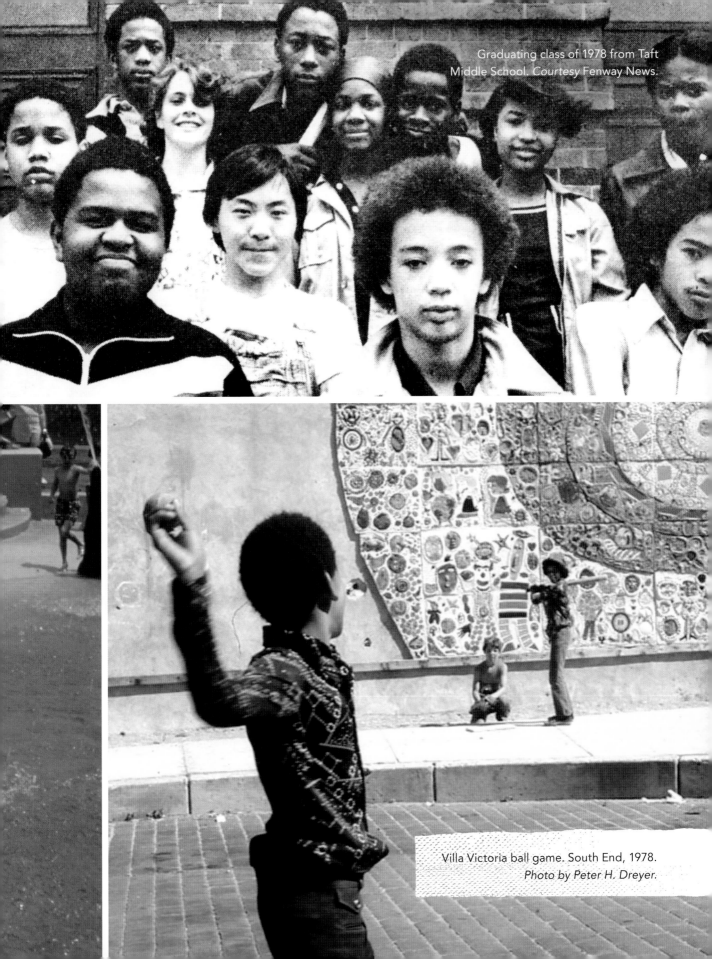

Graduating class of 1978 from Taft Middle School. *Courtesy Fenway News.*

Villa Victoria ball game. South End, 1978. *Photo by Peter H. Dreyer.*

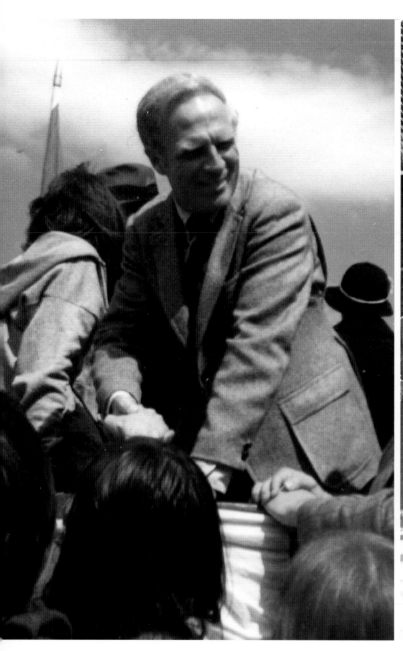

Mayor Kevin White at the Boston
Marathon finish line. Back Bay,
1973. *Photo by Richard T. Nolan.*

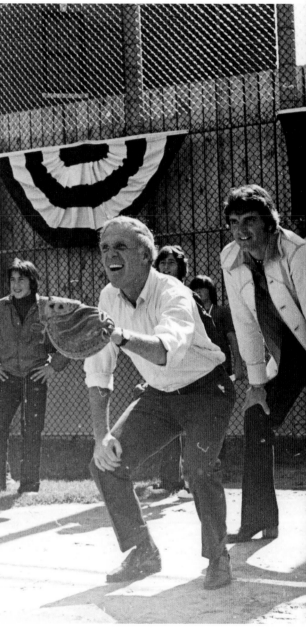

Red Sox right fielder Tony Conigliaro
plays umpire for Mayor Kevin White, 1975.
Courtesy City of Boston.

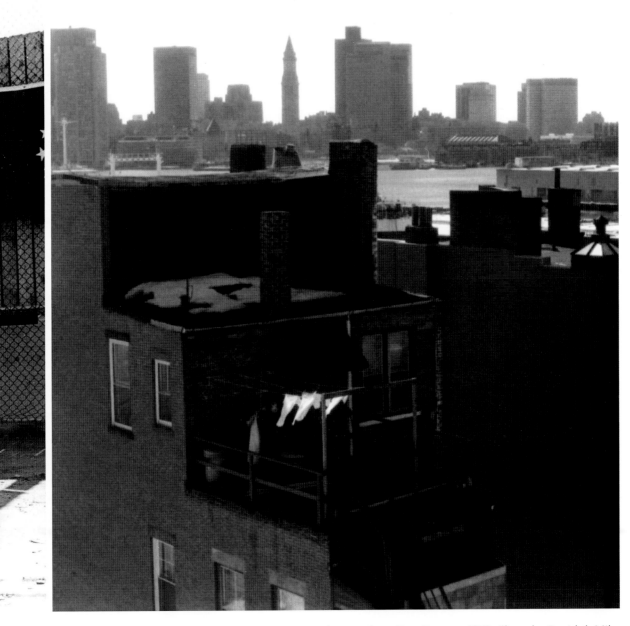

The view from East Boston, 1978. *Photo by David deMilo.*

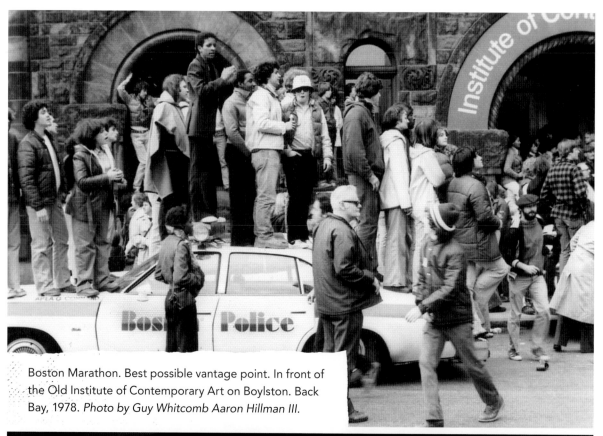

Boston Marathon. Best possible vantage point. In front of the Old Institute of Contemporary Art on Boylston. Back Bay, 1978. *Photo by Guy Whitcomb Aaron Hillman III.*

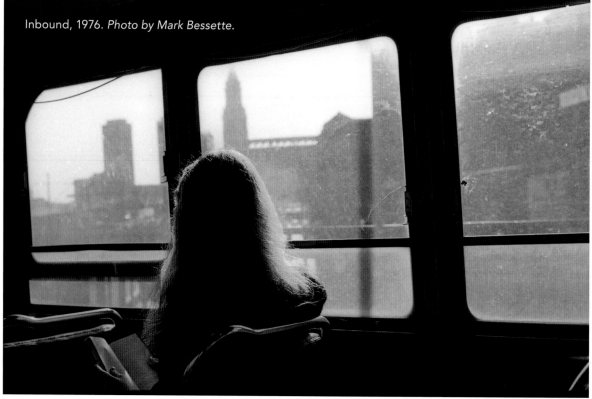

Inbound, 1976. *Photo by Mark Bessette.*

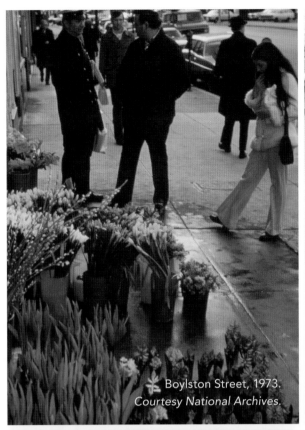

Boylston Street, 1973.
Courtesy National Archives.

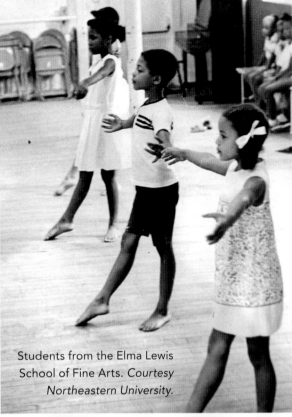

Students from the Elma Lewis
School of Fine Arts. *Courtesy
Northeastern University.*

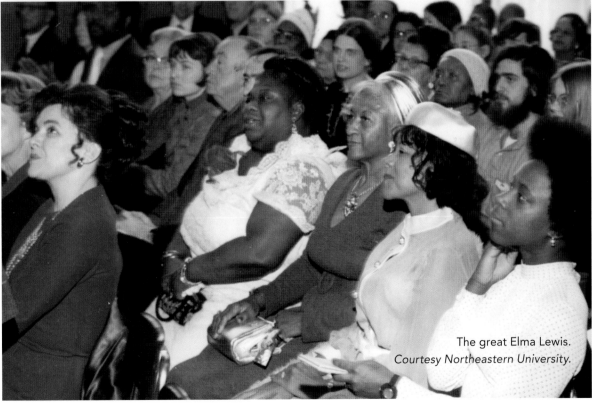

The great Elma Lewis.
Courtesy Northeastern University.

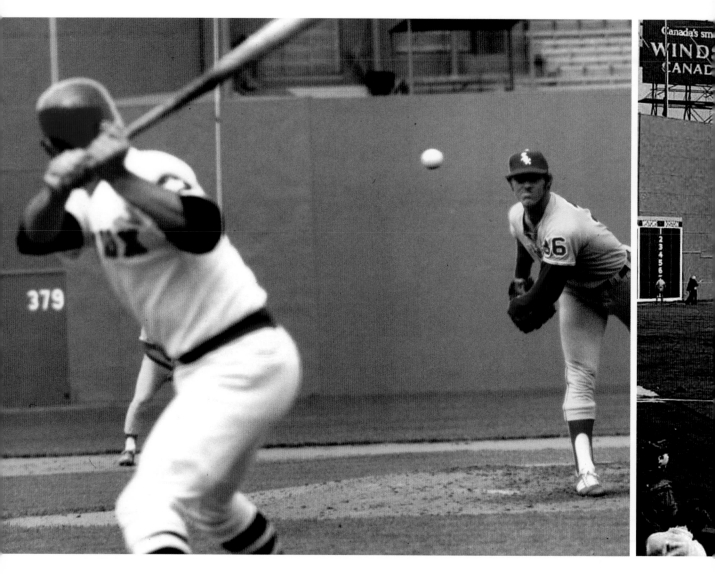

Yaz wields the bat against White Sox pitcher Jim Kaat, 1975.
Photo by Ed O'Connell.

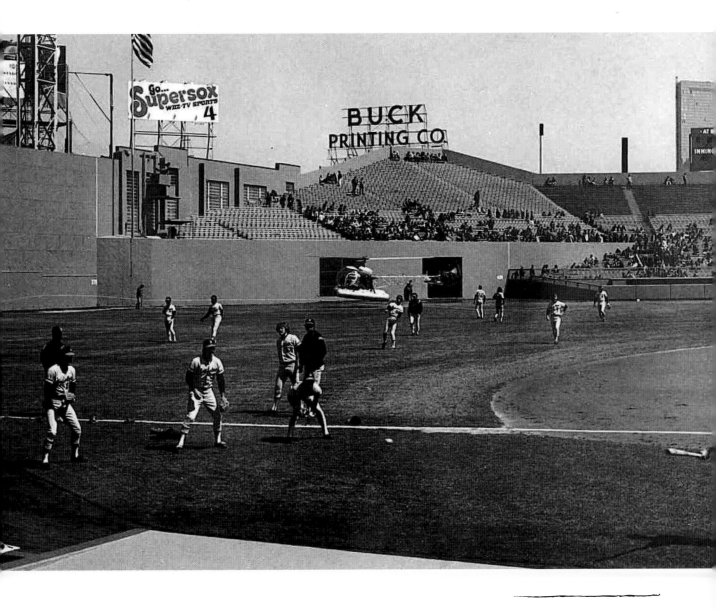

"I took this photo at the Red Sox Opening Day on April 11, 1974. I seem to remember the original day was postponed due to a snowstorm. The next day the rains came. On Thursday the skies were blue and the air was warm but the field was drenched. **The Fenway Park crew brought in a helicopter to dry out the field.**"

– Scott Belgard

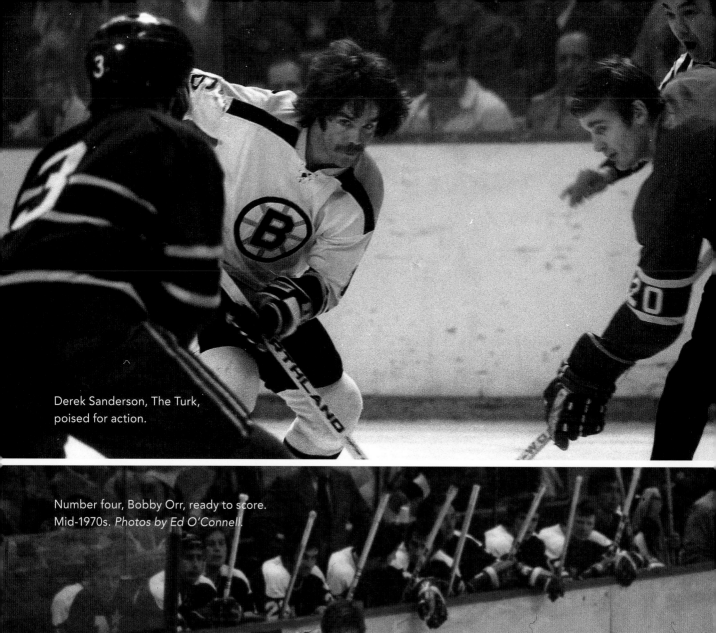

Derek Sanderson, The Turk,
poised for action.

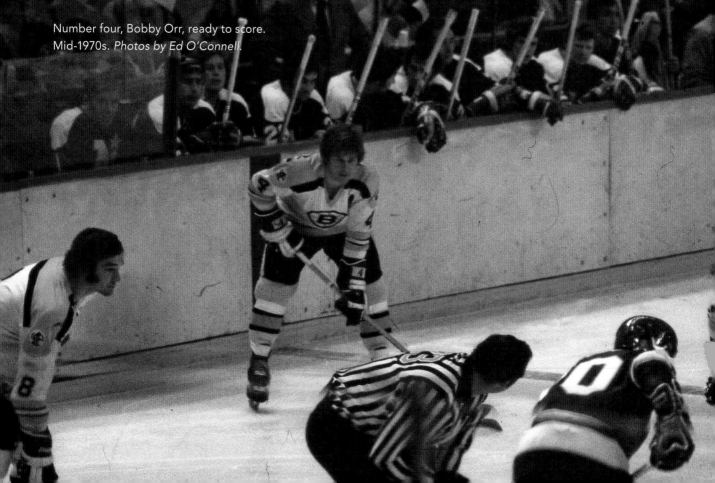

Number four, Bobby Orr, ready to score.
Mid-1970s. *Photos by Ed O'Connell.*

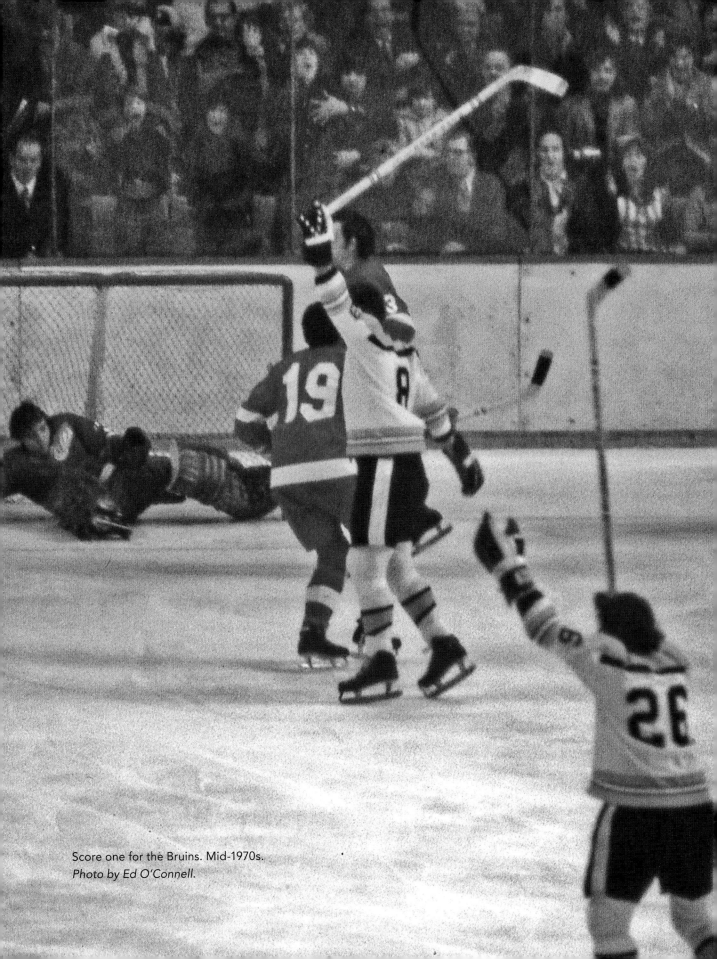

Score one for the Bruins. Mid-1970s.
Photo by Ed O'Connell.

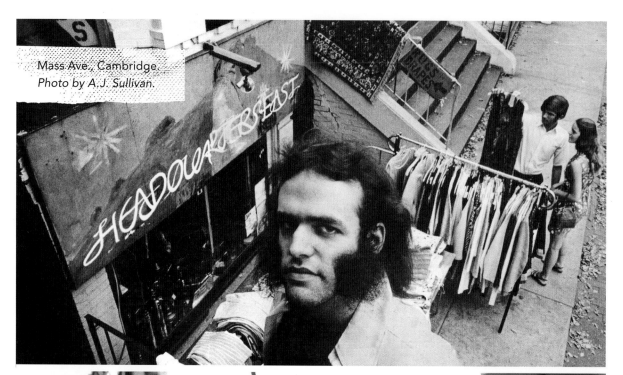

Mass Ave., Cambridge.
Photo by A.J. Sullivan.

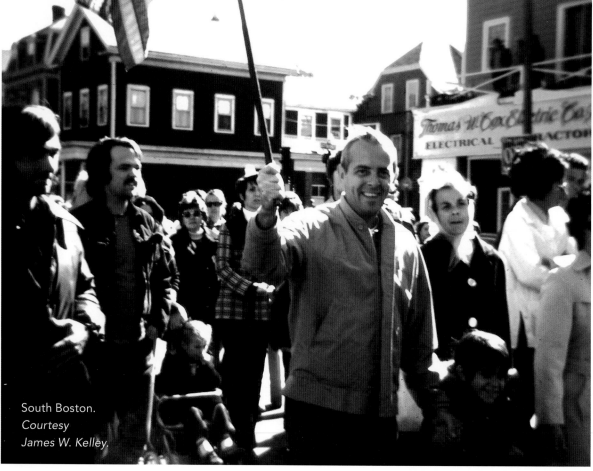

South Boston.
*Courtesy
James W. Kelley.*

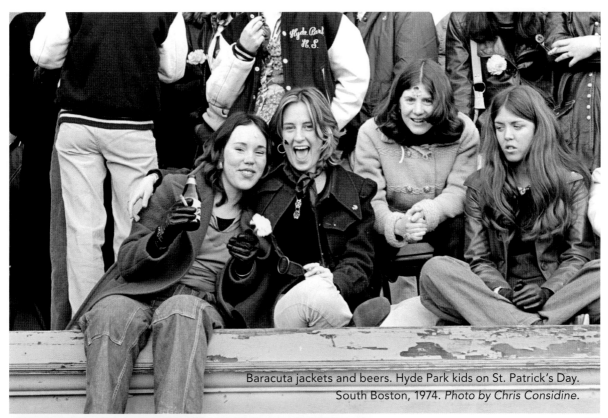

Baracuta jackets and beers. Hyde Park kids on St. Patrick's Day. South Boston, 1974. *Photo by Chris Considine.*

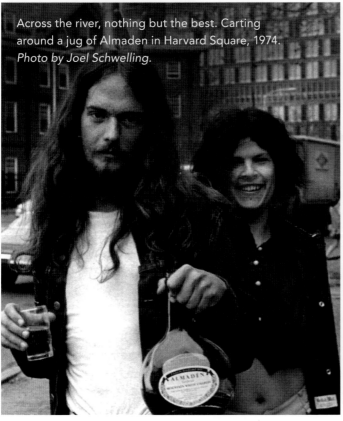

Across the river, nothing but the best. Carting around a jug of Almaden in Harvard Square, 1974. *Photo by Joel Schwelling.*

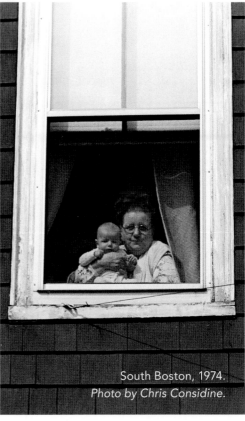

South Boston, 1974. *Photo by Chris Considine.*

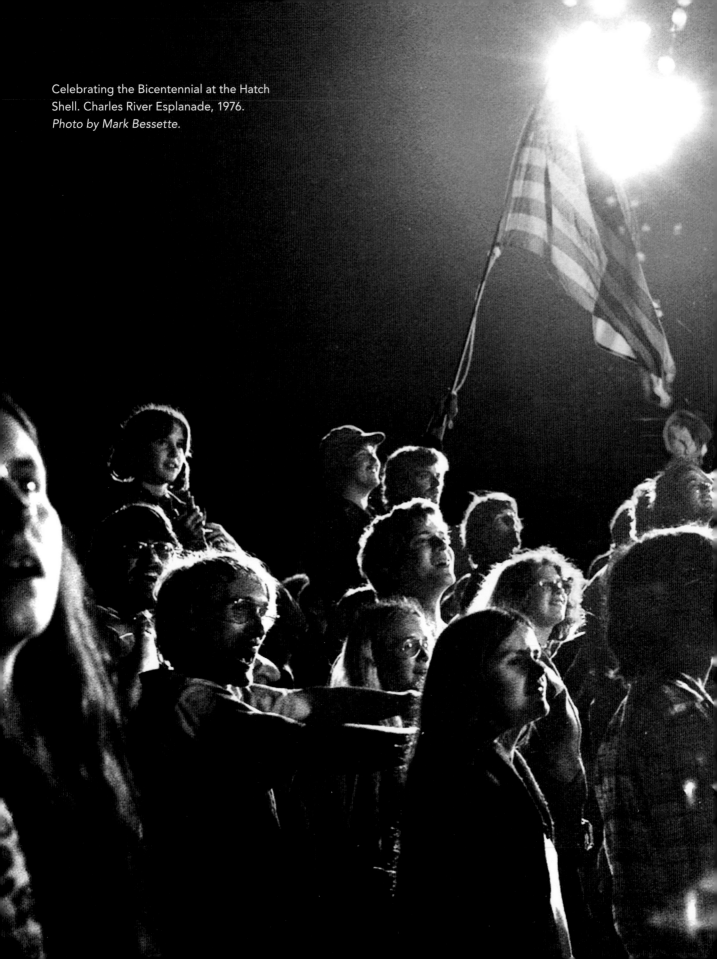

Celebrating the Bicentennial at the Hatch
Shell. Charles River Esplanade, 1976.
Photo by Mark Bessette.

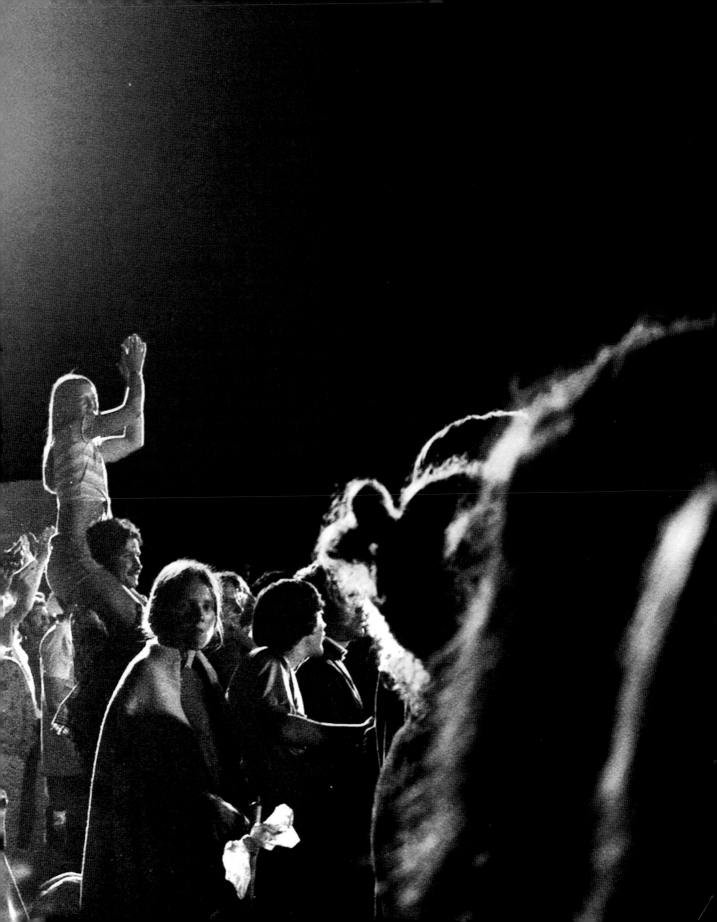

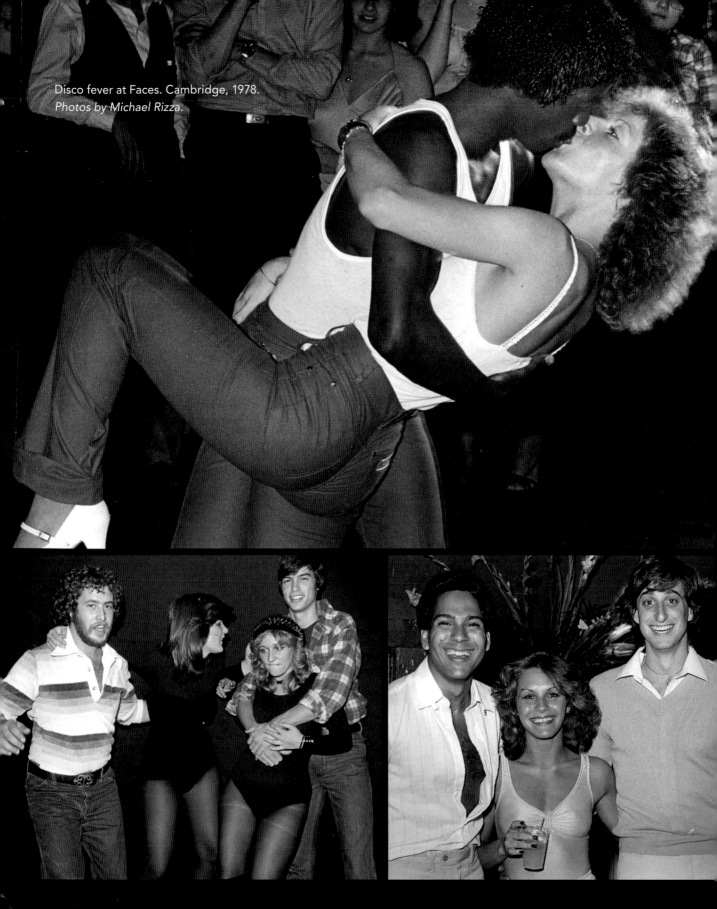

Disco fever at Faces. Cambridge, 1978.
Photos by Michael Rizza.

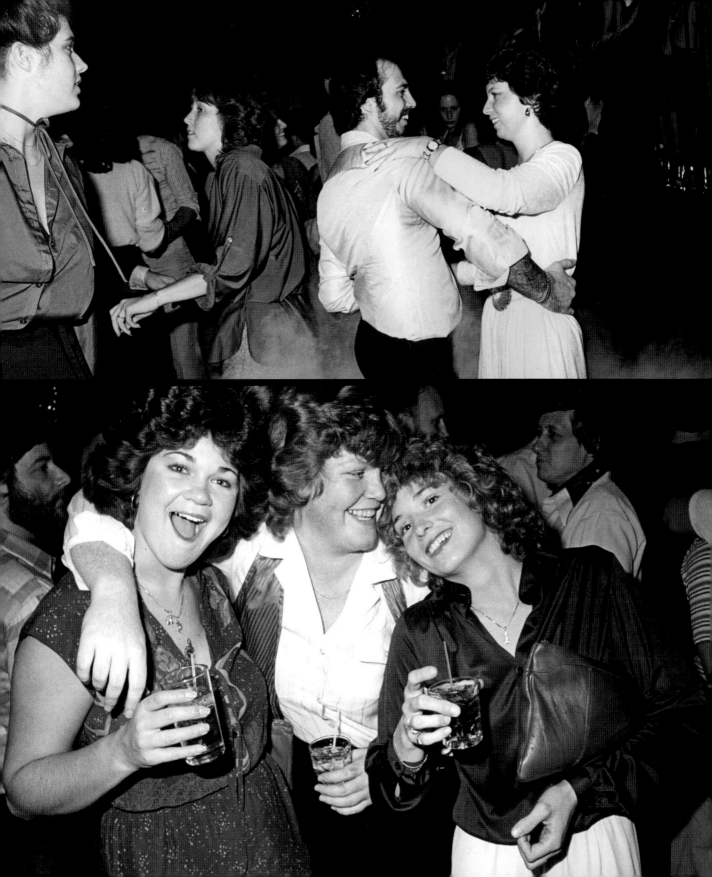

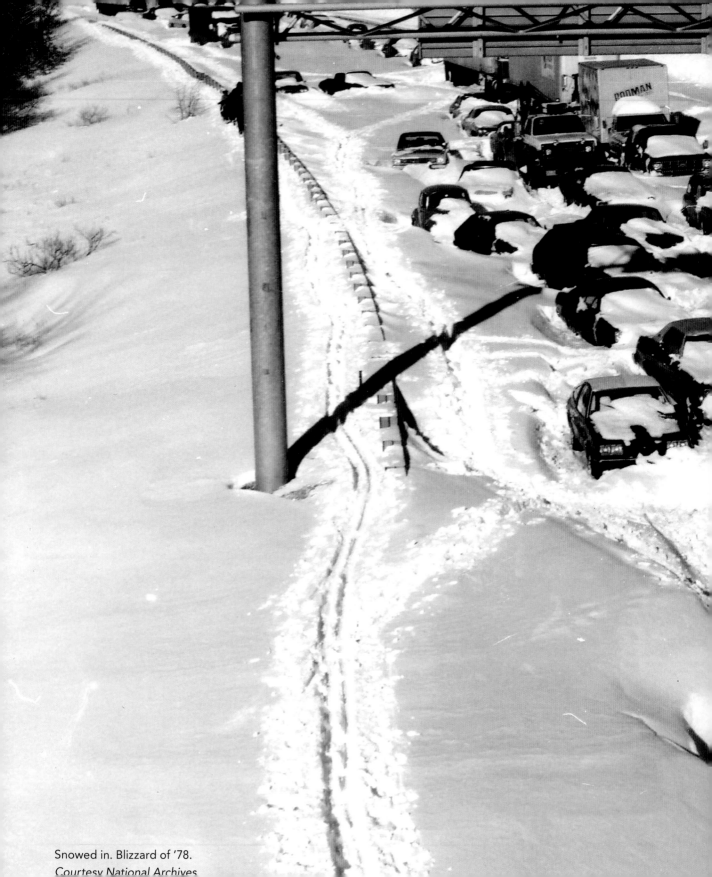

Snowed in. Blizzard of '78.
Courtesy National Archives

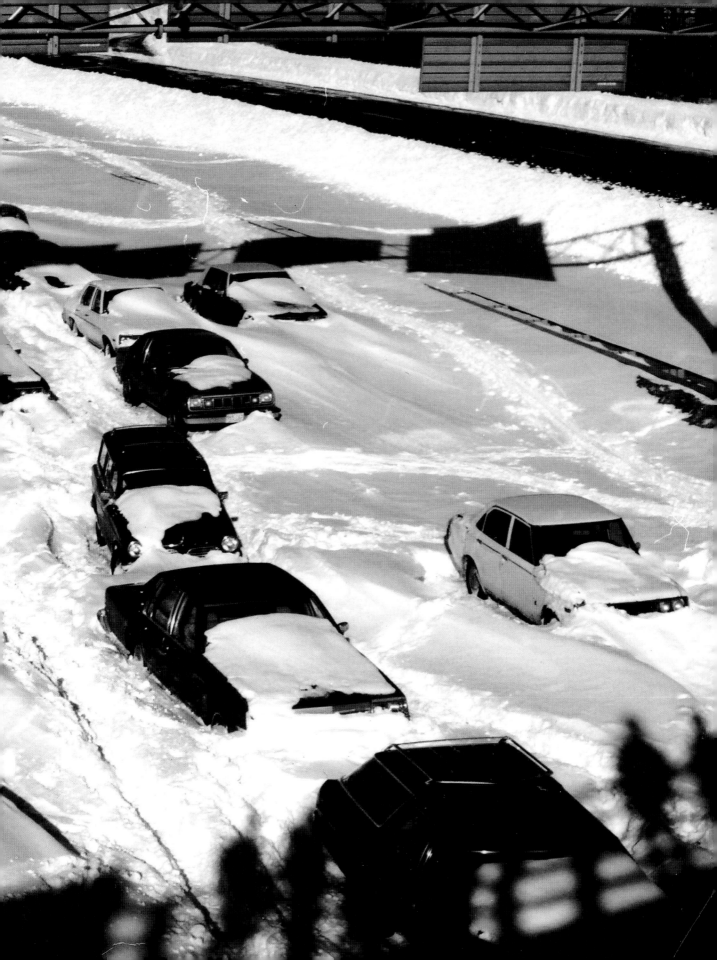

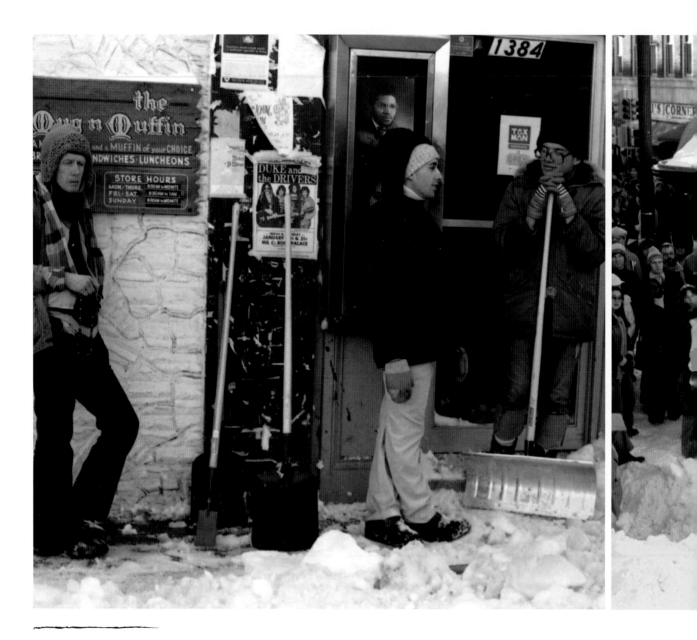

"The Blizzard of '78 closed universities in the city, and I took my camera out for the day and shot around Harvard Square. Here are a couple of snow shovelers taking a break in front of the Mug n' Muffin at the corner of Boylston (now JFK Street) and Mass Ave."

– David deMilo

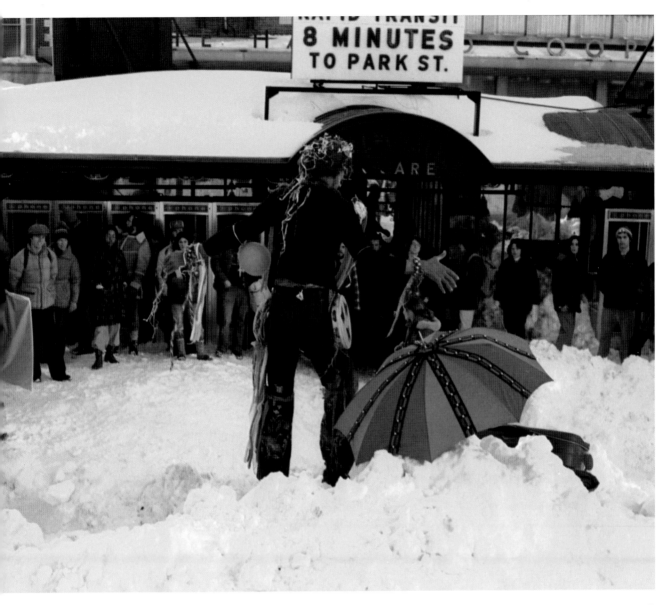

Renaissance man Brother Blue entertains a snow-weary crowd.
Harvard Square, 1978. *Photo by David deMilo.*

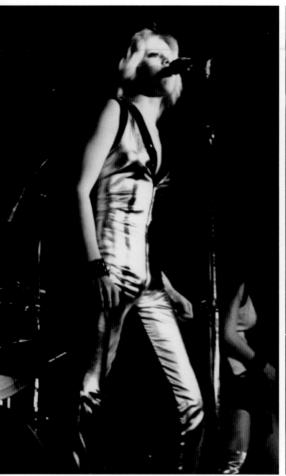

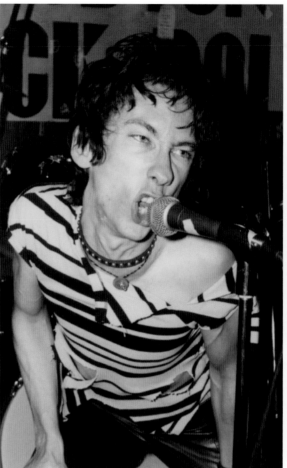

Cherie Currie of The Runaways
performs at the Rat, 1977.

Stiv Bators snarls at the audience as he
fronts the Dead Boys at the Rat, 1977.

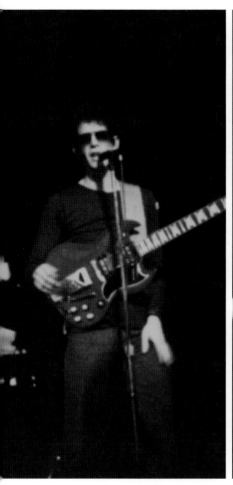

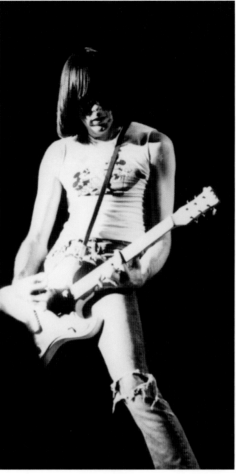

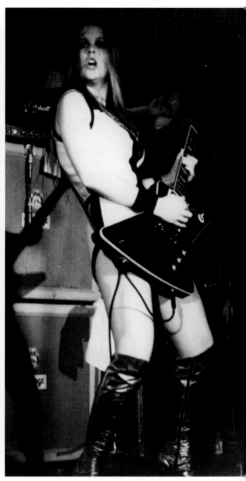

Lou Reed plays the
Orpheum, 1977.

Johnny Ramone strikes his
legendary rocker pose with the
Ramones at the Orpheum, 1977.

Lita Ford performs with
The Runaways at the
Rat, 1977.

Photos by Richie Parsons.

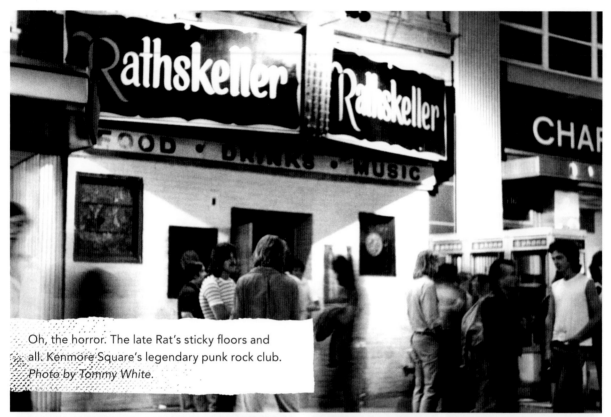

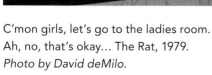
Oh, the horror. The late Rat's sticky floors and all. Kenmore Square's legendary punk rock club. *Photo by Tommy White.*

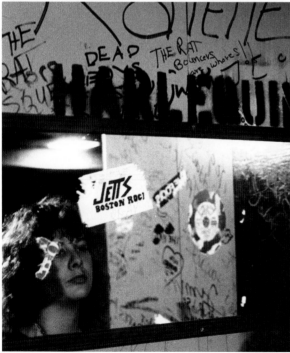

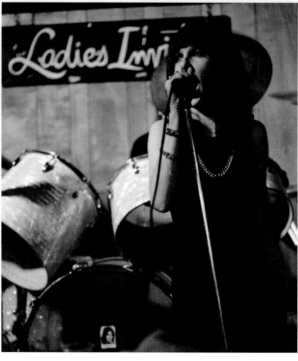

C'mon girls, let's go to the ladies room. Ah, no, that's okay… The Rat, 1979. *Photo by David deMilo.*

Barbara Kitson and the Thrills play at Cantone's on Broad Street, a popular venue for local bands, 1978. *Photo by David deMilo.*

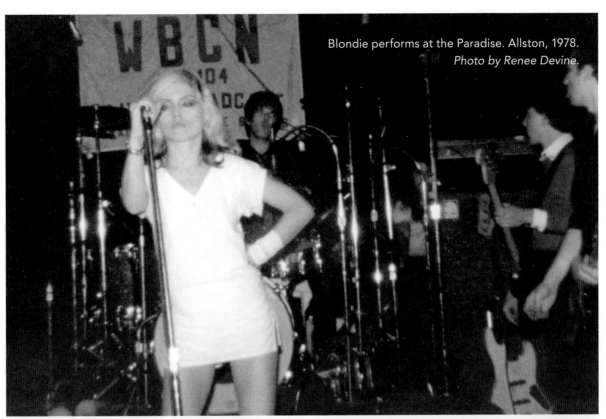

Blondie performs at the Paradise. Allston, 1978.
Photo by Renee Devine.

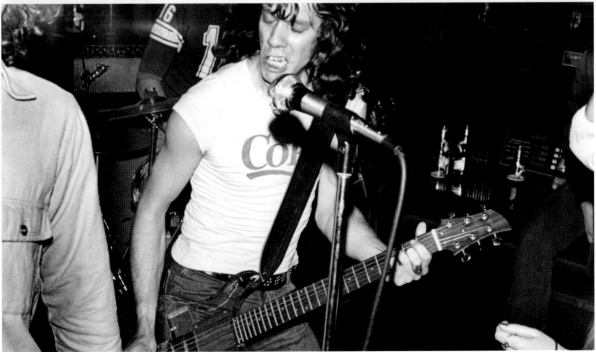

JJ Rassler plays with Boston punk rock pioneers DMZ at Cantone's.
Photo by Tommy White.

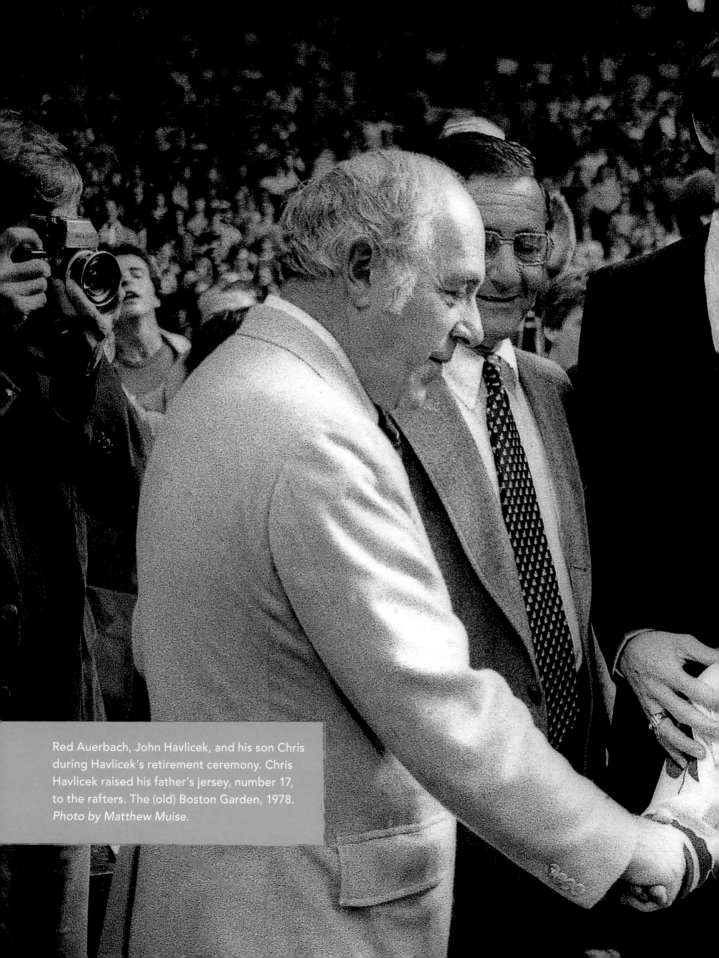

Red Auerbach, John Havlicek, and his son Chris during Havlicek's retirement ceremony. Chris Havlicek raised his father's jersey, number 17, to the rafters. The (old) Boston Garden, 1978. *Photo by Matthew Muise.*

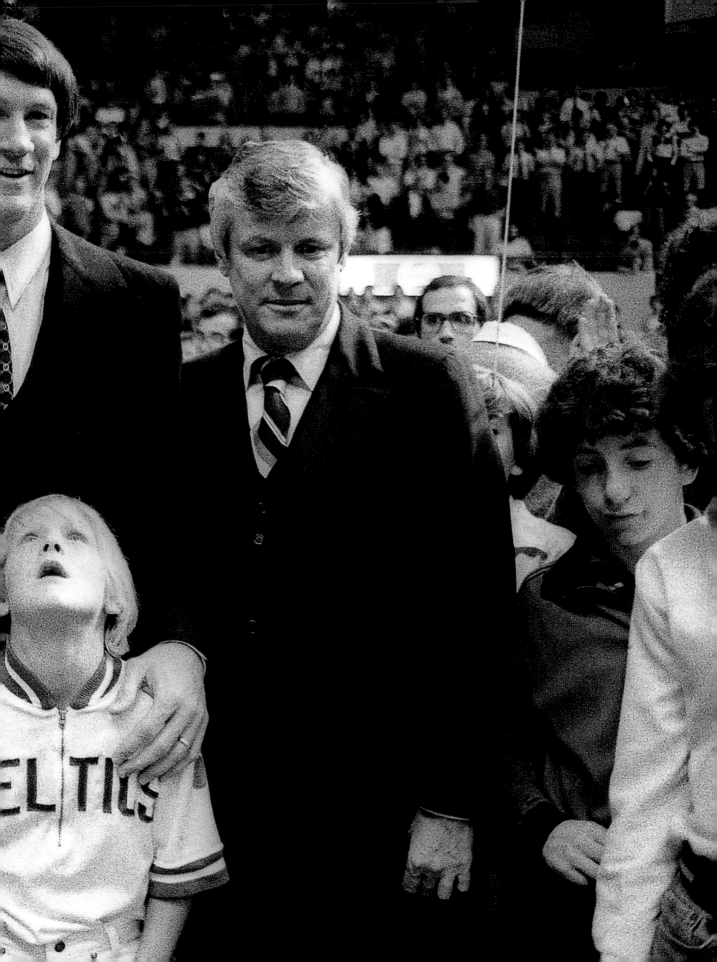

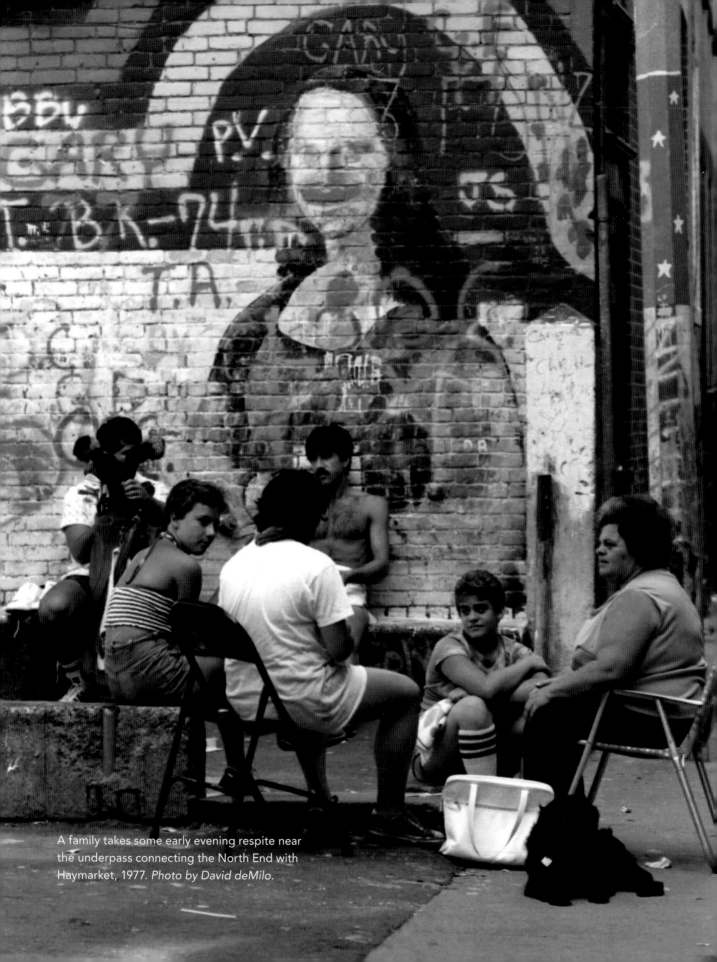

A family takes some early evening respite near the underpass connecting the North End with Haymarket, 1977. *Photo by David deMilo.*

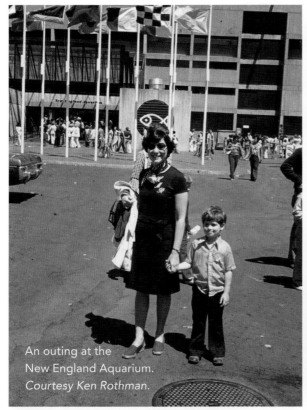

An outing at the
New England Aquarium.
Courtesy Ken Rothman.

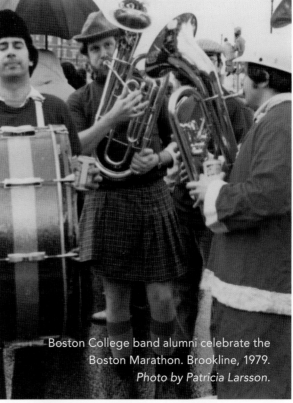

Boston College band alumni celebrate the
Boston Marathon. Brookline, 1979.
Photo by Patricia Larsson.

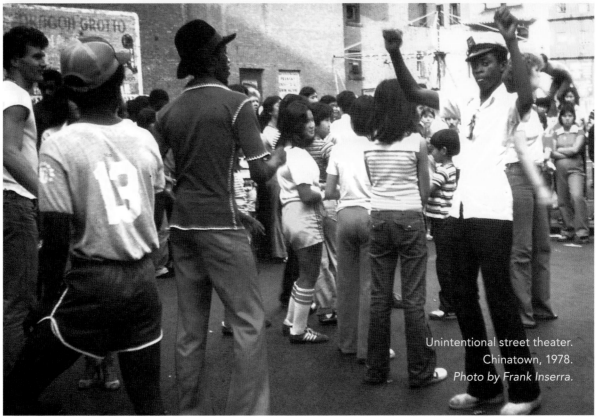

Unintentional street theater.
Chinatown, 1978.
Photo by Frank Inserra.

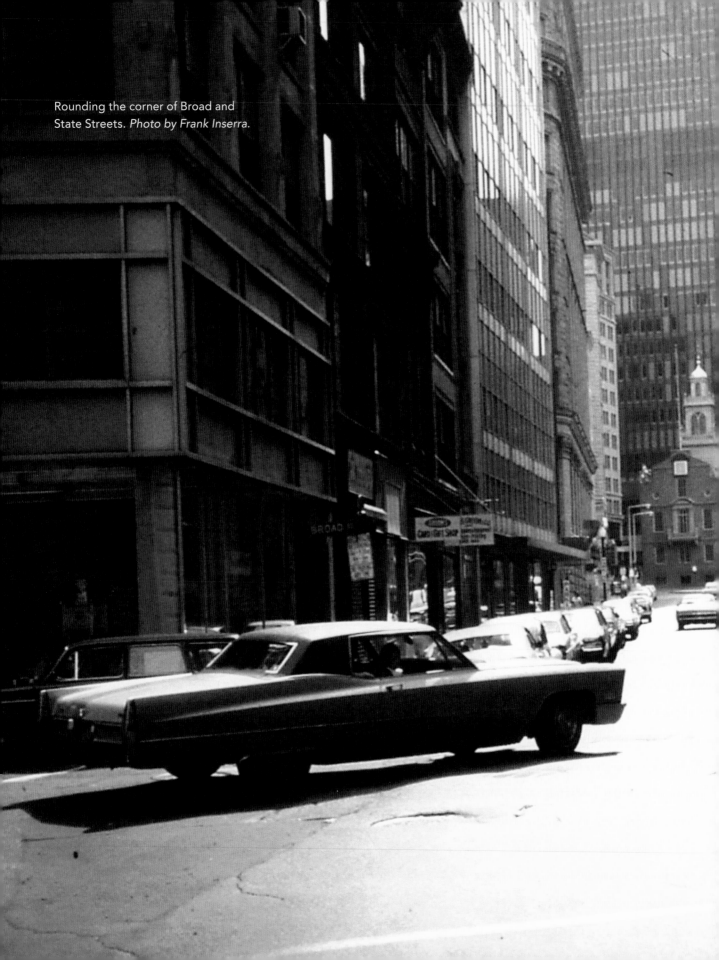

Rounding the corner of Broad and State Streets. *Photo by Frank Inserra.*

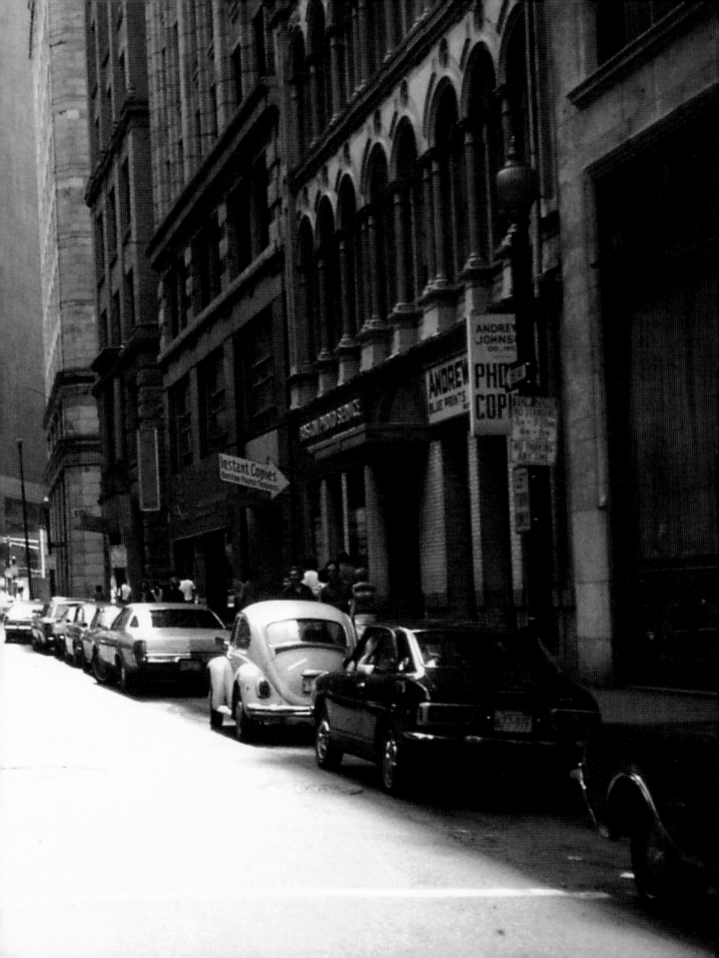

Breaking for lunch. Quincy Market, 1983.
Photo by David Henry.

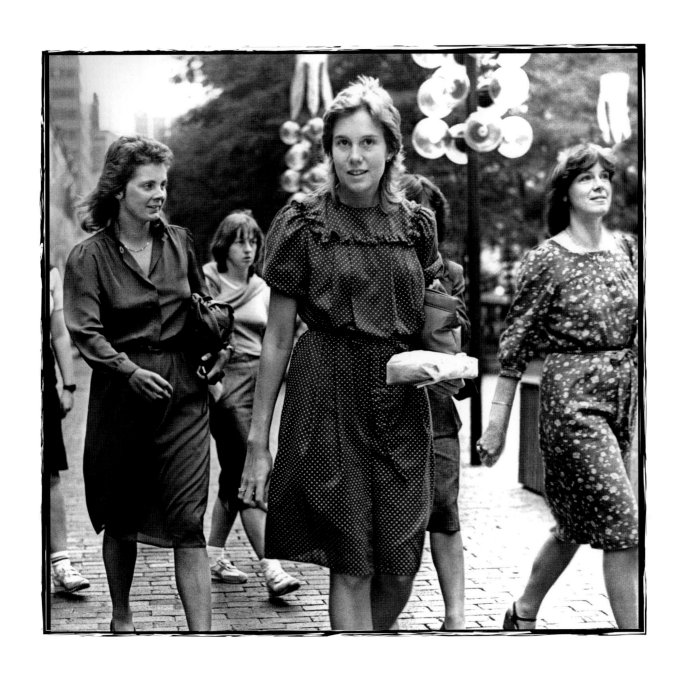

the **1980s**

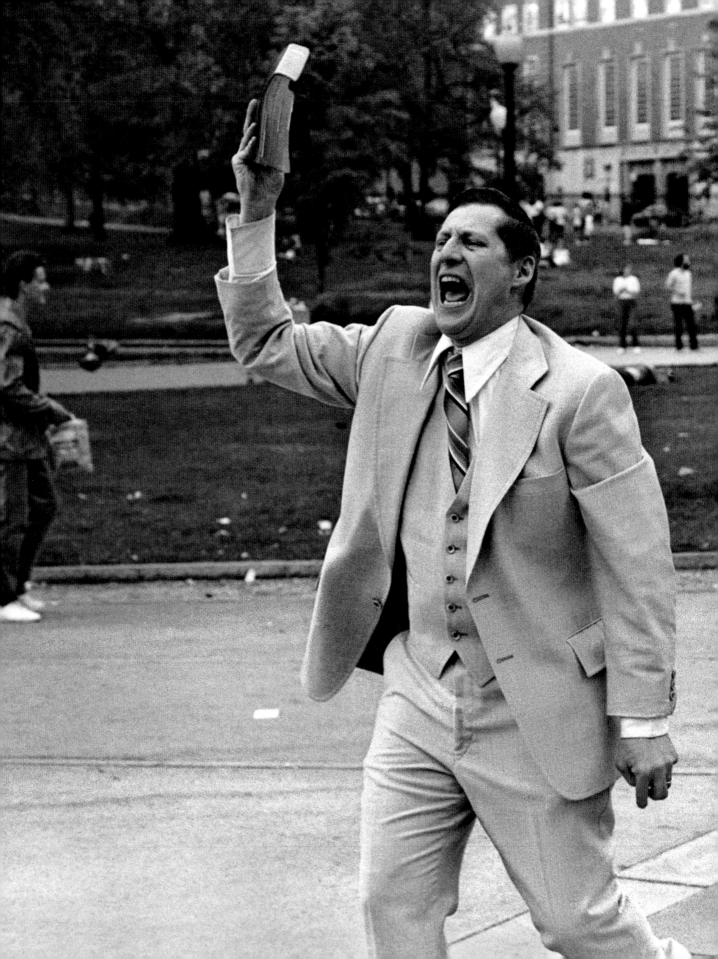

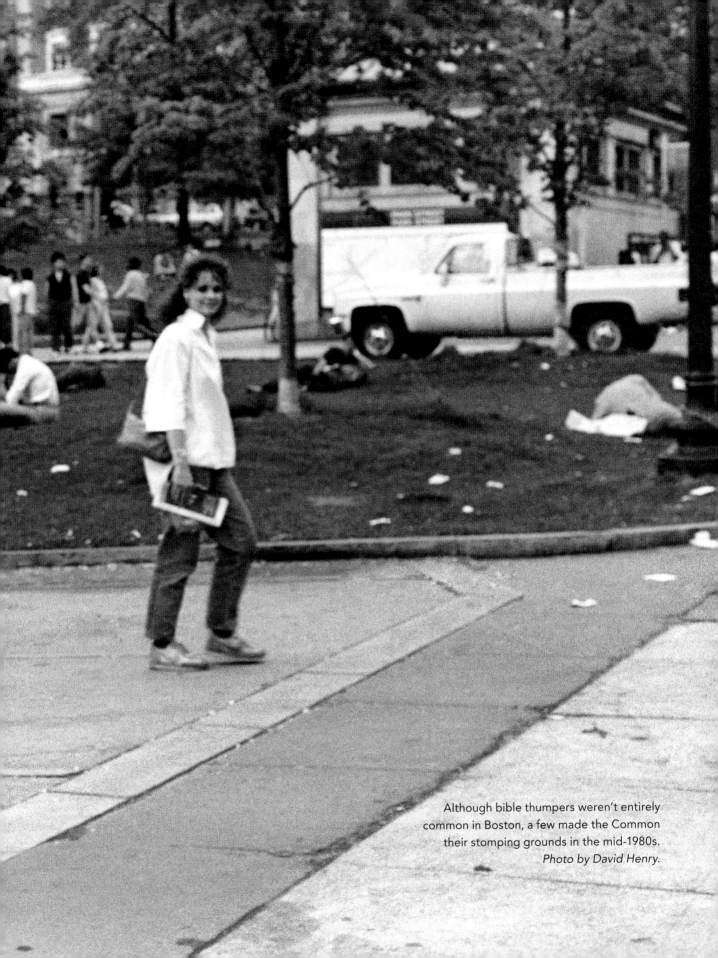

Although bible thumpers weren't entirely common in Boston, a few made the Common their stomping grounds in the mid-1980s.
Photo by David Henry.

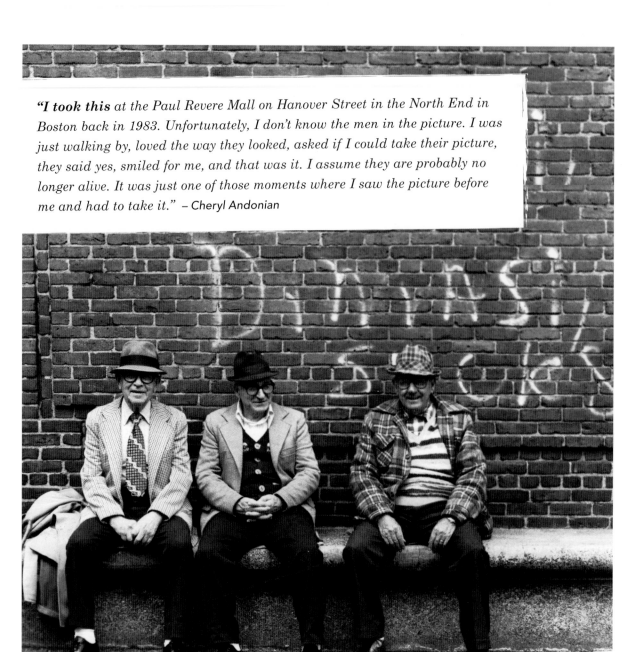

"I took this at the Paul Revere Mall on Hanover Street in the North End in Boston back in 1983. Unfortunately, I don't know the men in the picture. I was just walking by, loved the way they looked, asked if I could take their picture, they said yes, smiled for me, and that was it. I assume they are probably no longer alive. It was just one of those moments where I saw the picture before me and had to take it." – Cheryl Andonian

Photos opposite page: After the demise of good ol' Scollay Square, city officials—who were resigned to the fact that even a puritanical city like Boston wanted to be bawdy sometimes—designated an area known as the Combat Zone for adult entertainment. By the 1980s, the city might have regretted this decision and efforts were made to reinforce the Theatre District name. But, as seen here, rebranding can be challenging. Combat Zone, 1981. *Photos by David deMilo.*

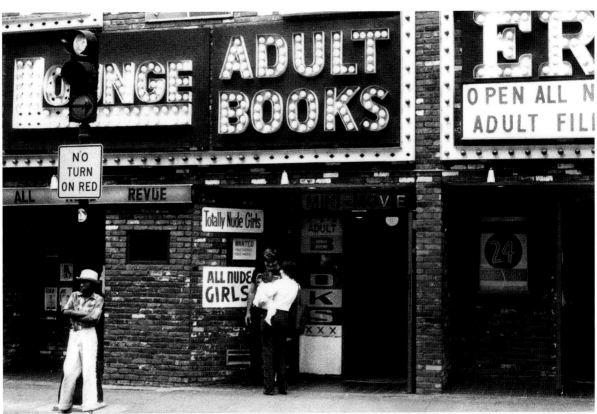

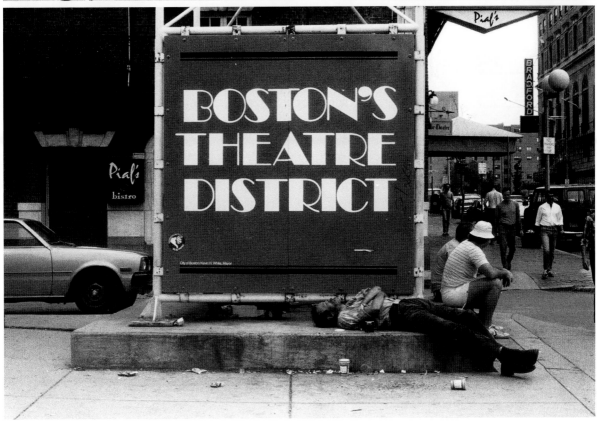

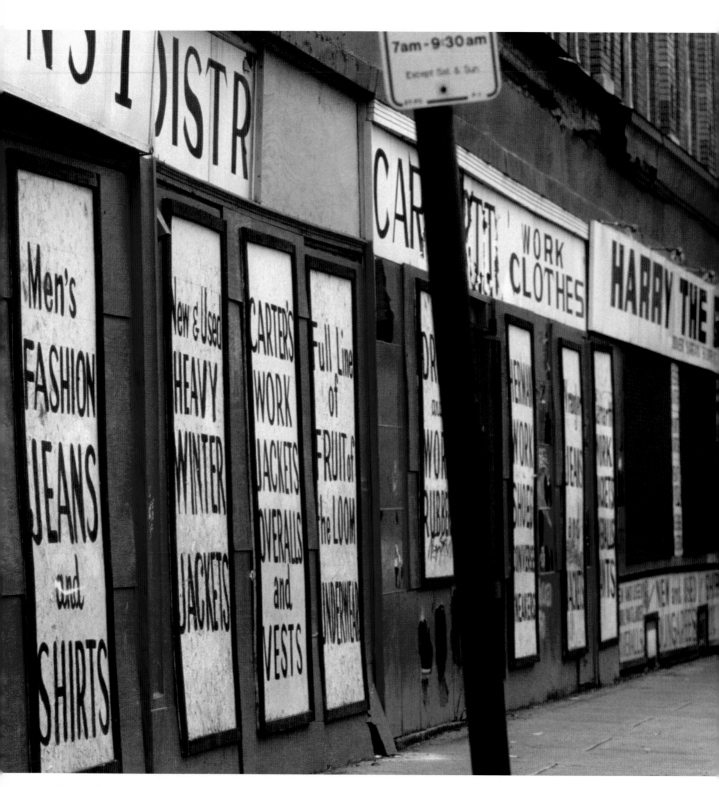

Opened in 1950 by the Kamenides family, Harry the Greek's, located on the corner of Dover (now East Berkeley) and Washington Streets, bought and sold what would be described today as "vintage" clothing. College students, professors, the rich, the poor, and everyone else shopped Harry the Greek's. South End, early 1980s. *Photo by Gail P. Rush.*

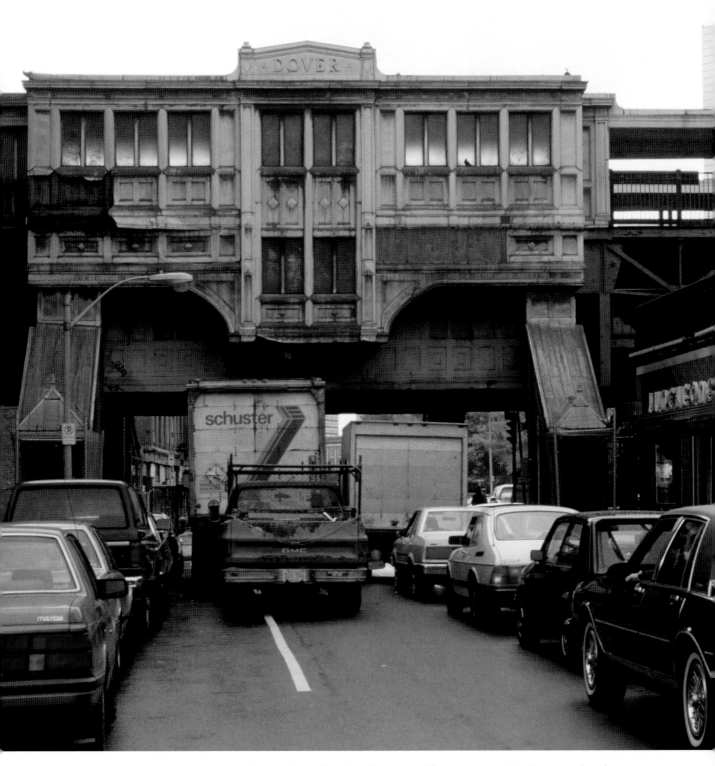

Dover Street Station. Gone now. If you want to visit the grave, head on over to East Berkeley Street. South End, early 1980s. *Photo by Gail P. Rush.*

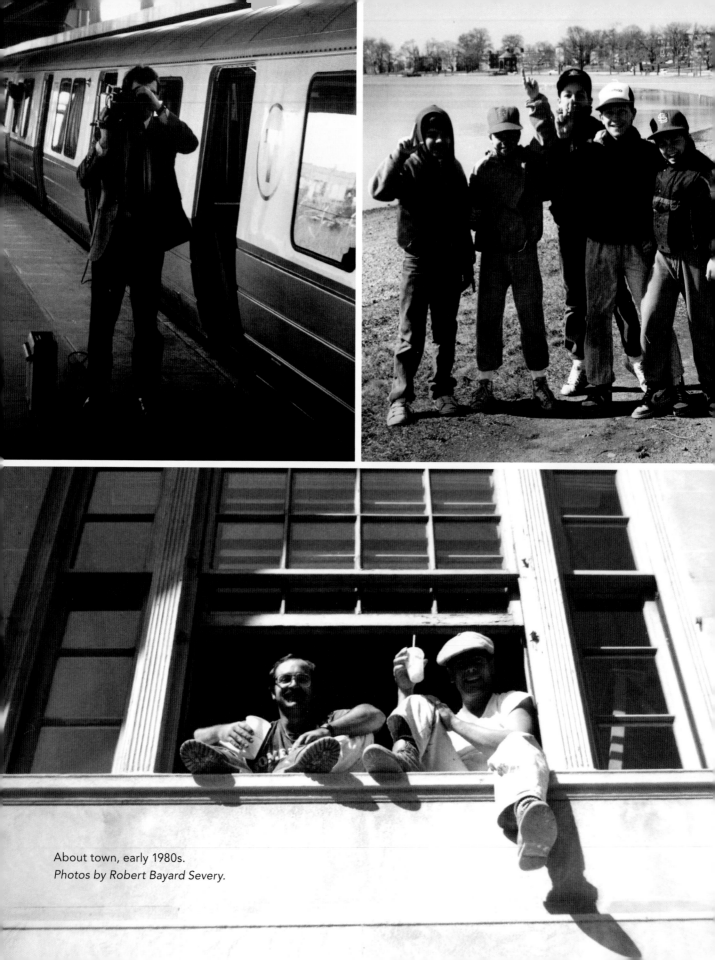

About town, early 1980s.
Photos by Robert Bayard Severy.

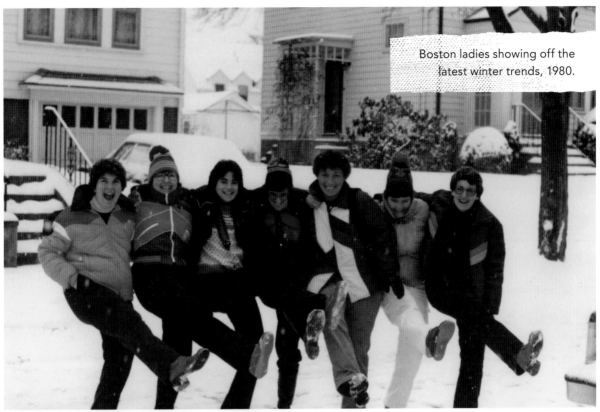

Boston ladies showing off the latest winter trends, 1980.

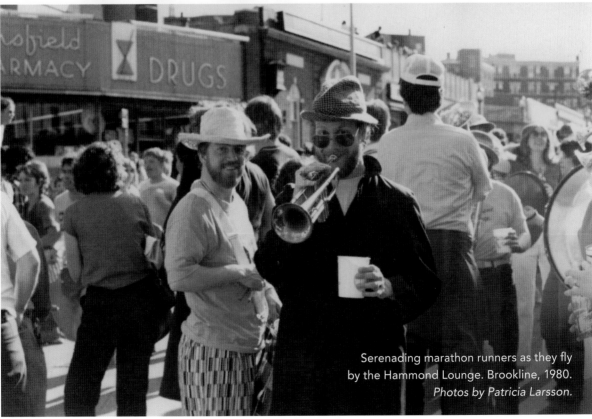

Serenading marathon runners as they fly by the Hammond Lounge. Brookline, 1980.
Photos by Patricia Larsson.

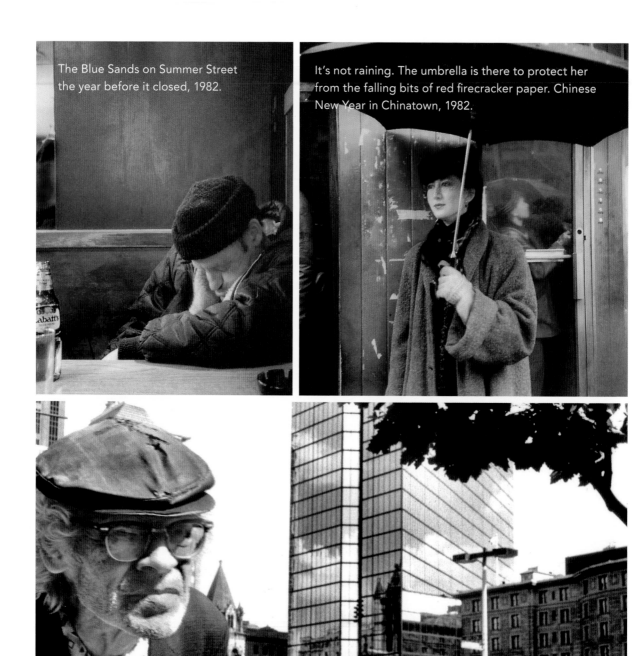

The Blue Sands on Summer Street the year before it closed, 1982.

It's not raining. The umbrella is there to protect her from the falling bits of red firecracker paper. Chinese New Year in Chinatown, 1982.

Buzzardman. Copley Square, 1982. *Photos by David Henry.*

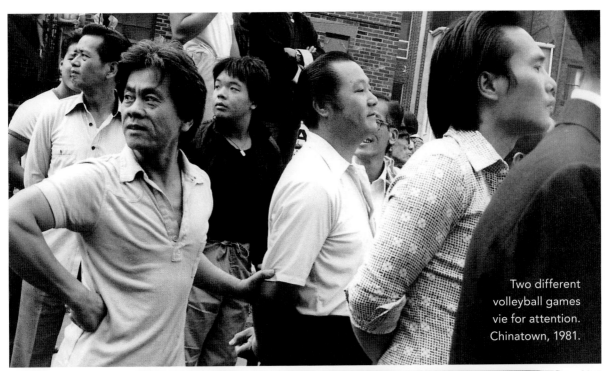

Two different volleyball games vie for attention. Chinatown, 1981.

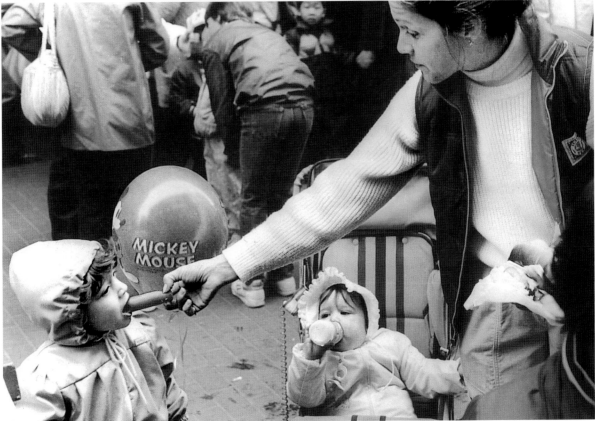

Festival on Summer Street between Filene's and Jordan Marsh. Downtown Crossing, 1985. *Photos by David Henry.*

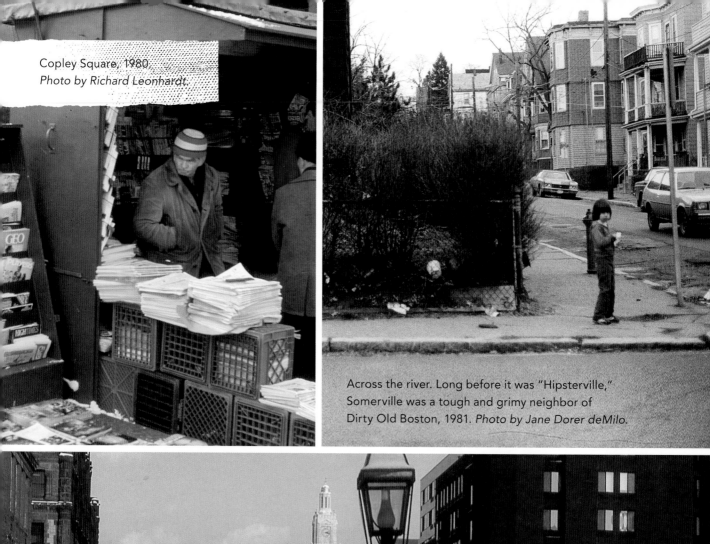

Copley Square, 1980.
Photo by Richard Leonhardt.

Across the river. Long before it was "Hipsterville,"
Somerville was a tough and grimy neighbor of
Dirty Old Boston, 1981. *Photo by Jane Dorer deMilo.*

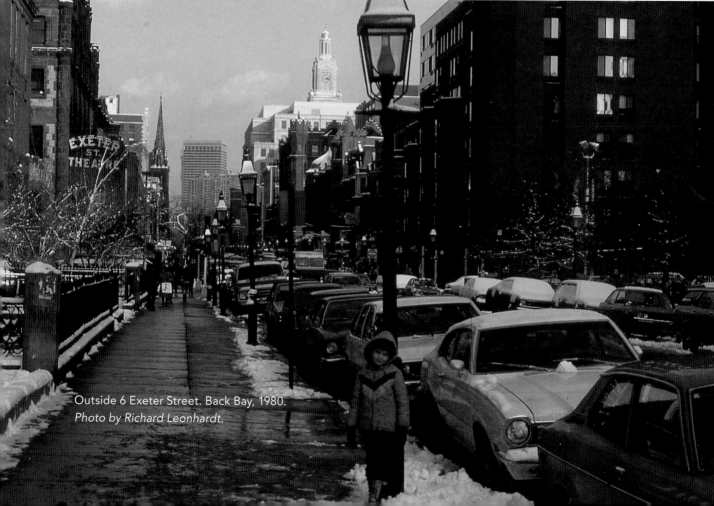

Outside 6 Exeter Street. Back Bay, 1980.
Photo by Richard Leonhardt.

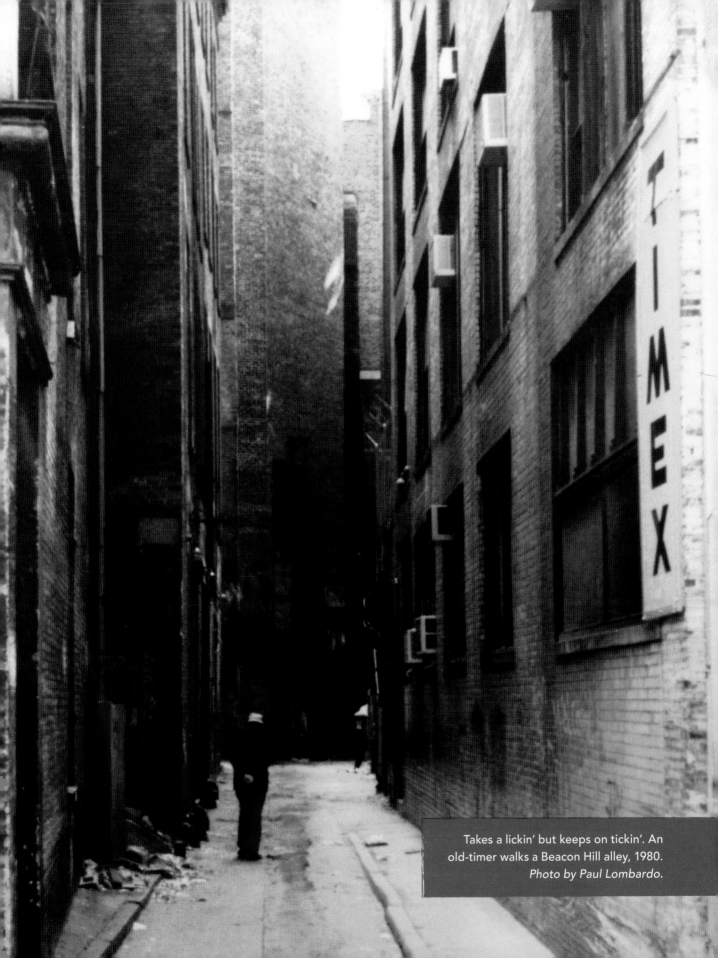

Takes a lickin' but keeps on tickin'. An old-timer walks a Beacon Hill alley, 1980. *Photo by Paul Lombardo.*

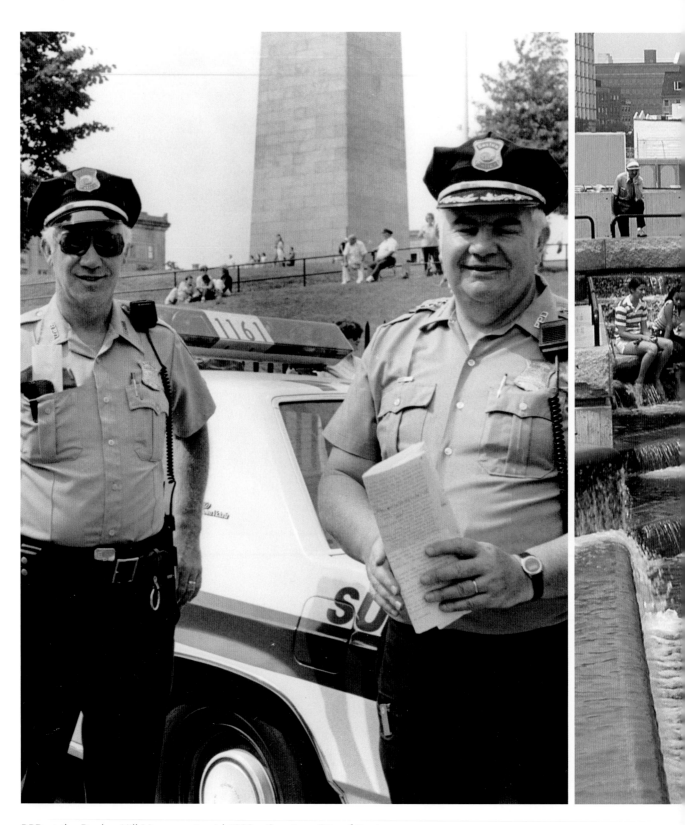

BPD at the Bunker Hill Monument, mid-1980s. *Courtesy City of Boston.*

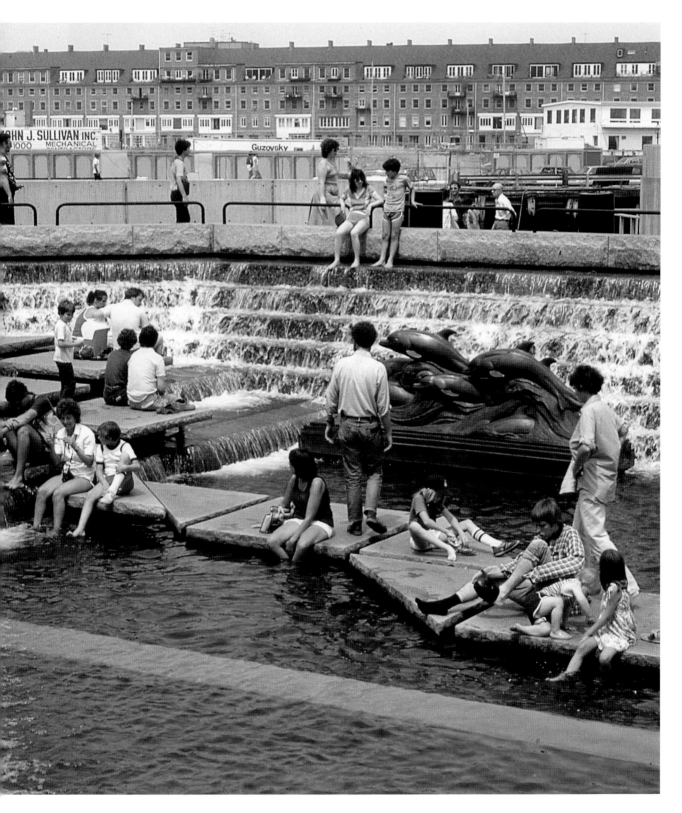

Cooling down outside the New England Aquarium. The fountain was built in 1979 but is now long gone. Note the background; no Long Wharf Marriott... yet. 1980. *Photo by Richard Leonhardt.*

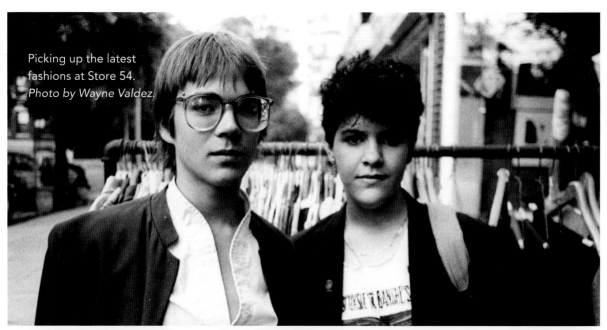

Picking up the latest fashions at Store 54.
Photo by Wayne Valdez.

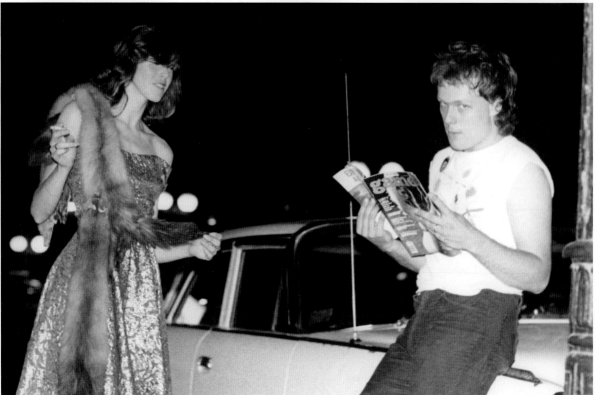

*"**I had a friend** who worked in a cool vintage shop, Blue Finger on Charles Street, who used to give me fabulous clothes. My dress had belonged to an Arthur Murray dance instructor, and although you can't see them, my shoes belonged to a former Miss America. And who doesn't wear her furs in the heat of the summer?…But that was me then. My kids' friends can't believe their mother has a picture of herself with GG Allin."* – Jan Collins

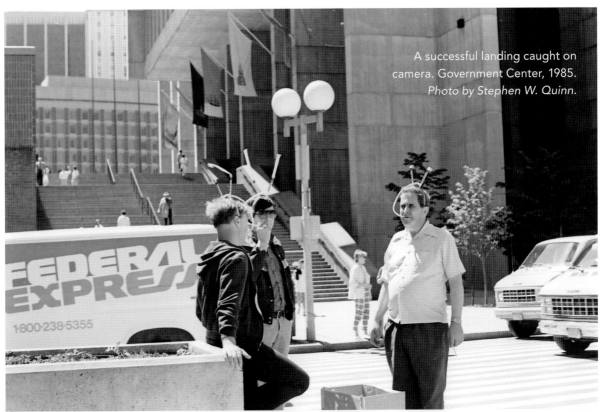

A successful landing caught on camera. Government Center, 1985. *Photo by Stephen W. Quinn.*

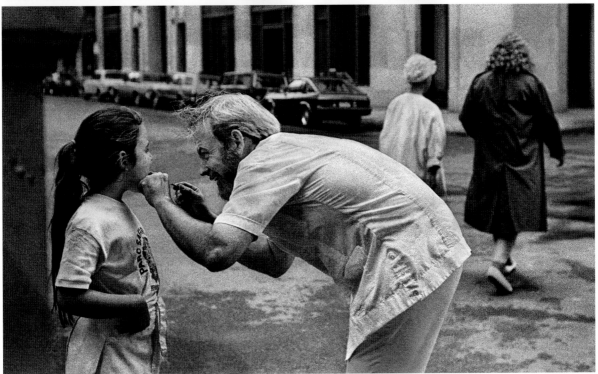

Open wide! A dentist inspects a young girl's teeth. Corner of Broad and Milk Streets, 1981. *Photo by David Henry.*

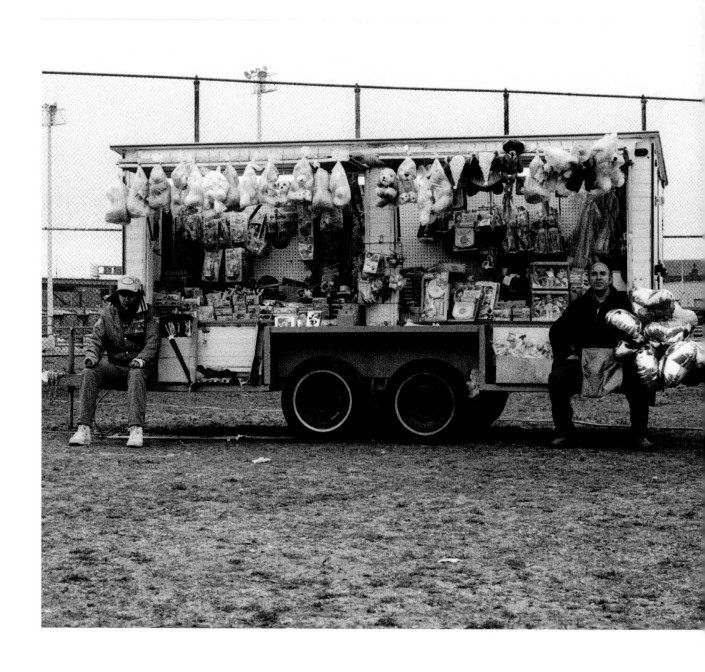

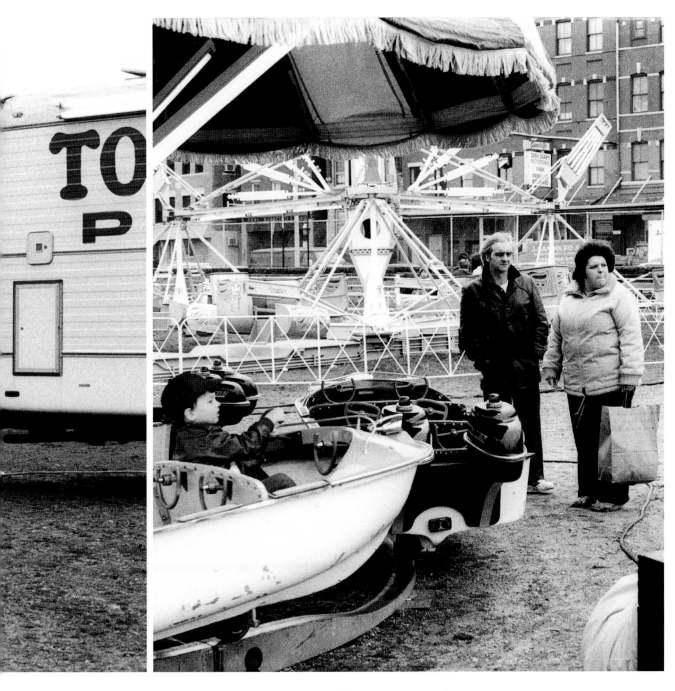

They are not amused. Sam Pino Amusements sets up camp on Boston's waterfront, 1985. *Photos by Jane Dorer deMilo.*

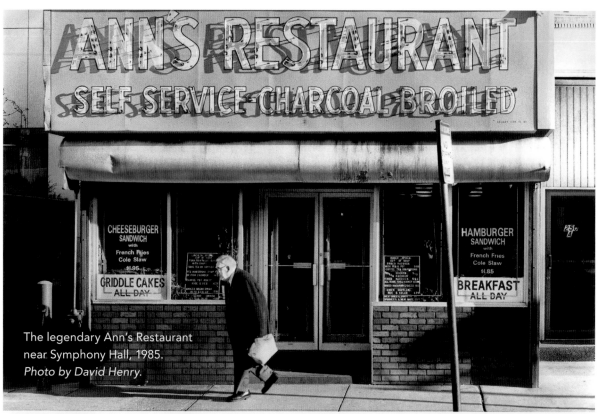

The legendary Ann's Restaurant near Symphony Hall, 1985.
Photo by David Henry.

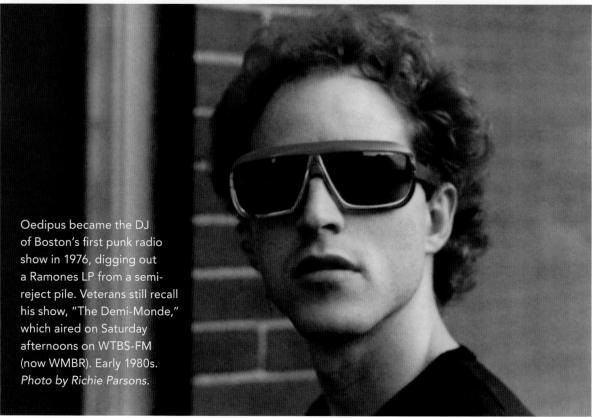

Oedipus became the DJ of Boston's first punk radio show in 1976, digging out a Ramones LP from a semi-reject pile. Veterans still recall his show, "The Demi-Monde," which aired on Saturday afternoons on WTBS-FM (now WMBR). Early 1980s.
Photo by Richie Parsons.

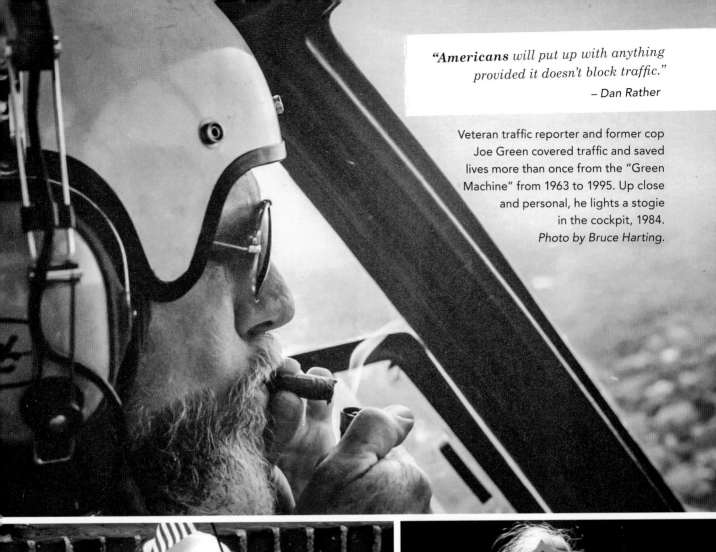

> *"**Americans** will put up with anything provided it doesn't block traffic."*
> – Dan Rather

Veteran traffic reporter and former cop Joe Green covered traffic and saved lives more than once from the "Green Machine" from 1963 to 1995. Up close and personal, he lights a stogie in the cockpit, 1984. *Photo by Bruce Harting.*

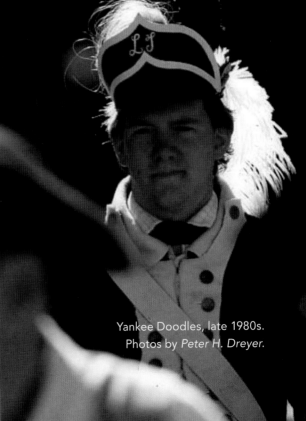

Yankee Doodles, late 1980s. Photos by *Peter H. Dreyer.*

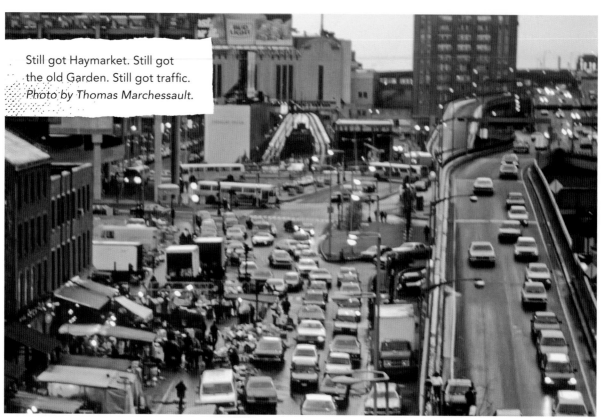

Still got Haymarket. Still got the old Garden. Still got traffic. *Photo by Thomas Marchessault.*

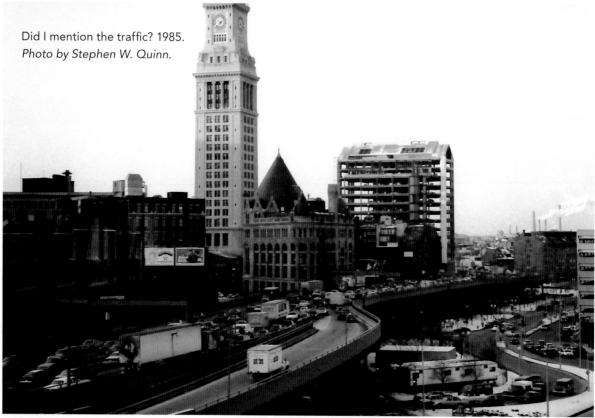

Did I mention the traffic? 1985. *Photo by Stephen W. Quinn.*

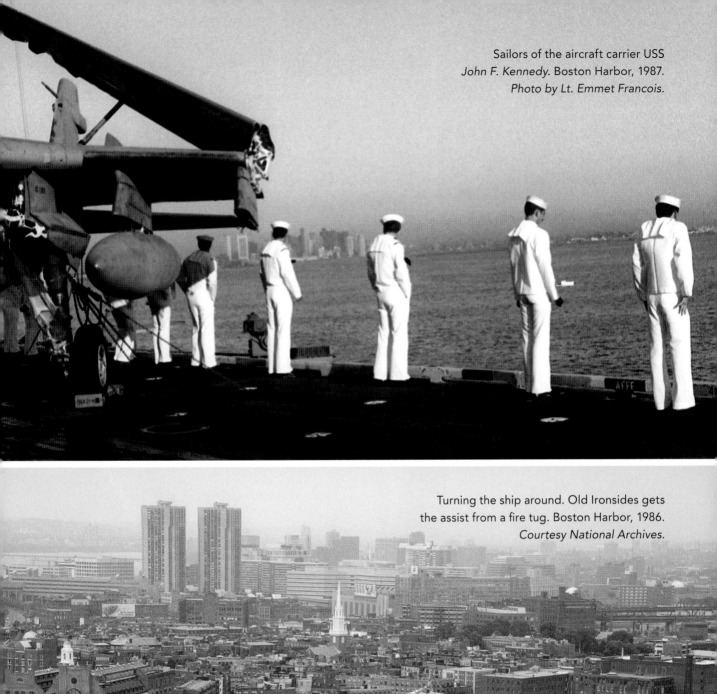

Sailors of the aircraft carrier USS *John F. Kennedy.* Boston Harbor, 1987. *Photo by Lt. Emmet Francois.*

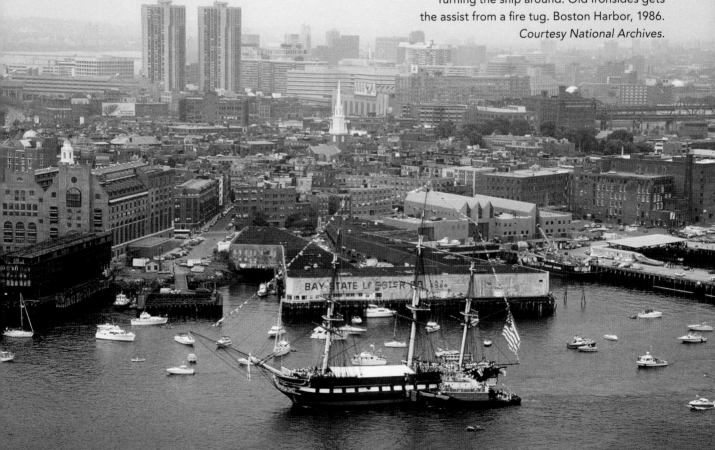

Turning the ship around. Old Ironsides gets the assist from a fire tug. Boston Harbor, 1986. *Courtesy National Archives.*

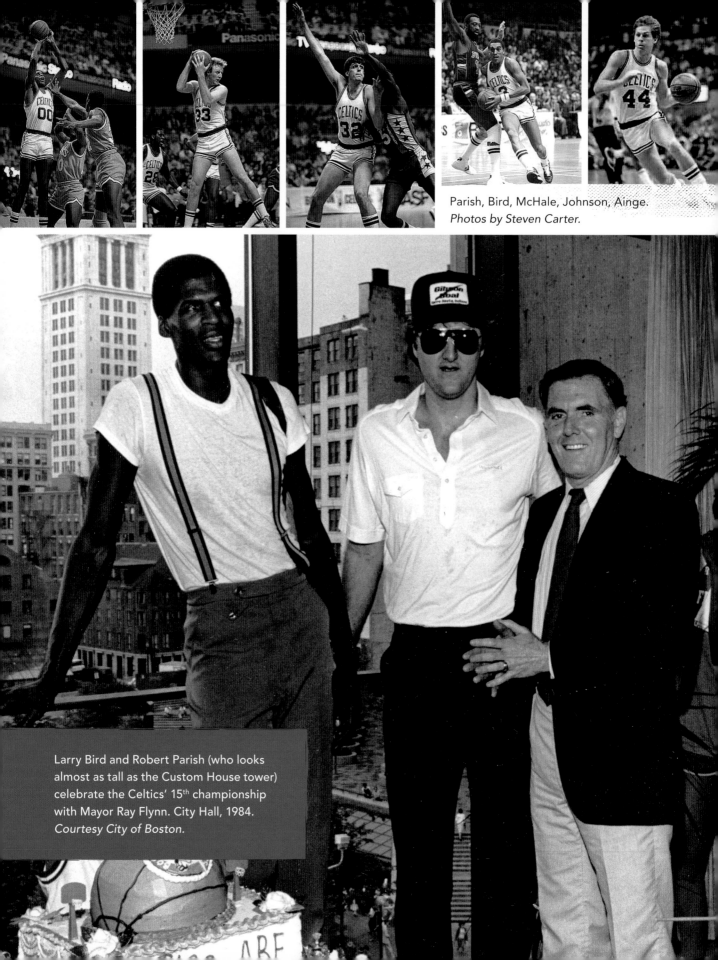

Parish, Bird, McHale, Johnson, Ainge.
Photos by Steven Carter.

Larry Bird and Robert Parish (who looks almost as tall as the Custom House tower) celebrate the Celtics' 15th championship with Mayor Ray Flynn. City Hall, 1984. *Courtesy City of Boston.*

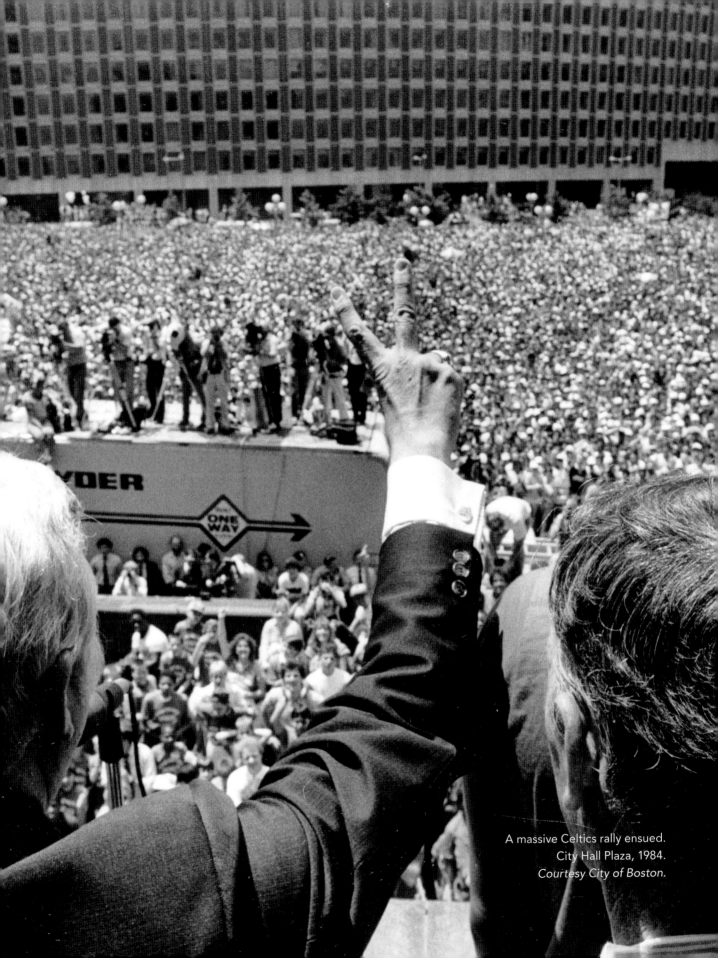

A massive Celtics rally ensued.
City Hall Plaza, 1984.
Courtesy City of Boston.

Celebrating Boston's Special Olympians. *Courtesy City of Boston.*

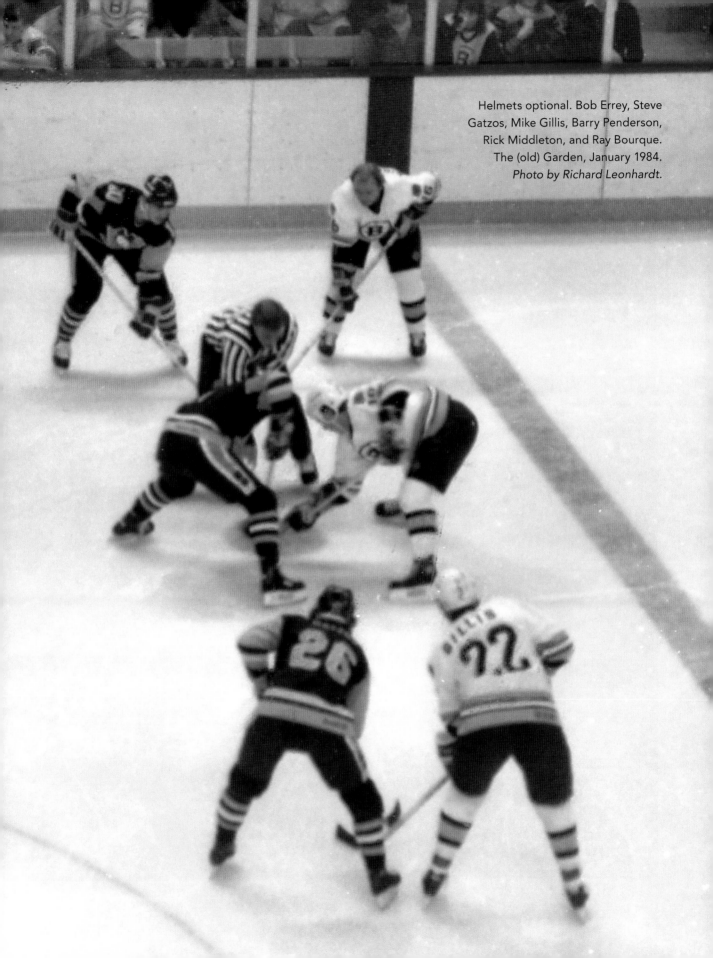

Helmets optional. Bob Errey, Steve Gatzos, Mike Gillis, Barry Penderson, Rick Middleton, and Ray Bourque. The (old) Garden, January 1984. *Photo by Richard Leonhardt.*

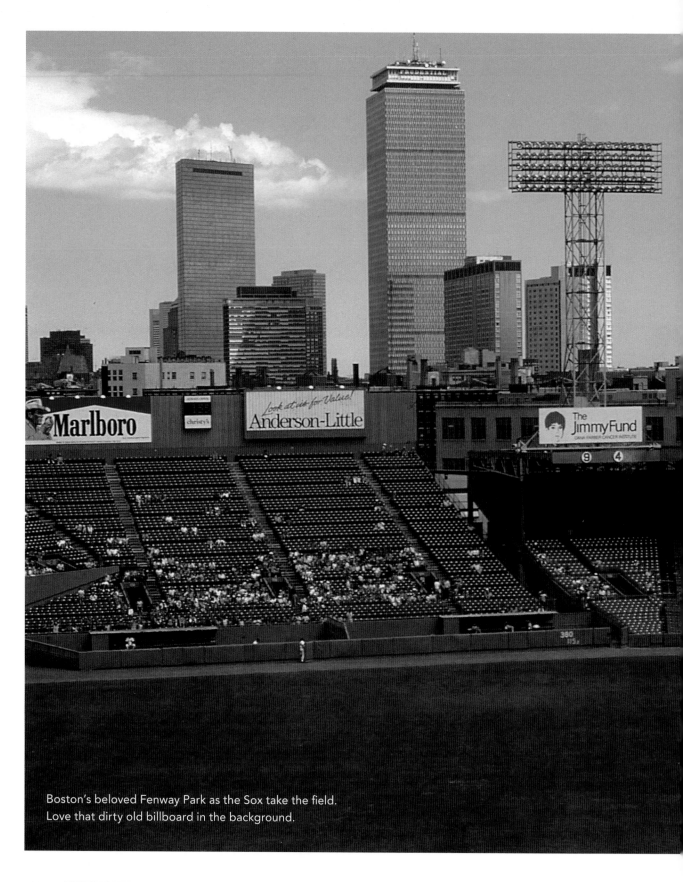

Boston's beloved Fenway Park as the Sox take the field.
Love that dirty old billboard in the background.

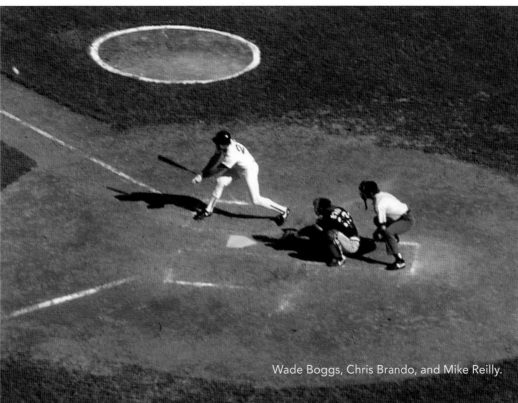

Wade Boggs, Chris Brando, and Mike Reilly.

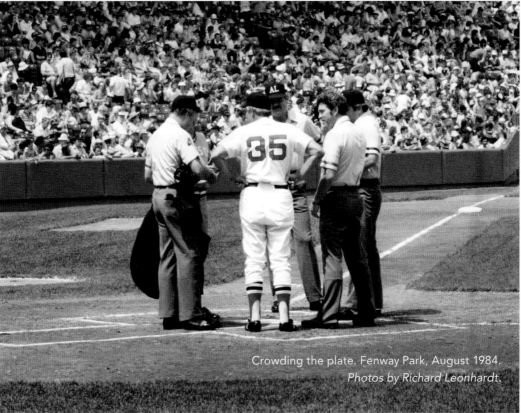

Crowding the plate. Fenway Park, August 1984.
Photos by Richard Leonhardt.

Woolworth's on Washington Street, mid-1980s. *Courtesy City of Boston.*

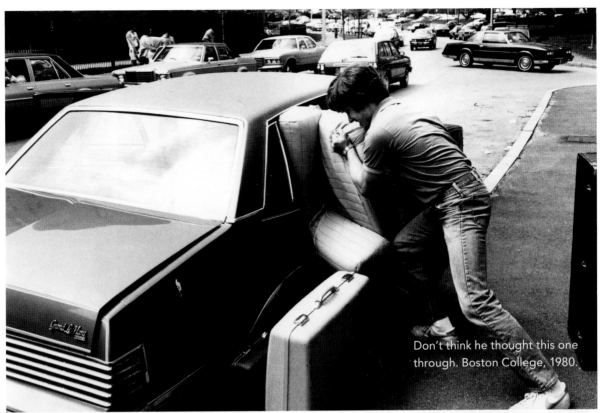

Don't think he thought this one through. Boston College, 1980.

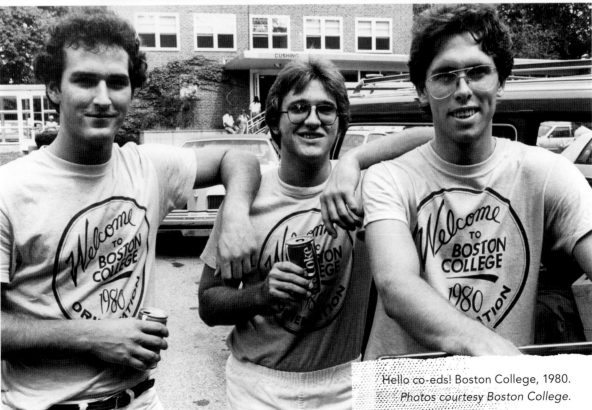

Hello co-eds! Boston College, 1980.
Photos courtesy Boston College.

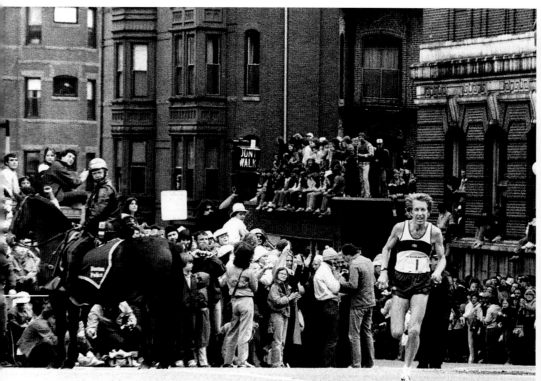

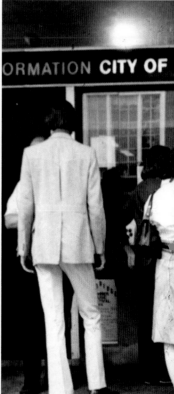

Billy Rodgers. Boston Marathon, 1981. *Photo by Matthew Muise.*

Soul food in the South End, early 1980s. *Courtesy City of Boston.*

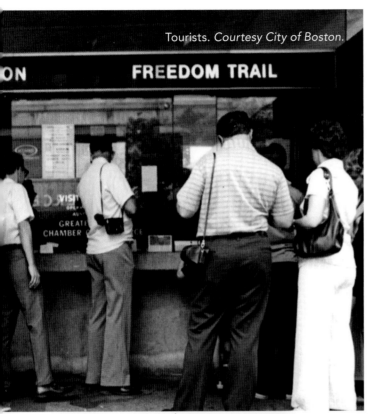
Tourists. *Courtesy City of Boston.*

FREEDOM TRAIL

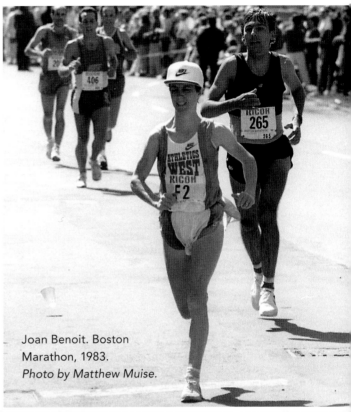
Joan Benoit. Boston Marathon, 1983.
Photo by Matthew Muise.

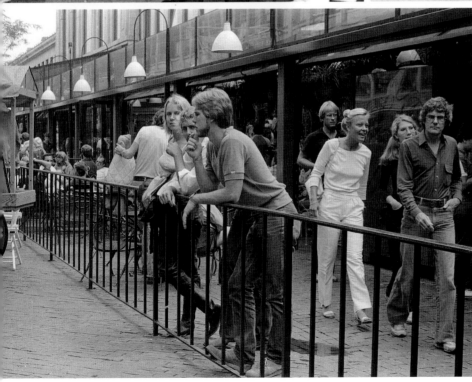
Kicking off the weekend. Quincy Market, 1984.
Photo by David deMilo.

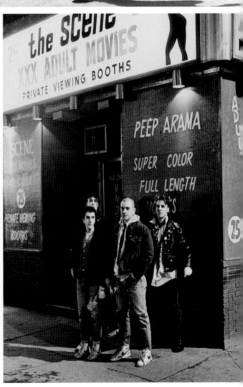
The Scene in the Zone.
Photo by Gail P. Rush.

*"**Once upon a time,** Digital Equipment Company (DEC) had its own fleet of helicopters that connected Boston's Logan Airport with DEC's campuses near Maynard about thirty miles west of Boston. It was often possible for visitors to get a seat on one of these flights, which were particularly desirable in the late afternoon and in the fall. This photo was taken from one of those helicopters over Boston Harbor. Since there was a plexiglass window between the city and me, the photo isn't as sharp as one might want. But it's still easy to make out the Charles River, the Hancock Tower, the Prudential Center, Faneuil Hall, Government Center, and more."* – Tony Wasserman

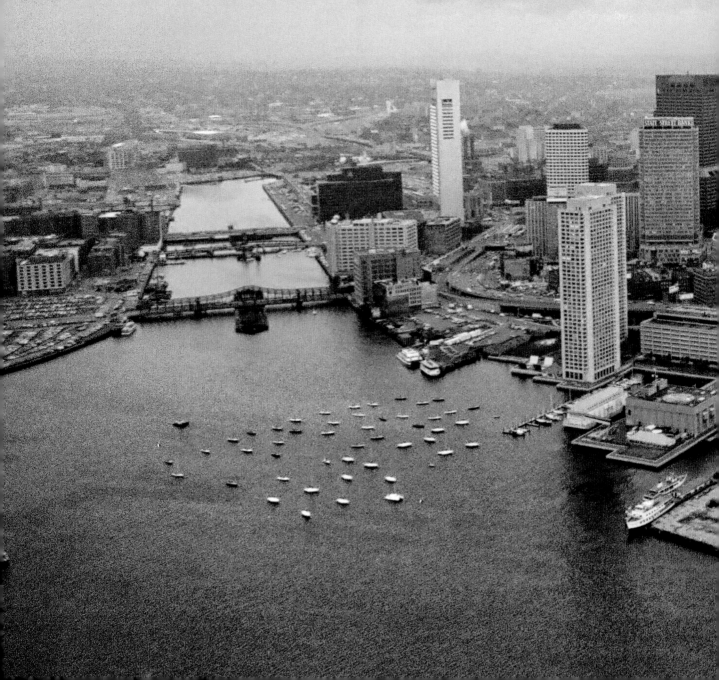

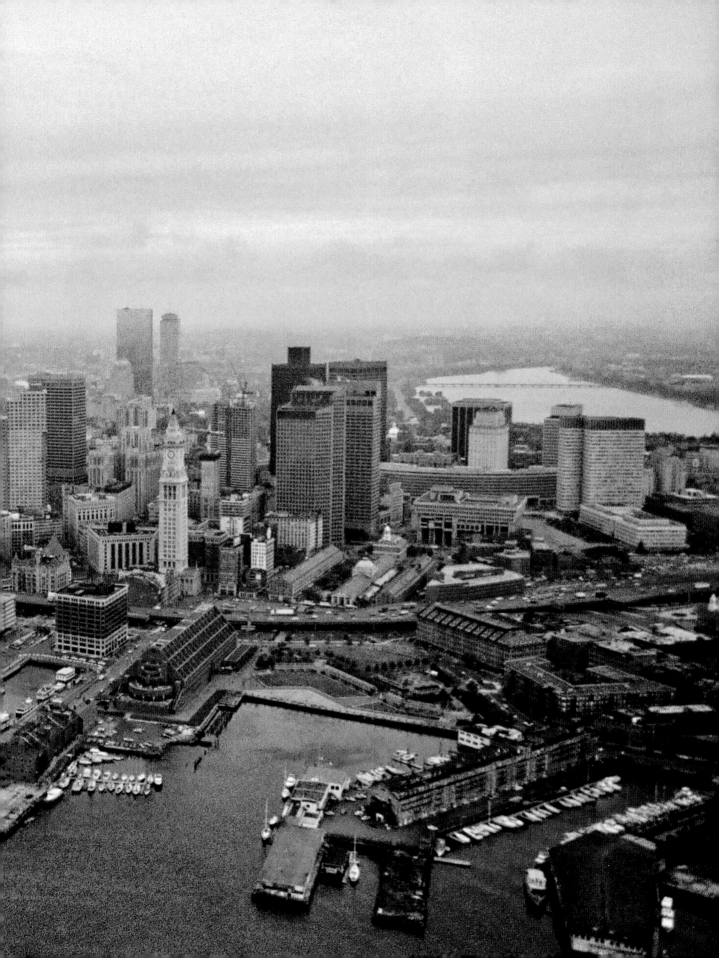

John Kerry running for Senate in 1984.

Ray does Roslindale, mid-1980s.

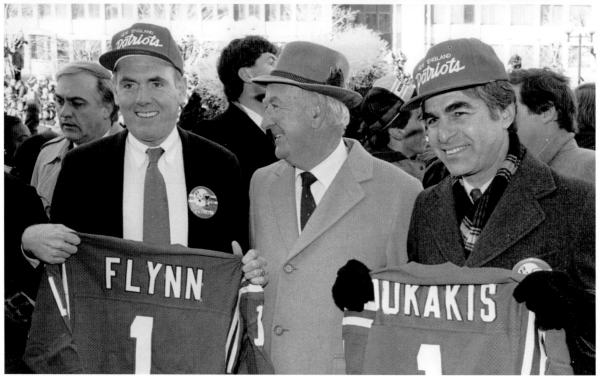

Go Pats! Mayor Ray Flynn, Patriots owner and founder Bill Sullivan, and Governor Dukakis, mid-1980s. *Photos courtesy City of Boston.*

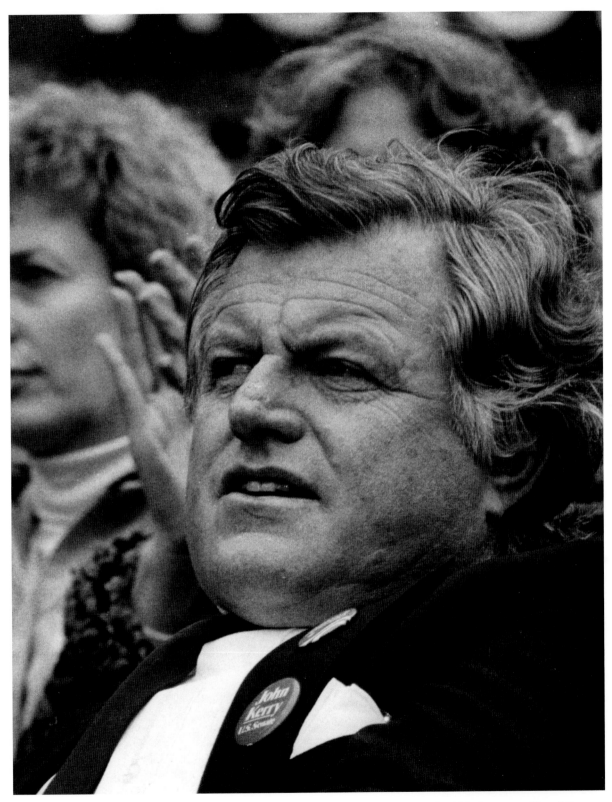

Ted, 1984. *Courtesy City of Boston.*

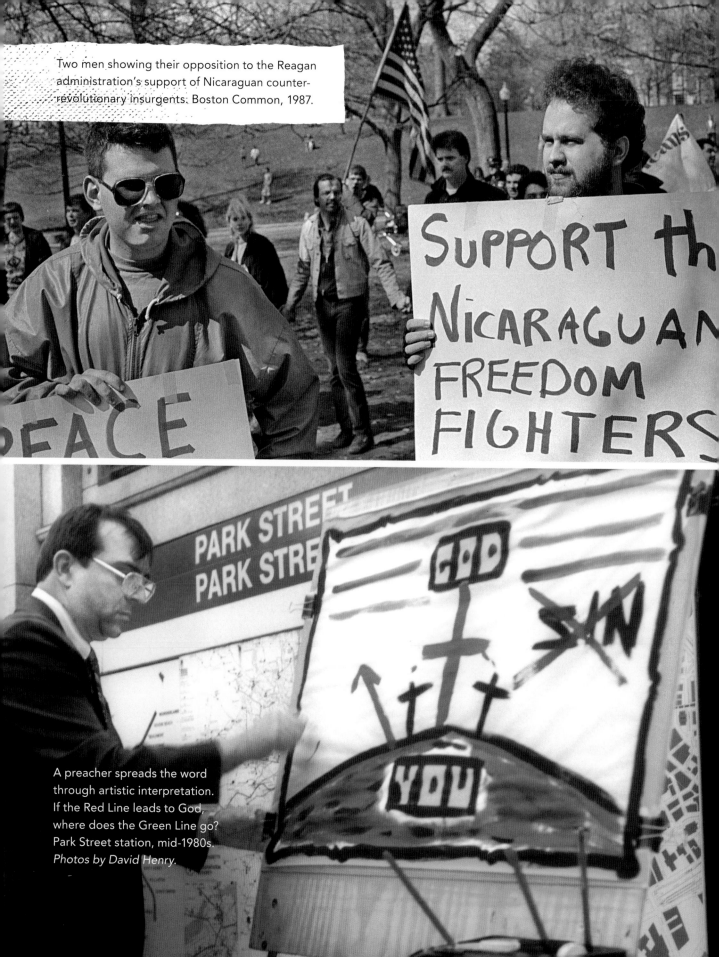

Two men showing their opposition to the Reagan administration's support of Nicaraguan counter-revolutionary insurgents. Boston Common, 1987.

A preacher spreads the word through artistic interpretation. If the Red Line leads to God, where does the Green Line go? Park Street station, mid-1980s. *Photos by David Henry.*

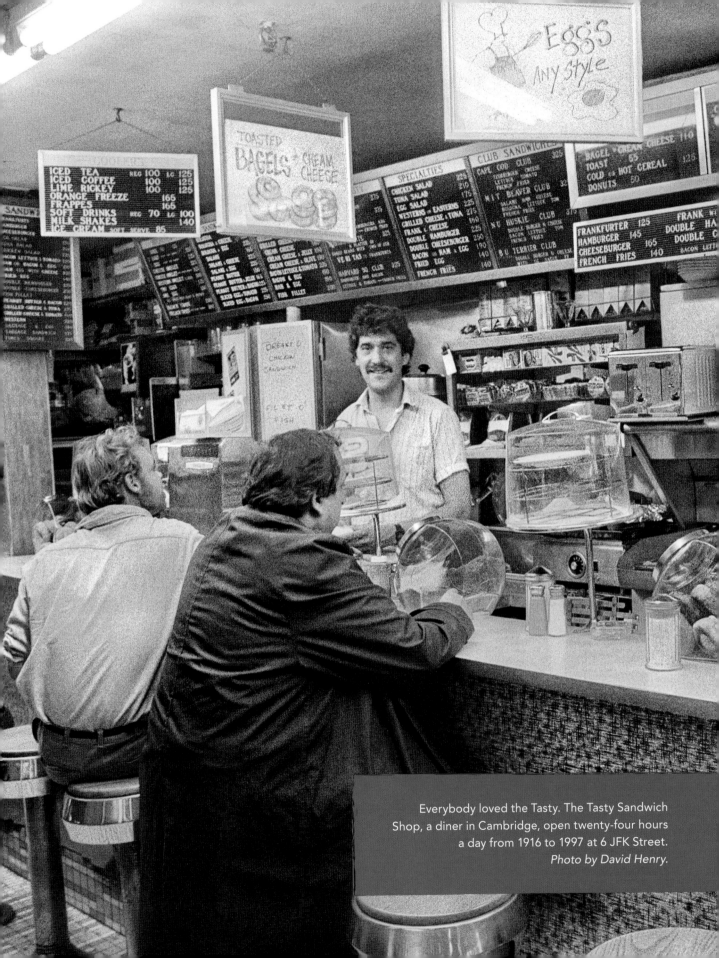

Everybody loved the Tasty. The Tasty Sandwich Shop, a diner in Cambridge, open twenty-four hours a day from 1916 to 1997 at 6 JFK Street. *Photo by David Henry.*

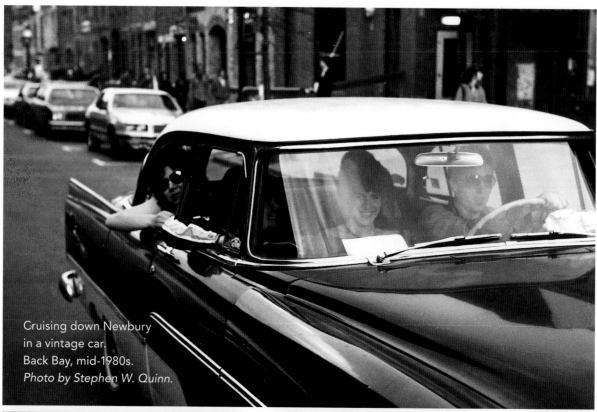

Cruising down Newbury
in a vintage car.
Back Bay, mid-1980s.
Photo by Stephen W. Quinn.

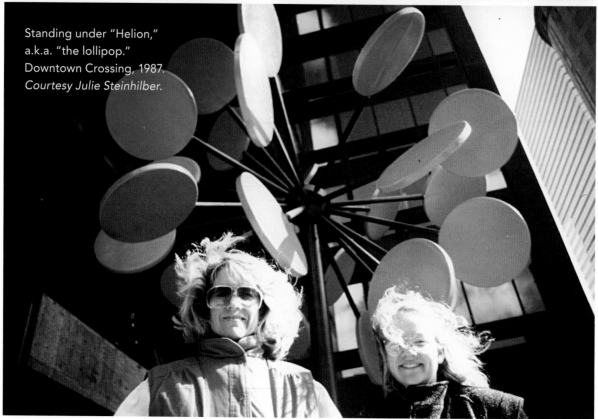

Standing under "Helion,"
a.k.a. "the lollipop."
Downtown Crossing, 1987.
Courtesy Julie Steinhilber.

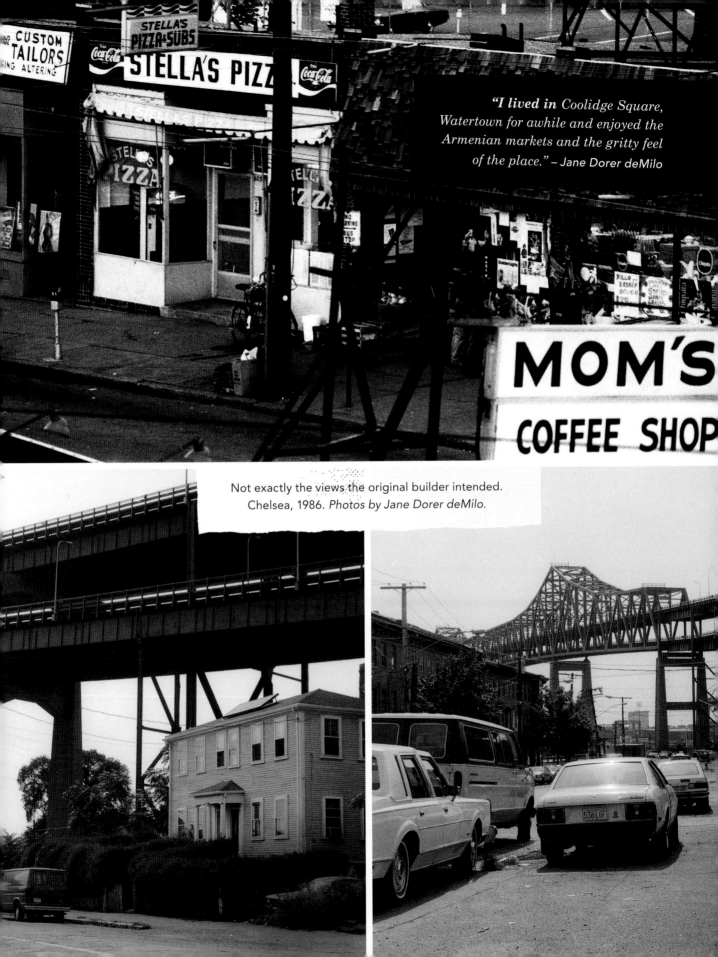

"*I lived in* Coolidge Square, *Watertown for awhile and enjoyed the Armenian markets and the gritty feel of the place.*" – Jane Dorer deMilo

Not exactly the views the original builder intended. Chelsea, 1986. *Photos by Jane Dorer deMilo.*

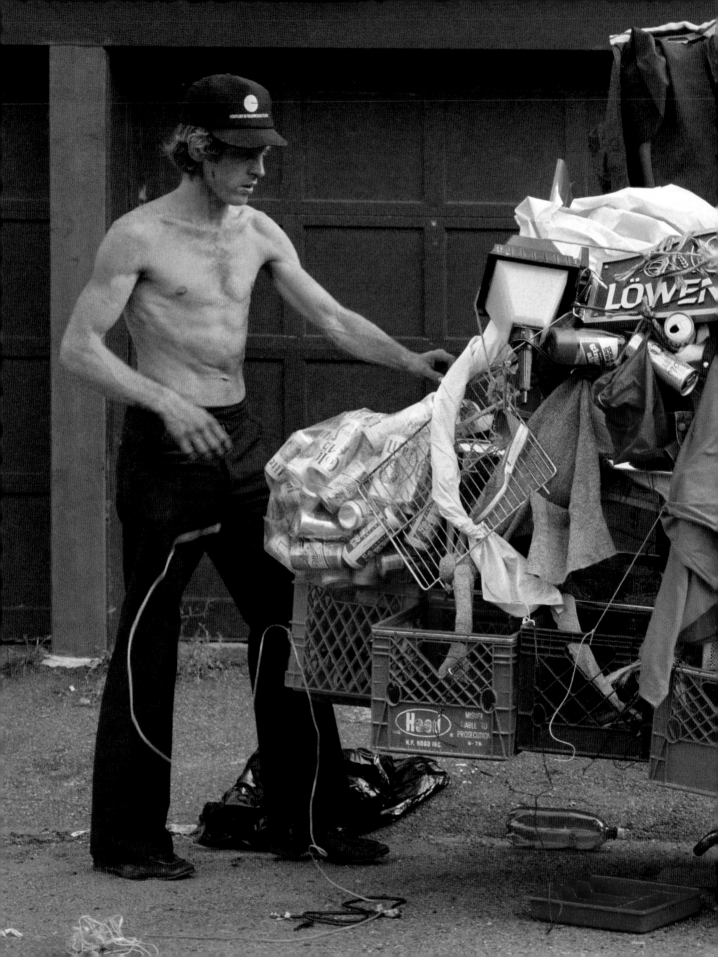

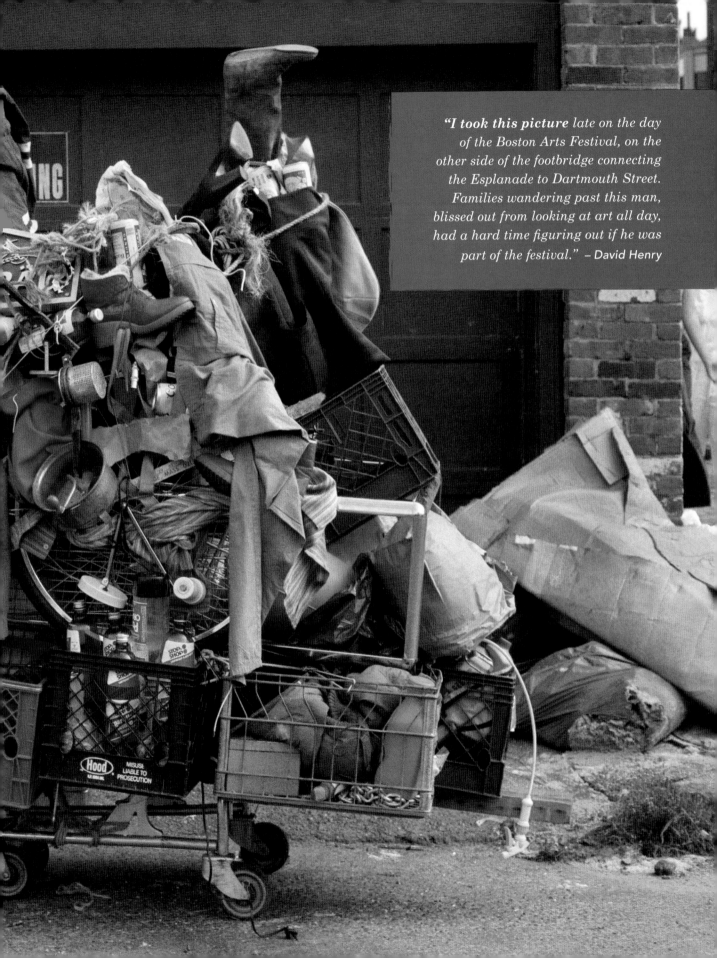

"I took this picture late on the day of the Boston Arts Festival, on the other side of the footbridge connecting the Esplanade to Dartmouth Street. Families wandering past this man, blissed out from looking at art all day, had a hard time figuring out if he was part of the festival." – David Henry

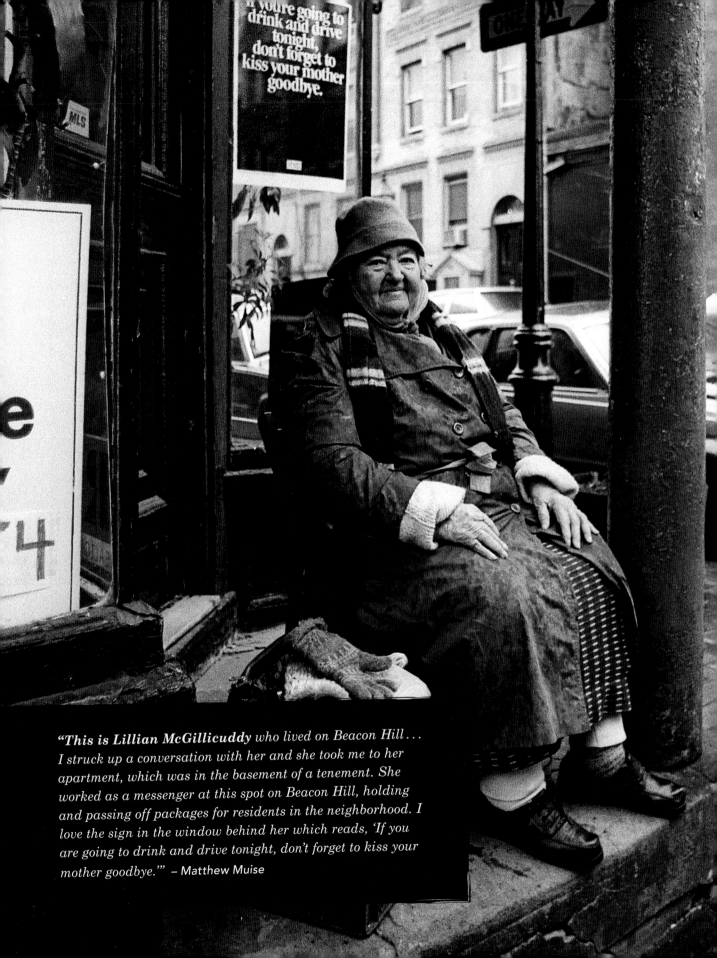

"**This is Lillian McGillicuddy** who lived on Beacon Hill . . . I struck up a conversation with her and she took me to her apartment, which was in the basement of a tenement. She worked as a messenger at this spot on Beacon Hill, holding and passing off packages for residents in the neighborhood. I love the sign in the window behind her which reads, 'If you are going to drink and drive tonight, don't forget to kiss your mother goodbye.'" – Matthew Muise

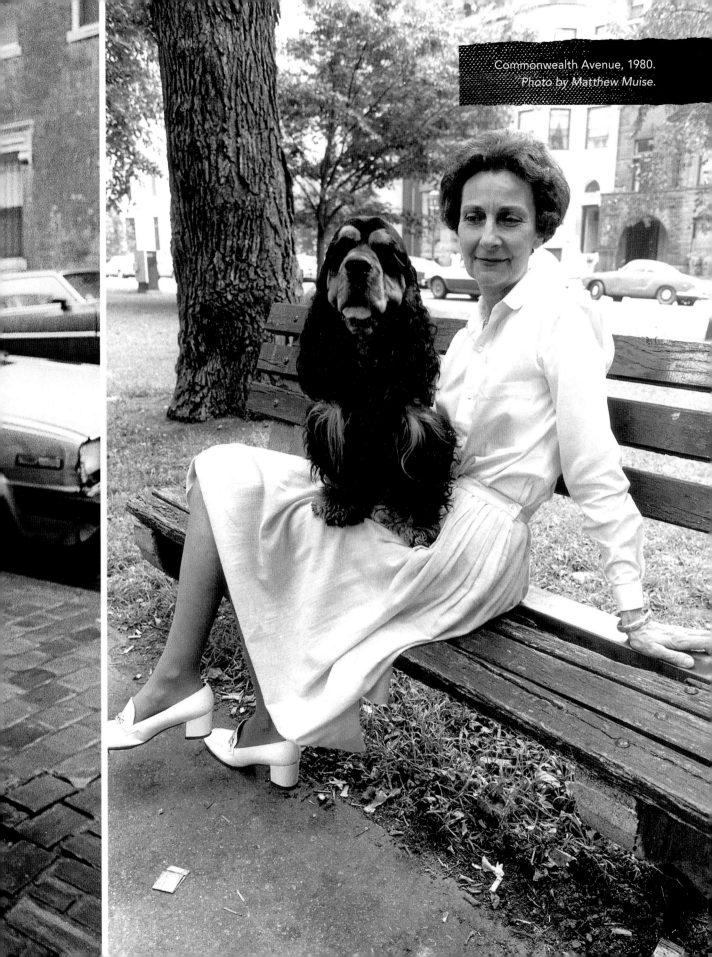

Commonwealth Avenue, 1980.
Photo by Matthew Muise.

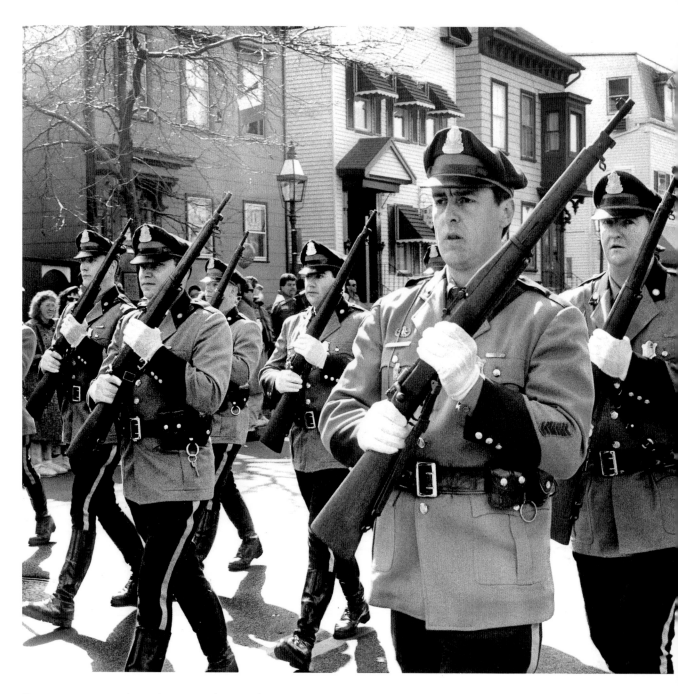

State troopers marching down Broadway in the St. Patrick's Day parade. South Boston, 1987. *Photo by David Henry.*

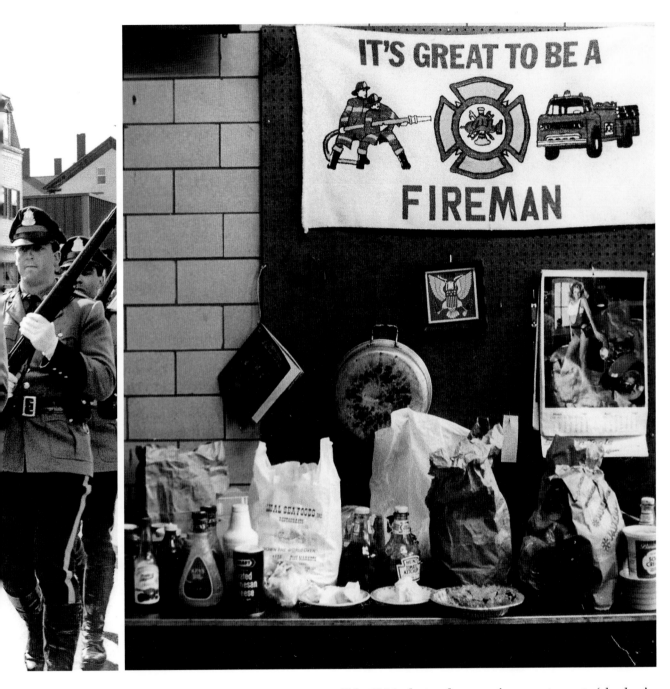

"My 1984 photo class assignment was to 'shadow' a fire station for a semester. This was taken in the kitchen of Division 1 Headquarters, where Engine 10, Tower Unit 3, and Rescue Unit 1 were based."

– Joanne Bissetta

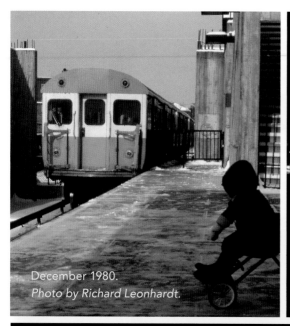

December 1980.
Photo by Richard Leonhardt.

From Green Street station into Ruggiero's.
Jamaica Plain, 1987. *Photo by Christopher Lovett.*

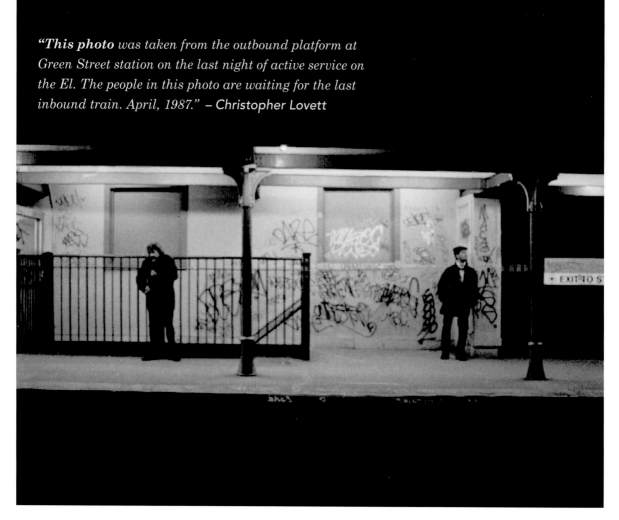

"This photo was taken from the outbound platform at
Green Street station on the last night of active service on
the El. The people in this photo are waiting for the last
inbound train. April, 1987."* – Christopher Lovett*

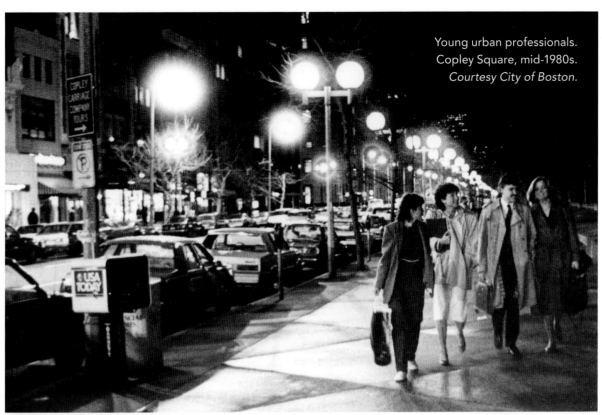

Young urban professionals.
Copley Square, mid-1980s.
Courtesy City of Boston.

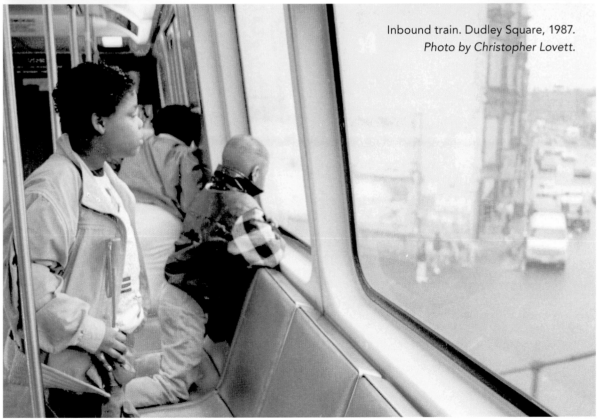

Inbound train. Dudley Square, 1987.
Photo by Christopher Lovett.

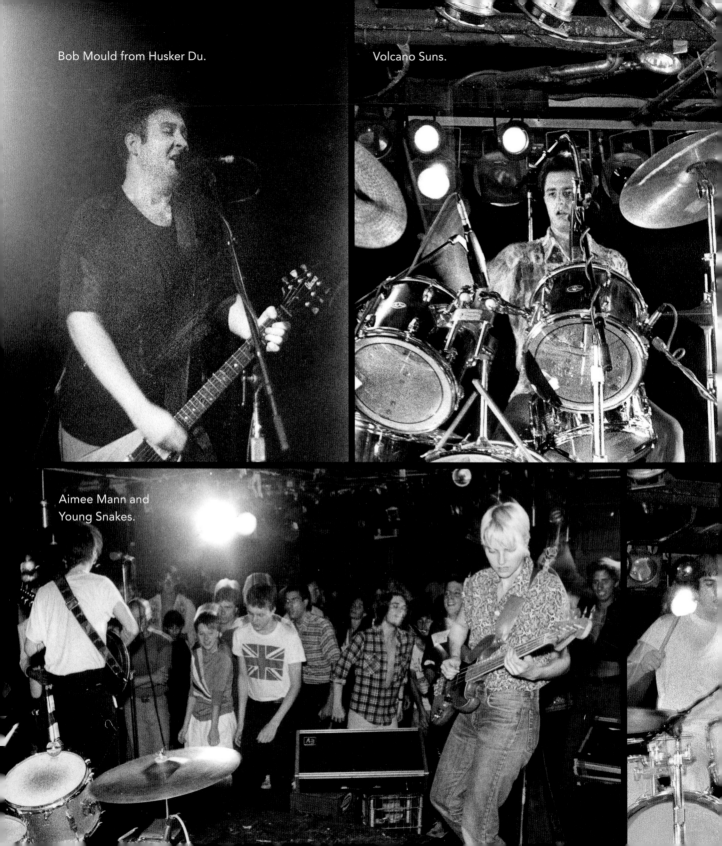

Bob Mould from Husker Du.

Volcano Suns.

Aimee Mann and Young Snakes.

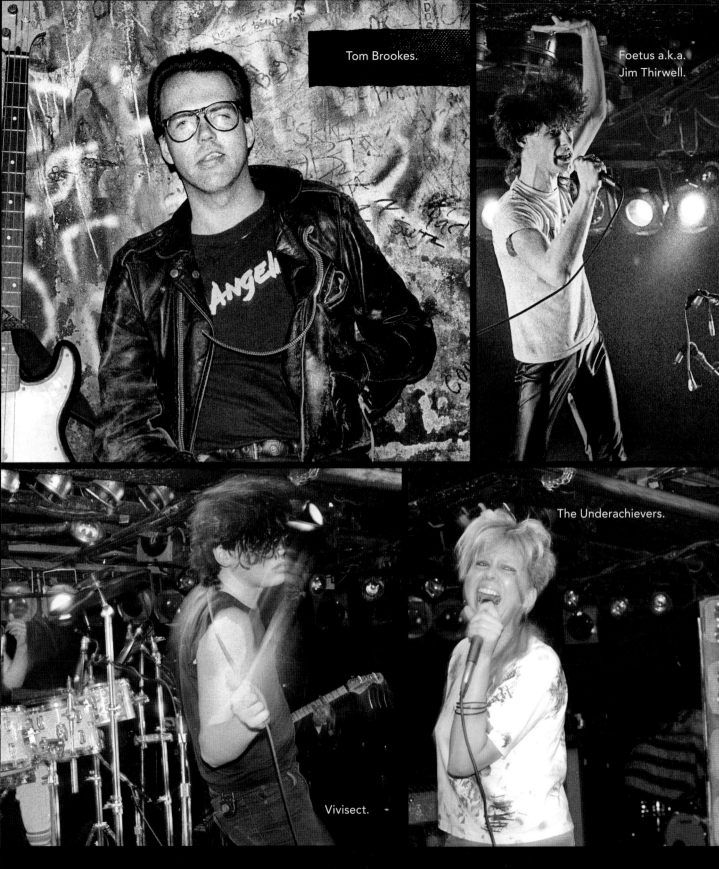

Tom Brookes.

Foetus a.k.a. Jim Thirwell.

The Underachievers.

Vivisect.

The Rat, 1982-85. *Photos by David Henry.*

Wall at the Underground Club. Packard's Corner, Allston, 1983. *Photo by Gail P. Rush.*

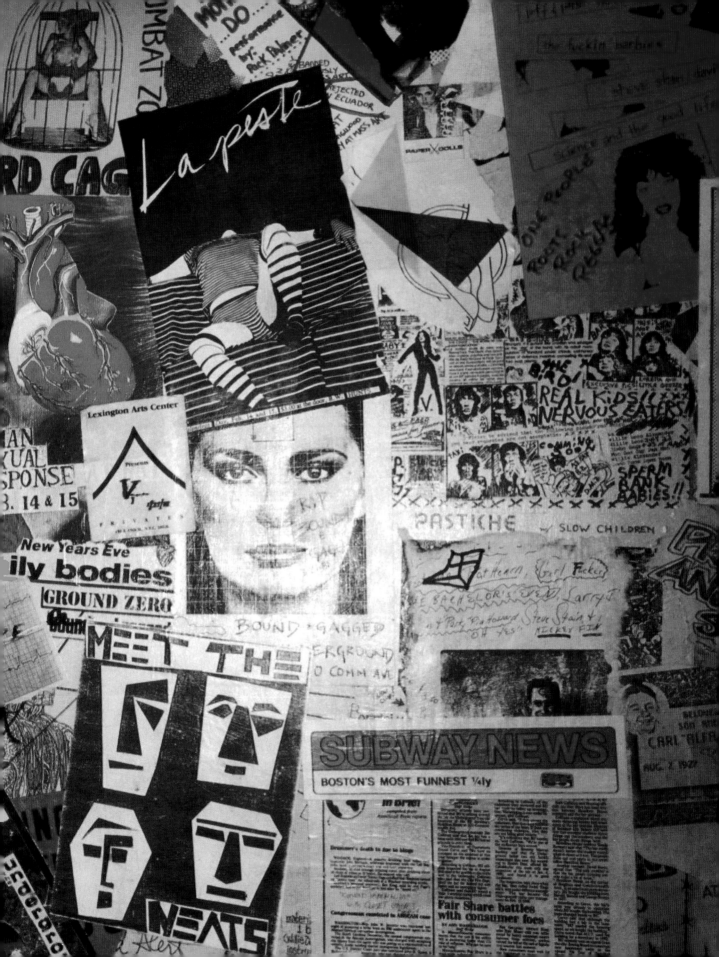

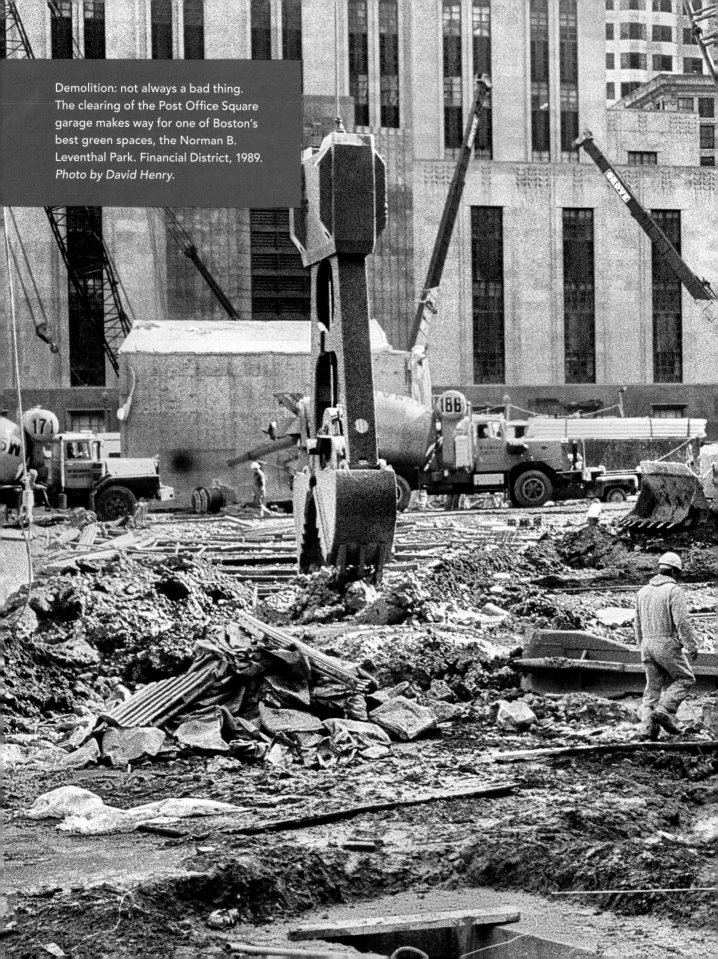

Demolition: not always a bad thing. The clearing of the Post Office Square garage makes way for one of Boston's best green spaces, the Norman B. Leventhal Park. Financial District, 1989. *Photo by David Henry.*

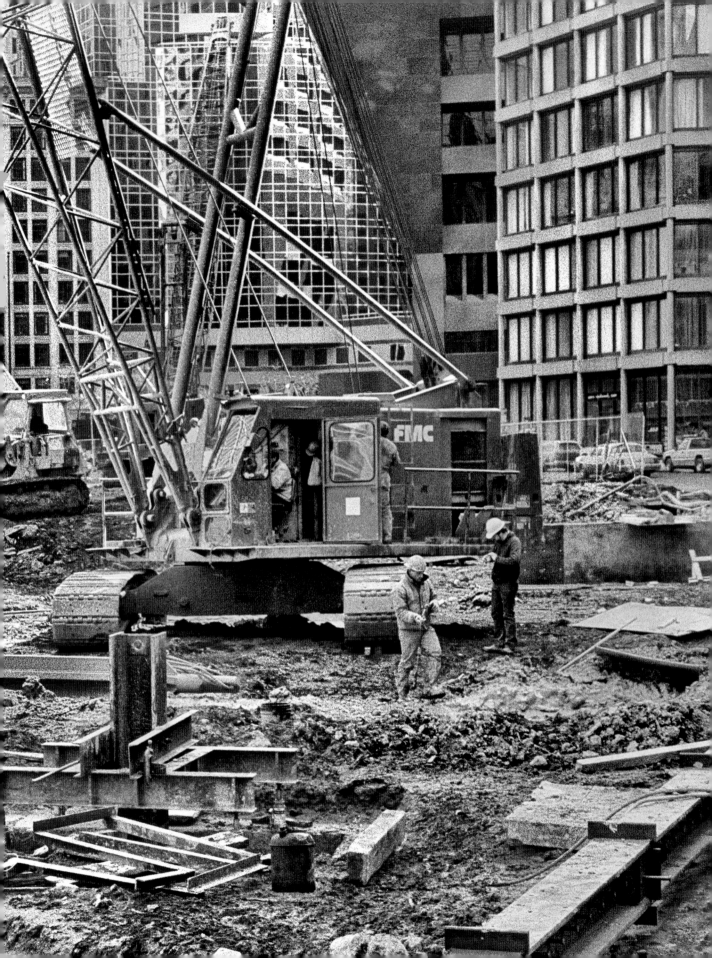

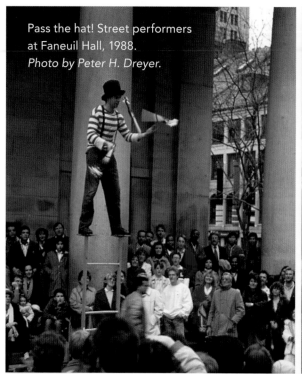

Pass the hat! Street performers at Faneuil Hall, 1988. *Photo by Peter H. Dreyer.*

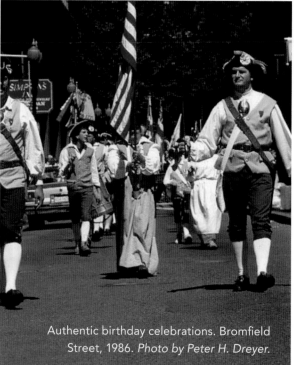

Authentic birthday celebrations. Bromfield Street, 1986. *Photo by Peter H. Dreyer.*

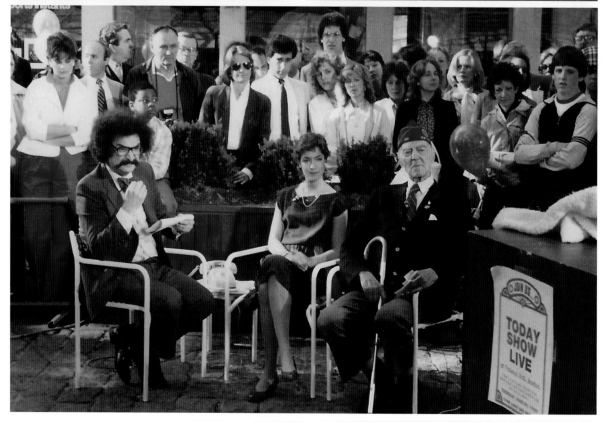

Gene Shalit and his haircut broadcast "The Today Show" live from Quincy Market, 1983. *Photo by Richard Leonhardt.*

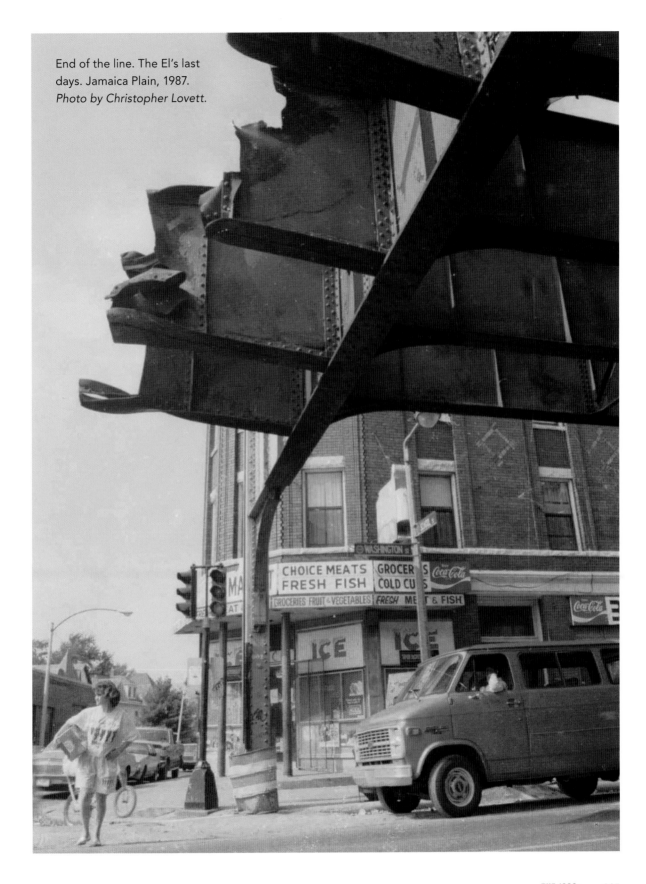

End of the line. The El's last days. Jamaica Plain, 1987.
Photo by Christopher Lovett.

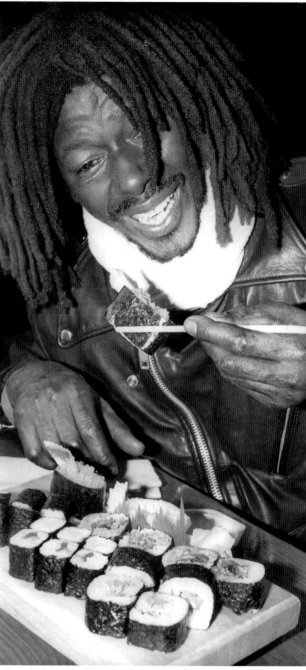

Many dream of reaching Xanadu, but Xanna Don't. Miss Xanna Don't, posing with a Rolls Royce in front of Lafayette Mall in Downtown Crossing, 1989. She spent ten years in Boston as a country singer before relocating to Austin.

Harold Madison, Jr., popularly known as "Mr. Butch," was a well-known public figure in Kenmore Square, and then in Allston, until his death in a scooter accident on July 12, 2007. Pictured here in Kenmore, 1987. *Photos by David Henry.*

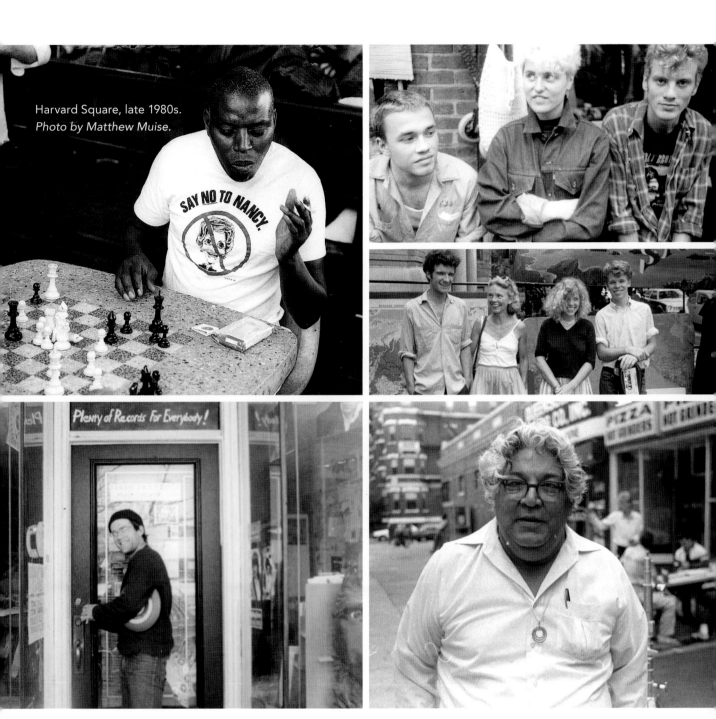

Harvard Square, late 1980s.
Photo by Matthew Muise.

Closing up shop. In Your Ear Records, Allston,
early 1980s. *Courtesy Reed Lappin.*

Above: Faces of the Fenway at Store 54,
early 1980s. *Photos by Wayne Valdez.*

Quincy Market, 1987. *Photo by Jack Boucher.*

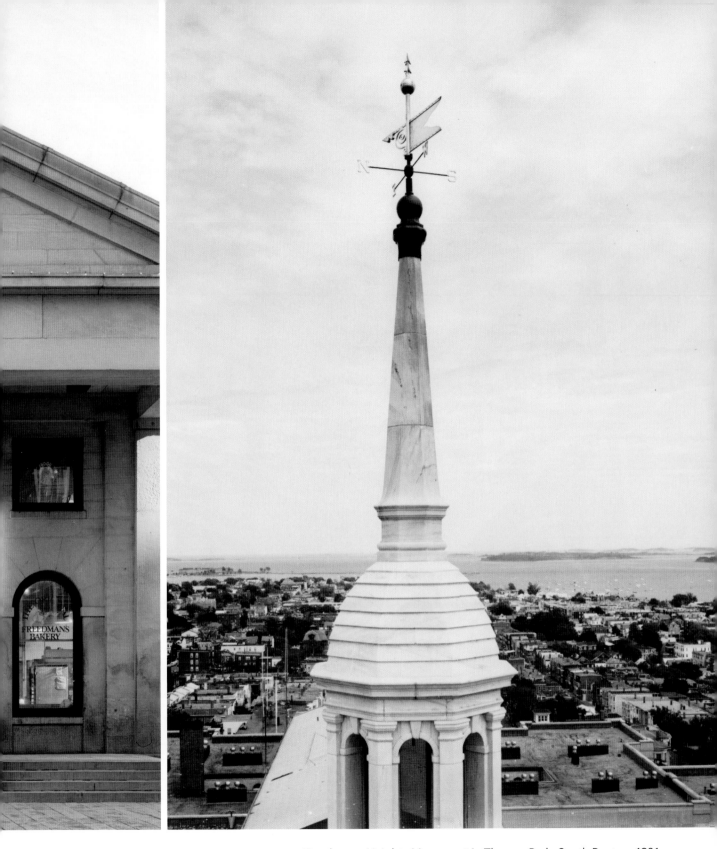

Dorchester Heights Monument in Thomas Park. South Boston, 1981.
Courtesy Library of Congress.

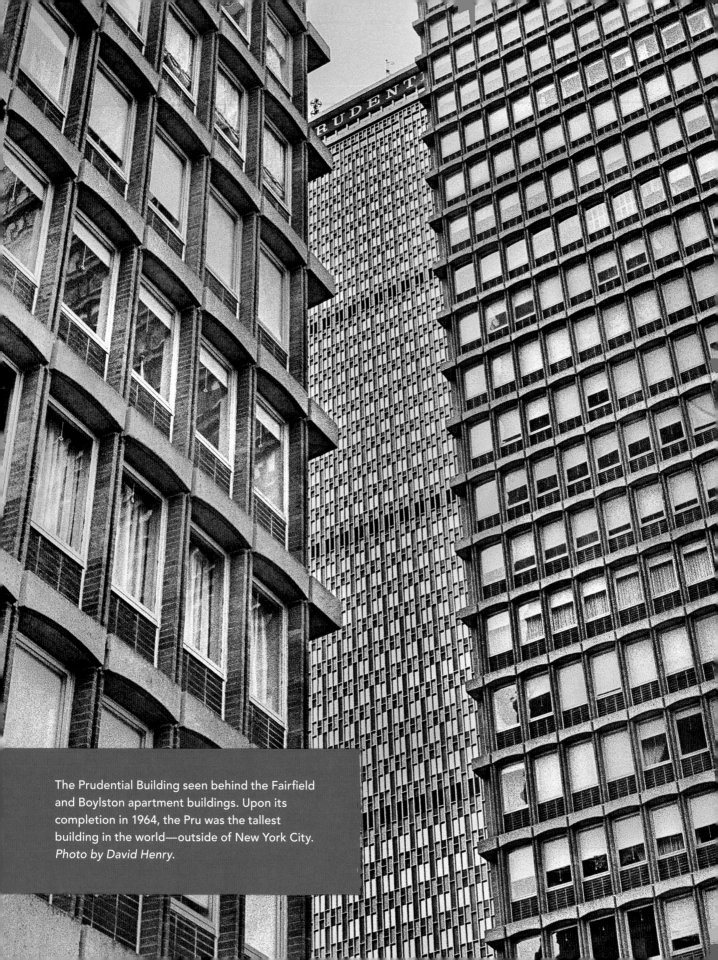

The Prudential Building seen behind the Fairfield and Boylston apartment buildings. Upon its completion in 1964, the Pru was the tallest building in the world—outside of New York City. *Photo by David Henry.*

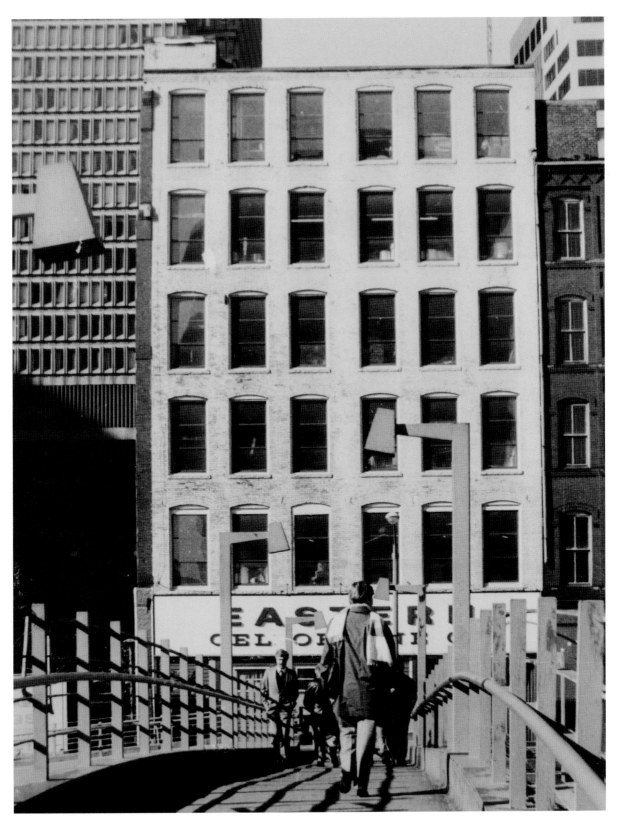

Purchase Street pedestrian bridge. *Photo by Robert Bayard Severy.*

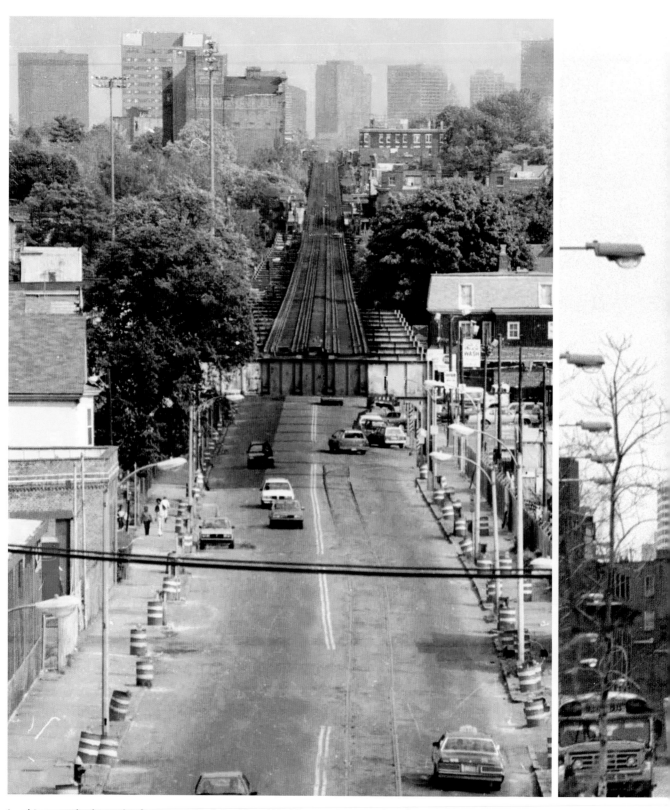

Looking north along the former path of the El on Washington Street, taken from the Casey overpass. Jamaica Plain, 1987. *Photo by Christopher Lovett.*

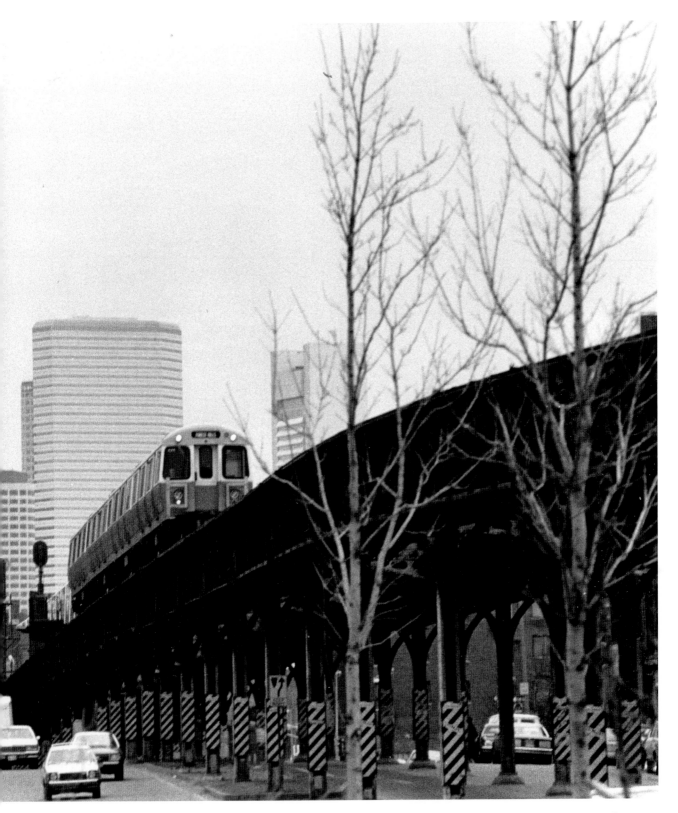

Courtesy City of Boston.

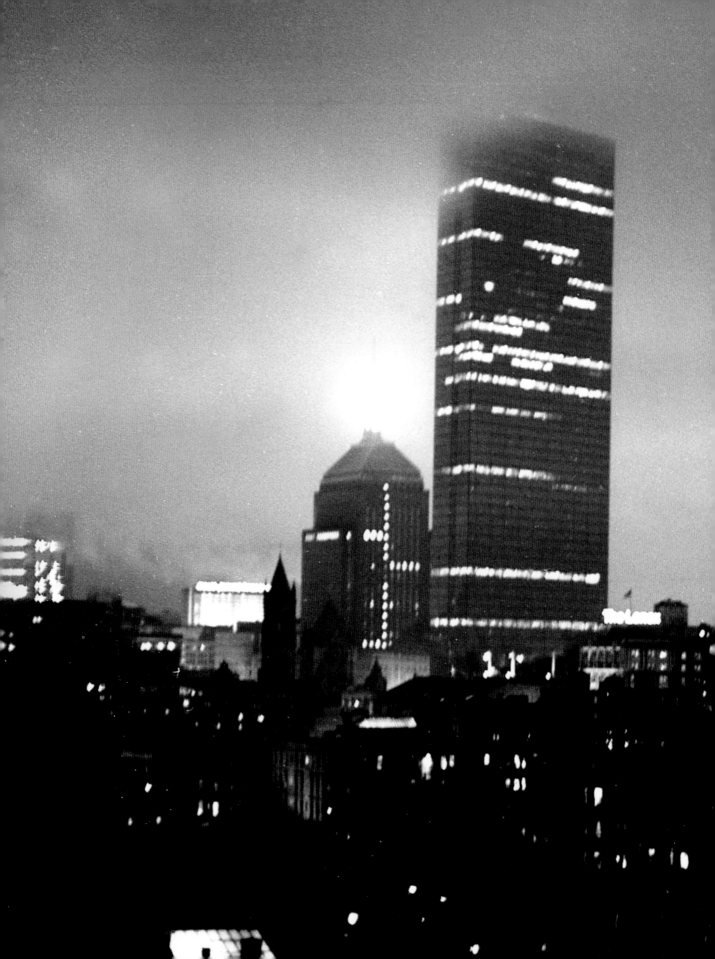

*"**I took this photo** when I was a student of photography at the Museum School of Fine Arts. The year was 1982. At the time I lived in the international dorm on Comm Ave., which had a spectacular view of downtown. Many tall high-rises had yet to be built. That is the old school skyline. I stood out on a small overhang outside my window, and, on a foggy March evening, took this shot with a 2 ¼ Mamiya medium format camera."*

– Elizabeth Budington

PUBLISHER'S NOTE

As Jim writes in his introduction, the images in this book came from numerous and varied sources. A great deal came to us via Jim's Facebook page solicitations—snapshots and memorabilia previously preserved in family albums. While it's remarkable to many of these folks that their photos have merit beyond their own family story, anyone who follows the Dirty Old Boston Facebook page knows it's often the most seemingly ordinary image that becomes the most remarkable. We are grateful for each and every submission we received during this project, and we thank these people for sharing their stories and recollections of Boston's past with us.

We sourced ample images from the collections of some of Boston's most prolific photographers, among them Charles Frani, Nick DeWolf, and Leslie Jones, whose bodies of work prove again and again that what has always made Boston such an exceptional place is the people. Photographers such as Chris Considine, Richard Leonhardt, Matthew Muise, Jack Leonard, David Godlis, David deMilo, Jane Dorer deMilo, David Henry, Gail P. Rush, Stephen W. Quinn, A.J. Sullivan, Steven Carter, and the late Ed O'Connell and Michael Rizza, generously submitted exquisite photos that helped us tell this story. There are too many individual photographers to mention here; suffice it to say, when asked, they delivered—often a deluge of wonderful, evocative moments.

We turned to images in the public domain as well. The National Archives, Massachusetts State Archives, the City of Boston Archives, and the Library of Congress proved invaluable, as was Boston's phenomenal network of historical societies, museums, and academic libraries, including the Bostonian Society, the Boston Preservation Alliance, and the South End Historical Society. If there is one thing to take away from this book, it is that every Bostonian should visit the West End Museum, where curator Duane Lucia provides a cogent and affecting message about the human cost of urban renewal.

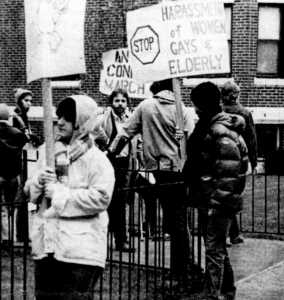

Luckily for the public, many of these institutions have made gallant efforts to digitize their collections; at the time of publication, however, a large amount still remain in boxes on racks in archives. We are happy that we were able to unearth photos that most of the public has yet to see. We can't thank enough the archivists who assisted Jim and the staff of Union Park Press in this process, in particular Marta Crilly at the City of Boston Archives and Jennifer Fauxsmith at Massachusetts State Archives. We are also indebted to Jane Winton and her staff at the Boston Public Library.

Our goal with this collection of images was to create a balanced but by no means exhaustive record. For many who lived through this era in the city of Boston, it was nothing short of revolutionary. From a so-called backwater in the post-war years to an unrecognizable landscape and the promise of a "New" Boston; from tight-knit, ethnic neighborhoods to the tumult of racial tension and compulsory busing; from the shuttering of historic burlesque theaters in Scollay Square to the city-sanctioned Combat Zone, Boston changed rapidly, without apology, for better and for worse, and in many ways forever.

The cost of "progress" is in no way unique to Boston, but it does seem that in a city with such an important role in the nation's history, Boston has dealt with progress in its own way. The Sox kept losing but we kept cheering, neighborhoods transformed but residents kept organizing, Logan expanded and the Central Artery congested… but the people of Boston soldiered on. For those who seek to understand the origins of what makes Boston so extraordinary, so persistent, so *strong*, they will find it amidst these pages.

Nicole Vecchiotti
Publisher, UNION PARK PRESS

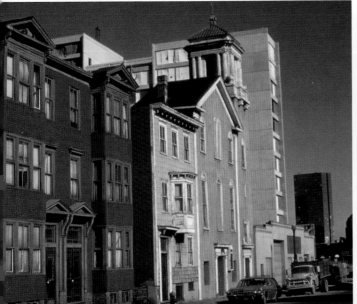
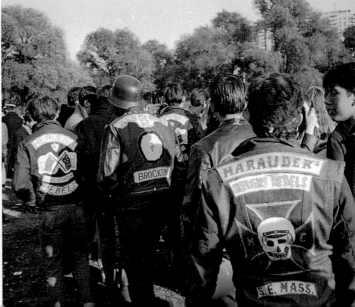

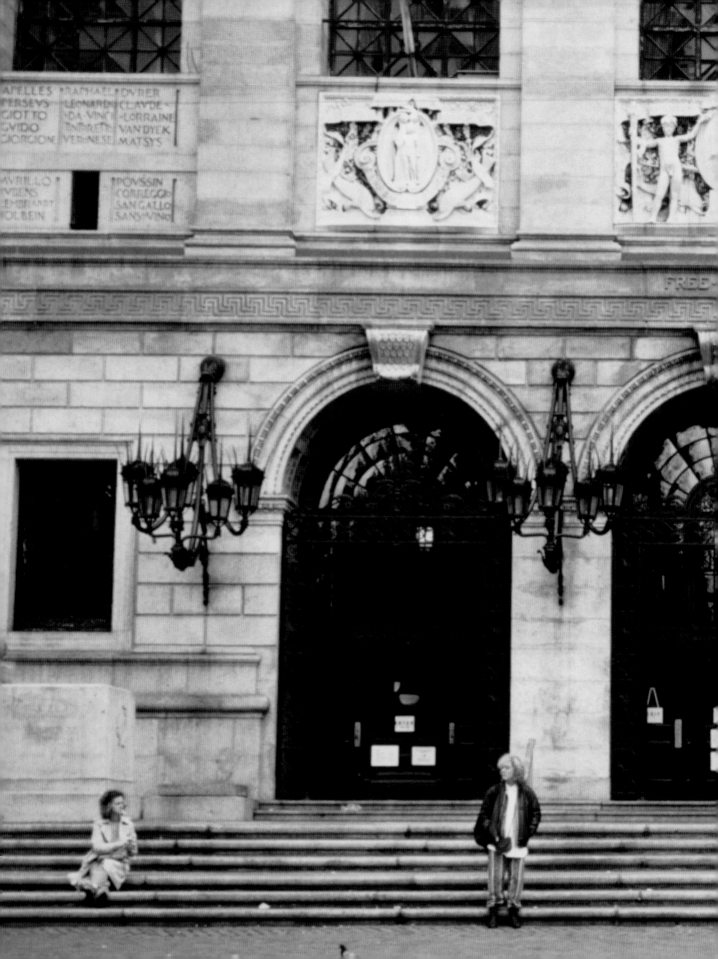

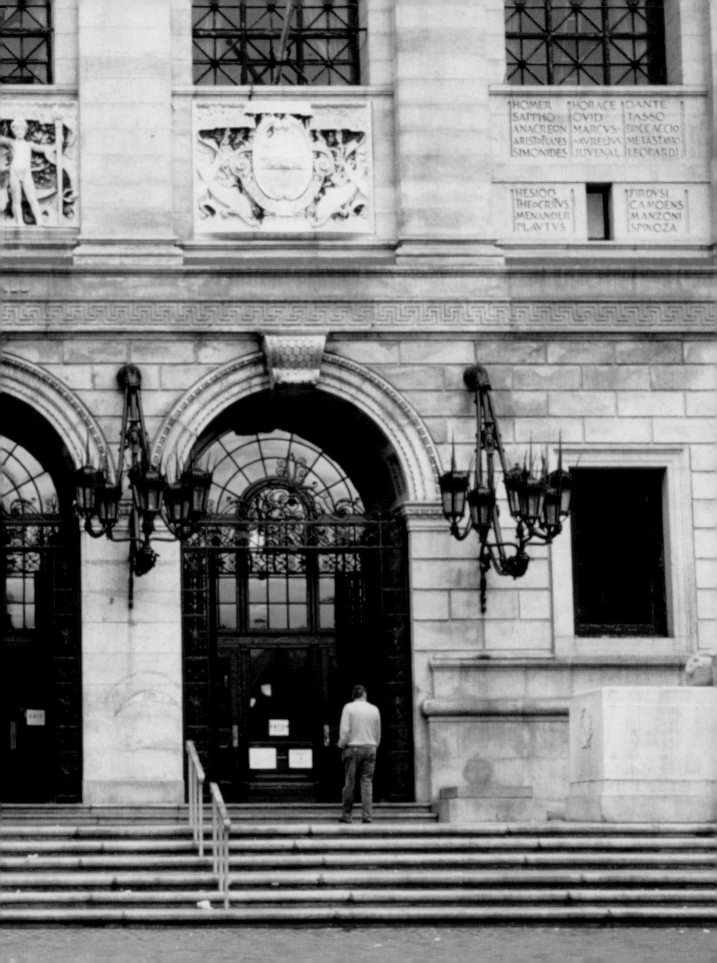

SOURCES

Photo credits are attributed in the text of the book. However, in some instances various institutions and individual photographers requested that additional information be supplied.

Front Matter

Page ii: Photo by Matthew Muise.

Pages iv-v: Photo by Jack Leonhardt.

Pages vi-vii: Mass State Archives. Transportation/ Construction, Public Works and Highway Construction Division, Contract Photographs. Box 1, J.F. Fitzgerald Expressway Construction, Contract C-1, #53, October 8, 1953.

Page viii: Courtesy National Archives and Records Administration.

Page x:
(First row, upper left) Charles Frani Photo Courtesy of the West End Museum; (First row, lower left) Photo by Frank Inserra; (First row, center) Photo by Matthew Muise; (First row, right) Courtesy City of Boston.
(Second row, left) Charles Frani Photo Courtesy of the West End Museum; (Second row, center top) Courtesy Nancy Tella; (Second row, center bottom) Photo by David deMilo; (Second row, right) Photo by Matthew Muise.
(Third row, left) Peter H. Dreyer slide collection, Collection #9800.007, City of Boston Archives; (Third row, center top) Photo by Steven Carter; (Third row, center bottom) Mass State Archives. Transportation/ Construction, Public Works and Highway Construction Division, Contract Photographs. Box 1, J.F. Fitzgerald Expressway Construction, Contract C-1, #53, October 8, 1953; (Third row, top right) Courtesy Robert Ketcherside; (Third row, right bottom) Courtesy Northeastern University, Archives and Special Collections Department.

Pages xii-xiii: Mayor John F. Collins records, Collection #0244.001, City of Boston Archives.

The 1940s & 1950s

Pages 4-5: Urban Redevelopment Division, Boston Housing Authority photographs in Boston Redevelopment Authority photographs, Collection # 4010.001, City of Boston Archives.

Page 6: Urban Redevelopment Division, Boston Housing Authority photographs in Boston Redevelopment Authority photographs, Collection # 5110.002, City of Boston Archives.
Page 7: Urban Redevelopment Division, Boston Housing Authority photographs in Boston Redevelopment Authority photographs, Collection # 5110.002, City of Boston Archives.
Pages 8-9: Courtesy of the Boston Public Library, Leslie Jones Collection.

Page 11: (Top and bottom) Urban Redevelopment Division, Boston Housing Authority photographs in Boston Redevelopment Authority photographs, Collection # 5110.002, City of Boston Archives.

Page 12: (Bottom right) Courtesy National Archives and Records Administration.

Page 14: (Top and bottom) Urban Redevelopment Division, Boston Housing Authority photographs in Boston Redevelopment Authority photographs, Collection # 5110.002, City of Boston Archives.

Page 15: (Top) Urban Redevelopment Division, Boston Housing Authority photographs in Boston Redevelopment Authority photographs, Collection # 5110.002, City of Boston Archives; (Bottom) Courtesy Massachusetts State Archives.

Page 16: (Bottom) © the Nick DeWolf Foundation.

Page 20: (Top) Mass State Archives. Transportation/ Construction, Public Works and Highway Construction Division, Contract Photographs. Box 1, J.F. Fitzgerald Expressway Construction, Contract C-1, #53, October 8, 1953. © Edwards Bishop Studios. TC4.07/series 1277. Mass Archives. Boston, Massachusetts; (Bottom) Massachusetts State Archives. Folder: 1277 Trans + Const / Public Works / Public Info / Expressway Construction Contract Photographs #22.

Page 21: Mass State Archives. Transportation/Construction, Public Works and Highway Construction Division, Contract Photographs. Box 1, J.F. Fitzgerald Expressway Construction, Contract C-1, #36, June 28, 1952. © Tele-Ad Corp. TC4.07/series 1277. Mass Archives. Boston, Massachusetts.

Page 22: (Top and bottom) Courtesy Mass State Archives. 1277X TRANS + CONST Public Works/ Public Info Expressway Construction Contract Photographs.

Page 23: (Top and bottom) Courtesy Mass State Archives. 1277X TRANS + CONST Public Works/ Public Info Expressway Construction Contract Photographs.

Pages 24-25: Courtesy of the Boston Public Library, Leslie Jones Collection.

Page 26: (Top) Courtesy of the Boston Public Library, Leslie Jones Collection; (Bottom) © Massachusetts Institute of Technology, Courtesy of MIT Libraries, Visual Collections; Photograph by Nishan Bichajian.

Page 28: Urban Redevelopment Division, Boston Housing Authority photographs in Boston Redevelopment Authority photographs, Collection # 4010.001, City of Boston Archives.

Page 29: © Massachusetts Institute of Technology, Courtesy of MIT Libraries, Visual Collections; Photograph by Nishan Bichajian.

Pages 30-31: Library of Congress, Prints & Photographs Division, Visual Materials from the NAACP Records.

Page 32: Courtesy of the Boston Public Library, Leslie Jones Collection.

Page 33: (Bottom left) Courtesy of Northeastern University, Boys and Girls Clubs of Boston, Inc. collection.

Pages 34-35: Urban Redevelopment Division, Boston Housing Authority photographs in Boston Redevelopment Authority photographs, Collection #4010.001, City of Boston Archives.

Page 36: Law Department records, Collection #0700.007, City of Boston Archives, Boston.

Page 37: (Top and bottom) Courtesy of the Boston Public Library, Leslie Jones Collection.

Page 38: Transportation/Construction, Public Works and Highway Construction Division, Contract Photographs. Box 1, J.F. Fitzgerald Highway Construction, Contract C-1, #31, June 2, 1952. © Tele-Ad Corp. TC4.07/series 1277. Mass Archives. Boston, Massachusetts.

Page 39: Courtesy of the Boston Public Library, Leslie Jones Collection.

Page 40: (Top and bottom) © the Nick DeWolf Foundation.

Page 41: Courtesy of the Boston Public Library, Leslie Jones Collection.

Pages 42-43: Courtesy of the Boston Public Library, Leslie Jones Collection.

Page 44: Courtesy Massachusetts Archives. Boston, Massachusetts.

Page 45: Urban Redevelopment Division, Boston Housing Authority photographs in Boston Redevelopment Authority photographs, Collection #4010.001, City of Boston Archives.

Page 46: (Top left) © the Nick DeWolf Foundation.

Page 47: (Bottom) Courtesy of Northeastern University, Boys and Girls Clubs of Boston, Inc. collection.

Pages 48-49: Courtesy of the Boston Public Library, Leslie Jones Collection.

Page 51: (Top) © the Nick DeWolf Foundation; (Bottom) National Archives and Records Administration.

Page 52: © Massachusetts Institute of Technology, Courtesy of MIT Libraries, Visual Collections; Photograph by Nishan Bichajian.

Page 53: © Massachusetts Institute of Technology, Courtesy of MIT Libraries, Visual Collections; Photograph by Nishan Bichajian.

Pages 54-55: © Massachusetts Institute of Technology, Courtesy of MIT Libraries, Visual Collections; Photograph by Nishan Bichajian.

The 1960s

Page 57: Charles Frani Photo Courtesy of the West End Museum.

Pages 58-59: Library of Congress, Prints & Photographs Division, HABS MASS, 13-BOST, 98—1.

Page 64: Library of Congress, Prints & Photographs Division, HABS MASS, 13-BOST, 34—3

Page 65: Library of Congress, Prints & Photographs Division, HABS MASS, 13-BOST, 54—6.

Pages 66-67: Photos courtesy Mayor John F. Collins records, Collection #0244.001, City of Boston Archives.

Pages 68-69: Charles Frani Photos Courtesy of the West End Museum.

Page 70: Charles Frani Photos Courtesy of the West End Museum.

Page 71: (Top) Charles Frani Photo Courtesy of the West End Museum; (Bottom) Boston Landmarks Commission image collection, Collection 5210.004, City of Boston Archives.

Pages 72-73: Charles Frani Photos Courtesy of the West End Museum.

Page 74: Mayor John F. Collins records, Collection #0244.001, City of Boston Archives.

Page 75: (Top) Charles Frani Photo Courtesy of the West End Museum; (Bottom) Copyright City of Boston, Boston Redevelopment Authority photographs, Collection # 4010.001, City of Boston Archives.

Pages 76-77: Copyright City of Boston, Boston Redevelopment Authority photographs, Collection # 4010.001, City of Boston Archives.

Page 78: (Top) Boston Redevelopment Authority photographs, Collection #4010.001, City of Boston Archives; (Bottom) Mayor John F. Collins records, Collection #0244.001, City of Boston Archives.

Page 79: (Top and bottom) Copyright City of Boston, Mayor John F. Collins records, Collection #0244.001, City of Boston Archives.

Page 80: Copyright City of Boston, Courtesy of the Boston Redevelopment Authority.

Page 82: (Top and bottom) Courtesy of Northeastern University, Boys and Girls Clubs of Boston, Inc. collection.

Page 83: Copyright City of Boston, Courtesy of the Boston Redevelopment Authority.

Pages 84-85: Copyright City of Boston, Courtesy of the Boston Redevelopment Authority.

Page 86: Copyright City of Boston, Courtesy of the Boston Redevelopment Authority.

Page 87: (Top, center, and bottom) City of Boston, Courtesy of the Boston Redevelopment Authority.

Page 88: (Bottom left) Boston Redevelopment Authority photographs, Collection # 4010.001, City of Boston Archives. (Bottom right) Copyright City of Boston, Courtesy of the Boston Redevelopment Authority.

Page 89: (Top) Copyright City of Boston, Courtesy of the Boston Redevelopment Authority.

Page 90: (Top and bottom) Copyright City of Boston, Courtesy of the Boston Redevelopment Authority.

Page 91: (Top and bottom) Copyright City of Boston, Courtesy of the Boston Redevelopment Authority.

Pages 92-93: Library of Congress, Prints & Photographs Division, HABS.

Page 94: (Top right) Courtesy West End Museum.

Page 95: (Top left) Mayor John F. Collins records, Collection #0244.001, City of Boston Archives; (Bottom) Courtesy West End Museum.

Page 96: (Top) City Planning Board photographs, Boston Landmarks Commission image collection, Collection #5210.004, City of Boston Archives.

Pages 102-03: Photos © the Nick DeWolf Foundation.

Page 104: (Top left) Courtesy West End Museum; (Bottom) Copyright City of Boston, Boston Landmarks Commission image collection, Collection 5210.004, City of Boston Archives.

Page 105: (Top left) Copyright City of Boston, Boston Redevelopment Authority photographs, Collection # 4010.001, City of Boston Archives, Boston; (Top right) Boston Landmarks Commission image collection, Collection 5210.004, City of Boston Archives, Boston; (Bottom) Copyright City of Boston, Boston Landmarks Commission image collection, Collection 5210.004, City of Boston Archives, Boston.

Pages 106-07: Copyright City of Boston, Mayor John F. Collins records, Collection #0244.001, City of Boston Archives, Boston.

Page 110: (Top) Courtesy Massachusetts State Archives.

Page 111: Copyright City of Boston, Mayor John F. Collins records, Collection #0244.001, City of Boston Archives.

Page 112: (Top) Courtesy West End Museum.

Page 113: Copyright City of Boston, Mayor John F. Collins records, Collection #0244.001, City of Boston Archives, Boston.

Page 115: Copyright City of Boston, Courtesy of the Boston Redevelopment Authority.

Page 118: (Top) © the Nick DeWolf Foundation.
Page 119: (Top right) © the Nick DeWolf Foundation.

Pages 120-21: Library of Congress, Prints & Photographs Division, HABS MASS, 13-BOST, 99—2.

The 1970s

Pages 124-25: Courtesy National Archives and Records Administration.

Pages 126-27: © the Nick DeWolf Foundation.

Page 129: Courtesy National Archives and Records Administration.

Page 132: © the Nick DeWolf Foundation.

Page 133: Courtesy National Archives and Records Administration.

Page 134: (Top) © the Nick DeWolf Foundation.

Page 135: (Bottom) Courtesy National Archives and Records Administration.

Page 136-37: Photos courtesy National Archives and Records Administration.

Pages 138-39: © the Nick DeWolf Foundation.

Page 140: (Top) Courtesy National Archives and Records Administration.

Page 141: (Top) © the Nick DeWolf Foundation.

Page 146: (Top and bottom) Boston Landmarks Commission image collection, Collection 5210.004, City of Boston Archives.

Pages 150-51: Photos courtesy National Archives and Records Administration.

Pages 152-53: Photos © the Nick DeWolf Foundation.

Page 154: (Bottom right) Copyright City of Boston, Courtesy of the Boston Redevelopment Authority.

Pages 156-57: © the Nick DeWolf Foundation.

Page 158: (Top) © the Nick DeWolf Foundation; (Bottom left) Courtesy National Archives and Records Administration; (Bottom right) © the Nick DeWolf Foundation.

Page 159: (Top) © the Nick DeWolf Foundation; (Bottom) Courtesy National Archives and Records Administration.

Page 160: (Top left) Courtesy National Archives and Records Administration.

Pages 162-63: Photos courtesy National Archives and Records Administration

Page 166: Boston Landmarks Commission image collection, Collection 5210.004, City of Boston Archives.

Page 167: (Bottom) Courtesy National Archives and Records Administration.

Page 178: (Bottom) Courtesy National Archives and Records Administration.

Page 179: (Bottom) Peter H. Dreyer slide collection, Collection #9800.007, City of Boston Archives.

Page 180: (Right) Courtesy City of Boston Archives.

Page 183: (Top left) Courtesy National Archives and Records Administration; (Top right and bottom) Courtesy Northeastern University, Archives and Special Collections Department.

Pages 194-95: Courtesy National Archives and Records Administration.

The 1980s

Pages 209-11: Photographs by David Henry © 2014, www.davidphenry.com.

Page 216: Photos courtesy of the Boston Public Library.

Pages 218-19: Photographs by David Henry © 2014, www.davidphenry.com.

Page 222: Mayor Raymond L. Flynn records, Collection #0246.001, City of Boston Archives.

Page 225: (Bottom) Photograph by David Henry © 2014, www.davidphenry.com.

Page 228: (Top) Photograph by David Henry © 2014, www.davidphenry.com.

Page 229: (Bottom right and left) Peter H. Dreyer slide collection, Collection #9800.007, City of Boston Archives.

Page 231: (Top and bottom) National Archives and Records Administration.

Page 232: (Bottom) Mayor Raymond L. Flynn records, Collection #0246.001, City of Boston Archives.

Page 233: Mayor Raymond L. Flynn records, Collection #0246.001, City of Boston Archives, Boston.

Page 234: Mayor Raymond L. Flynn records, Collection #0246.001, City of Boston Archives, Boston.

Page 238: Mayor Raymond L. Flynn records, Collection #0246.001,City of Boston Archives.

Page 239: BC0000169, John. J. Burns Library, Boston College.

Page 240: (Bottom) Boston Landmarks Commission image collection, Collection 5210.004, City of Boston Archives.

Page 241: (Top left) Boston Landmarks Commission image collection, Collection 5210.004, City of Boston Archives.

Pages 244-45: Photos courtesy Mayor Raymond L. Flynn records, Collection #0246.001, City of Boston Archives.

Pages 246-47: Photographs by David Henry © 2014, www.davidphenry.com.

Pages 250-51: Photograph by David Henry © 2014, www.davidphenry.com.

Page 254: Photograph by David Henry © 2014, www.davidphenry.com.

Page 257: (Top) Mayor Raymond L. Flynn records, Collection #0246.001, City of Boston Archives.

Pages 258-59: Photographs by David Henry © 2014, www.davidphenry.com.

Pages 262-63: Photographs by David Henry © 2014, www.davidphenry.com.

Page 264: (Top left and right) Peter H. Dreyer slide collection, Collection #9800.007, City of Boston Archives.

Page 266: Photographs by David Henry © 2014, www.davidphenry.com.

Page 268: Library of Congress, Prints & Photographs Division, HABS MASS; 13-BOST; 118.

Page 269: Library of Congress, Prints & Photographs Division, HABS MASS; 13-BOST; 101—19.

Page 270: Photograph by David Henry © 2014, www.davidphenry.com.

Page 271: Courtesy of the Boston Public Library.

Page 273: Mayor Raymond L. Flynn records, Collection #0246.001, City of Boston Archives, Boston.

Back Matter

Page 276: (Left to right) Courtesy Nicole Vecchiotti; Courtesy Fenway News; Courtesy National Archives and Records Administration; Photo by Stephen W. Quinn.

Pages 278-79: Courtesy Boston Public Library.

Page 284: Photo by Elizabeth Budington.

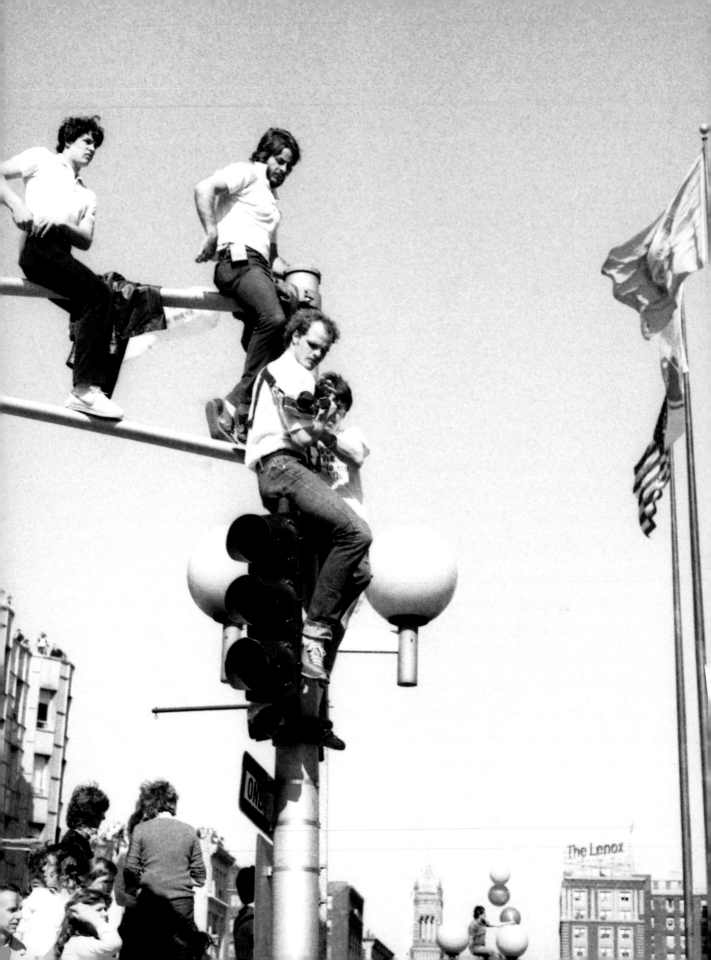